WHAT WE MADE

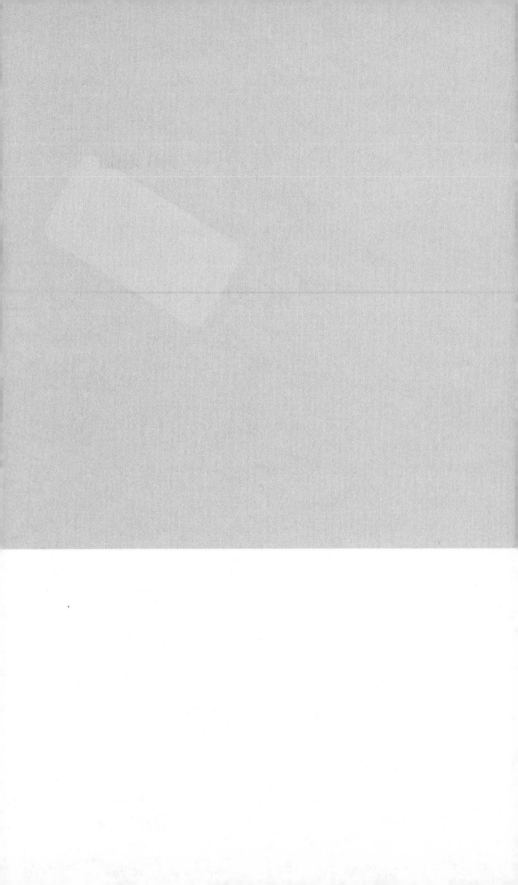

WHAT WE MADE

Conversations on Art and Social Cooperation

TOM FINKELPEARL

DUKE UNIVERSITY PRESS DURHAM & LONDON 2013

© 2013 Duke University Press
All rights reserved
Printed in the United States of America on acid-free paper ∞
Designed by Jennifer Hill
Typeset in Arno Pro by Tseng Information Systems, Inc.

Library of Congress Cataloging-in-Publication Data appear
on the last printed page of this book.

This book is dedicated to my most inspiring teachers:

> Jeff Weiss, *middle school science*
>
> Nancy Sizer, *high school composition*
>
> Richard Rorty, *undergraduate philosophy*
>
> James Rubin, *undergraduate art history*
>
> Alice Aycock, *graduate school sculpture*

They were often way off the (narrowly imagined) subject, so each one taught me far more than the curriculum might have predicted.

CONTENTS

PREFACE

IN THE FALL OF 1984, Group Material arrived at P.S.1, where I was work-
ing to install "Artists Call against U.S. Intervention in Central America."
Building the show was an interactive process; in the gallery the collec-
tive (which then comprised Tim Rollins, Julie Ault, and Doug Ashford)
worked with a couple of dozen other artists both physically and intellec-
tually to interweave art and political commentary into a forceful and de-
pressing timeline. During this process I asked Tim Rollins if he had a piece
in the show. He pointed out some painted bricks and said that he had
helped create them in collaboration with several young men and women
who were also in the galleries working on the installation. He identified his
collaborators as the "Kids of Survival" and told me that they had recently
been working together on a number of projects in the Bronx. I admired
the bricks, but I asked him if, aside from the collaboration, he had any
time to do his own work. Rollins told me his work was a contribution to
their collective work. I found the idea energizing, and twenty-seven years
later I still do. In 1987, along with Glenn Weiss, I organized a show at P.S.1
called "Out of the Community, Art with Community." That project intro-
duced me to Bolek Greczynski and his work at Creedmoor Psychiatric
Center, Mierle Laderman Ukeles's work with the New York City Sanita-
tion Department, and the ongoing debates surrounding cooperative art
that I have found fruitful and confusing ever since.

In 2003, as we were preparing for her exhibition at the Queens Museum
of Art, Wendy Ewald was telling me about her collaborative photography
and its reception. She said that after more than three decades of work, she
still sensed a profound misunderstanding of what she and her peers were
up to. Even after considerable critical writing on artistic cooperation, ex-
change, and artistic participation, people still ask her if the collaborations
are all she does, or if she has time for her own work. I cringed, remember-
ing my own question to Tim Rollins. We agreed that a book specifically on
socially cooperative art might be helpful.

With Sondra Farganis we gathered a group of colleagues for a one-day
symposium at the Vera List Center for Art and Politics at the New School
for Social Research. The discussion circled around a series of the most
important issues, in particular the ethics and aesthetics of collaboration.

After the conference Brett Cook, Wendy Ewald, and I continued our discussions regarding a possible publication and developed the format of this book: an introductory text setting a framework for cooperative practice inside and outside artistic traditions, followed by a series of conversations between artists and an array of thinkers from social history, aesthetics, political science, urban planning, education, and other fields. Since the conceptual, intellectual, social, and physical sites of these projects are so complex, it is helpful to look outside of the discourse of art criticism for new perspectives. And why not use conversation as a structure of a book on interactive, conversational, dialogue-driven art? Nine years later the project is complete. So first, thanks to Wendy and Brett for those generative early conversations and for the ongoing discussions that have followed.

I would like to thank Ken Wissoker and Jade Brooks at Duke University Press. Ken has been intelligent, patient, good humored, and encouraging while guiding me through the publication process. Jade was responsive and enthusiastic in every query and request. For Duke, Judith Hoover was a superb copyeditor with amazing attention to detail. The anonymous readers to whom Duke sent the manuscript were immensely helpful in this project. The review process can be a bit humbling, but it is what makes university press books consistently worth reading. The designer, Jennifer Hill, did a wonderful job making it all look great.

Prior to final submission of the manuscript I worked with Nell McLister, who is a truly excellent editor, and her invisible hand is on every page. Ricardo Cortes was a promising research assistant before his own book hit the bestseller list, but Adrianne Koteen stepped in and did a stellar job in his place. It really helped that Adrianne is so deeply steeped in the subject matter. Writing a book, even one filled with conversations, is essentially a solitary pursuit. I spent many long days at the computer overlooking the beach in Rockaway, Queens, breaking only for a Greek salad at the Last Stop Diner. The staff there was encouraging, and that mattered.

Finally, I want to thank my wife, Eugenie Tsai, for her cheerful support when I was off at the beach writing or editing and when I was running ideas by her over almost a decade. That might have been a bit tiresome, but she never let on. Her intelligent and honest insights were always on the mark.

ONE INTRODUCTION

The Art of Social Cooperation
An American Framework

Definition of Terms

Consider two art projects.

November 1986. At dusk on a fall evening, you are approaching a tan brick building on the grounds of Creedmoor Psychiatric Hospital at the far end of Queens. In this season, at this time of night, the hospital's campus looks very much like the state mental institution it is. But Building 75 has been renamed the Living Museum with a brightly colored sign. It is home to the *Battlefields Project*, a series of art installations that a group of patients has been working on for several years with the Polish-born actor and conceptual artist Bolek Greczynski, who is by this time fully ensconced as Creedmoor's artist-in-residence. You walk into the building, through a lush garden of natural and artificial plants, through the workroom where refreshments are being served, and into the "museum" proper.

The four corner rooms of the ten-thousand-square-foot space are devoted to installations that address the subjects of hospital, church, workplace, and home, four battlefields in the lives of the participants in this venture. The hallways and antechambers between these rooms are filled with art that ranges from haunting images one might expect from the mentally ill, to hard-edge minimalist painting on the floors and walls, to art that is competent in a rather commercial-realist style. There is a chess table dedicated to Marcel Duchamp, an overflowing bin of memos from Creedmoor's health care bureaucracy, and a book in which every line has been carefully crossed out.

At first you feel the need to determine the mental health status of each person you encounter. A woman clad in skin-tight leather and spike heels introduces herself improbably as Greczynski's dentist (this fact is later confirmed). You meet a young man from the lockdown unit attired in a

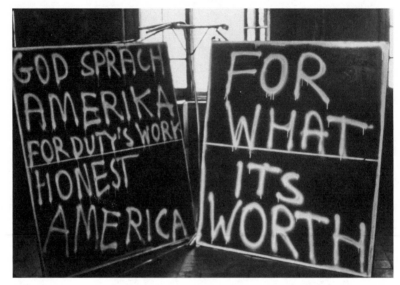

A short poem spray-painted on two sheets of plywood in a corner of the Living Museum at Creedmoor Psychiatric Center, 1986. Photographs of the project generally do not include the participants because psychiatric patients are not considered competent to agree to photograph releases. Photograph by Tom Finkelpearl.

three-piece suit. Another guy who looks like a doctor could just as easily be a patient. The crowd assembled for the occasion includes an assortment of Greczynski's eccentric, theatrical, art world, club world, outsider, and insider friends mixed with doctors, patients, and their families — so the distinctions are challengingly ambiguous at first but become less urgent as the evening progresses. The museum has been created in a complex series of interactions between Greczynski and a changing group of patients (hundreds have participated). But Greczynski will not call them patients. In the Living Museum they are artists. He does not see their work as symptomatic of their mental illness, he explains, but as a testament to their "strength and vulnerability." He sees their sensitivity, which may have forced them into this institutional setting, as an asset for an artist. The doctors tell you that for these patients, having the opportunity to assume the identity of an artist has therapeutic value, but Greczynski is suspicious of this approach, siding with the patient against the controlling institutions of therapy and the interpretation of art as a symptom — even as a symptom of healthy progress. After several hours you drive off, acutely aware that there are those who are left behind.

Mayor Michael Bloomberg of New York City speaking at a press conference in Times Square launching Paul Ramirez Jonas's *Key to the City*, 2010. The project was presented by Creative Time in cooperation with the City of New York. Photograph by Meghan McInnis. Courtesy of Creative Time.

Patrick Li (left) and friends exchanging keys as part of *Key to the City* by Paul Ramirez Jonas (center), 2010. Photograph by Meghan McInnis. Courtesy of Creative Time.

Spring 2010. Having received an intriguing email blast from Creative Time, a public art organization, you arrive in Times Square to experience a project by Paul Ramirez Jonas called *Key to the City*. You know little about what to expect except that it will be based on the longtime New York tradition of the mayor awarding a symbolic key to notable visitors and public heroes. You are informed that you will need a partner for a key award ceremony, and you pair up with a young woman, Annie, who has also arrived solo. You get in line with Annie (and a couple of hundred others), and you are instructed to fill in the blanks on the first two pages of a passport-size booklet that gives a bit of background. You and Annie chat as you decide why to honor each other with a key to the city. When you have arrived at the "Commons" area created for the event, she reads out the text: "I, Annie, on this third day of June, bestow the key to the city to you, being a perfect stranger, in consideration of your spirit. Do you accept this key?" Yes, you do. "Then, by the power temporarily granted to me and this work of art, I, Annie, award you this key to the city." She hands you the booklet and a key that is inscribed with a small drawing of hands exchanging keys. You reciprocate, reading the formal text and handing her the booklet that you have inscribed, and that is the last you see of Annie.

The project's key is the opposite of the traditional key to the city: anyone can get one, and it is not merely symbolic. Over the next couple of months the key unlocks doors, closets, gates, display cases, and so on, at

twenty-four sites indicated in the booklet. One afternoon you take the 7 train to Corona, Queens, and visit the Louis Armstrong House Museum, where the key opens the door to Armstrong's private bathroom. Then you walk over to the Tortilleria Nixtamal, where, remarkably, the key opens up the downstairs kitchen and you receive a lesson in taco making. Over twenty sweaty minutes you also learn how a tortilla kitchen in Corona operates: hot, fast, and in Spanish. As you make your way around the city, you see sites that are normally hidden and meet the New Yorkers behind the doors. The work becomes something of the talk of the town, as more than fifteen thousand people participate.

———

While both art projects were participatory, there were substantial differences. Both the Living Museum and *Key to the City* fall under the rubric of what is variously dubbed participatory, interactive, collaborative, or relational art. However, in recent texts on this sort of art, critics tend to distinguish between projects that are designed by artists and projects that are created through dialogue and collaboration with participants. For example, Grant Kester, an art historian at the University of California, San Diego, differentiates between collaborative, "dialogical" works and projects based on a scripted "encounter."[1] Claire Bishop, an art historian at City University of New York, identifies "an authored tradition that seeks to provoke participants and a de-authored lineage that aims to embrace collective creativity."[2] And the critic and curator Claire Doherty describes "those practices which, though they employ a process of complicit engagement, are clearly initiated and ultimately directed by the artist . . . and those which, though still often authored by the artist or team, are collaborative—in effect 'social sculpture.'"[3]

As Kester points out, the categories of the scripted encounter and the de-authored, dialogical collaboration are generalizations, and perhaps it would be more useful to describe a spectrum of activity rather than draw such a clear line between practices.[4] On this spectrum, *Key to the City* would tend toward the scripted encounter, while the Living Museum leans toward the dialogue-based tradition of works created collectively. Greczynski created a platform for the creativity of the patients at Creedmoor, while Ramirez Jonas sent the participants on a well-planned series of encounters. *Key to the City* was clearly a work by Paul Ramirez Jonas, though the individual participants—both the key holders and those who welcomed them to each site—took an active role. You were the actor, and

there were no spectators. The text you read in Times Square was prepared by the artist. As you traversed the city to the other sites, the interactions were considerably looser, but you were still on a route between access points prepared by Ramirez Jonas. On the other hand, the Living Museum was created in a long-term interactive process that was orchestrated (rather than authored) by Greczynski. The art projects that composed the Living Museum were created by Creedmoor patients working many hours a week over many years, interspersed with an occasional painting by Greczynski. The project was made by the group—hence the title of this book, *What We Made*.

When you visited an open house at Creedmoor, you seemed somewhat peripheral to the main event, which only Greczynski and the patient-artists experienced—an event that unfolded very slowly in a decidedly closed house. You got only a glimpse; you were welcomed as a temporary guest. This split between the collective creation of the art and the viewing and experiencing public is present in a number of projects discussed in this book. Importantly, the issue of social benefit was closer to the surface in the Living Museum than in *Key to the City*. Though Greczynski resisted the therapeutic interpretation of his project, the open and relaxed atmosphere at the Living Museum gave the tangible sense of a curative space for the mentally ill. While one can easily point to political meaning in the ways Ramirez Jonas opened up the city and in the democratization of an elitist tradition, there was no sense that the project was meant to turn around the life of its participants.

Walking through Building 75 at Creedmoor, the audience—art critics, psychologists, patients—had a hard time understanding the overall environment as an aesthetic project. Two decades later *Key to the City* unfolded in an art-historical context that has come to allow for an interactive moment in public space as an artistic product worthy of analysis. But the language surrounding the practice is still up for grabs. In her article "The Social Turn: Collaboration and Its Discontents," published in *Artforum* in 2006, Claire Bishop notes that there is a range of names for the activist wing of the less-authored practice, including "socially engaged art, community-based art, experimental communities, dialogic art, littoral art, participatory, interventionist, research-based, or collaborative art."[5] For the sake of that article, she settled on the term *social collaboration*. I would agree with Bishop's use of the word *social*. Though no word can sum up the efforts of any group of artists, the word *social*—as in social encounters across social classes—helps locate this practice in an experiential and

intellectual realm that also includes social studies, social work, and social housing.

However, I favor the term *social cooperation* over Bishop's *social collaboration.* There are three main reasons for this. First, in art criticism, *collaboration* often refers to teams such as Gilbert and George or collectives such as Group Material. It implies a shared initiation of the art, and start-to-finish coauthorship. We have no clue what Gilbert or George has independently contributed to one of their photographs, or what Doug Ashford, Julie Ault, Tim Rollins, or Felix Gonzalez-Torres individually contributed to a given Group Material installation. And even if we do understand that W. S. Gilbert wrote the words and Arthur Sullivan composed the music, there is a clear acknowledgment of equal coauthorship in a Gilbert and Sullivan opera. For many of the projects discussed in this book, collaboration is simply too far-reaching a claim to make; not all of the participants are equally authors of these projects, especially in the initiation and conceptualization. *Cooperation,* on the other hand, simply implies that people have worked together on a project. Even the projects on the de-authored side of the spectrum involve a self-identified artist who can claim the title of initiator or orchestrator of the cooperative venture, including the projects in which little or none of the final product is by his or her own hand. Second, calling the work *cooperative* situates the practice in the intellectual zone of human cooperation. There has been significant research in recent decades in the fields of evolutionary game theory, rational and irrational choice theory, theories of reciprocity and altruism, the new cognitive science of interconnection, and evolutionary economics. While acknowledging that human beings are territorial and aggressive animals, many in these fields are beginning to understand in what ways we are also a hypercooperative species.[6] Third, understanding what social cooperation means to John Dewey and other pragmatists has helped elucidate these artists' work for me, which I discuss in the conclusion. So for the sake of this book, I call the Living Museum and projects like it "socially cooperative," and works like *Key to the City* "participatory" or "relational." This is not meant to be a value judgment. There are trivial and profound projects throughout the spectrum, and both the Living Museum and *Key to the City* struck me as brilliant and provocative in their own right. Most of the projects in this book, however, lean toward the socially cooperative, works that examine or enact the social dimension of the cooperative venture, blurring issues of authorship, crossing social boundaries, and engaging participants for durations that stretch from days to months to years.

An American Framework

While this book focuses on an American perspective, I try not to define too narrowly what it means to be an American artist. A number of the interviewees were born abroad but live in the United States now, including Pedro Lasch, Tania Bruguera, Lee Mingwei, Teddy Cruz, and Ernesto Pujol. Evan Roth was brought up here but lives in France. In fact at this point in the country's history, it would be inaccurate to represent cooperative art practice in America without a considerable representation of immigrant artists. But first let us take a couple of steps back and consider a framework for the development of this practice here in the United States.

Historical Context: Social Movements in the 1960s

These practices, of course, have a history. In my conversations with progressive activists and artists, one after another they mention that they participated in, based their techniques on, or drew inspiration from the spirit of the 1960s, particularly the civil rights movement, the counterculture, and feminism. Some of the social relations and democratic institutions created in those movements during that period were mirrors of the socially cooperative art that was simultaneously emerging. In the 1960s there were competing models of negotiation and conflict within progressive political movements. In his essay "The Phantom Community," published in 1979, the Princeton sociologist Paul Starr distinguishes between two broad categories of counterinstitutions that developed during that period:

> An exemplary institution, such as a utopian community or consumers' cooperative, seeks, as the term suggests, to exemplify in its own structure and conduct an alternative set of ideals. . . . Compared with established institutions, it may attempt to be more democratic in its decision-making, or less rigid and specialized in its division of labor, or more egalitarian in its distribution of rewards. . . . In contrast, an adversarial institution, such as a political party, a union, or a reform group, is primarily concerned with altering the social order. Oriented toward conflict, it may not exhibit in its own organization all the values that its supporters hope eventually to realize.[7]

In Starr's dichotomy, cooperative action is associated with the egalitarian and democratic *exemplary* institutions, while conflict is associated with the *adversarial* groups. But the dialectic is not rigid, and Starr points out that some of the most famous adversarial groups in the 1960s also

sought to be exemplary. He cites, for example, conflict-friendly community organizing within the civil rights movement, as well as Students for a Democratic Society (SDS), which was adversarial in many of its tactics but engaged in "extremes of participatory democracy" in an attempt to exemplify the changes that it was fighting for in society.[8] It is the practices of exemplary groups like these that resemble most closely the practices of socially cooperative artists.

Civil Rights and Community Organizing

A number of the artists in this book cite the civil rights movement as an inspiration, including Wendy Ewald, who was stirred by the black power movement in Detroit as a kid; Brett Cook, who cites civil rights ideology; and Rick Lowe, who participated in African American activism in Houston.[9] But in the 1960s the civil rights movement was divided between the rhetoric of collective action most eloquently presented by Martin Luther King Jr. and a more radical politics of confrontation espoused by leaders like Stokely Carmichael and Malcolm X. Cook refers in his interview (chapter 10) to King's principle of a "network of mutuality," a term he often used, including in his final Sunday sermon on March 31, 1968, five days before he was assassinated: "Through our scientific and technological genius we have made of this world a neighborhood, and yet we have not had the ethical commitment to make of it a brotherhood. . . . We must all learn to live together as brothers. Or we will all perish together as fools. We are tied together in the single garment of destiny, caught in an inescapable network of mutuality."[10] King's goal is not only economic justice but interpersonal interconnection, a model of anti-individualist mutuality. Steeped in Gandhian nonviolence and a Christian ethic of brotherhood, King sees this mutuality as both desirable and inevitable. We are not only seeking interconnection, we are "caught" in this "inescapable network." But by the mid-1960s alternative voices were emerging. The Student Nonviolent Coordinating Committee (SNCC) was morphing into an increasingly radical counterinstitution. It had hailed the power of "redemptive community" in its Statement of Purpose in 1960 and had recruited countless northerners to engage in cooperative organizing in the South in the early 1960s.[11] But an SNCC memo from 1964 shows a growing frustration with the personal, self-actualizing impulse of some who were joining the civil rights fight. Lamenting their "bourgeois sentimentality," the memo notes, "Some of the good brothers and sisters think our business is the spreading of 'the redemptive warmth of personal confrontation,' 'emotional enrich-

The civil rights march from Selma to Montgomery, Alabama, in 1965. Photograph by Peter Pettus. Courtesy of Prints and Photographs Division, Library of Congress.

ment,' 'compassionate and sympathetic personal relationships,' and other varieties of mouth-to-mouth resuscitation derived from the vocabulary of group therapy and progressive liberal witch doctors."[12] Here the philosophy of cooperation is described as unsuited to the urgent work of resisting oppressive racism. This critique of cooperative action as accommodation and compromised liberalism is still leveled at socially cooperative projects, be they political or artistic.

But as Paul Starr points out, exemplary institutions were not limited to redemptive warmth and sympathetic relationships with those outside the group. Saul Alinsky, whose ideas took shape in the civil rights struggle, came to epitomize American community organizing. A hero of the non-communist Left, Alinsky was a pragmatist interested in what works for poor communities. In his book *Reveille for Radicals*, published in 1946, he outlines his strategies, which address many of the issues that cooperative art confronts. For Alinsky, the community organizer is a facilitator of social interplay out of which emerges the "people's program." His ideal organizer has faith in the ability and intelligence of the people to imagine a solution to their own problems. He wrote, "*After all, the real democratic program is a democratically minded people*—a healthy, active, participating, interested, self-confident people who, through their participation and

Saul Alinsky addressing a crowd before a meeting in Flemington, New Jersey, 1967. He was working with the coalition FIGHT (Freedom, Integration, God, Honor, Today) as part of an effort to promote racially diverse hiring practices at Kodak Corporation, whose shareholders meeting was taking place in Flemington at the time. Photograph courtesy of AP Photo.

interest, become informed, educated, and above all develop faith in themselves, their fellow men, and the future."[13] Alinsky does not deny the community organizer's pivotal role, especially at the initial stages of mobilization, but he insists that the action must come from the people themselves. After an additional twenty-five years of experience, Alinsky wrote *Rules for Radicals* (1971), in which the ethic of mutual growth is clear: "An effective organizational experience is as much an educational process for the organizer as it is for the people with whom he is working. . . . We learn, when we respect the dignity of the people, that they cannot be denied the elementary right to participate fully in the solutions to their own problems. Self-respect arises only out of people who play an active role in solving their own crises and who are not helpless, passive, puppet-like recipients of private or public service."[14]

For Alinsky, the process of addressing the problem collectively is a major part of the organizing initiative. But he was far from an advocate of "redemptive warmth" or "emotional enrichment" for its own sake. He states quite clearly that "a People's Organization is a conflict group," and his strategy revolves around identifying issues, provoking conflict, and finding

winnable battles—seeking what he calls the "displacement and disorgani-
zation of the status quo."[15] Through tangible and specific local victories, he
hoped that the communities could rebalance power. It was *within* the or-
ganization, through the local identification of social complaints, through
the activation of the community members, through collective, coopera-
tive action that Alinsky helped facilitate what Starr would call exemplary
institutions that also seek actively to change the social order. Community
organization, undertaken on a massive scale by SNCC and articulated by
Alinsky, became a staple of social movements throughout the country.
Throughout this book you will hear about community participation, active
contribution, and learning while teaching, all crucial ingredients of com-
munity organizing and urban planning in the 1960s.

In 1969 Sherry Arnstein, an advisor to the federal government's De-
partment of Housing and Urban Development, wrote an influential essay,
"A Ladder of Citizen Participation," in which she argues that participation
in decision making is a cornerstone of a democratic society and that poor
communities have traditionally been denied power over the use of federal
funds in the United States. She lays out a hierarchy of forms of "citizen
participation," starting at the bottom with the least desirable approach and
ascending to the most desirable at the top:

8. Citizen Control
7. Delegated Power
6. Partnership
5. Placation
4. Consultation
3. Informing
2. Therapy
1. Manipulation

Arnstein calls manipulation "the distortion of participation into a pub-
lic relations vehicle by powerholders." Therapy occurs when the power-
ful try to "cure" the apparent pathologies of the powerless—for example,
teaching the impoverished how to control their kids. Informing citizens
about plans for their community with a "one-way flow of information"
fails to tap into local knowledge. Consultation is a step closer to drawing
on community knowledge, but "offers no assurance that citizen concerns
and ideas will be taken into account." Placation allows a token amount
of community input into the project design. Partnership invites citizens
into the decision-making process. When an urban renewal program gives

majority say in a project to the local community, it has delegated power. Finally, when power and funds go directly to a "neighborhood corporation with no intermediaries between it and the source of funds," citizen control has been achieved.[16] Arnstein takes pains to point out that the ladder is a simplification, but the article was widely read, and its ideology of participation clearly echoes Alinsky's. It is easy to see how this taxonomy might apply to projects in this book. For example, Harrell Fletcher's film (chapter 6) might be considered a partnership with the gas station owner Jay Dykeman, while Rick Lowe's *Project Row Houses* (chapter 5) could be an example of citizen control.

Arnstein's ladder is useful shorthand for a model of cooperative participation in the late 1960s: the less top-down the better. Critics might shudder at the application of this sort of chart to the evaluation of art; it is easy to imagine an art project that reaches the highest level of participation but remains simplistic aesthetically. The mere presence of deeply engaged community participation in an art project is not the final word on its merit, even if it is a great sign for community organizing. But the negative values on Arnstein's list tend to echo what critics decry in some community art projects: manipulation, decoration, tokenism, and therapy. In any case the civil rights movement and community organizing of the 1960s offer models of participatory action that still resonate in present-day community organizing, urban planning, and art — not to mention social justice movements worldwide.

The Movement and Participatory Democracy

The counterculture of the 1960s also created a range of important exemplary anti-institutions formulated on a model of participatory democracy. "The movement" was a catchall phrase for the activities of the counterculture, from antiwar protests to sexual liberation and alternative living arrangements. Many of the most important activists in the movement cut their teeth organizing in the South for SNCC, and the tactics and rhetoric of participatory liberation ripple through their actions and texts.

Students for a Democratic Society started primarily as a civil rights organization but increasingly focused on the antiwar movement as the decade progressed. One of its founding documents was the Port Huron Statement, drafted mostly by Tom Hayden in 1962. The document is a far-reaching indictment of the status quo in America, with discussions of foreign policy, workplace discrimination, industrialization, and other topics.

Of particular interest here, though, is the statement's position on partici-
patory action:

> In a participatory democracy, the political life would be based in several
> root principles:
> – that decision-making of basic social consequence be carried on by
> public groupings;
> – that politics be seen positively, as the art of collectively creating an
> acceptable pattern of social relations;
> – that politics has the function of bringing people out of isolation and
> into community, thus being a necessary, though not sufficient, means
> of finding meaning in personal life.[17]

Like Alinsky, Hayden et al. are arguing that only through social and politi-
cal participation can democracy and justice be achieved, and that partici-
pation is both a means and an end, that "the political order should serve to
clarify problems in a way instrumental to their solution." The Port Huron
Statement argues that the isolation of contemporary American social life
can be overcome and community can be created when private problems
"from bad recreation facilities to personal alienation" are "formulated as
general issues."[18] It is a matter not simply of experts understanding and
solving the problems of the world, but of citizens themselves actively
working in "public groupings" to address society's problems and make
decisions.

SDS sought to bring these ideals into reality through its own demo-
cratic structure, through community organizing (much of it in the North,
though little was successful) and mass participation in the peace move-
ment. Hayden states that the heritage for participatory democracy was
transmitted to SDS through John Dewey, who was a leader of the League
for Industrial Democracy (the original name of the organization that
would become SDS). He cites Dewey's notion that democracy is not only
a governmental form but also a mode of living and communicated experi-
ence.[19] I return to Dewey in the conclusion.

In his essay on the history of communes, Timothy Miller, a religion
professor at the University of Kansas, states that while communal living
has existed in many periods in American history, in the mid-1960s "com-
munitarian idealism erupted in what was to be by far its largest manifes-
tation ever."[20] In their book on communes, co-ops, and collectives, the
historian John Case and the Tufts University sociologist Rosemary Tay-

lor argue that communes were emblematic of a difference between the American Left in the 1930s and the New Left of the 1960s. Unlike their predecessors, the New Leftists sought to practice a politics of everyday life. Hence the problems inherent in work and family life "could not be solved by individuals acting alone; they were, as the New Leftists saw it, the common costs of life in capitalist America, and they therefore called for collective action. One fundamental concern of the movement, then, was to find new ways of living and working."[21] One of the most famous communal groups was the Diggers in San Francisco, and participatory art was at the center of their endeavor. Born out of the highly politicized San Francisco Mime Group, the Diggers were primarily interested in living freely as a group, creating live anarchic street experiences, and de-commodifying the alternative lifestyles of Haight-Ashbury, following the maxims "Do your thing" and "Create the condition you describe."[22] It is impossible to draw a line between their art and their life, though their Intersection Game, which casually snarled traffic, tended toward participatory theater, while their Free Food initiative leaned toward community support.

The Diggers' influence was felt strongly in New York, where Abbie Hoffman, Anita Hoffman, Jerry Rubin, Nancy Kurshan, and Paul Krassner founded the Youth International Party, known as the Yippies. Kurshan, Abbie Hoffman, and Rubin had been important members of SDS and were schooled initially through the organizing efforts of SNCC in the early 1960s. According to Michael William Doyle, a historian at Ball State University, the Yippies began as the New York Diggers but soon found their own vision. While the Diggers were interested in live participatory action, the Yippies were intent on disrupting public discourse with their provocative street actions, and they developed a complex form of guerrilla political theater.[23] Famously, at the New York Stock Exchange in 1967, fifteen free spirits organized by Abbie Hoffman tossed hundreds of one-dollar bills from the gallery above the stock exchange, creating several minutes of mayhem as the stockbrokers scrambled to pick up the cash from the floor. It was a well-publicized and embarrassing moment for the center of American commerce.

Hoffman claims in retrospect that a source for his actions was Antonin Artaud's book *The Theatre and Its Double* (1958), in which Artaud calls for a new "poetry of festivals and crowds, with people pouring into the streets." Hoffman describes the planning process as relatively anarchic: the Yippies would just divide up into groups and work on various proposed actions. In some cases the results were well-planned tactical media events,

Yippies visit the New York Stock Exchange. Abbie Hoffman (smiling, right) and Jerry Rubin (right with mustache) hold up a burning five-dollar bill. The crowd applauds the parting gesture outside the Stock Exchange on August 24, 1967. Photograph by Jack Smith/*New York Daily News* via Getty Images.

while others were free-form "be-ins." Many of these collectively imagined actions allowed onlookers to become involved. "If observers of the drama are allowed to interpret the act," writes Hoffman, "they will become participants themselves. . . . The concept of mass spectacle, everyday language, and easily recognized symbols was important to get public involvement." Some of the actions had a handful of participants, as at the Stock Exchange, while others had thousands or even tens of thousands, such as an alternative Easter action in Central Park.[24] The Yippies, joined by other activists and agitators, gained international recognition for their disruption of the Democratic National Convention in Chicago in 1968. The whole world was indeed watching as they exposed the brutal side of the Chicago police.

Hoffman correctly observed that the art world was not particularly interested in his theater. Like the other groups that he saw as his brethren (e.g., Bread and Puppet Theater, who were also regulars at the mass demonstrations), Hoffman was more concerned with public communication than art magazine press. He argues that the Museum of Modern Art's interest in Allan Kaprow's happenings and Pop art "while ignoring our brand of political theater just proves the connection between suc-

cessful artists and the rich."[25] But just as the Diggers created a communitarian utopia that has echoes in today's micro-utopias, the Yippies created a precedent for interventionist artists like the Yes Men, who would follow a couple of decades later.

Starr concludes that on an organizational level, "the counter-institutions unquestionably failed."[26] One commune after another closed its doors; SDS, always plagued by a lack of structure, collapsed amid rancorous dispute in 1969. The intermingling of personal life, political action, and idealistic group orientation comes up over and over in accounts of the 1960s, but perhaps most importantly (and successfully) in feminism. While the living experiments of the communes seem to have risen and fallen in cycles in American history, the feminist movement has been more or less relentless in the past century. The progressive ideologies and practices of the 1960s were well suited to energize a new wave of feminist thought and action that still reverberates in American culture.

Feminism and Political Performance

After the Second World War many middle-class Americans sought refuge from what they perceived to be cramped and crowded cities. In the most advanced car culture on the planet, it was less imperative to live close to the center, as the husband could commute to his job while the wife organized the home and raised the kids. Suburbanization was in full swing for the white middle class. There were contemporary critiques, including *The Split Level Trap* (1960), an analysis of the psychosocial environment of the suburbs, and Lewis Mumford's book *The City in History*, written a year later, which lamented the social conformity of the suburbs and the housewife's alienation from the social relations of the city within a monotonous, uniform, television-dominated existence.[27] But the role of women in this world was blasted open with the publication in 1963 of *The Feminine Mystique* by Betty Friedan. At once a well-published author and a suburban housewife, Friedan was reacting against what she saw as the rigid and constricting life that confined women to the home without outlets to develop an individual identity. She wrote, "The problem lay buried, unspoken, for many years in the minds of American women. It was a strange stirring, a sense of dissatisfaction, a yearning that women suffered in the middle of the 20th century in the United States. Each suburban wife struggled with it alone."[28] Only by naming the problem and shedding the oppressive gender role assigned to her, only by finding herself through creative work of her own, Friedan argued, could the new woman become confident, self-

aware, and capable of self-fulfillment. *The Feminine Mystique* became a bestseller, catapulting Friedan to public prominence and jump-starting Second Wave feminism.

The Feminine Mystique struck a chord of discontent, poking a hole in the prevailing image of the woman. But it was not an overall critique of the social trends in America, and it implicitly centered on women like Friedan herself: middle-class white suburbanites. Gerda Lerner (later to become an eminent historian at the University of Wisconsin) wrote to Friedan upon the publication of *The Feminine Mystique*, hailing the book but also arguing that the problems that individual women face cannot be solved "on the basis of the individual family." Lerner argued that solutions need to be framed in terms of the larger community and require "a system of social reforms [including] day care centers, maternity benefits, communized household services," and so on.[29] In fairness, as the Cerritos College historian Susan Oliver points out, much of this agenda was embraced by Friedan when she became president of the National Organization of Women.[30] In *Redesigning the American Dream* (1984), the Yale architecture professor Dolores Hayden argues that the "haven" created for women in the postwar period, the architecture and community planning of suburbanization, was a gendered sociopolitical and environmental nightmare. While Friedan saw the main oppressor of women as "chains in her own mind and spirit," others saw more systematic oppression, especially for women outside the comfort zone of the suburbs.

But as the 1960s progressed there emerged a group of women with the tools to take the critique further, with the birth of the women's liberation movement. In her book *Personal Politics* (1979), Sara Evans, a historian at the University of Minnesota, argues that the roots of the women's movement were in the civil rights movement and the New Left. Using copious examples, Evans argues that women learned firsthand about gender inequality by working in male-dominated groups like SNCC and SDS. Of particular importance in these organizations were new models of egalitarianism, including "the anti-leadership bias and the emphasis on internal process," "the theory of radicalization through discussions," and "the belief in participatory democracy," but many women steeped in liberation ideology and Second Wave feminist self-confidence recoiled at the movement's consistent blindness to or acceptance of sex discrimination.[31] (Accounts of the woman's role in the Diggers commune are no better.)[32] "What was required to produce a movement," says Evans, "was only for women to apply the new ideas directly to their own situation, to make the connections be-

tween 'the people' whom they sought to aid and themselves as women."[33] This connection was made, and a new liberation movement emerged.

A key factor of women's liberation was the group. The late 1960s saw the rise of feminist consciousness-raising through group interaction, a practice formalized by a collective called New York Radical Women (NYRW). In 1969 the feminist pioneer Carol Hanisch wrote an article, "The Personal Is Political," in the Redstockings journal *Feminist Revolution*. She was responding to critics, including mainstream political feminists and radicals like the SNCC activist quoted earlier, who ridiculed consciousness-raising as self-indulgent "mouth-to-mouth resuscitation." Hanisch made the argument that the collective act of discussing women's personal issues (e.g., "Which do/did you prefer, a girl or a boy baby, or no children and why?") was valid feminist practice that transcended self-interested therapy: "We discover in these groups that personal problems are political problems. There are not personal solutions at this time. There is only collective action for collective solution."[34] Hanisch's article was widely reprinted and passed around in the next several years, and the notion that the personal is political is considered by many to be the "single identifying mantra" of Second Wave feminists.[35] As Mary Ryan, a women's studies professor at the University of California, Berkeley, has written, "The first task of feminist scholars and activists was to dredge through their personal lives and women's everyday experiences for those issues which required publicity."[36]

Indeed the personal issues were publicized. According to Kathie Sarachild, a member of the NYRW, it was Hanisch who prompted the group to expand their consciousness-raising into the public realm, to go beyond a service or membership organization to what she called "zap" action on the model of SNCC. The most famous action undertaken by the group was a protest at the Miss America Pageant in 1968: about a hundred women picketed the event, then threw high-heeled shoes, girdles, *Playboy* and *Good Housekeeping* magazines, and other implements of what they called "female torture" into a "freedom trashcan."[37] According to Hanisch, the impetus for the Miss America action came from a classic NYRW consciousness-raising session. After talking about the powerful and conflicting emotions evoked by watching the beauty pageant on television, the group decided to take action. Hanisch wrote, "From our communal thinking came the concrete plans for the action. We all agreed that our main point in the demonstration would be that all women are hurt by

An early consciousness-raising session at the Women's Center in Greenwich Village, 1970. Photograph by Bettye Lane.

beauty competition—Miss America as well as ourselves. We opposed the pageant in our own self-interest, e.g., the self-interest of all women."[38] In a flyer that was handed out on the Atlantic City boardwalk the day of the Miss America action, the organizers referred to the event as "boardwalk-theater" and "guerrilla theater."[39] Like the Yippies' action at the New York Stock Exchange, the Miss America action received tremendous publicity, including front-page coverage in the print media. According to Hanisch, the protest "told the nation that a new feminist movement [was] afoot in the land."[40] If the personal was political, boardwalk theater helped make it public. Though these actions did not have a huge impact in the art press, artists were simultaneously adopting, adapting, and translating this sort of collectively imagined, cooperatively created political theater in the aesthetic realm, even as the aesthetics began to blur with social action. With the well-known and broadly inclusive participatory experiments and community organizing of the civil rights movement, the counterinstitutions and street theater of the movement, and the collectivism and political theater of feminism, the table had been set for the emergence of cooperative art practices.

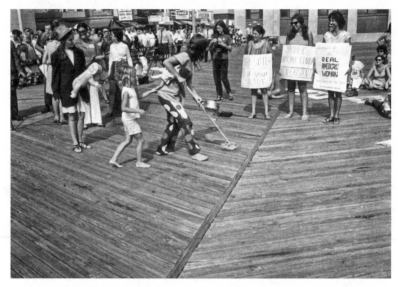

On the boardwalk in Atlantic City, New Jersey, New York Radical Women dispute the image of American women being presented at the Miss America pageant nearby. The action, which was suggested at a consciousness-raising session, gained national media attention in 1969. Photograph © Jo Freeman.

Pioneers in American Cooperative Art

Just as the publication of *The Feminine Mystique* in the early 1960s was a necessary precursor to the actions of the New York Radical Women toward the end of the decade, ideas in the Fluxus network were precursors to cooperative art that unfolded later. Fluxus intended to put an end to art reflecting the artist's ego in favor of ideas that were unprotected by copyright, often consisting of directions for actions that could be undertaken by anyone, thus allowing art into the realm of the everyday for the benefit of the people. If ultimately Fluxus failed to achieve its goal of integrating art and life, it nonetheless opened the door to a range of anti-individualistic, participatory art practices and provided early intellectual inspiration.

Fluxus was an international network that included important members in Europe and Asia, but for the most part it was centered around the self-appointed chairman, George Maciunas, in New York. In 1962 Maciunas proposed that art could "arrive at a closer connection to concrete reality" and that Fluxus "anti-art forms are primarily directed against art as a profession, against the artificial separation of producer and performer,

or generator and spectator or against the separation of art and life." Later he proclaimed that Fluxus "should tend towards collective spirit, anonymity and ANTI-INDIVIDUALISM."[41] For all of Maciunas's aspirations, however, there is no indication that Fluxus in fact broke out of the art world. A Fluxus store offering low-cost items, which was open for a year on Canal Street in New York, did not sell *a single item*.[42] As Joseph Beuys said, Fluxus "held a mirror up to people without indicating how to change things."[43] John Hendricks, a Fluxus insider who produced a number of their events at Judson Memorial Church, was of a similar mind. Frustrated by the in-group nature of their activities, along with Jean Toche he proceeded to take a more public tack with the Guerrilla Art Action Group later in the 1960s.[44] But Fluxus and its intellectual and artistic community was an important early testing ground for two artists who would have enormous influence on the genesis of cooperative art: Allan Kaprow and Joseph Beuys. Kaprow was a member of the Judson Church circle and the Rutgers University Fluxus crowd and submitted work for Fluxus special editions in the early 1960s. Beuys was an early Fluxus participant, and Fluxus ideas reverberated through his work from the beginning to the end of his career. I will return to Beuys later.

While Kaprow was involved early on in Fluxus, he made his name outside the network as the father of the happening during the 1960s. In his essay "Participation Performance," written retrospectively in 1977, Kaprow says that while there was audience participation in the happenings, the involvement was relatively inconsequential, akin to an audience member being called to the stage in a television show or a "guided tour, parade, carnival test of skill, secret society initiation," thus remaining within the genre of the scripted participation. Kaprow emphasizes that the audience participants were well aware of the style and taste of the artists, as they were initiated into the contemporary art world, and he proposes that continuity of taste culture and community are a prerequisite for this sort of participatory art. "This may seem truistic," Kaprow writes, "but participation presupposes shared assumptions, interests, languages, meanings, contexts, and uses. It cannot take place otherwise."[45] This sort of performance was not designed to cross social boundaries.

As the decade progressed, Kaprow moved on from happenings to "life-art" and the conscious blurring of aesthetic categories. In the spirit of the concretist Fluxus artists, Kaprow began to examine the potential in declaring certain everyday activities as art, to "consider certain common transactions—shaking hands, eating, saying goodbye—as Readymades."[46] As

he wrote in "The Education of the Un-Artist" (in 1969), "Random trance-like movements of shoppers in a supermarket are richer than anything done in modern dance."[47] He was playing consistently on the line between life and art in the form of small-scale participatory performance. The critic Jeff Kelley observes that by the end of the 1960s "a Happening by Kaprow was no longer something you went to, but something you and a few others undertook. Performers were no longer mixed with the crowd; there was no crowd, only volunteers. Resonance tended to reside in the specific settings, communitarian experiences, and big ideas (like imitating nature, or turning work into play) that were part of the background noise of 1960s American society."[48]

In 1969, the year he wrote "The Education of the Un-Artist," Kaprow collaborated on an education art project called *Project Other Ways* with the educator Herbert Kohl, who was teaching at UC Berkeley at the time. It was an uncharacteristic endeavor for Kaprow that highlights the relationship of participatory art and progressive education, a theme that runs throughout the projects in this book (Mark Dion in chapter 2, Tania Bruguera in chapter 7, Wendy Ewald in chapter 8, Brett Cook in chapter 10). Rethinking education was a hot topic in the late 1960s, from the battles over curriculum to the social restrictions placed on college students and the local control of school boards. In 1968 Kohl published *36 Children*, which is both a chronicle of his experiences as a sixth-grade teacher in Harlem and an indictment of the educational system's failures to meet the needs of inner-city kids.[49] Interest in radical pedagogy was opening the door to a flexible, interactive approach to working with students. As Kohl and Kaprow got started, there was ongoing turmoil down the street at UC Berkeley, and tear gas was in the air.

In *Project Other Ways* Kaprow and Kohl launched a series of pedagogical experiments to bring art into the Berkeley Unified School District, including a cooperative project with a group of sixth graders. Kaprow and Kohl had noticed that a faction of kids from Oakland who were thought to be functionally illiterate were in fact quite interested in writing—at least writing graffiti. After an initial positive experience with the kids over an afternoon photographing what was scrawled in the local bathrooms, Kaprow said:

> Kohl and I saw a germ of an idea in what had just happened. We covered the walls of our storefront offices with large sheets of brown wrapping paper, provided felt-tipped pens, paints and brushes, staplers and rubber

cement. We invited the kids back the following week and put on the table the photos they had taken. They were asked to make graffiti, using the photos and any drawings they wanted to make, like the graffiti they had seen on our tour. At first they were hesitant and giggled, but we said there were no rules and they wouldn't be punished for dirty words or drawings, or even making a mess. Soon there were photos all over the walls. Drawn and painted lines circled and stabbed them, extending genitalia and the names of locals they obviously recognized.[50]

In that Kohl and Kaprow were catalysts of the creativity they saw in these sixth graders, the project mirrors the work of Wendy Ewald, who started her collaborative educational practice the same year as *Project Other Ways*, and it presages the work of Tim Rollins, who would collaborate with the Kids of Survival in the Bronx more than a decade later. For these egalitarian progressives, the imbalance of the teacher-student relationship seemed like a good target, and the educational environment would prove receptive to this sort of interrogation. But from the beginning of Kohl and Kaprow's project, there was a question of political versus artistic agendas. Kohl, a prominent social activist and advocate of the open school movement, had politics in mind, while Kaprow was interested in artistic play, emphasizing the open-endedness of the process and the product. When a park that was cleaned up and reoriented through community collaboration during the project was soon vandalized, Kelley says, "Kaprow was characteristically philosophical—the parks had come from rubble and were returned to rubble."[51] But Kohl saw politics, not poetry.

After a year Kaprow left *Project Other Ways* to take a position at the newly founded California Institute of the Arts (CalArts), where at first he was surrounded by members of the New York scene, including Fluxus artists like Alison Knowles and Nam June Paik. So just as Diggers techniques were transplanted to the East Coast, post-Fluxus ideologies made their way across the continent to the West Coast. Kaprow's influence as a teacher (at CalArts and later at UC San Diego) was long term and profound. According to Kelley, when Kaprow got to CalArts, the same sort of social expectations that Kohl had for *Project Other Ways* were held by some of the students, particularly the feminists: "It was assumed by many activist artists that Happenings, if scaled to the ideological proportions of feminism, might change society. Students would often raise questions and issue challenges about the social efficacy and political purpose of

Audience members experience *Yard 1967* by Allan Kaprow at the Pasadena Art Museum. Photograph © 1967 Julian Wasser for *Life* magazine. Courtesy of the Allan Kaprow Estate, Hauser & Wirth, and The Getty Research Institute, Los Angeles (980063).

Kaprow's art. They wanted to change the world; Kaprow wanted to play with it."[52] One of those students was a young artist named Suzanne Lacy, and I will return to her soon.

Back on the East Coast, artists were beginning to experiment with models that crossed the line from intragroup participation to social cooperation. A major figure was Mierle Laderman Ukeles. Though she had not read Carol Hanisch's article in *Feminist Revolution*, Ukeles says, "We all walked around in the early '70s saying that the personal is political."[53] Ukeles went on to translate feminist dictum into action. In the late 1960s and early 1970s she began blurring her private and public life in so-called maintenance art works. In these performances Ukeles did what she did at home — cleaning and maintaining — in public spaces and galleries, performing the scrubbing of the sidewalk or the dusting of a museum. A year after the New York Radical Women's action at the Miss America Pageant (and the same year that "The Personal Is Political" was published), Ukeles wrote and distributed the "Manifesto for Maintenance Art 1969!":

> I do a hell of a lot of washing, cleaning, cooking, renewing, supporting, preserving, etc. Also (up to now separately) I "do" Art. Now, I will simply

Mierle Laderman Ukeles's *Hartford Wash: Washing, Tracks, Maintenance: Outside, 1973.*
Part of Maintenance Art Performance Series, 1973–74. Performance at Wadsworth
Atheneum, Hartford, Connecticut. Courtesy of Ronald Feldman Fine Arts.

do these maintenance everyday things, and flush them up to consciousness, exhibit them, as Art. I will live in the museum as I customarily do at home with my husband and my baby, for the duration of the exhibition. (Right? or if you don't want me around at night I would come in every day) and do all these things as public Art activities: I will sweep and wax the floors, dust everything, wash the walls (i.e. "floor paintings, dust works, soap-sculpture, wall-paintings") cook, invite people to eat, make agglomerations and dispositions of all functional refuse.[54]

In this text Ukeles set the stage for "service art": cleaning buildings and serving food are both strategies that have been carried out by others in subsequent decades. But most important, she made public her own "women's everyday experiences."

Ukeles continued to generalize her maintenance work and eventually formed a partnership with the City of New York Department of Sanitation, where she has served as artist-in-residence since 1977. Her interweaving of the domestic acts of maintenance that are mostly carried out by women and the public acts of sanitation that are almost exclusively executed by men, and her interweaving of the art world genre of performance with the world of urban systems, constituted an unconventional leap across borders of gender and class. For Ukeles, the women's liberation ideology of the political personal formed a foundation that would later be augmented by her interest in artistic traditions of collaboration that were beginning to bubble up.[55] Working with the sanitation workers in New York she has built exhibitions, parades, and a ballet for garbage barges on the Hudson River. She has gone on to collaborate with service workers in Europe and Asia. Her residency in the Sanitation Department is one of the best-known and most influential American examples of socially cooperative art.

International Influences: Debord, Beuys, and Freire

Any discussion of collaborative art in the American framework must acknowledge important intellectual and artistic contributions from abroad. There are several writers and artists from overseas whose influence is beyond question. I am not referring to Roland Barthes and others whose proclamation of the death of the author was much discussed at the time, but the ideas of Guy Debord, Joseph Beuys, and Paulo Freire that have resonated strongly with artists and intellectuals interested in notions of cooperation, dialogue, and participation.[56]

The French writer and filmmaker Guy Debord and the Situationist International movement he led loom large in the field. Debord's artistic, intellectual, and political project was a fight against passivity, against a society divided between actors and spectators. His writings differentiate between the "spectacle" that is grand and impersonal (e.g., the mass media) and the "situation" that is local, personal, and interactive. He strove to loosen the grasp of the debilitating stupor of the spectacular. In his essay "Towards a Situationist International," published in 1957, Debord wrote, "The situation is . . . made to be lived by its constructors. The role of the 'public,' if not passive at least as a walk-on, must ever diminish, while the share of those who can not be called actors, but in a new meaning of the term, 'livers,' will increase."[57] Ten years later, in Society of the Spectacle, he was even clearer about his desire to activate the spectator: "The alienation of the spectator, which reinforces the contemplated objects that result from his own unconscious activity, works like this: The more he contemplates, the less he lives; the more he identifies with the dominant images of need, the less he understands his own life and his own desires. The spectacle's estrangement from the acting subject is expressed by the fact that the individual's gestures are no longer his own; they are the gestures of someone else who represents them to him. The spectator does not feel at home anywhere because the spectacle is everywhere."[58]

Though he was active since the late 1950s, Americans often perceive Debord as a figure of the late 1960s. One year after the publication of Society of the Spectacle in France, he and the Situationists achieved mythic status when their ideas escaped the academy and spilled onto the streets of Paris in the events of May 1968. In the catalogue for the large-scale exhibition on the Situationists that made its way to Boston's Institute of Contemporary Art in 1990, the film theorist and avant-garde historian Peter Wollen writes that in the spring of 1968 "student groups were influenced by the SI [Situationist International], especially in Nanterre where the uprising took shape, and the Situationists themselves played an active role in the events, seeking to encourage and promote workers' councils (and a revolutionary line within them) without exercising powers of decision and execution or political control of any kind."[59] By this account the Situationists stayed true to their philosophy, and the workers and students were "livers," collective actors in an event that is honored in the memory of the Left across the world. In 1968 the Yippies' street theater created a memorable political spectacle in Chicago, but it is the Situationists' antispectacle

in Paris that seems to carry more weight in the imagination of American cooperative artists.

There is no clear narrative of how or when Situationist ideas came to the United States. The critic Peter Schjeldahl suggests that Gordon Matta-Clark was inspired by Debord and the Situationists when he was studying in Paris in 1968, and Matta-Clark's urban cutting has been compared with the Situationists "dérives."[60] There was a branch of the Situationist International in New York in the late 1960s, and Leandro Katz, an active New York Situationist, published a translated text by Debord in 1969. (*Society of the Spectacle* itself first appeared in English in 1970.) Katz told me that the artists he was close to at that time included Matta-Clark, Helio Oiticica, Suzanne Harris, Kathy Acker, Joseph Kosuth, and Charles Ludlam, so some Situationist ideas certainly made their way through the tight-knit New York art world.[61] And some of the interactive projects created by this cohort seem to be cooperative art. In 1971, along with Carol Goodden, Suzanne Harris, Tina Girouard, and Richard Lew, Matta-Clark opened a restaurant and meeting place called Food. According to Goodden, Matta-Clark saw Food as a sculpture. He designed everything in the space, cooked some of the food, made a film there, cut out a part of a wall (inspiring his cut sculptures), and "tried to sell the whole idea of Food to Castelli [Gallery] as an art piece."[62] So perhaps Matta-Clark is thought to be a translator of Situationist ideas into interactive art in New York in the early 1970s, though I have yet to see any specific documentary evidence of his connection to the group. In any case, mainstream knowledge of the Situationists came much later, with general interest in the late 1980s and especially after the exhibition in Boston in 1990. Thus at the moment when cooperative art was beginning to find greater institutional support in the 1990s, Situationist ideas were freshly circulating in the United States, especially their notion of the antispectacular "liver" and their involvement in politics on the streets of Paris.

The artist whose name came up most often in discussing influences with the participants in this book is Joseph Beuys, with his notion of "social sculpture." Beuys's post-Fluxus work was known in America from the 1960s, but it was not until the early 1970s that the art world really took notice. In fact, though Fluxus was centered in New York, it was Beuys who brought some of its important ideas back home. By the time he came to New York in 1974 for his first public lecture in the United States, he was already a huge draw, for fans and detractors alike. This was two years after he had been dismissed from his academic position in Düsseldorf for re-

fusing to impose entry requirements for his classes, and the year of his first performance in America, at the Rene Block Gallery. About seven hundred people showed up for his lecture in the New School for Social Research's auditorium, which held only 350; half the audience was stranded outside. The transcripts depict a raucous event in which the audience seemingly felt encouraged by Beuys's rhetoric of dialogue to interrupt, disagree, and generally create an unruly atmosphere that Beuys seems to have embraced. This was the first time an American audience heard his ideas firsthand, and here is how he described his mission:

> I would like to declare why I feel that it's now necessary to establish a new kind of art, able to show the problems of the whole society, of every living being—and how this new discipline—which I call social sculpture—can realize the future of humankind. . . . Here my idea is to declare that art is the *only* possibility for evolution, the only possibility to change the situation in the world. But then you have to enlarge the idea of art to include the whole creativity. And if you do that, it follows logically that every living being is an artist—an artist in the sense that he can develop his own capacity.[63]

Beuys is talking not only about social art forms but also about an open society that acknowledges the creativity of all, or, as he had said in 1972, "A total work of art is only possible in the context of the whole society. Everyone will be a necessary co-creator of social architecture, and, so long as anyone cannot participate, the ideal of democracy has not been reached."[64] In this text Beuys sounds a lot like the Port Huron Statement's call for participatory democracy, but the intellectual context was different. In an essay on Beuys's influence here, the critic Kim Levin argues that Americans saw his work in our context, not his own, and that we drew faulty parallels. "In our literal climate," writes Levin, "we never suspected that he was a symbolist, an expressionist, a mystical romanticist."[65] What seems to have stuck in the consciousness of many artists is the inclusive notion of "social sculpture," or at least an American literalist version of it. The self-defined "social sculptor" Rick Lowe (chapter 5) often cites Beuys as a major source of inspiration, even if he is not sure that Beuys would be able to relate to *Project Row Houses.*[66]

In 1973 Beuys said, "Communication occurs in reciprocity: it must never be a one-way flow from the teacher to the taught. The teacher takes equally from the taught."[67] He was inadvertently echoing both Saul Alinsky, with his notion of the community organizer as colearner, and the in-

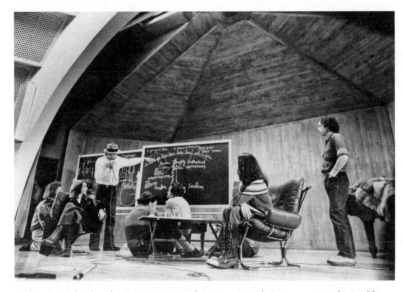

In the New School auditorium in New York in 1974, Joseph Beuys presented a "public dialogue" in which audience members were invited on stage to ask questions. Beuys answered and wrote notations on a blackboard. Photograph © Peggy Jarrell Kaplan. Courtesy of Ronald Feldman Fine Arts.

fluential theorist of dialogue, the Brazilian Paulo Freire, whose *Pedagogy of the Oppressed* was first published in 1968. When the book came out in English in 1970, it was embraced by many progressive educators in the United States and by artists as well. Freire's "problem-posing" pedagogy is based on dialogue in which the teacher and the student become "jointly responsible for the process in which all grow." In the 1980s *Pedagogy of the Oppressed* was ubiquitous in activist artists' studios. And while Beuys could sound like Freire, Freire could sound like Debord; in *Pedagogy of the Oppressed* Freire writes, "In cultural invasion the actors . . . superimpose themselves on the people who are assigned the role of spectators, of objects. In cultural synthesis, the actors become integrated with the people, who are co-authors of the action that both perform on the world."[68] Again we see the emphasis on the oppressed subject (the student, in this case) becoming an actor and coauthor. As opposed to Beuys, there was no mistaking Freire's politics; he had very clear leftist political goals, which he articulated as a dissenter under right-wing dictatorial rule.

Freire's theories were quickly translated into artistic form by his compatriot Augusto Boal, who published *Theatre of the Oppressed* in 1973. Like

Freire, Boal was interested in the activated, politicized participant, and he created a wide range of theater works to be performed by professional or nonprofessional actors and "spect-actors," the inadvertent participants in his public theater.[69] Both Freire and Boal were imprisoned in Brazil under military rule for their political activities and spent time in exile — Freire in Chile and the United States, Boal in Argentina and France. This exile, though painful, helped spread their ideas internationally.

The theorists discussed here would diverge on many points. However, when Debord envisioned situations lived by their constructors, when Beuys talked about the co-creation of social architecture, and when Freire spoke of people who are coauthors of the action they perform on the world, they promoted ideas that would influence American artists' emergent practice of socially cooperative art. Among others, these writers helped plant the seed of the activated audience that was translated by some artists into active experiments in group creativity. But before returning to the artistic developments over the last quarter of the twentieth century, we must understand how these practices emerged in a dramatically altered political environment.

Political Shift to the Right in the 1970s and 1980s

If the groundwork had been laid for socially cooperative art through participatory strains in political action, early experiments by a handful of pioneering artists, and intellectual influences from abroad, the full-blown emergence of the genre took place in a transformed political and social arena. In the late 1960s and early 1970s Kaprow, Ukeles, Matta-Clark, and other artists were working and living in an America in the late stages of a progressive period that had begun during the New Deal. Yes, America was still involved in the Vietnam War; yes, grave inequities remained a generation into the civil rights movement; but there was a sense that what Alinksy had called the "displacement and disorganization of the status quo" through mass movements and cooperative action was possible, if not inevitable. This was much less the case in the last decades of the century, as America swung to the right.

In the 1970s and 1980s a new balance of power was emerging in America. In his book *White Flight: Atlanta and the Making of Modern Conservatism* (2005), the Princeton history professor Kevin Kruse takes a look at how a new social geography realigned politics. He points out that by population, the suburbs were only a fourth of the country in 1950, a third in 1960, and fully half in 1993. According to Kruse, one of the main motivations for

flight from city centers was racism. The presidential election of 1968 was the first in which votes from the suburbs outnumbered those from either rural or urban areas. The Republican Party understood and capitalized on this new demography, and Richard Nixon prevailed. A Democrat was president thirty-two of the forty-four years that preceded Nixon's election; in the forty-four years since, Democrats have occupied the White House for only sixteen. During the 1970s the suburbs cut ties with the cities and created a new national power base "to ensure that the isolation they now enjoyed in the suburbs would never be disturbed." Kruse continues: "Free to pursue a politics that accepted as its normative values individualistic interpretation of 'freedom of association,' a fervent faith in free enterprise, and a fierce hostility to the federal government, a new suburban conservatism took the now familiar themes of isolation, individualism, and privatization to unprecedented levels. . . . At the dawn of the 21st century, America found itself dominated by suburbs and those suburbs, in turn, dominated by the politics of white flight and suburban secession."[70] What is conveniently described as a Red State–Blue State political divide in America is in fact more of a divide between the liberal cities and the conservative suburbs and exurbs. As mentioned earlier, the suburbs had been cast as inhospitable to interaction (Mumford) or as evolving hand-in-hand with an oppressive gender role for women (Friedan and Hayden), but the American apotheosis of domestic privacy, free enterprise, and home ownership continued to grow across the political spectrum. Dolores Hayden points out that "economic empowerment" for working women during this period often meant no more than home ownership.[71]

It is common knowledge that politics in the United States has become increasingly polarized over the past thirty years. In a *New York Times* column in 2002 titled "Things Pull Apart," the Princeton professor and Nobel Prize–winning economist Paul Krugman argues that this polarization echoes the growth of economic disparity between the rich and the middle class, starting roughly with the "conservative revolution" that brought Ronald Reagan to the White House. Krugman points out that after adjusting for inflation, middle-income Americans saw their income rise 9 percent between 1979 and 1997, while the income of families in the top 1 percent of the spectrum rose 140 percent. During that time, Krugman observes, American conservatives swung far to the right, while moderates remained constant in their economic policy. There was a sense among progressives that the division of wealth fueled by reduced taxation of high-income Americans was becoming disturbingly one-sided, but the

response was generally muted. Krugman says that we probably need look no further for an explanation for this passivity than "campaign finance, lobbying, and the general power of money to shape political debate" in the United States.[72]

In this conservative context art became a convenient target for ridicule. Grants awarded by the National Endowment for the Arts were questioned as profane or obscene. The museum education theorist Philip Yenawine writes, "Without question, the culture wars of the late 1980s and '90s changed the context in which the art world operates, particularly in its relationship to government. A vocal, organized, and motivated body politic, rooted in fundamentalist religious beliefs, called art from the margins of society, where it thrived, to center stage of American culture, where it appeared bizarre and even ludicrous."[73] In many cases the culture wars unfolded under the cloud of the AIDS epidemic that was ravaging communities across America. The formula for division and misunderstanding was almost perfect, pitting the increasingly empowered conservative sectors of society against artists, gays, and people of color. As opposed to the 1960s and early 1970s, when political action (even political street theater) was fairly well separated from participatory art practices, there was more crossover in the 1980s. As the University of Rochester art historian Douglas Crimp points out in his book *AIDS Demo Graphics* (1990), the urgency of the crisis led to collective efforts, centering around the AIDS Coalition to Unleash Power (ACT UP). The visual imagery of AIDS activism was generally created by collectives like Gran Fury, DIVA TV (Damned Interfering Video Activist Television), Little Elvis, Testing the Limits, and LAPIT (Lesbian Activists Producing Interesting Television). Crimp situates this sort of activism in direct opposition to the hermeticism of critical postmodernism, which, he argues, never transcended an art world audience. Throughout *AIDS Demo Graphics* one gets a sense of the enraged and self-critical mind-set of ACT UP and its admittedly propagandistic motivation. Each poster, video, and act of street theater was analyzed in terms of instrumental results: What did the press say? Will it help open the door to greater distribution of health care resources? Will it destigmatize AIDS? For artists who came of age in this period, the model of art as collective political activism in the face of an immediate life-or-death threat was deeply imprinted.

Meanwhile new populations were arriving in American cities from around the world even as the white middle-class outflows continued. In 1965 President Lyndon Johnson had signed into law the Immigration and

Consciously framing events for media consumption, ACT UP brought AIDS into the spotlight. On the lower right an ACT UP member is being interviewed as a compatriot is hauled away by the police, 1987. Photograph courtesy of ACT UP New York Records, Manuscripts and Archives Division, New York Public Library, Astor, Lenox and Tilden Foundations.

Nationality Act. When the bill was passed, the percentage of immigrants in the United States was at a historic low, and the number of people to be admitted under the reunification provisions seemed relatively modest. But the legislators underestimated the implications of the law, and within a decade American cities were seeing the results. Between 1931 and 1965 only about 5 million immigrants entered the United States (147,000 per year), but between 1970 and 2000, as the effects of the new law kicked in, about 28 million arrived (933,000 per year).[74] The northern industrial cities that had been the destinations of the great African American migration north, now abandoned by the white middle class with suburbanization, were being refilled by new immigrants from Asia, the Caribbean, and Latin America, groups that had been virtually excluded under the old immigration quotas.[75] New Chinatowns were born along with Latino and Caribbean neighborhoods, each with its own habits of sociability. Across the country, but particularly in the Southwest, a massive flow of immigrants from south of the border began — with and without documents. To some, the new waves of immigration were undermining the very notion of what it means to be American. To others, these immigrants brought re-

newed vibrancy to cities, filling in the neighborhoods that the European Americans had fled.

One cheerleader for these transformations is the Los Angeles–based cultural critic Mike Davis. "Immigrant homeowners are indeed anonymous heroes," writes Davis in his book *Magical Urbanism: Latinos Reinvent the U.S. City* (2000). "While there is much abstract talk in planning and architectural schools about the need to 'reurbanize' American cities, there is little recognition that Latino and Asian immigrants are already doing it on an epic scale." And new populations bring culture with them, a set of sociospatial habits. Davis writes, "Across the vast Pan-American range of cultural nuance, the social reproduction of *latinidad*, however defined, presupposes a rich proliferation of public space. . . . Latin American immigrants and their children, perhaps more than any other element of the population, exult in playgrounds, parks, squares, libraries, and other endangered species of U.S. public space, and thus form one of the most important constituencies of the preservation of our urban commons."[76] Davis points to the reinvention of American cities as a positive phenomenon, counteracting mainstream America's devaluation of the commons, focusing specifically on the relational, interactive use of public space. Interestingly, at the turn of the millennium the same flows that have been transforming cities are beginning to break the monocultural definition of the suburbs. According to the Brookings Institution, in the first decade of the twenty-first century, "for the first time, a majority of all racial/ethnic groups in large metro areas live in the suburbs. Deep divides by race and ethnicity still separate cities and suburbs in metro areas like Detroit, but others like Los Angeles show much greater convergence between jurisdictions."[77] And as the suburbs are becoming more diverse, it is becoming more difficult to peg the politics of participation; in the late 1980s and especially in the early 1990s communitarian thought took on a new public face as a mainstream, moderate political stance.

By the late 1990s the UC Berkeley sociologist Robert Bellah seems to have domesticated the participatory ideology of Tom Hayden when he writes, "Participation [is] both a right and a duty. Communities become positive goods only when they provide the opportunity and support to participate in them." Instead of seeking a radical reorganization of American society, the communitarian periodical *Responsive Community* takes up unthreatening questions like how best to design a park for community participation, how to strengthen family bonds, and how to devise requirements for school-based community service. Yes, articles also appear in

that journal on how to create an informed electorate, but certainly not on how to bring down the capitalist state.[78] The communitarians found allies along the way in the anti-ironist Duke law professor Jedediah Purdy, as well as the "social capital" theorist and Harvard politics professor Robert Putnam.[79]

Meanwhile participation as an essential aspect of democracy was being espoused in some mainstream planning circles as well, much in the spirit of Arnstein's "Ladder of Citizen Participation" and Alinsky's community organizing. For example, John Forester, a planning professor at Cornell University, outlines a philosophy of interactive, socially cooperative planning in his book *The Deliberative Practitioner* (1999). In his case studies one gets a sense of how a process of active dialogue transforms an understanding of a city and its inhabitants. Forester argues for the transformative effect of dialogue:

> Inspired by liberal models of voice and empowerment, many analyses unwittingly reduce empowerment to "being heard" and learning to considering seriously local as well as expert knowledge. Participation is thus reduced to speaking, and learning is reduced to knowing—and the transformations of done-to into doers, spectators and victims into activists, fragmented groups into renewed bodies, old resignation into new beginnings are lost from our view. . . . The transformations at stake are those not only of knowledge of class structure, but of people more or less able to act practically together to better their lives, people we might call citizens.[80]

In Forester's approach, with its strong rhetoric of inclusion, spectators become activists. Like Freire, Forester works with a "dialogic and argumentative process." Here again, becoming active is linked to acting together.

Finally, before we return to cooperative art, it is important to take note of the technological tools for cooperation that emerged at the turn of the millennium. In an essay titled "Technologies of Cooperation" (2007), the Internet theorist Howard Rheingold argues that electronic communication opens a door to larger-scale social cooperation than we have seen in any period of our development as a species. This communication technology can lubricate the operation of traditional cooperative ventures or engage with new sorts of social organization that will develop with the new tools. Rheingold's Internet optimism may be proving correct—for example, in the large-scale, relatively leaderless, cooperative political movements that have challenged autocratic leaders in Tunisia and Egypt, fueled by social media from Facebook to Twitter. Rheingold sees the growth of

the "cooperation commons" in a wide range of new practices, from open-
source software to social mobile computing and knowledge collectives.[81]
While Robert Putnam blamed screen time (including both computer and
television use) for a decline in interpersonal connection, it is far too soon
to definitively evaluate the social implications of new social media. This set
of issues is discussed in chapter 11.

Cooperative Art since the 1980s

If Mierle Laderman Ukeles was New York's leading cooperative artist
of the 1970s, Tim Rollins + Kids of Survival (KOS) were the best known
of the 1980s. Rollins was a member of Group Material, a visual arts col-
lective that was active beginning in the early 1980s. Their work generally
consisted of organizing group exhibitions and street art on sociopolitical
topics. Some of these projects could be considered curating as art, with
the overall artwork emerging from the group decision making and cre-
ative contributions of numerous artists. However, it was the other side of
Rollins's practice that emerged as a model for socially cooperative artists.
He was teaching in the New York City public school system at the time,
and he began working with a group of young people from special educa-
tion classes in the South Bronx. The collaboration began at Intermediate
School 52 and expanded into an independent out-of-school program called
the Art and Knowledge Workshop. Typically the group would read a book
together, interpret and distill it, and then literally take it apart, gluing its
pages to a canvas and making a painting on them. In time these paintings
began to enter major museum collections and fetched high prices at com-
mercial galleries. The proceeds from these sales funded the workshop and
were shared among the participants. Their work was warmly embraced in
activist and mainstream art circles alike. In January 1987 Jean Fisher wrote
a glowing review in *Artforum*: "Tim Rollins + Kids of Survival (K.O.S.)
radically challenge purist and elitist notions. Their collaborative art inter-
prets culture through young people who are generally dismissed as having
virtually nothing to contribute to it. . . . Political without being propagan-
dist, the work has a breadth that extends beyond its subtle commentaries
on white/nonwhite cultural relations, and seeks to dismantle the repre-
sentations that support dominant myths."[82] Rollins was seen as a Freire-
inspired pioneer, and the Kids of Survival became art world fixtures.[83]

However, the accolades were not universal. There were some rumblings
of discontent from the CUNY cultural critic Michele Wallace about the
mostly white authors that the collaborative tended to focus on in a cata-

ONE INTRODUCTION

A year after their founding, Tim Rollins + KOS shot this photograph of themselves at their studio in the Longwood Community Center in the South Bronx. Back row: George Garces, Nelson Montes, Nelson Ricardo Savinon, and Arecelis Batista. Front row: Tim Rollins, Chris Hernandez, Annette Rosado, and Richard Cruz. 1985. Photograph courtesy of Tim Rollins.

logue for their show at Dia Art Center in 1989.[84] However, the general tenor of the Dia publication and even much of Wallace's essay was laudatory; this was an exciting new sort of social collaboration in painting that used an experimental process to produce highly credible aesthetic results. Two years later a much more severe critique appeared in *New York Magazine* that depicted Rollins as domineering. While the project had produced compelling paintings and was motivated by the best intentions early on, wrote Mark Lasswell, it had degenerated when Rollins became increasingly disinterested in collaborative process as he pursued the dream of opening a school to be called the South Bronx Academy of Art.[85] While many people allowed for the sensationalism of a *New York Magazine* investigative report, and though the bitter accounts of former (sometimes expelled) members were never substantiated,[86] the article did some damage. Perhaps if the social benefit for the Kids of Survival was less than advertised, the art product was less worthy of purchase or display. In this view Rollins, the idealistic cofounder of Group Material, the innovator in dialogical education, was successful in direct proportion to the social

progress of his collaborators. Fairly or unfairly, Rollins + KOS faded some-
what from view. In 2011 Rollins + KOS seemed to be reinvigorated and ac-
cepting new members on the heels of their first full-scale traveling retro-
spective.

If Rollins + KOS were the familiar face of artistic social cooperation on
the East Coast, Suzanne Lacy took much the same role on the West Coast
in the 1980s. But while Rollins had only a peripheral conceptual connec-
tion to the 1970s generation, Lacy was a direct disciple; she had been a stu-
dent of Allan Kaprow and Judy Chicago and merged their practices into
her own brand of feminist performance. When Jeff Kelley said that some
students at CalArts interrogated the "social efficacy and political purpose"
of Professor Kaprow's happenings, he was certainly speaking of artists
like Lacy. She experimented with feminist body art in the 1970s, making a
turn toward cooperative practice late in the decade, though never losing
sight of Kaprow as a mentor; she dedicated her collected writings to him
in 2010.[87]

Unlike that of Rollins + KOS, Lacy's work unfolded far from the com-
mercial gallery scene. By the mid-1980s she was creating large-scale co-
operative performances. In 1984, for example, she orchestrated *Whisper,
the Waves, the Wind*, in which 154 women over the age of sixty-five, dressed
in white, sat at tables for four on the beach in La Jolla, California, speaking
of "death, the body as an aging shell, prettiness, nursing homes, leaving a
mark on life, feminism, traditional roles of women, sex, face-lifts, the kind
of strength that comes with age, personal tragedies, the need to identify
with younger people, and the myth that only the aged die."[88] Audience
members observed from a boardwalk nearby, listening to prerecorded
tapes, and then were admitted to wander among the tables as the women
continued their discussions. Clearly the structure of the all-women discus-
sion of personal issues echoes women's liberation consciousness-raising,
restaged as a public performance. For the New York Radical Women, a
consciousness-raising session led to the Miss America action; in *Whisper,
the Waves, the Wind*, the consciousness-raising session itself became a per-
formance. Lacy has used similar communicative structures for a number
of other works, often centering on issues of the female subject but also
exploring issues of race and class—while always remaining faithful to the
feminist notion of making the personal political.

Lacy was not working in a vacuum, of course, and other important
artists, like Jerri Allyn, a product of the Feminist Studio Workshop at the
Woman's Building in Los Angeles, were experimenting with interactive

Women converse around tables on the beach as onlookers view from above at the beginning of Suzanne Lacy's *Whisper, the Waves, the Wind*, 1984, La Jolla, California. Photograph by Barbara Smith.

feminist performance in the late 1970s. But Lacy became a leader of the emerging move toward experimental, activist public art. And through her art, teaching, and writing, she was a major figure for many artists, particularly those educated on the West Coast. One younger-generation artist who calls Lacy his mentor is Lee Mingwei, the subject of the second section of chapter 10.[89] It should come as no surprise that, given the economic structure of the art world, a noncommercial artist like Lacy (or her mentor Kaprow) made a living for the most part by teaching. In this book Daniel Martinez, Harrell Fletcher, Pedro Lasch, and Teddy Cruz are full-time professors, and many others, like Wendy Ewald and Tania Bruguera, have taught extensively. This concentration of participatory artists in the academy has helped spread the practice, even as MFA programs have gained power in the past three decades.

By the 1990s the public art movement in the United States was in full bloom. Across the country public art programs were sprouting up in city governments under the banner of Percent for Art (governmental programs that require a percentage of the construction budget of new buildings to be used for public art). For the most part these programs did not commission socially cooperative art, as the requirement to build perma-

nent works was often incompatible with process-oriented work. However, these programs brought thousands of artists out of the studio and into contact with neighborhoods and public sites far removed from the museum and gallery system. Simultaneously an array of opportunities for temporary projects appeared—in New York, for example, in the form of sponsoring and commissioning organizations like Creative Time and the Public Art Fund. On the model of these temporary interventions, there was sufficient activity in socially based work to merit some large-scale initiatives.

In the early 1990s Mary Jane Jacob organized two urban art events, each of which was accompanied by a significant publication. In May 1991 an exhibition opened across the city of Charleston, South Carolina, called *Places with a Past*, which included a series of site-specific installations by a range of artists, among them David Hammons, Ann Hamilton, and Lorna Simpson. The exhibition was widely covered in the press, and the reaction was mixed. Some hailed the originality of the work and saw new developments in site-specific art, while others, most notably the UCLA art historian Miwon Kwon, criticized the project as complicit with the development objectives of the city. In her book *One Place after Another: Site-Specific Art and Locational Identity*, Kwon points to the sometimes hidden institutional control of the projects and the conscious or inadvertent complicity of these institutions in uneven urban development practices. Most notably, perhaps, there was what Patricia Phillips, an art historian at the Rhode Island School of Design, calls a growing "sense of artists and their works being parachuted into fashioned, artificial opportunities."[90] Whatever the validity of that criticism, it would be hard to argue that Jacob herself parachuted into Charleston or retreated quickly, as she continued to work on a series of art projects in the city for another decade.

In any case it was not this criticism that got Jacob thinking about new directions. Leaving *Places with a Past*, she was intrigued by the possibilities suggested in David Hammons's project, which was unusually interactive and inclusive. I asked Hammons how he came to create a cooperative artwork in Charleston, something he did not do before and has not done since. He answered:

> How can you *not* when you're in someone else's community? It's so arrogant not to have any kind of interaction. It's just polite, and it's so easy. They'll protect you. They're the ones who are going to keep you safe or just save you verbally, saying, "I like this piece in my community." Others

might say, "Well, you like it because you got paid working on it." But still it's better than just jumping in there and putting something down and leaving.

When I started working on this lot, a guy named Albert Alston [a local builder] came up to me saying, "What you doing in the neighborhood?" I told him, and I ended up *giving* him the whole project. He did the whole thing. I just sat back and watched. Plus I gave him all the money and that was the real deal—to give them the budget and let them distribute it among themselves in the community. I automatically cleared myself of any wrongdoing. The situation could have been embarrassing. You know, northerners coming down South to take on this town.

There was a kid, Larry Jackson, an artist in the neighborhood. He had made paintings of houses from all over the neighborhood. I said, "Make yourself a gallery." So he made a gallery and put his paintings in. Young kid. He told me, "Man, this is a dream come true; I can't believe it. Are you really going to let me do this?" I said, "Sure, let's go down to the office, and I'll give you a check." I got him a check for $500 for being on the team. I was giving money out left and right, employing people from the neighborhood. Again, I felt that was as important as the art itself.

I was saying, "Help me, I'm drowning. I'm out here in no man's land and I don't know what to do." So I sent out an SOS. They said, "We'll help you out."[91]

The final product was a slim house that looked a lot like a Hammons sculpture, immaculately constructed though abject in its materials. Hammons made the very best of a complex situation by embracing the possibilities of cooperative process. This embrace was on Jacob's mind as she pondered her next venture.[92]

Jacob moved on to a second large-scale urban project two years later, in 1993, called *Culture in Action*, organized with Sculpture Chicago, that penetrated the city more deeply and consisted of cooperative art to a much greater extent than *Places with a Past*. While the structure of the projects in Charleston was generally fairly conventional, *Culture in Action* included not just artists but their collaborators, sharing authorship: Suzanne Lacy and a Coalition of Chicago Women; Sperandio and Grennan with the Bakery, Confectionery and Tobacco Workers' International Union. One of the projects was a pair of elaborate cooperative endeavors initiated by Daniel Martinez (discussed at length in chapter 2). *Culture in Action*, the wide publicity it received, and the publication that accompanied it cre-

ated a watershed moment in American socially cooperative art. This was a
large-scale, big-budget project in a major city organized by a well-known
former museum curator, and the accompanying book featured a signifi-
cant contribution from the former *New York Times* critic Michael Bren-
son.[93] It was a watershed not only in the art created and the press it gener-
ated but also in the increased level of critical attention and insight. Around
this time book-length studies and anthologies began to emerge that were
highly influential. While the earlier artists invented the field, the younger
generation had the opportunity to read volumes that began to lay out the
parameters of the practice and define the vocabulary.

Bay Press, the publisher of the book accompanying *Culture in Action*,
released two other books in 1995: *But Is It Art? The Spirit of Art as Activ-
ism*, edited by the critic Nina Felshin, and *Mapping the Terrain: New Genre
Public Art*, edited by Suzanne Lacy. While neither book was exclusively
about socially cooperative art, both included extensive coverage of artists
like Ukeles, Lacy herself, and Peggy Diggs. In her introduction to *But Is It
Art?* Felshin dwells on the interactive and dialogical nature of activist art.
She acknowledges the socio-aesthetic sources in the activism of the 1960s
but also argues that the new activist art has roots in the postobject, imma-
terial, process-oriented practices of Conceptual art. In fact she sees the
new activist art as fulfilling the promises of Conceptual art, which never
thoroughly escaped the power structures of the art institutions.[94] The
book includes chapters on the emerging canon of artists (Ukeles, Lacy,
Helen and Newton Harrison, and Group Material) but also, as the title
might suggest, is particularly useful in tracking public advocacy projects
that may or may not be considered art, like Gran Fury's AIDS graphics
and the Guerrilla Girls' poster campaigns. On the other hand, *Mapping
the Terrain* places socially collaborative practice in a public art context,
examining, for example, the genesis of guidelines in the NEA's Art in Pub-
lic Places program. Like Felshin, Lacy sees roots for this art in American
political action and the feminist movements.[95] These books point to the
emergence of cooperative art into the critical light of day in the 1990s. It
became a viable practice for artists and a topic worthy of serious criticism
in the United States. Socially cooperative art was more or less on the map.

During this period other artists began to open doors to participatory
practice even if they were not consistently working in this mode. For ex-
ample, Krzysztof Wodiczko worked collaboratively with immigrants on
Alien Staff, creating a multimedia walking staff as a mechanism for inter-

Adul So and Hamed Sow operating *Alien Staff (Xenobacul)* by Krzysztof Wodiczko in Stockholm, 1992. A video of the operator telling his own immigration story is playing on a small monitor on the front of the staff. Photograph © Krzysztof Wodiczko. Courtesy of Galerie Lelong, New York.

action that included their videotaped statements about immigration. Wodiczko was supported by critics like Rosalyn Deutsche, who had been skeptical of emerging public art practices, and his politically charged work seemed to convince more theory-driven critics of the potential of cooperative art. Likewise Mel Chin, a conceptual artist whose work traverses media like few others, created several cooperative art projects, including *In the Name of the Place*, for which he enlisted scores of graduate students to work with him making set pieces for the television series *Melrose Place*. It was a rare venture by a cooperative artist into the sphere of popular culture.

Back in the galleries, the New York–based artist Rirkrit Tiravanija was beginning to experiment with food-based performances. In an economical and rather anticommercial gesture, Tiravanija created a series of installations that centered on serving Thai food to gallery-goers, creating a site for social interaction rather than an art object. This social performance became his signature piece, appearing in shows in the United States and abroad. By 1996 he had participated in the watershed show *Traffic*, organized by Nicolas Bourriaud, the French curator and critic. Bourriaud's book *Relational Aesthetics*, which developed themes that he had first proposed in the *Traffic* catalogue, was published in 1998, though it was not translated and published in English until 2002. In the book Bourriaud's

Nine instances in which Mel Chin and the GALA Committee placed artworks in scenes on the television show *Melrose Place*. The project, *In the Name of the Place*, was a collaboration between Chin, MFA students in Georgia and Los Angeles (hence GALA Committee), assorted other artists, and the set designers and script writers of the television show. The project was originally commissioned as part of the exhibition *Uncommon Sense* at the Los Angeles Museum of Contemporary Art, 1997. Photograph courtesy of the GALA Committee.

opposition of the words *relational* and *private* sets the stage for a discussion of a new sort of work based on a framework of interaction rather than isolation:

> The possibility of a *relational* art (an art taking as its theoretical horizon the realm of human interactions and its social context, rather than the assertion of an independent and *private* symbolic space) points to a radical upheaval of the aesthetic, cultural, and political goals introduced by modern art. . . . What is collapsing before our very eyes is nothing other than the falsely aristocratic conception of the arrangement of works of art, associated with the feeling of territorial acquisition. In other words, it is no longer possible to regard the contemporary work as a space to be walked through. . . . It is henceforth presented as a period of time to be lived through, like the opening of an unlimited discussion.[96]

Audience members gather for a collective meal in Rirkrit Tiravanija's *Untitled 1992 (Free)* (1992–) at David Zwirner Gallery in New York City, 2007. Photograph courtesy of the artist, Gavin Brown's enterprise, and David Zwirner.

In his notion that works of art can be "lived through," Bourriaud echoes Debord's vocabulary—that "situations" can make people into "livers." Bourriaud goes on to say that while art has "always been relational in varying degrees," there is now a fundamental change: "Unlike an object that is closed in on itself by the intervention of a style and a signature, present-day art shows that form only exists in the encounter and in the dynamic relationship enjoyed by an artistic proposition with other formations, artistic or otherwise." Bourriaud's interest in art that is "focused upon the sphere of inter-human relations" has led him to works that fit into the category of the encounter (a word he employs to describe the work) more than social cooperation.[97] The artists he champions in his criticism and curatorial work tend toward the scripted interactive moment in the gallery, but his vocabulary has been broadly adopted within the field.

In *Relational Aesthetics* Bourriaud notes that some critics claim that the restricted context of the gallery contradicts "the desire of sociability underpinning [the relational work's] meaning." He goes on to say, "They are also reproached for denying social conflict and dispute, differences and divergences, and the impossibility of communicating within an alienated space."[98] Indeed the Princeton art historian Hal Foster writes in a critique of Bourriaud that the "possibilities of 'relational aesthetics' seem

clear enough, but there are problems, too. Sometimes politics are ascribed to art on the basis of a shaky analogy between an open work and an inclusive society as if a desultory form might evoke a democratic community, or a non-hierarchical installation predict an egalitarian world."[99] Claire Bishop writes that there may be a post-Bourriaud move toward more socially engaged collaboration: "Perhaps addressing the sense of unrealized political potential in the work that Bourriaud describes, a subsequent generation of artists have begun to engage more directly with specific social constituencies."[100] For some artists and critics, it is Bourriaud's ground-breaking vocabulary and philosophical observations, rather than his specific art criticism and curatorial work, that resonate, and many may agree with Foster's and Bishop's relational skepticism. Indeed there does seem to have been a swing toward more socially oriented art in recent years, but the older generation of American socially cooperative, activist artists got started decades before Bourriaud wrote *Relational Aesthetics*, and the younger generation often found motivation elsewhere.

In 2004 Grant Kester published *Conversation Pieces: Community and Communication in Modern Art*, a book-length theoretical explication of and argument for the value of dialogue-based art. He calls for a shift of focus; if we are looking for art that challenges "fixed categorical systems and instrumentalizing modes of thought," then, with performative and collaborative art, we can look beyond the art object itself to the "open-ended and liberatory possibility" in the "process of communication that the artwork catalyzes." Kester argues that this sort of analysis requires two changes in perspective:

> First, we need a more nuanced account of communicative experience: one capable of differentiating between an abstract, objectifying mode of discourse that is insensitive to the specific identities of speaking subjects (the kind targeted by figures such as Lyotard) and a dialogical exchange based on reciprocal openness. This distinction, between what Jürgen Habermas terms "instrumental" and "communicative" rationality, is typically collapsed in modern and postmodern theory. The second important shift requires that we understand the work of art as a process of communicative exchange rather than a physical object.[101]

Of course, the possibility (or desirability) of communication based on dialogical exchange and reciprocal openness divides critics. And it is an acceptance of the possibility of this sort of communicative exchange that opens the door to the sympathetic reception of cooperative art. Crit-

ics who champion activist, cooperative art practices look to theorists like Habermas and Freire as well as to the dialogical practices of activist political organizations for their theoretical horizons. On the other hand, writers like Kwon, Deutsche, and Bishop have attacked the political theoretical legitimacy of this position, often in the name of European postmodern writers like Jean-Luc Nancy, Jacques Rancière, and Jean-François Lyotard.

By 2005, with the publication of *What We Want Is Free: Generosity and Exchange in Recent Art*, edited by the artist Ted Purves, the art of gift exchange and reciprocity was on the table. Throughout the book a number of critics and artists debate the notion of generosity, with particular interest in the idea of two-way or cyclical exchange. Mary Jane Jacob, for example, proposes a notion of "reciprocal generosity" to create a mutual relationship, in contrast to the "deficiency model" that sees audiences as empty vessels needing enrichment. Jeanne van Heeswijk, on the other hand, critiques the "problematic nature of generosity" and its implications of hierarchy—the empowered "giver" being above the recipient. At the end of *What We Want Is Free* there is a short essay by the artist and critic Francis McIlveen that attempts to put exchange-based art in a historical context. While McIlveen makes a number of excellent observations about the usurpation of the commons and the etymology of *hospitality*, he ends up making the same sort of grand claims for interactive art that got Bourriaud in trouble with Hal Foster and Claire Bishop.[102]

In a closely related development, collectives have become a new art trend: from the Critical Art Ensemble to Flux Factory, from the Center for Urban Pedagogy to the Center for Land Use Interpretation. A good summary of this new phenomenon is *Collectivism after Modernism: The Art of Social Imagination after 1945* (2007), edited by the artist Gregory Sholette and the UC Davis art historian Blake Stimson. While not all of these collectives create socially collaborative art, they occupy cooperative territory that Sholette and Stimson describe as "neither picturing social form nor doing battle in the realm of representation, but instead engaging with social life as production, engaging with social life as the medium of expression."[103] If cooperative activity is an element of the spirit of our time, collectives are as much a part of it as socially cooperative art.

By 2008 scores of exhibitions, projects, and books were under way that addressed participation, but there was still no consensus on exactly what to call the art projects or how to narrate their genealogy. In the fall of 2008 the San Francisco Museum of Modern Art mounted *The Art of Participation 1950 to Now*, which emphasized the influence of performance

art (particularly Fluxus) and the sociotechnological possibilities of the Internet. On view almost simultaneously at the Guggenheim Museum in New York was *theanyspacewhatever*, a collaboratively produced show of relational art. The Guggenheim's publication includes Bourriaud's formulation of the notion of relational aesthetics in an essay called "The Relational Moment," reprinted from the catalogue of *Traffic*, the 1996 exhibition, and *theanyspacewhatever* included all of the same artists as *Traffic*. These artists are the core relational cohort, and they have shown together on a number of occasions as a loose collaboration. Nancy Spector, who organized *theanyspacewhatever*, situates this relational art as a quintessentially 1990s aesthetic, created in the "post-representational" period, under the theoretical sway of Gilles Deleuze's philosophy of multiplicity and difference.[104] Surprisingly, then, from the East Coast to the West, from museums to public spaces, there was a movement toward mainstream interest in cooperative art. The relatively rapid rise in 2009–10 of Theaster Gates as an important artist in the emerging field of social practice, then, was not so surprising. He has an appealing set of talents and training from urban planning to ceramics, merging the resonant materials of inner city life (à la David Hammons) with the social intent and pragmatic approach to problem solving of Rick Lowe. His practice is rooted in the local, with an intense long-term investment in the Dorchester Project in Chicago. But he has reached out internationally at the same time. Gates sprung onto the mainstream art scene much quicker than his predecessors did, presenting at museums, art fairs, biennials, and Documenta. While Gates's art veers in and out of the socially cooperative mode that is the subject of this book, the rapid ascension of an artist with his dedication to direct action and interactive approach is a symptom of an art establishment that is at least for the time being ready to open its eyes to new forms of engagement.

———

I am claiming that socially cooperative art in the United States was born from a confluence of local political sensibilities and international artistic influences. The exemplary counterinstitutions of the 1960s created models of participatory action from community organizing to progressive planning, communes, and consciousness-raising groups that sometimes morphed into performances at the New York Stock Exchange and the Atlantic City boardwalk. Simultaneously, through the 1970s artists were experimenting with social forms: happenings, sanitation ballets, feminist group performances. When international writings brought the

notions of lived situations, social sculpture, and dialogical learning to our shores, their vocabulary was readily absorbed into American practice. In the 1980s cooperative practice gained a strong foothold in more public venues, in the shadow of an increasingly conservative nation, and once again the international vocabulary, this time of relational art, merged with local traditions of artistic political action. Finally, cooperative art made it into mainstream museums and a string of influential books in the first decade of the twenty-first century even as a split began to emerge more visibly between activist and relational strains of participatory art.

One way or another the artists discussed in the following chapters have been working with artistic social cooperation. This core cooperative process infuses all the projects, but what they made differs widely. In some cases they made objects; in others, social environments. These ventures might take the form of a classroom or educational institution (Wendy Ewald, Tania Bruguera, Brett Cook, Mark Dion), a party or parade (Pedro Lasch, Daniel Martinez), a cooperatively created film (Harrell Fletcher, Evan Roth), an intercommunity meeting place (Mierle Ukeles), a research project (Ernesto Pujol), or an urban redevelopment project (Rick Lowe). But for all these projects, the art is a process of cooperative action — even as conflict and argumentation are sometimes important constituent elements. In the conclusion I make my own argument for the value of an American pragmatist reading of the antispectatorial art of social cooperation. But first I would like to pause for several hundred pages and share the podium with an interdisciplinary group of artists and writers. How did they cooperate? What did they make?

TWO COOPERATION GOES PUBLIC

Consequences of a Gesture and
100 Victories/10,000 Tears

DANIEL JOSEPH MARTINEZ,
ARTIST, AND

GREGG M. HOROWITZ,

PHILOSOPHY PROFESSOR

A PAIR of urban art initiatives organized by Mary Jane Jacob in the early 1990s constituted a watershed in the history of American socially co-operative art: *Places with a Past: New Site-Specific Art in Charleston* for the Spoleto Festival USA in 1991 and *Culture in Action,* organized through Sculpture Chicago in 1993. Two of the *Culture in Action* participants were interviewed for this chapter: Daniel Joseph Martinez, an artist who cre-ated two large-scale projects in Chicago, and Naomi Beckwith, who was a teenage participant in Mark Dion's *Chicago Urban Ecology Action Group.* The very title *Culture in Action* signals the activist bent of the project, which played out across the city, reverberated in the press, and provoked debate as to the useful function of art.

In her book *One Place after Another: Site-Specific Art and Locational Identity,* Miwon Kwon argues that Sculpture Chicago presented the *Cul-ture in Action* artists with "prescriptive and overdetermined situations" by mandating a certain genre of social partnership.[1] Daniel Joseph Martinez paints a very different picture. He describes an investigative process, an open-ended, two-year exploration. Martinez was pleased to be supported in an in-depth endeavor and used the time to understand the site and its possibilities, some of which revealed themselves only toward the end of his time in Chicago. In fact Martinez sees this open-endedness as funda-mental to artistic process and emphasizes that artists have a unique license to try out propositions without a utilitarian purpose.

Throughout this book artists are interviewed with professionals from related fields, including architecture, education, and city planning. Often there is a marked difference in vocabulary, but throughout this chapter, in which the philosopher Gregg M. Horowitz joins Martinez in discuss-ing his Chicago projects, there is more continuity than dissonance in the

mode of address. This suggests that Martinez is a philosophically inclined person, that artists who make a living by teaching tend to be well read and philosophically grounded, and that Horowitz has an artistic sensibility.

Many critics, including myself, see *Culture in Action* as a beginning, as an important salvo in the battle to bring socially cooperative art into mainstream art venues (for better or for worse). But there is a sense of melancholy in Martinez's commentary—a feeling that the project represents an era that has passed, a hopeful time before the culture wars were lost, an end rather than a beginning. In recent years, even as social practice and cooperative art have gained new acceptance, Martinez has moved away from participatory art toward intense political commentary and photo-based practice.

———

DANIEL JOSEPH MARTINEZ is a professor of theory, practice, and mediation of contemporary art at the University of California, Irvine. His work has been shown widely at galleries and museums, notably in the politically charged Whitney Biennial in 1993. His recent work includes text-based political artworks as well as severe photographic and three-dimensional self-portraits that often depict physical injury and psychological pain.

GREGG M. HOROWITZ is chair of the Social Science and Cultural Studies Department at Pratt Institute, where he teaches aesthetics and critical theory of culture. The author of *Sustaining Loss: Art and Mournful Life* (2001), Horowitz is currently at work on two books: *The Weak Father* examines the politics of the psychoanalytic encounter, and *Old Media* deals with regressive tendencies in the postmedium arts.

———

The following discussion took place in March 2007. Gregg M. Horowitz joined Tom Finkelpearl at his loft in New York; Daniel Joseph Martinez participated by phone from his studio in the Crenshaw district of Los Angeles.

DANIEL JOSEPH MARTINEZ: It's impossible to discuss *Culture in Action* without talking about the context of its time. A war was taking place—not the conventional type, with armies, but an ideological one. It might be that this was, and is, the type of battle that tests who we are as a nation. It poses the question, "Are you willing to fight for the autonomy necessary to have true freedom of expres-

sion?" It was a very difficult time, and in the end there weren't many survivors and we had lost the war.

Culture in Action, which was organized by Mary Jane Jacob, probably represented the vanguard of curatorial thinking in relation to this area of art—namely, socially motivated installations and collaborative community projects. Mary Jane had been chief curator of the Museum of Contemporary Art in Los Angeles, and she stepped down from that position while she was probably at the height of her power and curatorial reach. The institutional frame was not porous enough to allow her ideas to come to fruition. And so she became an independent curator and started developing these very complicated, multilayered projects. Places with a Past, in Charleston's Spoleto Festival USA in 1991, was a watershed moment; she took artists who hovered on the edges of certain kinds of aesthetic propositions and brought them the opportunity to embrace both history and a contemporary practice that engaged specific sets of communities and geographies—the whole range of possibilities within the social milieu of a particular place. And Charleston, South Carolina, as I'm sure you both know, is a loaded city.

GREGG M. HOROWITZ: Historically loaded.

DJM: Yes, the depth of its history is immense. Culture in Action was a response, I believe, to what had happened in Charleston. Some critics didn't think that Places with a Past broke the ground that Mary Jane had envisioned. In my opinion, they just couldn't comprehend the radicalism in her proposals. So the next step was to go even further curatorially and conceptually, this time in Chicago, her hometown, working with individuals who believed that art is more than just a tool for emotional or psychological transformation—it can be something that affects their everyday lives.

Mary Jane partnered with an organization called Sculpture Chicago, which had a history of placing sculptures in plazas, the courtyards of banks, and large buildings. There's a treasure trove of works all over Chicago because of Sculpture Chicago. But they had a fairly conventional way of thinking about art in public places, even though the director, Eva Olson, was quite progressive.

This could be seen as the first level of the collaboration, from a curator's point of view. Mary Jane found an institution that had

never worked like this previously, and she suggested a new way to consider public art as aesthetically and socially active. This suggestion became an intervention at the level of the institutional structure. It brought awareness that some other processes were possible, like rethinking who the public really was, as well as re-envisioning how artists worked. It showed the possibility that artists could interact with the public and have a reach beyond what is available with the art object itself; it opened up a new consideration of the efficacy of art as a social practice. What if artwork became more temporal—as opposed to a fixed, secured, permanent object? What if fluidity became the organizational and operating principle?

GMH: When did Mary Jane first approach you? And what in your previous work made her think of you as a good fit for *Culture in Action*?

DJM: It was sometime in late '90 or early '91. Mary Jane knew I had been invested in an approach inspired by Joseph Beuys, whose work embodies the concept of social sculpture and direct engagement through teaching and education, along with aesthetic and social responsibility. At the beginning of the project the proposals were shaped by the participants, by how they envisioned the roles and collaborative possibilities. Then the challenge was to see how communities or groups of individuals could be invited into a dialogue, so that the emphasis was no longer on the artist but on some more abstract quality. This decentralization of authorship allowed for a new set of individuals to lay claim to the ideas that were being investigated. This process, which involved an organically unfolding yet directed combination of concerns, de-emphasized the end result and prioritized the interaction. It was all about process. And actually it was about the reorganization of the aesthetic-social matrix. The full course of the exhibition actually transpired over the years that were invested in individuals, communities, and the geography of place. For those of us who had come out of communities that were involved in activism as early as the 1960s and '70s, this idea wasn't necessarily new—but it somehow was new, just the same. Institutional and organizational entities, when they carry out complex, large-scale projects like these, can shed new light on opportunity and generate hope in communities that are starved for resources. Mary Jane was saying to the artists, "Here is the opportunity to create new infrastructures within these communities—

structures that can last much longer than the artist's presence, that will go beyond the artist and even beyond the art." What a wild idea!

Mary Jane created an environment that allowed the artists to approach their projects in ways that seemed fresh and exciting. I maintained a residence in Chicago for the almost two years that I worked on the project. I became as familiar with the city and the individuals I wanted to work with as was humanly possible. The projects were very open-ended — you could start in one place with your idea, but it was understood that it might not be anything remotely close to what you would have done by the time you had finished the project. This organic methodology — to say it was exciting would be an understatement. We were given an opportunity to set into motion something unknown.

It's hard to even define the possibilities and formulate intentions in such a context. We were trying to tackle projects on the scale of the city — that's really what we were working with. It was almost as if we were artists as social architects and our palette the mechanisms of an entire city. How does one go about determining what one would want to effect? Some artists would choose to be intimate; others worked on much grander scales. In my case, I was interested in the labor history of Chicago: in the development of the first factories in the Midwest, which were in Chicago; in May Day; the Haymarket riot; Jane Addams; Hull House and all of these overlapping and groundbreaking social movements that occurred in Chicago. Chicago has very rich political and social histories. The history of immigration combined with the achievements of the working class through the socialist and labor movements suggest that Chicago has been a lightning rod of progressive thinking. I had a particular interest in the May Day parades and the Haymarket martyrs and in how this came to symbolize the socialist and labor movement in the world as International Workers' Day. Social anarchy as a form of public spectacle — this is what attracted me toward thinking about new forms of parades and how they might function. We hardly have anything in Los Angeles beyond one corporate parade, the Rose Parade, which services a wealthy community.

GMH: Is that true? But you've got all those streets.

DJM: We have all kinds of streets, but we have no parades.

The parade follows its route through Garfield Park in Daniel Martinez's *Consequences of a Gesture*, 1993. Photograph by Antonio Perez Photo, Chicago. Courtesy of Sculpture Chicago.

TOM FINKELPEARL: And no pedestrians.

DJM: Even the Rose Parade seems cut off from most of Los Angeles, probably because it's in Pasadena. Chicago neighborhoods have a type of intimacy that seems very different from other places. Each neighborhood seems to function almost as its own separate, autonomous zone, as its own city, and the events that happen there are very specific to those social geographies. The question was: What if you cut across some of these invisible boundaries that exist within the demarcations of class and race? It seemed to me that the most emancipatory and celebratory act that one could involve people in is a parade, and our event could build upon the previous history of the May Day parades and redirect the underlying meaning to impact specific groups and neighborhoods.

So I picked three disparate locations in Chicago that had never had a parade. First Harrison Park, which the locals call Zapata Park; next Garfield Park; and last Maxwell Street Market. I collaborated with a musician friend of mine named VinZula Kara, who is an experimental composer of new music. He was amazing to work with, because structurally we could approach the idea of the abstraction of the parade form and fractionalize it through

both its musical and visual representations. VinZula was the musical director, helping and teaching music lessons as we developed the project. The final parade was composed of around 120 different groups, organizations, and schools from in and around the three neighborhoods that had been chosen as sites for the parade. Some of the groups were the Amalgamated Workers Union, the Juvenile Temporary Detention Center, Redmoon Theater, Spray Brigade, Henry Booth House, Cash Money, African American Arts Alliance, New Sounds—a collection of different groups of people who had likely never been approached to participate in a parade. We invited them not to celebrate something specific, like a holiday, but rather to celebrate themselves. Two others who were instrumental were Elvia Rodriguez and Angela Coleman, who were our project coordinators from Chicago. They knew the city and were key in making introductions and connections in ways that wouldn't be possible unless one were actually from Chicago.

Traditionally parades follow a single route to one location. For our nontraditional parade, we decided to be nomadic, in an attempt to splinter some of those geopolitical boundaries. The social hierarchies of the city were challenged and reorganized by this form of social anarchy. The event began with everybody performing in one neighborhood, then the parade packed itself up on buses and drove to another neighborhood, where everyone got out, performed, and got back on the buses, then went to the next neighborhood, got out and performed again, and then we held the final celebration. At each location we determined a specific route and followed the traditional protocol of a parade: police escorts, stopping traffic to allow the parade to pass, lots of floats, bands, music, grand visuals and costumes, and, of course, the streets lined with spectators cheering and shouting as the parade passed by. It was a daylong event, and it was hard work, but unbelievably fun and exciting. We had the broadest mix of individuals, from little kids to eighty-five-year-old men and women, and they all went outside of the normal places where they lived and ate and shopped; they crossed borders that they might never have imagined crossing in that way. This aggregate of social representation utilized a theatrical seriousness that excavated the political triumphs of the past—combined with the absolute absurdity of the event itself and its outward manifestation as a type of Arte Povera, which created

visual excitement. The chance of unexpected interaction and the possibility of the unknown were exceptionally potent.

TF: You say there were around 120 different groups involved. Can you talk a bit about the process and about what was or wasn't collaborative? Artists usually come in with a plan, even if the plan anticipates change.

DJM: I knew I wanted to work with the city's labor and immigrant histories, and I knew I wanted to organize a parade, but beyond that, my role was really as conductor, choreographer, director. When the project began, I didn't know anyone in the city. The process began with setting up a series of town hall meetings with various individuals who played key roles in their communities. I would introduce myself and my work and lay out a sketch of an idea and ask, "Does it sound like something we could work on together?" It's very difficult to explain to people that you're an artist and that this can be a new way to think about art. I wanted to explain that it's a gesture, a form of poetry, a protest, and an extravagant spectacle, all with a means and a purpose. There's no profit to be made, no reason to do it except that we decide that it can be done and we want to make it happen. What if we just get together and try to create a brief moment of absurdity and surrealism in our daily lives? So it started like that, and soon a form started to take shape.

GMH: Did you have in mind a vision of what the parade should look like? Or did you go in thinking that it was something that had to be worked out in the process?

DJM: It was conceived of as an unconventional parade from the beginning, so I never had a fixed idea of what it had to be. In the end some people had costumes, some had props, some had homemade floats. There were carts for tamales and ice cream. We had fifty of those. It was beautiful to see all those carts going down the street ringing their bells. Each constituency was responsible for deciding how they wanted to represent themselves; we had a series of discussions to determine how to facilitate each group's ideas. So the answer is, we attempted to remain in a constant state of flux and accept change as process and innovation. The key was to give over authorship and decision making to people as individuals working in collective processes. One of the results was the range of participation and commitment. Some groups worked night and day; others kept their involvement much more simple. For example,

one group wanted to dance all day; they elicited awe and won-
der as they danced their way up and down all three parade routes.
The project was an experiment in generosity—being generous
with people whom we didn't know at first, but people who became
friends in the process.

GMH: Are you describing your own generosity in your role as the insti-
gator of the project, or the generosity shown by the parade partici-
pants coming out into the public to manifest themselves?

DJM: Several types of generosity took form as the project developed and
everyone became more and more involved and committed to the
final result. Incidentally I think it would be very hard for people to
do this without an artist. Because I am called an artist, I had license
within these communities to create an event that appeared to have
no particular purpose. I would say that these people had to act
upon their own generosity to be involved with other people they
didn't know. The forms of social exchange and the possibilities of
community building manifest themselves here, at the street level,
which is the location where true organizational thinking and action
take place. There was this viral condition, where all of a sudden
people acted like neighbors and treated one another with an un-
usual degree of respect and friendship. The obvious race and class
differences seemed to melt away, and suspicion was exchanged for
solidarity, if only for a moment. Is it possible that such a moment is
enough to suggest that there can be renewed hope for us as a civil
society? A thousand-plus people get together to become a force,
to act on their own accord to create something with meaning and
yet with no purpose—except that of acting out a gesture of hope-
fulness, a genuine celebration, an open display of love.

I have to tell one story that might be emblematic of the entire
project. It's what I call a Fellini moment. No matter what you do,
there's always a Fellini moment, right? We were in Garfield Park,
which is a predominantly black neighborhood. The parade was
under way, and the sun was shining. It was a beautiful Chicago
afternoon, sultry and mysterious. The police were blocking traf-
fic so we could pass, with crowds of people watching the parade.
We were pretty well organized—walkie-talkies and the like. The
parade was coming up to a major crossing, this one major inter-
section at the entrance of the park, when the sky started turning
that steel gray color. You could feel the air shift, like a mood shift-

Redmoon Theater with Chicago youth in Maxwell Street Market, 1993.
Photograph by Antonio Perez Photo, Chicago. Courtesy of Sculpture Chicago.

ing from euphoria or happiness to something more sullen, almost melancholic. You could sense it: the sky was pregnant with anticipation, as if it were watching the events as they unfolded like a passion play in the damp and heavy air. My first thought was, I hope it doesn't rain, but the sky just kept getting darker and darker. I was directing at the front of the parade, which had reached the intersection, and I could see down the way that there was a whole string of cars coming toward us with their lights on, and other cars were stopping and making way for what appeared to be another procession. Then there it was: a very old-fashioned hearse leading a funeral parade. And I thought, Well, this is going to be interesting. I actually didn't know what to do or what was going to happen, because how do I stop one parade to let another one go by?

The sky was really dramatic as this hearse, which seemed to come straight out of a 1930s movie, was rolling up. It stopped at the edge of our parade, and the driver got out, a dignified and elegantly dressed man. His persona matched the car perfectly. He looked carefully in both directions at our parade, watching silently as if time had slowed down. The few moments he was watching seemed to stretch on forever. He paused, and it felt like he was lost in his own thoughts. Then he looked up and smiled at us. With a single

motion, he just put up his hand and waved us on. It was amazing. I fashioned the thought that he made this decision to let life pass by before death. It was beautiful — an exquisite moment of exchange, of unspoken communication, just pure poetry. There was an acknowledgment in his gesture, in his action, in his eyes that something was taking place in front of him that needed to pass, and he allowed it to continue without question.

GMH: An unanticipated, unrehearsed collaboration?

DJM: Absolutely. It was as unique a moment as I have ever experienced, a moment when once again the unknown came into play. It was breathtaking and humbling.

TF: Can we talk about the notion of beauty? It seems obvious that interactive, collaborative art creates a different sort of beauty than art objects do. Are you saying that there was a beauty in the interaction — a beautiful moment on the route, a beauty in the various unusual intersections across borders?

DJM: The conventional idea of beauty has been predicated on a specific set of trajectories derived from art history. Today we see the effects of the market and a global economy of free-market exchange, and we see how they have impacted the objects of art and their potential as commodities for exchange and financial gain. I am suggesting that an equally intense investment can occur in nonobject manifestations and in aesthetic social exchanges that replace the object with experience and prioritize the event itself over other considerations. Can we introduce an idea of art that can stand alongside and equal to artworks that take the form of discrete objects displayed in a gallery or museum?

Once you begin to enact ideas that are ephemeral, transitory, that work with experiential concerns and non-object-oriented subjects, their forms and ideas begin to blur the more traditional boundaries of what an art object is and how it functions. This challenge to what art is makes it more difficult to identify what beauty might be and for whom. For example, if you look at May '68 in Paris, at the riots at the Sorbonne, those could be seen as extraordinarily beautiful events. The culmination of circumstances that brought together students and striking workers —

TF: It is the moment of integration that is unusual. It wasn't *either* student radicals protesting *or* workers going on strike. Some borders were crossed.

DJM: In the Chicago parade there was a possibility of building upon histories like May '68 through a similar mechanism. Of course the scale was different, but you have to think of May '68 in its time, and we were working in Chicago in the early '90s, to make visible continuing cycles of politics and how art has always had a role. I think it's fine to engage in a debate about beauty in its physical form, but in the case of the project in Chicago, it's more about the possibility that ideas, when genuinely integrated into a milieu, can lead people to take action toward an objective of radical democracy, to participate to a degree that their lives and their existence are tested. Not only can people take authorship of ideas, but those ideas can create a momentum that is potentially unstoppable, and there is an inherent beauty contained within the possibility of those ideas. Allowing agency to be a possibility for people who perhaps believe that they have none is something that is subtly beautiful, though it rejects all of the conventions of beauty and suggests that the ability to quantify and validate lies elsewhere — and why? Because it's interactive, speculative, and unpredictable.

There was a kind of jubilation during those years. Truly we did think that anything was possible. Everybody felt that for once we really could create works for social change; we could work through a cultural apparatus in which the terms of the interaction were not predetermined. There were artists all over this country who were engaged in social activism, aesthetic activism — it was amazing, it was euphoric, extraordinary. And then, like all things, inevitably it all came crashing down [laughs].

GMH: Daniel, I don't entirely understand what you mean when you say it all came crashing down. Would you prefer that situation of extraordinary euphoria to have been preserved? Let me use Tom's question about the meaning of beauty in your art to press my point. In the way you describe the glories of the parade, it seems to me that for you, beauty is essentially tied up with ephemerality, with letting something happen and not with trying to make something last. In fact as I was listening to you talk, an old-fashioned conception of beauty came to mind, according to which, beauty is the formal integration of elements that don't have any business being together in reality but that are brought together by artists to unexpected effect. But what that means is that beauty, or artistic effect

The Chicago Boys Club Drum and Bugle Corps, Henry Horner Unit—one of many groups assembled for the parade—makes its way through Garfield Park in Daniel Martinez's *Consequences of a Gesture*, 1993. On the far left is VinZula Kara; on the far right, Daniel Martinez, wearing black, is shooting video. Photograph by Antonio Perez Photo, Chicago. Courtesy of Sculpture Chicago.

more generally, has to be unstable. To keep it around forever is, paradoxically, to kill it.

DJM: Absolutely. But beauty's instability is also its strength, its vitality. It's not about permanence. It does not need to sustain itself as an institutional structure. The potency of this kind of beauty lies in its leading us to rethink the organizational structures of what we call human experience. What if the most powerful thing that we can create is an experience that someone cannot forget? Is that not what is felt when one lives one's life with the possibility of freedom? Or when one falls in love? How can we sustain a set of principles that set autonomy and responsibility in motion at the same time?

So the parade was one project, but there was another, odder and more clandestine than the parade. At that time there was an extraordinary street market [on] Maxwell Street. It happened every weekend as it had done for the past hundred years. It was made up primarily of minorities and people of lower income groups who would go to this place and trade and exchange anything that you

could imagine. You could buy everyday types of products much cheaper than in a store. It was a bit of a black market where you did not ask questions. On this social stage was this anomalous event of trickle-down capitalism and economic sleight of hand, an event of sublime magic as much as it was an event of necessity.

It just so happened that Maxwell Street was contained in the last piece of open real estate left in the Chicago Loop, an unbuilt piece of land ten city blocks wide. It was clearly quite valuable property, and there was a lot of discussion about what was going to happen to this space and about how the market was going to come to an end. But the market was so successful and well known that it had developed its own economic exchange, which in many ways became a symbolic exchange. In fact there were many who depended upon this market for their daily existence. Across the street from the market is the University of Illinois at Chicago. The university was built by a well-known architect, Walter Netsch, in a Brutalist style of architecture somewhat similar to that of the Whitney Museum in New York. Netsch used these beautiful, giant pieces of granite throughout the university. He built a platform of raised walkways with a series of four agoras. Through the architecture he was attempting to create a forum where free discussion could take place, hoping to create a renewed sense of civil society by establishing a place for public debate. These structures were built and designed acoustically according to the classical Greek model, so that a person standing in the center could speak, and the sound would carry with great clarity to all the listeners sitting around.

GMH: This was entirely within the university? It sounds rather academic.

DJM: To me it sounds more like someone trying to make architecture go beyond mere utility. Imagine this giant platform in the air, acting as the heart of the university, its metaphysical center. On the top of the platform, the students were raised to a place where they could read, study, and relax under the open sky of Chicago while being lifted up by a set of columns. But underneath the platform, it was said to have become dangerous — possibly unsound structurally, but especially a locus for potential crime. I wonder if this development was really caused by the architecture, as it was suggested, or if it was instead a sign of the times. Over the years this architecture had been accused of being ugly, depressing, of lacking

Daniel Martinez (left) and the architect Walter Netsch (1920–2008) at the site of the Maxwell Street Market, standing on granite slabs salvaged from the demolition of Netsch's work at the University of Illinois, Chicago. Black directional signs were repurposed as benches. *100 Victories/10,000 Tears*, 1993. Photograph by John McWilliams. Courtesy of Sculpture Chicago.

a human touch—all the criticisms usually leveled against Brutalism. But now they were also saying that it was a public menace.

TF: Uh oh, I think I know where this is heading, another Modernist failure . . .

DJM: Then, at a dinner party one night, I met a man named Antonio Pedroso, who owned a business called Granite and Marble World Trade. I learned that Antonio's father had quarried the granite used at the university. What a fortuitous moment to meet the son of the man who had quarried the original granite! This was flame-torched granite that was over one foot thick. Twelve-foot-wide by twenty-five-foot-long stones made up the platform. From my conversation with Antonio, I saw that he was an open and adventurous man, and he seemed to understand the need for and the possibilities of incorporating art into our daily lives. He told me about his father's experience working with Netsch, and then I learned that, ironically, he—the son—had been hired to deconstruct the structures that his father had originally participated in building. This center, this heart of the university, these agoras were going to be

destroyed. They were going to flatten the platform and create an open grassy field as a common area that they believed would be more conducive to current university life.

By this time Antonio had probably had a couple of drinks, and he was reminiscing about his family's quarry and its history of supplying the stone for great buildings. So I was beginning to think, and I asked him, "Well, how do you do this, exactly? Do you blow it all up?" He said, "Oh, no. The granite is too valuable. We are going to take it apart one stone at a time." To move one of these giant stones would take an entire eighteen-wheeler flatbed truck. Each slab weighed 85,000 pounds, and there were hundreds and hundreds of them. The slabs were going to be moved one at a time — picked up by a big crane, put on the truck, and driven away to a holding site. As fortune had it, the path of the trucks would go right through Maxwell Street. So I said, "So if you were driving those trucks with those stones on them, and somebody happened to, every so often, take one of them off, do you think that anyone would even notice?" He just thought it was the funniest thing he had ever heard. Then he said, "You know, it might just be possible that nobody would notice." And I thought, Aha! So we agreed and staged a hijacking of the detritus of the university as it consumed itself in a kind of autocannibalism. I got thirty or forty stones, and we rebuilt the agoras and pathways from the university using their own material, except on Maxwell Street. It was an active simulacrum of the university relocated onto this contested space of the marketplace. Not only would the market be able to replace their dirt floor with granite, but the act exposed the need for designating a safe place, an open autonomous zone, to publicly test the limits of democracy. Replacing earth with granite: it's a poetic gesture that then becomes a powerful symbol. It reminds me of the Cuban Revolution, when the peasants celebrated victory by dancing on the marble floors of the palaces. Can a symbol such as these granite floors stand as a platform of authority, as all monuments and symbols have been in history?

So a new challenge had been issued, and it was taken up by all the political groups that were trying to save Maxwell Street, in addition to countless others who saw the opportunity to express their views and debate the most important subjects of the time.

The Sunday Maxwell Street market in action, 1992. Photograph by John McWilliams. Courtesy of Sculpture Chicago.

Many social and political organizations in Chicago realized that I had built them a physical, public forum by which to create events and upon which to hold rallies and demonstrations. It was a free space to discuss publicly whatever someone wanted and needed to discuss, and it happened upon this granite floor on top of this contested earthen floor. And it was all from hijacked material from the son of the man who had originally quarried the material for an architect who was never even consulted when his architecture was being destroyed, a distinguished man of ninety who cried when we discussed what was happening.

The university hired a strip mall architect to come in and redesign the space and tear out what had existed, without any consideration of or understanding of the original intent. It was horribly sad — so much to take in so short a time. But the granite floor on Maxwell Street stayed for years after the *Culture in Action* exhibition had ended, until they finally displaced all of the people who came to Maxwell Street and built profitable, useful, commercial structures.

TF: In a way the Maxwell Street project was a fluke. You were around Chicago long enough to be in a position to get lucky. But you had

to be in the physical place and in the mental state to allow the co-incidence to happen. The project was a product of your long-term commitment to that particular set of sites or that city.

DJM: Oh, absolutely. That's the beauty of the event, trusting in people and places that you don't know. It is a way of working, being aware and open to the timing, being able to see the opportunity and move accordingly. I believe that if one is acting with intention and purpose, the elements start falling into place as if they're meant to be.

GMH: So you built a forum right in the middle of a swap meet, making it possible for commercial life to give birth to a marketplace of ideas. That's exactly how Plato begins *The Republic* . . .

DJM: How perfect. Forms of interaction beyond commerce are made possible—public discourse in a genuinely interactive social space, in this case upon the ruins of the university, which one might think of as the officially sanctioned site of democratic ideals. I heard many debates and discussions take place there with an extraordinary degree of success. Some of the university's professors even brought their students to our new agora to conduct their classes. It makes one wonder what would happen if we were really a nation governed by and for the people. And these people spoke there with authority—their speaking had a different texture, compared to how they would speak in the university, the home, or the local community center. It was extraordinary.

GMH: Daniel, you said earlier that the context that supported *Culture in Action* came crashing down. Would you say something more about the aftermath, the years following 1993? My sense is that much of the art of the 1990s, as well as a lot of the critical and theoretical discourse about it, exhibited a pervasive disappointment with developments in the artistic public sphere and in the politics that sustained it—or failed to sustain it.

DJM: I was referring to the culture wars that took place from the late '80s into the mid-'90s, in particular the attack upon freedom of expression in the arts. Let me give you one example where I was personally involved. In the late '80s I sat on a peer-review panel for the National Endowment for the Arts. Because of the ongoing censorship controversy and the NEA's own actions, we believed that the integrity of the institution and the principles we were supposed to be governed by were being compromised and even disregarded.

So as a panel we debated and deliberated how we might act in a responsible manner that could protest the egregious actions of the NEA at the very same time that we were in Washington sitting on its panel. In the end we decided to actually forfeit the fellowship monies that would have been granted directly to artists.

Well, our gesture didn't go over very well. Many artists were furious—in particular those who believed they were going to receive a grant. I received hate mail and was verbally assaulted by artists when it became known who was on the panel. "How dare you intervene in the possibility of my winning this money?" And my response was simply, "The money is irrelevant. What matters here is that we as artists were losing the autonomy and freedom to act and create without government intervention." The members of the panel felt that our values and ethics were being eroded by tolerance of the governmental structure that was, with one hand, giving out grants and, with the other, taking them away from those who did not fit within the moral framework it dictated was acceptable.

What happened for me was a shift in my thinking. I had believed that idealism was not just a dream, that there was a possibility to change the world you lived in. Then another level of clarity came to me: I realized, like a rock had hit me, that—as opposed to my earlier support—I had changed positions 180 degrees on the NEA. I started asking a different set of questions: Why are we defending the rights of these institutions when they act hypocritically and fail to fulfill their mission to support the arts? What would happen if we rejected the NEA and the insignificant grants that were called "support for the arts"? What if we openly shamed this government for its attitudes toward culture and the arts? For not supporting the very principles the country was founded on? How could we create a more effective means by which to support ourselves? When it came around to the discussion of the NEA being dismantled, I was all for it. My thought was, let's amputate the gangrenous legs and save the body. And next we should try to dissolve museum structures, because museums have turned into corporate enterprises.

Well, it got very complicated and messy, and it got ugly. The euphoria and the optimism disappeared. There were a lot of casualties.

GMH: Are you talking about the years shortly after '93?

DJM: That's right—when the culture wars ended and we lost. It just

got darker and darker. It became impossible for us to operate in the milieu that we believed possible in the late '80s and early '90s, which we really thought was a "culture in action." It became a culture of inaction.

GMH: This may sound like an aggressive question, but at the beginning of the '90s you didn't strike me as an artist who gave a flying fuck what the official guardians of culture wanted. You were working in a collaborative way with diverse communities, and you had a very open-textured conception of the aims of art.

DJM: Yes, in one sense that is true, because there was the possibility of ideas being enacted by artists who could sustain themselves without market intervention. Now that is no longer possible. What we saw in the early '90s was the end of the artist as a free agent. Since then we have seen unprecedented changes in the operating system of the art world. Everything has changed — aesthetics, economics, politics, curators, museums, collectors, art fairs. The art world of the pre-'90s does not exist anymore.

GMH: But why would the corporatization of mainstream culture change your particular practice? If you were an artist who thought he could challenge the status quo by making, say, paintings, I can imagine you saying, "Man, I was barking up the wrong tree." But you had shaped your artistic practices oppositionally and seemed so prepared to understand and respond to those regressive changes as they were happening. Why did they get under your skin the way they did?

DJM: That's a very complicated question, but I will try to answer you. There was such a myriad of factors that came into play. I believe in social responsibility. I believe in education. I believe in the sharing of and the dissemination of ideas that can be accomplished through a practice that is not dependent on the markers of validation propagated by the conventional means by which the art world functions.

I also believe that a complex, multifaceted practice would allow for a mutative process to be invoked that would, in turn, allow richness to occur. Because mutation, by its very nature, is unpredictable and uncontrollable, it's actually an important foundation to predicate a set of ideas upon. The suggestion then is for perpetual motion, constant flux, so that a project doesn't become calcified. For me, there were so many lost battles between '93 and

'95 — everything we fought for seemed lost. After '93 and *Culture in Action* there were no more possibilities for curators and visionaries like Mary Jane. There were no more projects that worked with the same scope and caliber of ideas. That moment was a truly radical, innovative time in art. It became impossible to carry on with the same tactics; everything needed retooling. A radical rethinking of what was to come, a new future, needed to be envisioned.

GMH: And so that open-weave aesthetic that we saw both in the parade and the agora was an artistic expression of the possibility of political transformation at that moment. And the loss of that possibility meant things were closing down around you?

DJM: Yes, that is correct. That artistic expression precisely characterizes one of the goals of *Culture in Action*: to encourage the creation of an open-ended discursive space that allowed for experimentation, theorizing, and the possibility of genuine transformation of people's lives. Tom brought up a question earlier: Is the subject of art reduced to being "Art," with a capital A, or is there room for social activism? But the question itself forces the ideas into a binary division; it implies a prescriptive view of the function of art, as if the possibilities were limited to a predetermined understanding of what art is and how it should operate.

TF: When we talk about attributes of art that are admired by experienced viewers, complexity often seems to rank very high on the list. It took you quite a while to describe that one moment in the parade when the funeral procession arrived, and there was a lot going on, both physically and psychologically. Do you see complexity of experience as an important value when assessing your parade?

DJM: If we imagine that art is not only an object in a gallery or museum and that experience is fundamental to change on a deeply personal level, then we can conclude that all art is invested in experience. For example, an Ad Reinhardt painting may look simple on the surface, but the complexity of the intellect behind it slowly seeps to the surface.

TF: Here is something I have been thinking about: in a museum, in order to make sense of or evaluate a work of art, the perspective is from the viewer toward the object. Just the opposite might be said for public art: to understand and evaluate the work, you might need to look from the work of art out at the participant [or] audi-

ence member and to the physical and social context it inhabits and creates. You need to ask: What is the social or intellectual space that is created or destroyed or brought into question by the piece?

DJM: You don't look at the object, you have to look at yourself, within the physical and psychological context. It's crucial to be willing to risk not knowing. To continue the debate between the aesthetic value of the artwork and the potential social value — can we go beyond the modernist relationship between the gaze and the object, and can we enter into relationships that suggest a utilization of many means simultaneously?

GMH: One of the side effects of those standard museum practices that exhibit works of art in dehistoricizing contexts is that they neutralize the viewer's ability to look back at the world from the point of view of the work. It makes artworks into objects, and an object, by definition, is something you look at rather than a perspective you look from. So you could say that museums tend to neutralize the complexity of our interaction with works of art. Public art and collaborative art reverse that process. They try to enliven situations, to make what otherwise would be unanimated space, or at least space that's simply *there*, alive with fresh points of view. So I agree with Tom about the importance of complexity. I'm sitting here looking at a picture of the agora now. Daniel, you described this as a project in which you put granite slabs down in a place where there used to be just a patch of mud. Aesthetically that's not a huge accomplishment. But what you did, really, is that you turned a patch of mud into a fresh situation, from which the world can be looked at and engaged with in a variety of ways.

TF: But when you say, "Aesthetically that's not a huge accomplishment," there is the question of whether you can take a different aesthetic angle. One of my pet peeves, which is relevant here, is that I don't like to look at photographs of public art that don't include the audience. It can be misleading. Here in New York we are looking at the cover of the *Culture in Action* book with the site on Maxwell Street — but there are no people. It seems to me that the photographer is looking at the platform as an object rather than as a place for interaction. I would like to see pictures of it both empty of people and while being used, side by side, because I feel that that would illustrate two very different ways of looking at art.

DJM: I agree that it's a highly aestheticized object when there's no one there. But as I said, I don't see that as a negative. It is, rather, a strength that can be capitalized on in relation to its collaborative and performative counterpart. When the market is being used, it's a completely interactive space. Without people the object is pregnant with potential in its silence, but the true nature of that particular work happens when someone comes upon it and a discovery is made.

TF: Well, you could see it as a piece of minimalist sculpture in the genre of Carl Andre's work.

DJM: Absolutely. That aspect of the work requires more consideration.

TF: But it is interesting that you say that without the people present, the work is "aestheticized." You are making a correlation between aesthetics and the notion of object analysis—the museum-bound notion that the aesthetic experience is based on looking at objects, as Gregg said. But there are other aesthetic values based on the social, interactive intent of the work. I would like to go back to a notion that Gregg brought up when we first met to discuss these ideas. Gregg postulated that, in socially collaborative practice, the various collaborators—the artist, the institutional structure, and the so-called community participants—each bring a part that is inaccessible to the other people. Each brings his or her own experience, power, history, skill, or resources, creating a whole that simply cannot exist without the active participation of all the various parties. In the case of the parade, your vision as the artist is incomplete without the community participants' representation of themselves. They come into the picture with their own agenda related to their identity or self-representation. So together you are creating some kind of whole from a sum of different parts that could only be created in this collaborative process. Does this have anything to do with what you said, Gregg?

GMH: It fits perfectly. Nicolas Bourriaud makes a similar point in his criticism of Guy Debord. Bourriaud distinguishes "relational aesthetics" from "situational aesthetics" when he says that "the idea of situation does not necessarily imply a co-existence with my fellow men. It is possible to imagine 'constructed situations' for private use, and even intentionally barring others.... The constructed situation does not necessarily correspond to a relational world, for-

mulated on the basis of a figure of exchange."[2] Tom, I think you are calling attention here to the relational aspects and aspirations of Daniel's collaborative projects.

DJM: I think the reference to the distinction between relational and situational aesthetics is excellent. If transformation is woven into the subject and intention of the event of social exchange, it seems that there must be some form of collaboration that, of course, requires the involvement of others. In fact it might be necessary that its publicness is also mandatory. But I am not convinced by Bourriaud's theorems or what seems to be the rigid confinement of the effectiveness of the artists he champions. In contrast, we are still unraveling the events of May '68 and discussing the still potent writings of Debord.

TF: Is the artist a catalyst, like the element that creates the chemical reaction?

DJM: The word *catalyst* makes me nervous. I would prefer artist as *agent* or *component* in this context. I do think there's something of value that people still respect when you say *artist*. The word still conjures up a specific image in people's minds. I am sure it's attached to some highly romanticized notions of what an artist is, but it can be useful. We should try to extend and expand the entire domain of what we call *artist* and how we describe it.

TF: Can we get back to the question of what Gregg said about creating a whole? In Chicago you were an agent for two different interventions in the city that involved a bunch of other people. Is there an aesthetic value in creating this whole from the sum of these various social parts?

DJM: I think that the phrasing of each work allowed for a poetic moment, something intangible. And there can be beauty in the disparateness of the components, or the individuals, or the characteristics of those individuals. The process allowed for an open-ended conversation that was ripe with potential.

GMH: Theodor Adorno said something to the effect of "Contradiction is difference seen from the point of view of utopia."[3] It's a short and massively compressed thought, but it's relevant right now because you were talking about the romantic conception of the artist as an agent whose responsibility is to resolve differences, to create an organic unity, a whole in which differences are reconciled. And that has always seemed to me to be an ideological misconception.

Artists don't resolve differences. They ramp up the differences to the point of contradiction.

DJM: Absolutely! Confusion opens up the possibility of the unknown.

GMH: And when you're in a contradictory relationship to someone, it means that you're different from them, but also that you can't get away from them without a sacrifice of something in yourself. They really are your "other." That's the utopian moment, when you're involved in a relationship where the wholeness is constituted not by the resolution of differences but by their unyielding, absolute complexity.

TF: Would you agree that generosity and empathy are elements of these projects?

DJM: Yes, I think generosity is the key to efficacy in an artistic practice. There are many conditions of the art world that we live in, and not very many of them are directed toward a condition of generosity. Teaching seems to be one of the last domains in which there is an open exchange that can establish new possibilities. Somehow we must construct a new means of interaction. We must reconfigure the environment so that art that is critical and challenging can thrive. Perhaps Adorno does say it best. I remember he said that art is the aesthetic space of utopia that has not been realized elsewhere—it is representative of the Other, of that which has been exempted from the processes of production and reproduction.

Chicago Urban Ecology Action Group NAOMI BECKWITH, PARTICIPANT

DISCUSSIONS OF SOCIALLY cooperative art generally revolve around the artist's intentions, the ethics of institutional involvement, and the politics of sharing "voice." What tends to be left out is an inquiry into the motivations and outcomes for the so-called community participants. In Miwon Kwon's *One Place after Another* there is a photograph of a young woman working on a *Culture in Action* project as the artist Mark Dion looks on in the background. This young woman is Naomi Beckwith. Following is an interview with Beckwith regarding her participation in the *Chicago Urban Ecology Action Group*, a project instigated by Mark Dion. One of Kwon's critiques is that socially cooperative art projects can have the effect of the "reification and colonization of marginal, disenfranchised groups."[1] As a participant, potentially a subject of this sort of "colonization," Beckwith is aware of Kwon's critique but remains loyal to the memory of Dion's orchestration of the cooperative venture. However, at times she hints at ambivalence about the sorts of pressures the organizing body was placing on the artist, conforming to another of Kwon's critiques.

Dion's process often takes the form of a scientific or semiscientific investigation of the natural world. The results of the investigation are typically presented in an installation that has a Victorian look and feel, in the mold of a cabinet of curiosities. In *Culture in Action* he engaged in a cooperative science project, but this time it was a thoroughly process-oriented venture with no collectible final product. In his early thirties at the time of *Culture in Action*, Dion was one of the younger artists involved in the initiative. Interestingly, when she was a graduate student Beckwith worked with Dion again as a coordinator of a project called *Two Banks (Tate Thames Dig)* at the Tate Gallery in London (1999). Later, when Dion had moved to Harlem and Beckwith was a curator at the Studio Museum

there, they worked together on a small project. In this rare trajectory Beckwith was first a youth participant in Dion's work, then a paid coordinator, and finally a curator in charge of his project.

Throughout this book artists and critics address the issue of instrumental result: If the project changes the life of a participant in a positive way, does that make it a success? Surprisingly, while Beckwith confirms that her participation in the *Chicago Urban Ecology Action Group* changed the course of her life, she is not particularly interested in assessing the project on the basis of this very personal result. Of course her opinion does not disqualify this social outcome as worthy of consideration. Just as the artist's intent is only one of many readings of its meaning, the audience-participant does not have exclusive rights to an understanding of her participation and its evaluation.

NAOMI BECKWITH is a curator at the Museum of Contemporary Art, Chicago. After completing a master's degree at the Courtauld Institute of Art in London, she was a critical studies fellow in the Whitney Museum Independent Study Program in New York. Prior to her appointment at MCA in 2011, she was an associate curator at the Studio Museum in Harlem, where she managed the artists' residency program and organized a number of shows, including *Zwelethu Mthethwa: Inner Views*, three series by the South African photographer.

The following conversation took place at Tom Finkelpearl's loft in October 2009.

TOM FINKELPEARL: How did you first hear about Mark Dion's *Chicago Urban Ecology Action Group* for *Culture in Action*?

NAOMI BECKWITH: In my sophomore year in high school a science teacher pulled me aside and said there was this project I might be interested in joining. I remember there was a bit of a process—we had to write a paragraph about why we would like to participate in an art, science, and ecology program. Around fifteen students from two high schools would be invited. Early on there was mention of a possible trip to Belize, so I was interested from the start! The schools were Lincoln Park High School, where I went, and Providence St. Mel, a Catholic school on the West Side. Lincoln Park is on the North Side of Chicago, toward the east. It had a reputation as a yup-

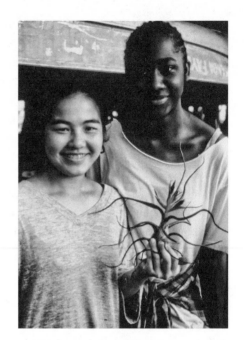

Naomi Beckwith and Kazumi
Yoshinaga with found epiphyte in
Belize, 1992. Photograph by Marc
PoKempner, Chicago. Courtesy of
Sculpture Chicago.

pie high school and was in a mostly upscale neighborhood. I was not
from that exact neighborhood; I was at Lincoln Park through a mag-
net program. Providence St. Mel was a great school yet was located
in a sort of socially fraught West Side area.

TF: Do you know how they chose those two high schools?

NB: I don't, but we always joked that something was up — that there was
a little social engineering going on, pairing the North Side "white"
school and the West Side "black" school. But it did not turn out that
way because, ironically, many of the students who participated from
my North Side school, including myself, were black. In any case the
idea was to join students from Lincoln Park who had a science back-
ground with art students from Providence St. Mel. All of the Lincoln
students chosen for Mark's project were either from the baccalaure-
ate program or the honors science program.

TF: High achievers?

NB: Yeah, high-achieving women [*laughs*]. Exactly. In fact there were
boys in the group, but after a few weeks only one, Jerry, remained.

TF: What were your first impressions?

NB: The project took the form of an extracurricular school program on
Saturdays. We had to get out to Providence St. Mel in the morn-

ing, so it felt like they were testing our allegiance, our ambition for the program. I was expecting an art class, but I remember it as more science-based, which was particularly interesting for me at the time. We were studying ecology. I definitely knew it was an art project, but it was structured like a tutorial. We would read; we would talk; Mark would give us these lectures on ecology, both urban and tropical, and would invite guest speakers like Alexis Rockman and other artists.

TF: Was Dion always present?

NB: Yes, just about every weekend. So it was an ecology study group. But there was also some screen printing of T-shirts and the beginning of the schematics for what was going to become a watershed model to install in this "museum" in Belize. I put the word *museum* in quotes because it was essentially a teeny building the size of this office [*laughs*]. At that time we were learning about tropical ecology to create what would be a fair rendering of how water originates at the top of a mountain in Belize and makes its way through the landscape and into a reservoir. We worked on the watershed model until December, when we went to Belize to install the model. The trip was amazing. We stayed in Victoria National Park in the rainforest and visited several ecological sites around Belize. We also visited nature preserves outside the rainforest, the Belize Zoo, and a studio where wildlife nature programs were filmed! At each spot we either were given a guided tour or got a chance to spend time with a local scientist or naturalist.

TF: Did you interact with Belizeans while you were there?

NB: Yeah, definitely. In the rainforest we primarily met with two caretaker Mayans, whom we knew by their first names: Pio, who was a younger gentleman, and Ignacio, who was an older gentleman, both from the village nearby, about an eight-mile walk away. They were our guides, and they took us on walks through the rainforest. Ignacio ended up being an interesting soul; he was in his seventies or eighties, but didn't look a day over forty. Of course we didn't believe his age until Mark pulled out some book from the library that had a black-and-white picture of Ignacio from the 1940s! Mark already had a relationship with these people. It seemed pretty natural—a group of teenagers coming down who have a project to contribute. For the most part I think our hosts thought we were cute. Overall it was fun, but it was also pretty much an educational trip for us.

TF: What was the relationship between the group and Mark?

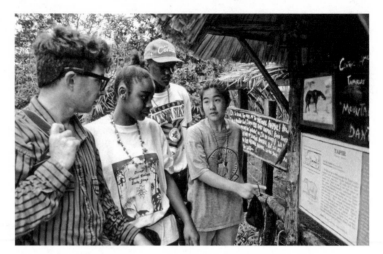

Chicago Tropical Ecology Group (the precursor to *Chicago Urban Ecology Action Group*) at the Belize Zoo, 1992. From left: Mark Dion, Sharmaine Hendrix, Jerry Winners, Kazumi Yoshinaga. Photograph by Marc PoKempner, Chicago. Courtesy of Sculpture Chicago.

NB: He was young enough that we could banter with him, but he was also very much like the teacher, really. He was the one to guide us through the ecology classes, to teach us about installation art. But he also really allowed a great amount of freedom and outspokenness. He wasn't a taskmaster. The sense was: "You guys are on your own. You can do what you want as long as you're responsible with your time."

TF: What was the dynamic like among [the members of] that group?

NB: There were around ten members left after the trip. We all got along famously; it was a good time. Well, I did have a small rivalry going on with another woman from my school, but that had nothing to do with the group itself, just something high schoolers will do.

TF: So, back from Belize, you began to work on the project that would be part of the public face of *Culture in Action*.

NB: Yes, we got a small building, a former fly-fishing club in Lincoln Park near Lincoln Park Zoo. The building hadn't been used in many years, and the city gave us access to it. We fixed it up, redecorated it, and turned it into our working space. We were still thinking about urban ecology, but this time we started creating more projects as individuals rather than the collaborative project for the museum in Belize, so at this point it turned more into an art school. The projects

Chicago Urban Ecology Action Group collecting samples from a research area near the clubhouse, 1993. Walking figures from left: Jerry Winners, Mark Dion, Naomi Beckwith, Karlyn Westover. Photograph by John McWilliams. Courtesy of Sculpture Chicago.

were partly inspired by the trip to Belize, but also Mark would give us a series of assignments—something sculptural or photographic. And then often there was an ecological component, now focused in Chicago—local migratory patterns of birds or the aquatic systems of the city. We were given a couple of weeks for each project, and this lasted all the way through the summer. We were around eight months into the project by then. We also started making sculpture from detritus left in the park after Friday night. The immediate area around this little pond next to the clubhouse was a gay cruising area. So we would go out and collect things like clothes, condoms, and so forth—in a safe way, of course. It was a revealing exercise; we were thinking about ecological systems as much as human social activity. Since then that area has been cleaned up, and the city has built the Museum of Natural History on the site. That summer was the *Culture in Action* show.

TF: Did you read the press about the project?

NB: Yeah, a little bit. We weren't paying much attention, though. We knew a bit about Sculpture Chicago and Mary Jane Jacob. We knew that Sculpture Chicago historically had done more traditional placement of sculpture around the city, and this year they decided to work on

these community-based projects. We knew that it was an unusual move, and we did go visit the other projects. I loved the *Flood* project because of the AIDS activism mixed with ecology. [Initiated by the art collective Haha, *Flood* took the form of a hydroponic garden to produce food for people with AIDS.]

TF: When people started to come see the project, what role did you play?

NB: I was vocal, so I kind of ended up being an unofficial spokesperson by default. Mary would often bring around groups, and she loved for me to speak [*laughs*].

TF: What did the project look like?

NB: Our final project was really our working space, which was fascinating. We built up a selection of sculpture installations in this clubhouse, and that was really what people came to visit. By now the project included a roving cast of characters, including Dan Peterman, who became a cotutor with Mark.

TF: When I have seen photos, they tend to show Mark working with a group. I've seen pictures of the process, but not of the so-called product.

NB: Right. The project was viewed as a process rather than a product, but by the time the project ended there was this accumulation of things in the clubhouse. I think that the visitors focused on these things as "products" but were told about the process on the way from one site to the next.

TF: Was there also foot traffic from the surrounding neighborhood?

NB: No, the visitors were mostly on tours. Don't forget, our site was on a pond away from the neighborhood center. It wasn't an accessible place, and it was meant to be "in nature." Not to say we were in the middle of the woods or anything. Most people who stopped by were Mark's colleagues or others who sought out the site intentionally.

TF: Was there an impact back at the schools?

NB: Yeah, and in the end a few of us even started an ecology group at our high school. It was the core group from Mark's project plus a few other sympathetic students. In addition, the baccalaureate program required us to have majors, even in high school, so art became one of my concentrations after the project.

TF: Beyond that, do you think it made a difference in the trajectory of your life?

NB: Well, I am a curator! The way I narrate my life trajectory is that I went

into the program as a science geek, planning to be a doctor. In college [at Northwestern University] I started out majoring in chemistry but had this existential crisis, like everyone does when you map out what to do with your life and then it doesn't work out. I was not going to become a doctor after all. But I remembered the other thing that I enjoyed doing and challenged me the most aside from science: art. I finished with a degree in African history, but then I got a master's in art history at the Courtauld Institute of Art in London. The *Culture in Action* project changed the way I looked at art. Even though contemporary art can be really cryptic, the project introduced me to new forms, like installation. I think this equipped me to tackle art history in graduate school even though it wasn't my major in undergrad. After the program we participants could tell that we probably had a better grasp of contemporary art than not only most people our age but also a lot of people who had a real interest in art. That helped a lot.

TF: In Miwon Kwon's book *One Place after Another: Site-Specific Art and Locational Identity*, there is a photograph of you working on the project. Do you remember what you were doing when the shot was taken?

NB: I think I had just taken what is called a Hach test. That's when you take water samples to test its oxygen and pollution levels. The map in front of me seems to show the northern border of Wisconsin with Lake Michigan, including Chicago. The photograph was taken inside the clubhouse.

TF: One could read the photograph in terms of Kwon's critique of this sort of art—the artist in the background pulling the strings as the participant in the foreground, which happens to be you, enacts "education" or "community participation" on his behalf.

NB: Yes, I am aware of that critique, and I know that Mark found it upsetting, the idea that the artists created these superstructures and organizing principles in alliance with the institution and the curator's wishes. But the criticism didn't really attempt to understand the dynamic between the artists and the participants, or the personal motivation of the participants. These critiques also take issue with the fact that communities are sort of flattened out and assumed to be preexistent to the project and tend to break up after the project runs its course.

TF: Was the "community" created for this project, and if so, did it dissipate afterward?

Project review for the *Chicago Urban Ecology Action Group*, 1993. Clockwise from center: Mark Dion, Catherine Mach, Kazumi Yoshinaga, Charmaine Morgan, Naomi Beckwith, Karlyn Westover, and Jerry Winners. Photograph by John McWilliams. Courtesy of Sculpture Chicago.

NB: Yes to both, but I don't think I'd call that problematic. The project was understood as temporary, though I remember our parents saying, "How can we make this last?" But I think it should be thought about as this didactic system, a yearlong seminar program. Then the participants graduate; that academic model is underestimated. Also in this case there was a residue, the eco club, which went on for another year at my high school.

TF: Another way to read this photograph is to look at how Kwon and her editors chose to present the photograph in her book. In full the caption reads, "Mark Dion and Chicago Urban Ecology Action Group, *The Chicago Urban Ecology Action Group*, 1993. (Photo by John McWilliams; courtesy Sculpture Chicago.)" So Dion, Sculpture Chicago, and the photographer are named, but you are not, even though you are at the center of the photograph.

NB: That is a probable reading, and it's interesting that no one is named even within the critique of the project. It's an oversight that goes back to my point about not investigating the motives of the community participants.

TF: Did you get what you expected to get out of the project?

NB: I don't know if I expected that much going into it. I expected it to be

a trip to Belize, which was exciting, and that happened. I expected it to be more of a traditional art experience, and that didn't happen. But that was the really formative thing: I came to understand that there is this practice of art that's not media-specific. That was exciting. I think we fully understood Mark's practice, before the project was over, as a critique of knowledge formation. How does someone practice art: by acting like a botanist or a nineteenth-century man of letters? That was pretty fascinating, so I walked out of there thinking, There's this thing called art that doesn't have to exist as an object—art could be performing a gesture, and the residue of that gesture can be an art project.

TF: Were there times when you felt a sense of voyeurism from the audience?

NB: Yeah, but it wasn't distracting; it was sort of understood that the tours would be coming through. It was understood that we had to speak, and it was only slightly annoying [laughs].

TF: Was there a sense of the well-to-do audience on tour to the authentic city?

NB: No, there wasn't that sense at all. I remember most of the visitors being interested in art, and I don't remember a lot of funders visiting. But we were young, and we may not have totally understood what was going on. For the most part we felt, "They're here, but we're doing our thing. We're kids, and Mark takes us on cool field trips." We were pretty self-contained and self-assured. It was a consensual relationship.

TF: Looking back, do you see it that way?

NB: In retrospect, you get a little distance and become savvier about an institution's need to cultivate support. I really came to understand *Culture in Action* as a tour de force of Mary Jane Jacob's personality. She was orchestrating it like an impresario. I suspect many of those visitors were there for the greater good of the reputation of the project of Sculpture Chicago.

TF: If the project was an educational experience, then you, the student, or at least the intellectual development of the student, could be seen as the product.

NB: I think that's somewhat how we were presented. I mean, I don't think I understood what was presented as the product for the audience: that the interaction with the artist was the artwork.

TF: Do you find that problematic?

NB: I don't know if I can say that. It was a process of understanding for all of us. It could be seen as a great educational opportunity no matter what Sculpture Chicago was putting out as the "art project."

TF: You've kept in touch with Mark?

NB: Yes, we kept in touch. In fact we worked together again. When I was in London it turned out that he was invited to do an urban ecological project for the Tate, not so far removed from what he did in Chicago. I attended a talk he gave about it, and soon after he got me hired by the Tate to actually help manage the project. That project was called *Tate Thames Dig*. It was conceived of as a bridge project between the Tate Britain and the new Tate Modern. The participants were high school students from a school in the area, about the same ages as the group in Chicago. It was a rather small group, eight to ten kids. And for me this was now a paying job. Now I was one of *those* adults working with the high school students selected for Mark's project. For the project we would go down into the Thames during low tide, dredge the river bottom, bring in what we found, clean it off, and fill this large antique-like display case that Mark had designed. It was like a cabinet of curiosities, literally. We were acting as amateur archaeologists bringing this stuff up, and no matter how mundane the object was, we had to tag it, treat it as an artifact. When the Tate was in the planning stages, they were aware of some of the criticisms of the Sculpture Chicago project, so they invited me in, and we sat down with Mark, and the curators asked, "What were your impressions of the program? What was problematic?" One big difference at the Tate was that there was a final product, a work of art that entered their collection. The process became also part of the product; it was reintegrated into the product.

TF: You say that the Tate folks asked about your reaction to Sculpture Chicago because they were aware of some of the criticisms. What were your reactions at the time to the emerging critiques?

NB: I was pretty angry about it [*laughs*] because I was dedicated to the integrity of the project. I mean, it's not that I had no criticisms of the overall *Culture in Action* endeavor. I was somewhat wary of the project's relationship to Sculpture Chicago, not on the basis of any particular thing they had articulated, but just based on a vague understanding that there was this scheme driving all this. I had a sense that there was an overall agenda, but no sense of whether or not Mark was fulfilling it. I can't articulate what those expectations were, but

I could see that Mark had an ideal program in mind, yet Sculpture Chicago had their own ideas, so he had to reconcile those two things. I think that this might have created some stress. The Tate seemed to be much more open as a process; it was an easier and looser summer project, at least for me.

TF: How would you evaluate the success of the projects?

NB: It's difficult to know what sort of criteria to apply. As a curator I'm always a little wary of judging projects by their social effectiveness. Though I'm always happy to see that as a byproduct of the art project, I don't know how to judge it as such. Still, there were personal and social outcomes for us. I think the participants did develop a sense of responsibility to and for the project. I was able to recruit my younger sister into the project, and it seemed to be fairly self-sustaining. We were committed to the process—and we produced some pretty cool-looking art [*laughs*]. High school is definitely a hierarchical situation in terms of the teacher-student relationship. But this was different—truly unconventional, at least for me. As teenagers we were trusted for the first time, trusted as intellectual beings. It was a learning process where we were encouraged to think among ourselves, to talk among ourselves, and develop individual projects. It helped create a certain curiosity about the world, and sense of understanding, a performing of gestures that can be thought of as art in hindsight. Also, if you think about the intellectual legacy of the process, the individual development was impressive, even though I'm the only one from Lincoln Park who went into the arts as a career.

TF: Quite naturally, you are expressing the participant's perspective. Now that time has passed and you're a curator and art historian, do you see other aesthetic values, perhaps in the "relational" structures that emerged?

NB: Well, I struggle with relational aesthetics, even as a trained art historian. I think more in general terms of conceptual art—which is where I find my intellectual allegiances. I like to evaluate a project generally in terms of its aesthetic or conceptual rigor rather than its results—no matter how an-aesthetic or pedestrian the project, I think it should have a guiding rhyme or reason. Mary Kelly, I think, was really instrumental in opening up these possibilities. I don't mean to sound conservative, but I do mean to try to parse out the conceptual parameters of a project from its functional capacities or goals, which certainly can be wrapped back into its aesthetics, but not necessarily.

For instance, I am personally interested in projects that sort of set up uncontrollable systems, like Phoebe Washburn's biospheres work or Yukinori Yanagi's ant farms — the results are random and can't be adequately measured in languages of affect, but the frameworks are very strict. Sometimes collaborative projects are like that: a framework is established and followed, and the commitment to the process is more important than delivering results.

TF: How do you think the project entered art history?

NB: I'm not sure. After I finished college I ran off to Europe to apply for graduate school. I was going for an interview and happened to see a *Culture in Action* catalogue.[2] I was in Berlin with a friend of mine, just perusing the bookstore, and *voilà* [picking up the *Culture in Action* book], this book pops right out! I had no idea that a book had been published. I thought it was hilarious! I wasn't expecting a scrapbook to remember the project by. I wasn't thinking of the media [or] critical response. For the most part, I think most participants walked away thinking, "That was a really interesting year!" But then I found out that there is this historical record.

TF: And you're in the book.

NB: I'm sure I am somewhere. Yeah, here — that's in a classroom in Providence St. Mel; this is the art teacher with Mark and most of the students, and that's me on the right, kind of in the background.

TF: Yeah, there you are. And next to the photo it says, "The students who commit to joining the environmental study group will be encouraged to become personally involved in global concern of wildlife conservation. — Mark Dion." Once again the actor in the photograph is seen as Mark, the guy who is setting the agenda.

NB: Yes, there is a sort of negligence on the part of the historical record, but the "secret" publication of the book never bothered me at all. I had profited, and also probably wasn't aware of some of the protocol one follows when creating a publication. You know, sometimes it's difficult for an institution to work with communities, right? The protocol may be to get every single person's information and make sure that all are properly credited, everything is cleared for publication permission, everyone's invited to a publication party, and so on — but it does not always work out that way!

In hindsight I feel that the whole experience was a bit like the Whitney Independent Study Program, which Mark had attended and I did later. The *Culture in Action* group had an amazing time with ex-

cellent artistic and scientific tutors helping us work with others and work independently. It was a temporary community modeled as a school. The funny thing is, I never thought of the measure of the project being around the career outcomes of the participants, not now or even then. Oddly enough, I have done summer science programs that keep tabs on participants to see how many of us ended up working for NASA, but this seems like a bad way to judge art. I always thought of the success in terms of having the participants be able to replicate Mark's system of archaic science as art practice, and with that comes a different understanding of knowledge production. So there were some dropouts, but overall the program ran really smoothly. Thus I would call it a success. That may make the project sound a bit severe, but as I said before, it was so much like a didactic exercise and, in the end, it was about shifting perspectives — about how we inhabit the world intellectually and ecologically.

THREE MUSEUM, EDUCATION, COOPERATION

Memory of Surfaces ERNESTO PUJOL,

ARTIST, AND

DAVID HENRY,

MUSEUM EDUCATOR

ALTHOUGH PARTICIPATORY ART practices were beginning to gain some traction in the art world in the 1990s, it was still unusual for museums to undertake such projects, and when they did it was often at the invitation of the director of education, not the curator. For example, Mierle Laderman Ukeles says she felt it was extraordinary to be working in the main gallery instead of the education wing for her project at the Museum of Contemporary Art in Los Angeles in 1997 (see chapter 10). In general, education departments may have been more comfortable with social goals and less exclusively centered on visual experimentation than their curatorial colleagues. For some education departments, cooperative projects were simply a form of community outreach. For other educators steeped in progressive pedagogical theory, participatory projects were valued because of their potential to break down hierarchical teaching practices, as espoused, for example, in the writings of Paulo Freire and John Dewey.

The following interview traces a cooperative project by Ernesto Pujol, working within *Art ConText*, a program initiated by David Henry, then head of education at the Museum of Art at Rhode Island School of Design (RISD). During 1999 and 2000 Pujol was artist in residence both at the museum and at the Providence Public Library. His project entailed in-depth interactions with librarians, RISD students, museum audiences, staff, and teenagers from a local charter high school, and concluded with a site-specific temporary installation at the museum, *Memory of Surfaces*. In a structure reminiscent of *Culture in Action*, *Art ConText* was initiated by Henry to bridge relationships with local communities through an arranged marriage of the artists and a nonart organization, the local library system. Pujol had the opportunity to choose which library constituency to collaborate with, and he made the unconventional choice to work with

the community of the library itself—not to use the library system as a ve-
hicle of interaction with, for example, the local Hispanic community. The
project mirrored libraries in the sense that the contents of the project were
borrowed and then returned.

In the interview Henry observes that education departments are gain-
ing prominence and power within museums and that this has helped the
emergence of participatory and collaborative practices. This role for edu-
cation departments was discussed by many at Transpedagogy: Contem-
porary Art and the Vehicles of Education, a conference at the Museum of
Modern Art in New York in May 2009. The event, naturally, was organized
by the museum's education department, principally by the artist, writer,
and educator Pablo Helguera and the education director Wendy Woon.
The museum flew in Tania Bruguera, Qiu Zhijie, and other artists, and the
panelists included the critics Grant Kester and Claire Bishop. Even so, few
MoMA curators attended, and no senior curators were present when the
symposium began after the morning coffee. But there was a great deal of
excitement in the audience about the educational potential of participator
or pedagogical art. In an email exchange before the conference, Dominic
Willsdon, the curator of education and public programs at the San Fran-
cisco Museum of Modern Art, wrote:

> Education Curators are looking to redefine the scope of what they do.
> Their traditional role of mediating between legitimated knowledge and an
> imagined general public is dissolving (now that Art History is no longer
> the sole, or even primary, knowledge base either for new art practice or
> the public encounter with art, and the general public is more visibly frag-
> mented). They find themselves with the job, not of mediating, but of cre-
> ating platforms, occasions, situations for an educational experience (or
> an experience of education) to take place. Institutional art spaces have
> become some of the most visible, even spectacular, theatres of informal
> education and educational expectation in public view.[1]

At the conference one speaker after the next—educators and curators
alike—spoke of art and education that is experiential, dialogical, and par-
ticipatory.

David Henry speaks the language of pedagogy. In this interview he
articulates the need to create evaluation criteria and says that a goal for
education is to prepare people to ask their own questions and to em-
brace complexity. Pujol, on the other hand, is alternately political (though
melancholy, like Daniel Martinez in chapter 2, about the state of American

politics) and spiritual. (It is revealing to compare Pujol's Buddhism with the discussion of spirituality in chapter 10.) But throughout the interview the mutual respect of Henry and Pujol is evident. Henry may be an expert in education, but he is also Pujol's friend and collaborator.

———

ERNESTO PUJOL is a New York–based conceptual artist known for his multimedia public art practice. He studied at the University of Puerto Rico and Universidad Complutence, Madrid; did graduate work in education at the Universidad Interamericana, San Juan, Puerto Rico; and earned an MFA in interdisciplinary practice from the School of the Art Institute of Chicago. During the 1990s he was known for large-scale installations that addressed personal, racial, social, and political memory. More recently his performance work has focused on ecological issues, war, and mourning in America.

DAVID HENRY is the director of programs at the Institute of Contemporary Art in Boston, where he is responsible for all aspects of education, media, and performing arts programming. Henry was the head of education at the Museum of Art at RISD from 1995 to 2004, and between 1998 and 2002 he was the project director for *Art ConText*, commissioning leading artists to be in residence at library branches throughout the city. Aside from Pujol, participating artists included Wendy Ewald, Pepón Osorio, Edgar Heap of Birds, and David Wayne McGee. Henry holds an MFA from Visual Studies Workshop in Rochester, with a focus on photography and its history. In 2005 he was named National Museum Educator of the Year by the National Art Educators Association.

———

The following exchange took place via email, with the final edit completed in April 2005.

DAVID HENRY: Why don't you start by describing the results of our collaboration for the *Art ConText* series?

ERNESTO PUJOL: *Memory of Surfaces* was a site-specific installation. Its classical form was that of a large diorama, which I conceived and designed with your curatorial input. It was constructed by a team of museum staff, students, and volunteers. We built it with artifacts borrowed from the Providence Public Library branches and the RISD

Museum of Art. It was also accompanied by digital images, ambient audio, and curatorial text. The piece paid homage to the nineteenth-century heritage of the city of Providence and its public library and art museum, while commenting on notions of empire, debunked knowledge, collecting practices, and information gathering and archiving at the end of the twentieth century.

Memory of Surfaces was an incredible learning experience for me. Process-wise, I chose early on to create an ephemeral installation. After studying what previous artists in residence had done, I decided it was important to create something that proceeded from the community and returned to it, so that it always belonged to the people. I am always trying to avoid invading and colonizing a community, exploiting and mining a community's history and then packaging, shipping, and selling it elsewhere. I am also very wary of decontextualized art. I wanted the Providence project to be seamlessly embedded in the community, interconnected and interdependent in every way. Once I decided on this ethical methodology, the rest followed organically. The many charged objects we found in deep storage—such as the gemlike glass inkwells still full of dried ink from the last time they were used, plaster of Paris alphabets, architectural fragments, Italianate busts, mortuary art, prints, and hundreds of rare marbleized hardcover nineteenth-century books—all helped to anchor the piece locally.

Nevertheless, in terms of the production calendar it was an extremely demanding project. My initial proposal was approved after only a daylong scouting of the place. I remember that we were always running around, as I was commuting between New York, where I lived, the School of the Art Institute of Chicago, where I was teaching that semester, and Providence, where I stayed in a youthful artists' commune. Remember that I arrived in an unfamiliar place with the mandate of creating a piece that would engage a particular community in Providence. Therefore I had to immerse myself immediately; I had to make myself completely vulnerable to that environment, absorb it, and ultimately be transformed by it. But once I identified the large staff of the library network, a formerly invisible but very real community, as one of my targeted communities, that actually became the easy part. I loved the old libraries and felt like Alice in Wonderland walking through their off-limits basements and attics,

having access to their deaccessioned books. As you know, we ended up using over seven hundred early to mid-nineteenth-century books as a mosaic, a great literary American quilt on the floor, on which the diorama was built, like an enormous still life. This presented all sorts of archival issues for the museum; the books had to be dusted and decontaminated. But in the end it was worth it. They looked majestic, and their quiet carpeting of the gallery was exquisite.

Actually the project's most challenging aspect was that I had to serve the demanding and even conflicting interests of various communities, some of which had not been completely acknowledged before. First there was the museum community, which was opening itself to showcasing diverse community-based contemporary art without realizing the curatorial and social challenges that a multidisciplinary practice often brings to an institution that, thus far, had operated like an elitist vault. Most museums are used to being socially engaged through their education departments but not through their curatorial departments. Moreover, historical museums are used to dead artists, not to living artists walking around asking questions, providing opinions, writing and editing—actively participating in the inner life of the institution, even if uninvited. I tried to be very diplomatic with the somewhat impenetrable museum staff, which unfortunately often acted passive-aggressively, as if invaded and threatened, because they were not used to such dialogue, to the risktaking of staging truly socially engaged contemporary art.

Then there was the surrounding low-income Hispanic/Latino community, many of them recent immigrants. The museum's education department had been reaching out to them for years, and there was a strong mandate to use the project as a bridge to continue doing so. But even that was complex, as some staff only saw them as potential new museum members, whereas officials like you saw them as a population with a lot of potential, which the museum could truly serve. As for my role, there is no such thing as a universal Hispanic, a pan-Latino. Not all Hispanics are people of color, nor are they all poor. There are many white affluent Latinos. And just like there are many races and classes within this American-assigned reductive category, there are many cultures. So I listened to their expectations for the project, through free public lectures in libraries and meetings in people's homes. This was an equally delicate situation, but for different reasons: some of the community's self-taught artists were

Stairs to the collections storage
basement in the Knight Memorial
branch, Providence Public Library,
where librarians found books used
in *Memory of Surfaces*, 1999. Photo-
graph courtesy of Ernesto Pujol.

jealous of me, had no perspective, and wanted to be shown in the
museum in my place. We recruited adolescents from a nearby charter
high school into a free afterschool photography seminar, later install-
ing their artwork in the museum's education gallery and including
their voices as part of the audio in *Memory of Surfaces*.

Finally and most important, there was the library community. The
Providence Public Library is a network of ten libraries, with count-
less staff and volunteers. They were partners in the project and,
up to that point, had been an unacknowledged professional com-
munity within the greater community. They had been entrusted
with the nineteenth-century heritage of the libraries, with current
information-gathering tools, and with social services they never envi-
sioned having to provide, such as serving as afterschool day care cen-
ters to the children of working-class immigrants and offering English
as a Second Language and literacy courses. They were an exhausted
group that nevertheless felt great pride in their work. I quickly devel-
oped a profound admiration and respect for this overworked, hyper-
educated group of white grassroots professionals. And I am proud
to say that I was the first artist to address them, to try to pay homage

to them, past and present. Moreover, to their credit, even though I was a stranger and they could have reacted like a walled city, as the museum initially did until I later proved myself, they performed an act of blind faith and gave me full access to their inventories and resources. I remember walking through the richly cluttered dusty attic of the Washington Park Library, a former fire station and one of the first libraries I visited. It felt like an amazing journey through the distant past. And I will never be able to thank librarian Kathleen Vernon of the Knight Memorial branch enough. She loaned us hundreds of deaccessioned books from her several basements. In the end I believe that the librarian community was the most transformed by the experience. I understand that, after my project, they really gave themselves to the task of opening up even more and embracing the artists who followed, realizing art's potential on behalf of promoting the libraries. Those are the individuals I remember most fondly, the ones I would have loved to stay in touch with.

Of course, the launching of the piece concluded with a lecture to RISD art students. I had also taught an installation seminar to them, in which they elaborated project proposals. Indeed, by the night of my final lecture I felt that you and I had performed a Buddhist gesture, like contemporary bodhisattvas, trying to listen and guide these people unto a higher level of consciousness. But *Memory of Surfaces* was only one of a number of collaborations that the RISD Museum commissioned. Can you speak about some of the others that framed my project?

DH: Yes, your project was one of eleven artist residencies we commissioned as part of the *Art ConText* program. Besides you, there was Pepón Osorio, Lynne Yamamoto, Edgar Heap of Birds, Shimon Attie, Wendy Ewald, Barnaby Evans, Jerry Beck, Indira Freitas Johnson, Rebecca Belmore, and David Wayne McGee. As you suggest, *Art ConText* asked a great deal of the artists. We asked them to be in residence for two to five months at one of the ten library branches in the city, each of which is like its own community center. We asked them to identify a community to work with in that neighborhood. We asked them to create art informed by their community interaction. And we asked them to display it in the museum as part of a major exhibition in one of our larger galleries. As if that were not enough, we also asked them to mentor RISD students throughout their project.

As project director I was fascinated to see how these eleven differ-
ent artists met the challenge in their own way. The exhibitions ranged
from installations to photo shows to multichannel video projections
to paintings. The mentorships of RISD students included courses in
community-based art, contemporary Native American culture, and,
in your case, a course on installation art. Each of the artists actively
engaged the students in the development of their projects, and many
of the interactions between artists and RISD students were informal.
But to me the most fascinating decisions were the different ways that
artists identified community. Some chose a neighborhood. Others
chose an ethnicity. Still others chose an age group. One artist even
chose diabetics as the community. I must say I was a bit surprised
when you chose the library staff as the community you were most
interested in. These diverse ways of thinking about community —
geography, age, interest, ethnicity, profession, or disease — certainly
confirmed the notion that *community* can mean many things and that
we all belong to multiple communities.

 As I think back on *Art ConText*, I realize that one of the things that
all the artists had in common was their articulateness. They all had
a desire to communicate with a wide range of people — in their day-
to-day interactions as well as in their art. You were so good at this. I
am wondering if *Memory of Surfaces* is typical of the way you work.
Do you only do collaborations?

EP: I live solely for collaborative, site-specific, ephemeral projects. They
are the compasses to my life. However, I do divide my art making be-
tween projects I coproduce in community settings and studio-based
projects I author alone, as the result of subject matter I pursue pri-
vately. I parallel collaborations with more personal solitary projects.
These more intimate projects fulfill my responsibilities with myself,
with my search for consciousness. Ultimately I need to do both in
order to balance my practice.

DH: What initially attracted you to doing collaborative projects?

EP: My mother, Alma Pujol de la Vega, was an educator for more than
forty years, and she instilled in me a profound notion of service. I
also received comprehensive training in the humanities, studying
how historical painting and sculpture served politics and religion
during our pre-advertising centuries, when art was our main visual
communicator. I have always understood art both as the personal ex-
pression of an artist about his or her individual life and as a vehicle

Over seven hundred deaccessioned nineteenth-century books from the Knight Memorial branch on their way to being fumigated for use in *Memory of Surfaces*, 1999. Photograph courtesy of Ernesto Pujol.

for communicating messages, ideologies. Art has always been educating us about something. It is only very recently that we bought into a Western postindustrialist notion of art for art's sake, which has become increasingly commercialized. And this can sadly be perverted into a self-indulgent narcissism that allows artists to ignore the demands of citizenship. The problem is that when art and artists become irrelevant to society, democracy suffers. Our creative critical thinking tools are vital to the sustainability of democracy.

Collaborations are about reinserting citizenship into art making. They reintegrate art into society as cultural expression rather than as strictly personal gesture. The personal is not always political; it needs to be historically educated.

DH: Was this idealism reflected in *Memory of Surfaces*?

EP: Yes, although I would not call it idealism. That word immediately connotes the utopian, the unattainable, and, as many a Buddhist teacher would tell you, idealism can breed disappointment and the subsequent abandonment of a cause. I prefer to approach it from the point of view of humanism, of placing art in the context of the humanities, as a subcategory. For me, this is the most real endeavor

I could pursue. Now, in your estimation, why do museums generate collaborative projects? What is in it for them as institutions?

DH: Historically museums have not made art and education collaborations a priority, although they have long claimed a commitment to education for the public. Indeed there is evidence of museums working with schoolchildren and doing lectures for the public for more than a hundred years.

Museums are organisms with many mutually dependent organs working together, each with its own function. Putting an exhibition together requires a great deal of cooperating partners: curators, educators, fundraisers, exhibition designers and installers, security officials, and more. In that sense museums are as collaborative as most nonagrarian organizations and enterprises in this country. However, what was different about our project was that the art being presented, the main product, if you will, was the result of collaboration with partners outside the enterprise: schools, libraries, community centers, and the like. And these collaborations were undertaken simultaneously for serious artistic and educational reasons.

EP: So this is a recent evolution?

DH: I think that museums have undertaken educational collaborations almost since their inception. But these were often seen as outside their artistic mission. Instead they were a way to educate people about an art that had been chosen for reasons that had nothing to do with them.

I can think of a number of reasons why collaborative art and education projects have been propelled forward over the past twenty years or so. First, as you already suggested, there has been an increasing number of artists creating important and challenging art as part of educational collaborations. Many museums, particularly those that show contemporary art, have the mission and thus the obligation to reflect this contemporary artistic practice.

A second reason has to do with the increasing prominence of educators in the museum hierarchy. As museums have recommitted themselves to educational missions, there has been a call to involve education at the very beginning of the exhibition development process. While some may be unfamiliar with museum politics, it should be obvious nonetheless that the choice of an exhibition's content, its interpretation, and its display is key to its educational value and impact. To carry this to its logical conclusion, when you create collabo-

rative projects that include artists, community stakeholders, and museum staff, you can integrate the artistic and education goals better.

Finally, I agree wholeheartedly with your answer about giving something back to society, about making art that is an expression of a culture, not just personal. If artists and museums are truly interested in engaging audiences, they need to know their audiences. There is much we can know about our fellow men and women through our own lives, and that is why so many people are able to make such deep connections to art of the most personal nature. But art over the past hundred years has developed a language not readily understood or appreciated by large numbers of people. As institutions committed to the so-called general public, it is imperative that we test our assumptions; it is imperative that we create art that speaks to the world. To do this we must be involved in the world. To bend a phrase you used earlier, collaborative art reintegrates society into the art. I daresay that your presence in the library and the larger community talking about *Memory of Surfaces* helped people better understand it as a work of art: your use of materials, symbolism, and installation, all of which can be challenging to people who don't spend a lot of time following art trends.

EP: And what about for you, personally?

DH: As an art educator, I am aware that if I want my students to have an open mind, I too need to maintain an open mind. In order to be a good teacher, you need to be a good learner. This requires, first of all, being a good listener. One of the greatest pleasures I receive from art and education collaborations has to do with the things I learn from my artist and nonartist collaborators. I have learned about ancient cultures, unrecorded histories, disease, politics, religion, nature, and so much more. I have met people whom I never otherwise would have met and heard some remarkable stories of human endurance. The expertise and contributions people have to make offer incredible raw material for art, its exhibition, and its interpretation.

You made me focus on how thoroughly the museum and library are steeped in nineteenth-century ways of thinking and how that continues to define our missions today. Early on in our partnership with the library, I learned that RISD and the library were founded a year apart, in 1875 and 1876, and were initially intended to be part of the same institution. But I had not stopped to think that the Enlightenment notions that led to the formation of the two institutions

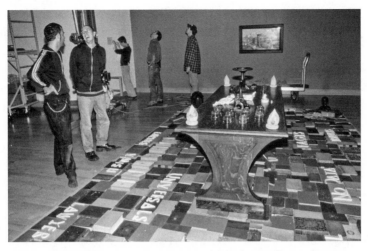

Ernesto Pujol talking with RISD Museum crew during the installation of *Memory of Surfaces*, 1999. Photograph courtesy of Ernesto Pujol.

continue to drive their missions today, even if the world has moved on. I think *Memory of Surfaces* was a strong impetus for the staffs to reflect on the organizational structures, collecting patterns, educational goals, and notions of patronage and audience, and the ways in which the nineteenth-century foundation of these was shifting as we entered the twenty-first century. Maybe we should discuss some of the challenges of these types of collaborations.

EP: Well, as I briefly mentioned before, some of the self-taught, community-based local Hispanic artists may have become involved in this project with the unrealistic expectation — which later became an outright demand — that they would eventually obtain one-person shows in the museum. This was a very unfortunate misunderstanding, resulting from a lack of professional experience. They did not understand the discriminating mandate of museums, as opposed to the programming of community multiservice centers. So it placed me in a very uncomfortable position. They might have also thought that this marked the beginning of a curatorial practice based on a multicultural quota, which was not the case. In the end they were not considered for shows because their work was not proficient enough, and this created tension. We tried to model formal standards of excellence, beyond particular aesthetics, but this takes time.

In hindsight I also think that I would not have worked with the

high school students. It is very hard to say no, but I think that we had enough work converting historical museum staff from an adversarial role to a supportive one, addressing the library staff network, and providing professional pedagogical experiences to RISD students. I believe that every time we try to engage children and/or adolescents, we should concentrate on them only and not treat them as merely another piece of the art education initiative. Capturing kids' attention presents too many challenges these days, with their attention-deficit disorders, depression, obesity, alcohol and drug abuse, undisciplined behavior, guns, absentee and unemployed parents, et cetera.

Making collaborative art is very challenging. Unfortunately there is much misuse of the term. The theatrics of cheap and even free orchestrated local labor often try to pass for it, as visiting artists enter and exit all too quickly. The goals and challenges of collaborative contemporary art and education projects must be clearly articulated at all levels of production. We cannot afford to be uninformed about their complexity, about how fragile the process is. We must protect every step of the way from hidden agendas, inflated egos, and subtle to crass misunderstandings. Things can easily go wrong when so many individuals and expectations are involved, resulting in local professionals and stakeholders feeling used after an artist leaves. I have witnessed this several times; it can produce terrible long-term effects. When the next artist arrives, the doors may be shut. I have found myself in that position, having to regain the trust of a community. Marginal communities tend to have long memories, ancestral, more so than many mainstream communities.

DH: How do you keep from falling into those traps?

EP: In acknowledging and balancing the artist's needs with a community's needs, I always remember Carol Becker's essay "The Education of Young Artists and the Issue of Audience." Carol states that the amount of information disclosed by a work of art is the measure of how much power the artist bestows on an audience. Therefore potentially successful project collaborations are those based on artistic generosity, which in turn is based on selflessness. All the players, at all levels of importance, should be fully and sometimes equally empowered. That empowerment should be carefully established according to their experience, skills, responsibilities, and product delivery. Even if not everyone can share in a conceptual project's intellec-

tual decision making, strategic aesthetic crafting, and final product coauthoring, all should be appropriately informed every step of the way. Clarity and transparency of process are key to project ethics. Because information is power. In addition, individual and group evaluations should be part of the process, so that everyone can periodically stop, review, question, meditate, and learn as they go. New positive experiences, personal and professional, that undo bad memories can be a form of payment in no-budget environments.

DH: What you are talking about is communication — sharing and listening. How do you know if you are successful?

EP: The most important measure of success in collaborative contemporary art and education projects is the long-term effect on a community. Of course, as artist in residence, I left at the end of the project and was not able to see the long-term effects. Were there any?

DH: Absolutely! I mentioned earlier how the different *Art ConText* artists defined community in unique ways. Of them all, though, I thought yours was the most fascinating choice and one that troubled me initially. In retrospect, though, it saved *Art ConText*. Yours was the fourth residency, and through the first three we had struggled with all the demands of managing three of these residencies a year — housing, transportation, contracts, getting supplies, commissioning new work, three major exhibitions a year, and more. Through this time the library had been very accommodating but not very engaged with the projects.

For instance, Pepón Osorio, who did the first project, was provided with a good-size room in the basement of the South Providence branch. He created his installation, *Transboricua*, there and exhibited it there before moving it to the museum. Schoolchildren came to visit, other members of the Latino community came, but the librarian mostly stayed upstairs. To be honest, it was mostly our fault. In all our concern to get the project started, we had overlooked the need to communicate with the librarians. We were taking them for granted. When you decided to make the library the community you wanted to work with, my first reaction was that it was not really a community, they were us. But it really was a different community, and *Memory of Surfaces* shone a light on that. Because of your generous and patient willingness to communicate openly and regularly with the librarians, and the curators of the museum, *Art ConText* moved forward in a much better way than it had before. The librari-

ans became much more engaged, identifying their own related programs. We had regular meetings from that time on, and we continue a collaborative school program with them.

EP: Then there are other kinds of success for the visiting artist and the host institution. From the artist's point of view, there is the project's conceptual authorship, individual or shared, with its resulting short- and long-term benefits in terms of career advancement. For the host institution, as well as for the artist, success can also be evaluated through critical art reviews and profit making if the project produced a material product that was not ephemeral. Of course, many such projects are ignored by the art press, so this is tricky. A museum can also benefit through board satisfaction and future grant possibilities, not to mention community relations. A collaborative process should first be educational in-house, long before any education programming starts in the public sphere. Ironically sometimes the very institution that commissions you as an educator and me as an artist becomes your first and foremost adversary, distrusting and even sabotaging your every gesture, because you bring much more complexity and change than they bargained for and were structurally ready for. Indeed more often than not the museum may have to sacrifice some of its power for the public good.

DH: Interesting that you should mention that, because there has been lots of talk about what artists give up in collaborations, such as their individual voice, but little about what host institutions sacrifice. Traditionally in art museums content is developed by curators, and curators have traditionally developed this content with a very narrow audience in mind. In fact there is a similarity between curators spending years researching for an exhibition and artists spending years on a body of work. After decades of study and research, you can be sure that curators have their egos every bit as attached to their exhibitions as artists do to their artworks. And like the artists they are understandably more concerned about the reaction of the art media and their colleagues than the reactions, or lack of reaction, of the public.

Asking museums, and the curators who have defined their own missions for so long, to collaborate with people who have different interests can feel like a challenge to justify their life's work. That is often the first thought. It can be hard to get to the second thought, that something can be gained by collaborating with others across

the economic, educational, and generational divides that exist in our country. It *is* a sacrifice to move away from your life's work. But society does not support museums as a refuge for a few really well-educated people. It is imperative that we find applications for the wealth of knowledge that exists in every art museum in the country. Just as important, we need to validate the multitude of relevancies that art has.

Then there is the uncertainty that comes with commissioning new work, not to mention that lots of bad art has been produced in the name of education. When we learned we had received funding from the Pew Charitable Trusts for *Art ConText*, and the curators were reminded that it meant three exhibitions per year developed with community interaction, they had a real concern. First, any commissioned artwork comes with uncertainty as to the final result, and that is something curators are not comfortable with. Second, they did not have any good models in their vocabulary for community works that were successful artistically. On the contrary, they had many models of unsuccessful works.

However, you did something that turned them around. You showed a real interest in their collections—particularly the collection of decorative arts from which you borrowed a number of items for your installation. By the end of *Memory of Surfaces*, instead of hearing the curators fret or disown these projects, I was hearing how pleasantly surprised they were by their artistic quality.

EP: That is what I mean by "educational in-house." The first body that needs to be comprehensively educated into fully understanding and unconditionally supporting collaborative multidisciplinary art education projects is the hosting institution. I am happy that you believe that *Memory of Surfaces* accomplished this at the RISD Museum. I believe you, although I was not there to experience and enjoy the fruits of this, as other artists did subsequently. But that is the lot of this nomadic existence.

DH: This is a very important point in any discussion of collaborative projects that often goes unspoken. It can be very hard to criticize art that is made with community involvement. It might seem that you are criticizing the people involved, who often are not knowledgeable about contemporary art. But I have also seen way too many art and education projects done with lofty goals and empty pockets— a bad recipe for successful art commissions. Museums have to be

concerned with excellence in their exhibitions. Our project certainly challenged the normal way of assuring that excellence.

EP: How do you define collaboration, as a museum-based art educator?

DH: I would start with a basic definition, such as two or more people or organizations working together on a shared project. In this basic respect most professional activities are collaborative. It is only in the visual arts that one can envision working solo. Modernism asserted the value of individual solitary genius, with an artist delving into his or her inner psyche seeking to unveil some larger truth about the meaning of life.

Painting, which some still consider the highest form of art practice, tends to remain a private process. It is hard to collaborate on the creation of a traditional painting. So a conservative notion of art still leaves out most of society from participating in art making of any significance. I would add to your criteria for collaborative art making that, in spite of the fact that all participants need to know the larger goal and their role in achieving it, the artist needs to retain aesthetic control for a successful collaboration.

I remember that when you were creating *Memory of Surfaces*, you continually fought to "hold onto mystery," out of concern that if you ceded too much information or control, the artwork would lose its magic. In your project, I would say that the education, research, and development were all collaborative—with the librarians and curators as well as community members and students. And you certainly had help in the actual art installation. Nevertheless, I think that you had total control of all aspects related to the creation of the artwork itself.

EP: If you have an artist working with nonartists, he or she is the leading art professional involved, just as participants from other disciplines will be their masters in turn. Some well-intentioned art and education projects oversimplify art making. I never want to mislead people into thinking that everyone can spontaneously make museum-quality art. I do not want to cloud my conviction that creativity is part of the human condition with the fact that art is a talent-based trained professional practice. Art is a great educational tool, but it should not be deprofessionalized in the museum art education process. These projects are hybrids of art and education. While the criteria may shift, their success as artworks is as important to me as their success as educational tools.

Memory of Surfaces installation, Rhode Island School of Design Museum, 1999. Photograph courtesy of Ernesto Pujol.

DH: Actually, now that I am thinking of it, there is one aspect of the final installation that you did alter because of the collaborative nature of the project. Do you remember what I am referring to?

EP: Yes, I remember that I had to make changes to the audio, based on concerns expressed by the most senior library director, Dale Thompson, whom I liked very much. I respected and trusted her, and when she sounded the alarm about her concern that what some of the adolescents were contributing to the audio component of the installation might be misunderstood as ignorant and violent — these are my words, not hers — I had to pay attention for the sake of protecting everyone: the library, the museum, and the adolescents. They belonged to a Latino low-income group attending a high school where, according to the principal, their students often graduated into prison. They certainly did not need any more racial and ethnic stereotyping. It was hard to edit what the kids were saying, but I had to be responsible, understanding the fine line between censoring and parenting. Collaborations can teach artists the difference between censorship and education.

DH: Our generation has not yet codified the many ways of working together in the creation of new works in the visual arts. However, I do think that there are many artists today — particularly since the 1960s, when Andy Warhol's Factory challenged the notion of a single

person creating everything—who are more producers than artists in the traditional sense. But we need to address the other aspect of this conversation, having to do with education.

EP: Well, since our focus is contemporary art and educational collaborations, perhaps we also need to define education.

DH: For the purpose of our conversation, I am interested in education that opens people's hearts and minds to a broader understanding of the world, to different cultures, social patterns, histories, et cetera. I am interested in an education that prepares people to assertively ask their own questions, rather than answer other people's. I want an education that acknowledges the greater complexities of our world, exciting people to embrace rather than fear that complexity. For this, I think we need an education that actively engages with the real world, that connects us with different people across traditional boundaries. And art is such a great resource and vehicle for this kind of education.

I found it appalling when Vice President Cheney ridiculed John Kerry during the 2004 presidential election for suggesting that he would offer a "more sensitive foreign policy." Cheney literally spit out the word *sensitive* in order to gain political points. It made me very sad for our country that being sensitive to others was a pejorative. With so many smart, passionate, and talented people aware of the educational needs in our society and aware of what art can bring to a well-rounded education, I do not understand why strong art and education collaborations are still rare. Perhaps we are to blame for not providing some standards-based assessment. But how would we measure the education that the kids from the charter school received from their interactions with you, or the RISD students? So often what we as museum educators do is show people doors—to new cultures, new forms of knowledge, new people. It may be years before conditions in people's own lives lead them to walk through those doors.

EP: I think that such projects, fully understood in all their possible ramifications, carry such enormous and complex social responsibilities that institutions can easily become afraid of them. Just look at the society we now have. Everyone now speaks of Ronald Reagan as a hero, but the Reagan administration dismantled our access to college- and university-level education, forcing students into bank loans as their main alternative to post–high school training. This has produced

artists who immediately have to find a full-time job after gradua-
tion to pay their deferred bank debt, more often than not as teachers
with little field experience and no training in pedagogy. This has pro-
duced textbook art by artists who are completely institutionalized.
This has also produced an increasingly uneducated mass. The media
and the government have created two societies: a shrinking middle
class that is castrated from its human potential and thus alienated
from its deeper self, vulnerable and manipulated by propaganda,
and an elite minority that rules with much wealth and power. Cheap
fast foods make middle-class Americans increasingly obese and de-
pressed. And anti-intellectual superficial Christian cults pose as their
only existential road map.

Cultural expression has been kidnapped by the most basic forms
of entertainment, generated by an artificial hunger for ongoing fan-
tasy spectacles, totally distracting us from what really matters. It
is sad and ironic that these are now being strategically packaged
as reality shows. No one wants to see images of naked Iraqi pris-
oners being tortured by U.S. soldiers and civilian contractors; no
one wants to see our men and women returning home in body bags.
That is our "real reality show" from which we are being shielded like
children. As an infantilized society we have walked so far down this
anti-introspection path that if art suddenly confronted us with our
intellectual and spiritual impoverishment, we would be devastated.

Finally, the art world's own media does not know how to handle
these art and education collaborative projects. Prejudicially they
think these projects are compromised by an education agenda and
thus lacking in formal qualities. But the fact is that too many art crit-
ics are traditional medium-specific reviewers; they do not have the
training to understand interdisciplinary projects.

It is hard for contemporary art to suddenly try to reclaim our
shortened attention span, because much of it has been disconnected
from society for a while. Everything has a sensationalistic latest-news
quality, but art operates according to a different dynamic, inviting us
to slow down, stop, reflect, meditate.

DH: I am afraid that, historically, our country has never valued intellec-
tualism or art. Collaborations are hard; they demand giving up con-
trol and take a real sense of commitment and mission. And for the
past hundred years the art world did not validate the practice. I agree
with you that collaborative art with an education mission was seen

to be compromised. Murals made as part of the WPA in the 1930s or with and within African American and Chicano communities were not given the same status as Surrealist production. And in education the traditional model places a lone teacher in front of a group of students, feeding them information. That is not a very collaborative model, I am afraid. Nor is it a very successful educational model!

EP: I have concluded that collaborative art and education projects cannot go it alone. Such projects need to be accompanied by multidisciplinary strategies, grants, and programs that begin to provide people with real alternatives. Otherwise, as a Buddhist, I think that we are simply creating "art shock epiphanies," or as Eckhart Tolle calls them, "gaps," which stir people momentarily in between long naps of unconsciousness. The collaborative project initiatives that I am currently interested in developing require long-term partners. I don't want to do one-shot deals, hit-and-run interventions, anymore.

Just as the medium of photography ultimately relieved painting from the responsibility of being the only literal document of reality so that it could evolve into a more intimate practice reflecting upon itself, an increasing overabundance of images and objects—the stockpile of art history—has relieved artists from the urgency of making art. There is no need to make any more art, to create more stuff, to add to the visual and physical clutter that surrounds us. But there is an urgent need for the meditations and insights that art provides humanity. I want to keep finding ways to make art without the anxiety of making art.

DH: I think the issue you keep raising concerning sustainability is an area where institutions can help artists. For instance, your time in Providence was limited to a few months, but the library and museum continue to collaborate on education programming for schools and community centers, thanks in no small part to your project.

We need to assert the importance of the unique products that can only come from contemporary art and education collaborations. I would like to think that schools realize this and have been promoting team teaching and more open-ended interactive pedagogies. While some artists and educators, such as you and I, are waking up to these same realizations, we need to develop evaluation criteria and model structures that can get past Modernism's formal aesthetics as the sole criteria for awarding value.

In *Memory of Surfaces* you made a decision to create something

Ernesto Pujol with RISD students participating in *Memory of Surfaces* installation. Front row, from left to right: Anne Finnerty, Lori Dawson, Pujol, and Jason Sung Won Yoon; back row, from left to right: Saskia Bostelmann, Tomoo Nitta, and José F. Vazquez Perez, 1999. Photograph courtesy of Ernesto Pujol.

transitory. At the end of the project all that was left was photo documentation. At the time, I saw that gesture through a revolutionary prism—you took no product away and, like a theater production, when its run was over, it was over. However, there are times when I wish that we had made it permanent. Its message—how the nineteenth-century Anglo-American way of perceiving the world continues to inform our institution's understanding of knowledge while being less and less satisfactory for our super-wired global world—would be a great permanent reminder in one of the recently renovated library branches in Providence. So perhaps we sometimes need to create projects that have more permanence in museums and in communities.

EP: Well, I can always go back and restage it, because the raw material, the cultural fabric with which I created that installation, is still there. So I agree with you. I too would have loved to create a much longer-lasting gesture. I often miss the physicality of that installation very much. That was a very emotional and difficult decision for me, much more so than I communicated to you at the time. But I had to remain true to my working values. I tried to place my installation gesture not only at the service of those constituencies, but also, as I said

before, in the context of what other artists had done there, seeking to balance the larger initiative. Previous artists had created things they took back to their studios or sent on to their commercial galleries. I wanted to quietly balance that with something that was not so market-driven. Several years later, in a project called *Becoming the Land* at the Salina Art Center in Kansas, I negotiated my need for some art residue differently. Even though the Kansas project consisted of four ephemeral installations and a film series, it also included nine large-format framed photographs. I left a set of them behind, to help the center pay project costs and as gifts to project partner institutions. But I also took copies to exhibit them in a gallery, to help fundraise for my next nonprofit project.

DH: I believe that we also need to make sure that community engagement is given prominence in our art schools. At RISD there are separate divisions for the design arts and the fine arts. It is my observation that designers, as a matter of practice, work collaboratively and are more mindful of the wishes and desires of clients. Painters, sculptors, and filmmakers are still taught primarily to find their own individual voice. What would it look like if their class critiques included "citizen critics" or community-based scholars? What if they were required to study models of art making that were collaborative in nature, developed for nonart communities? It would be very different, I assume. I have no doubt that many of these artists will still make tremendous contributions to our cities and villages. But if this mode of working were currently validated by their teachers, departments, schools, and the art world in general, it would be amazing.

On a positive note, over the past couple of years I have become aware of more and more students interested in identifying different kinds of outlets for their art and more social concerns. And there are a number of art schools that are beginning to incorporate community programming into their curriculum. I know the Maryland Institute College of Art, the California College of Art, and RISD all have moved forward on this. This bodes well for more of these projects.

Finally, what was your experience with the RISD students? How did you view your mentorship responsibilities?

EP: First of all, I would like to address our relationship, as we have not spoken about it directly during this conversation. Readers should know that you and I were complete strangers before this project. Colleagues had simply recommended us to each other. The fact is

that this complex endeavor would not have worked if we had not given each other our unconditional trust right from the start. I think that this was a combination of sharing the same methodology and intuition. I was always struck by your fine regard for artists, and you were always hearing me say that I trusted your experience. You were often extremely demanding, and I was frequently on the edge of exhaustion. I was often trying to put the magic of art making back on the agenda, while you were trying to respond to the many politics involved. But there was this ongoing mutual respect through a constant suspension of judgment. And, as an unexpected byproduct, a real friendship grew over time between us.

I had a good experience with the RISD students. They were very serious and committed to the experience. Several participated in the photo seminar for high school students. Two helped me produce the frames for the digital images. And most of them helped install the hundreds of books on the floor, which they had also pulled out of the library basement, with dust masks, loading them into boxes and a truck. Most were doing this for the first time and did not know or understand the full scope of the project, although I spent time with them every week and explained its progress. But this was an ambitious project, and they had preconceptions and misconceptions. They did not always understand that such projects are messy, more often than not about living with imperfection, always risking the possibility of failure. Even if a project succeeds overall, there will always be one or more weaker parts.

Some of the RISD students became overly protective of the high school students, like big brothers and big sisters. That was good, but also a bit too emotional. I had to constantly ask some of them to trust the process. It was an added stress between us. I went between being a hero and being a bad cop. But if you engage in the training of young artists and open your creative process to them, something is going to drag once in a while. Because they have not yet had the experiences I have had, and they do not trust their own creative processes and are afraid of making mistakes. I would love for more young artists to be trained in our practice. Nevertheless the fact is that these collaborations are not for everyone. They take a lot of multidisciplinary training, work ethic, watchful discipline, spontaneous flexibility, expanding vision, and courage.

FOUR OVERVIEW

Temporary Coalitions, Mobilized Communities, and Dialogue as Art

GRANT KESTER,
ART HISTORIAN

GRANT KESTER became a prominent advocate for dialogical art with the publication of his book *Conversation Pieces: Community and Communication in Modern Art*, in which he examines a series of projects with diverse goals and strategies that "define dialogue itself as fundamentally aesthetic." One project was designed to catalyze consensus around the living conditions of sex workers in Zurich; another challenged media stereotypes of young people in Oakland, California; and a third sought to recover neglected traditions of workplace interaction in Belfast. While some of the projects produced concrete social results (e.g., the opening of a residence for the sex workers), others succeeded in opening communication or creating new models for dialogue in their settings, which Kester sees as valuable in itself. "We are all too familiar with ways in which communication can fail," he writes. "What we urgently need are models for how it can succeed."[1]

Kester has taken his place somewhere between "theory"-oriented writers like Miwon Kwon and Claire Bishop, who tend to draw their inspiration from French postmodernism, and more project-oriented practitioners like Mary Jane Jacob. As an art historian, Kester espouses a position based on a deep understanding of theory but draws conclusions that run contrary to a certain brand of European pessimism. This debate became public in the spring of 2006, when Bishop wrote an article in *Artforum* titled "The Social Turn: Collaboration and Its Discontents," which detailed the shortcomings of what she called socially collaborative art. While Bishop does leave room in the article for art that delivers "sheer pleasure," most of her praise is reserved for art that is disruptive. In a letter published in the subsequent issue of *Artforum*, Kester responded to Bishop's article, arguing that her approach is "based in part on the his-

torical identification of critical theory with the act of revealing the (struc-
tural) determinants that pattern our perception of reality." That "paranoid
approach," he continues, "obsessively repeats the gesture of 'unveiling hid-
den violence.'"[2] In a response to Kester printed in the same issue, Bishop
holds her ground, proclaiming, "I believe in the continued value of dis-
ruption, with all its philosophical antihumanism, as a form of resistance to
instrumental rationality and as a source of transformation."[3] The *Artforum*
exchange had been much discussed in art circles by the time this interview
took place, in October 2007, and the issues were still fresh on the table.

———

GRANT KESTER is an associate professor of art history in the Visual
Arts Department at the University of California, San Diego. *Conversation
Pieces: Community and Communication in Modern Art* (2004) positioned
Kester as a public champion of socially engaged, dialogical art. His book
*The One and the Many: Agency and Identity in Contemporary Collaborative
Art* was published by Duke University Press in 2011.

TOM FINKELPEARL: Despite quite a bit of artistic activity and some
emerging critical discourse, it is my sense that the mainstream art
media still seems to ignore collaborative art practice. Would you
agree?

GRANT KESTER: Yes. I would say that there is a negative perception,
especially of projects that involve collaboration between artists and
nonartists, people from other backgrounds and other contexts. As
a result there aren't many critics who are prepared to address this
work in a substantive manner. I'm hopeful that this is beginning to
change. I really do think the nature of contemporary art production
itself is undergoing an important transformation in the shift toward
collaborative and collective practices. This has been intensified re-
cently by the collapse of the global art market, but it has roots that
extend back many years.

TF: Why do you think it's been difficult for critics to come to terms with
this work?

GK: That's a really good question. I don't have a definite answer. I know
that there is some discomfort in the mainstream art world with
projects that don't incorporate a sufficient degree of ironic detach-
ment, especially socially engaged or community-based practices.
Critics have really come to expect the artist to take up a cynical, dis-

tanced relationship to virtually any form of collective social or political life. So when you find artists whose relationship to a given constituency or community or site is more reciprocal or integrated, and less detached, it can evoke a sacrificial response in which the work is dismissed out of hand as naïve, complicit, patronizing, and so on. I think a more balanced assessment would be that there's a continuum of practices in contemporary art that involve collaboration. I happen to be more interested in socially engaged or activist practices, but I don't really view it as a Darwinian struggle in which a single superior tendency will eventually triumph and win some art historical competition. In fact the tendency in the art world over the past thirty or forty years is for activist work to emerge into a more general consciousness for a brief period and then disappear from the radar screen.

There's another factor at work here. I think that many conventionally trained critics and historians have a really difficult time moving past a textual paradigm of art production: the idea that an isolated viewer confronts the work of art as an isolated object or event. This approach is based on a principle of repetition: the work of art essentially replicates a vision or an idea generated by the artist and then set in place before the viewer. Most of the projects that interest me don't really operate on this basis. They typically involve extended interactions that unfold in ways that lie, quite deliberately, outside the artist's original control or intention and that evolve in concert with the particular intelligence of participants or collaborators.

TF: I have been thinking about the art world's veneration of discomfort and rupture that you mentioned in one of your interviews.

GK: Yes.

TF: I am thinking about this in terms of the dominance of Freud in twentieth-century psychology and his almost unrelenting emphasis on negative emotion. In recent years there has been a new swing in scientific communities toward the study of happiness, empathy, and positive emotion. But the art world seems to be stuck with negative criticality—the idea that criticality and negativity are one and the same.

GK: Yeah, absolutely. I've found Eve Sedgwick's later work useful here. She describes what she terms a "paranoid" consensus in contemporary critical theory in which the artist or intellectual takes on the task of "unveiling hidden violence" to a benumbed or disbelieving

world.[4] The past twenty years or so have seen the consolidation of a new canonical form of art practice and theory centered on post-structuralism, or on the rapprochement between poststructuralism and postconceptual art practice. Deleuze, Rancière, Agamben, and Derrida have become as doctrinaire as Wölfflin, Riegl, Panofsky, and Greenberg were for earlier generations; they're on the reading lists of most of the prestigious art history and studio art programs. The assumptive world of these thinkers was really formed by the perceived failure of May '68, specifically the failure of the French Communist Party and the unions to support the student protesters. The lesson, very much in line with Schiller's arguments in *On the Aesthetic Education of Man* [1794], is that we are unprepared for true revolution. Inevitably we'll screw it up because our language, our very sense of being, is saturated by the instrumentalizing violence of rationalist thought. The only option is to withdraw to the margins of society, to the art world and the university, and engage in subversive forms of textual politics or *écriture*. In a way the lesson was of the utter futility of any direct political action. The only hope for real change supposedly lay in sustained exposure to avant-garde art practices that would purge us of our conventional notions of agency and identity. Change must be endlessly deferred until we are prepared to receive it.

After several decades, of course, this approach has become almost entirely naturalized, or maybe ritualized is a better way to describe it. That's why so much contemporary art practice comes off as a kind of potted cultural studies in which the artist selects a particular social, cultural, or representational system, identifies the often self-evident ideological compromises and complicities committed by its various participants, and then boldly "intervenes" by pointing out these gaps and aporia, confident that he or she has radically subverted, desta-bilized, or otherwise transformed the consciousness of all involved. I'm not arguing that one should abandon critical distance, only that we begin to question the singular authority claimed by the artist or intellectual in managing to achieve this distance and develop a some-what less mechanistic understanding of what forces solicit belief or catalyze nonbelief.

I went through something like this myself as a critic. The "Aes-thetic Evangelists" essay, which I wrote more than ten years ago, in-volved a fairly detailed analysis of the ways in which certain collabo-rative, community-based practices were being appropriated by an

emergent neoconservative agenda in the United States. I still think it is a valuable criticism, but at a certain point I realized it was not sufficient. Critique as the simple negation of any and all organized systems of knowledge only takes us so far. For me the challenge was to acknowledge the fact that, as with any art practice, there are contradictions and compromises, but that there were also aspects of community-based work that I found very positive. Critique was relatively easy; for me the more difficult job was how to build an analytic model that could identify or begin to define those things that I found most productive in these practices while retaining a critical sensibility.

TF: It's as if there has begun to be an uncritical embrace of a narrow idea of what criticality means. If everybody's so intent on being critical, why does the critique always sound the same? After the first flush of creative thought, ideas tend to get institutionalized. Recently I was looking back at Laura Mulvey's groundbreaking and brilliant essay "Visual Pleasure and Narrative Cinema" [1975]. There's a line in that essay: "Analyzing pleasure or beauty destroys it. That is the intention of this article." When I reread those words, my heart sank. When Mulvey wrote that, it was a creative and original proposition, but for that sentiment to become dogma is sad.

GK: Yeah, it does lend itself to a kind of moral entrepreneurship in which the theorist or artist becomes the adjudicator of a proper ethical relationship to pleasure, or identity, or agency, or collective formation, the single cultural agent who manages to transcend the various snares laid for us by the nefarious forces of Western metaphysics. That whole routine got a little tiresome to me after many years of visiting galleries and museums and encountering the same formulaic approaches. I suppose that this kind of work performs a useful function in the institutional spaces of the art world; I'm just not convinced that it operates in the way that its advocates claim it does in terms of laying bare the operations of power and so on. One of the biggest problems in contemporary art criticism, in my view, is the lack of a very persuasive reception theory. It's also this liturgical relationship to theory itself: a tendency to simply reiterate theoretical precepts as axioms and then apply them to practice in the most programmatic way possible. To me this speaks of a lack of faith in the kinds of unique insights that practice can generate and a failure to attend closely to the complex and contradictory ways that people

interact with art. This isn't an argument against theory at all, but rather a call for a more critical and reciprocal relationship between theoretical and artistic practice. I much prefer readings in which the theory itself is complicated, tested, and challenged through its proximity to practice, even as the practice is illuminated by a given theoretical paradigm.

TF: Yes. For example, Santiago Sierra is an artist whose enterprise fits this mold. The notion seems to be that his work will shock the viewer into recognizing inequality, unbalanced power relations, and/or the underlying structures of the institutional frame — the site of display.

GK: Sierra is a really good example of the textual paradigm I mentioned earlier. He essentially constructs installations by deploying bodies in space. His "collaborators" don't have any agency to speak of; they simply perform or arrange themselves in response to his choreography; they're raw material. This is where the ethical questions arise in his efforts to shock or provoke the audience. There's an interview with Vanessa Beecroft where she uses precisely this term to describe her models: they are simply a "material" that has the capacity to generate certain symbolic or somatic associations for the viewer; it could just as easily be Cor-Ten steel, or lard, or a video projection.[5] This is why I find some of the rhetoric surrounding relational art practice a bit misguided. Just because an artist uses a human body in their work doesn't make it any more relational than a painting or sculpture in terms of the artist's role and the way the viewer is positioned. My argument isn't that this textual or specular approach makes the viewer more passive than a collaborative or participatory work. In fact sympathetic critics will usually claim that this kind of art activates the viewer in some way. My concern is really with the broader set of assumptions *about* the viewer that are encoded in this activation: the particular form of agency it claims to give the viewer and the essentially scripted nature of the viewer's presumed response.

This is clear in Sierra's *Wall Enclosing a Space* for the Spanish Pavilion at the 2003 Venice Biennale. If I don't have a Spanish passport I'm not allowed in, so large numbers of art world cognoscenti from Europe, the U.K., and the U.S. were denied entry. Here's a typical interpretation, in line with the general critical response to Sierra's work. The physical experience of having my free passage into the exhibit blocked isn't simply annoying or inconvenient. Rather it has a pedagogical effect. My desire to see, to know, to consume Sierra

GRANT KESTER

has been interrupted, and I've learned by extension to empathetically identify with those global Others who don't possess the geopolitical privilege and freedom of movement that I possess, with my U.S. or E.U. passport. The artist has produced this lesson by momentarily inverting the conventional subject-position of the viewer. This all sounds good. I'm just not sure I buy the idea that someone who has shelled out $30 or $40 to get into the Venice Biennale was walking around prior to this experience blithely ignorant of their own privilege and that, once having had their entry to the Sierra exhibit blocked, they would necessarily respond with the "proper" insight and mend their ways. Given the vast number of biennial-based works over the past fifteen years that have been devoted to discomfiting the viewer, it seems likely that their experience of these provocations are considerably more complex and contradictory, that they may include elements of pleasure and even self-affirmation. In fact the work of Sierra and others is as likely to reinforce a particular sense of identity among art world viewers — as tolerant, enlightened, willing to accept risk and challenge — as it is to effect any lasting ontic dislocation.

TF: Here is a question I have been pondering. I know that the kind of art you champion is generally complex conceptually, or socially, and you are looking carefully at the way in which a project unfolds. But what if there were a rather simple-minded project based on sentimental or naïve notions of community that nevertheless led to a measurable positive social outcome? What if at the end of the day five homeless people found housing? How does that rank against a critically sophisticated project that fails in its social goals?

GK: Your question is really about metrics: How do we come up with evaluative criteria for this work? Since there is no widely accepted consensus about the standards we use to evaluate any other form of contemporary visual art, I don't find the question especially surprising; it just seems to come up more frequently relative to socially engaged or activist practices. I'm always somewhat surprised when critics of this work attack it for failing to foreground "artistic" or "aesthetic" meaning but make absolutely no effort to define either term. What they generally mean, I suspect, is that activist work is too proximate to other areas of cultural or political practice, that it doesn't maintain a sufficient degree of ironic detachment or ambiguity relative to a given life world. Critical distanciation may or may not be intrinsically artistic, but it's hard to have a conversation about it. It's

become so naturalized as the only proper role for art to play that it's not even visible as a distinct aesthetic paradigm. I would argue that there is more than one way to produce critical insight, and that the conventional avant-garde technique of an artist-administered ontic disruption is only one of them.

I wouldn't want to collapse the evaluation of a given work into a calculation of social utility. This seems simple on the surface, but it can be extremely difficult to define, or to separate out, the "utilitarian" aspects from the totality of a given work. Pragmatic effects, concrete changes in social policies, the transformation of consciousness or perception, subtle changes in cultural discourse, all of these things get mixed up together in really complex work. It's different from an object-based practice. I can walk into a gallery and see a Jeff Koons sculpture and have an instantaneous response: I like it or I don't like it. Although I sometimes do get an immediate feeling about a given collaborative project just based on a limited exposure to it, it's more often the case that my understanding unfolds over a very extended period, as I start to peel back the layers of interaction and transformation at a given site.

I've been researching the work of an Indian artist named Navjot Altaf recently, which provides a good example of this. Over a period of about seven years she has developed a series of projects in rural villages in central India. The first set of projects involved the collaborative creation of *nalpar*, or water pumps and enclosures. The water pump is a center of village life, and the water is typically collected several times a day for cooking, cleaning, and so on. The collection is done by young women and girls, who often develop physical problems, musculoskeletal disorders, as a result of lugging around heavy buckets. Navjot worked to redesign the pump sites, to make them more ergonomic, and then she worked with artisans in the villages to create large decorative walls around the pump sites, which previously had been little more than pipes with faucets sticking out of the ground. She produced quite a few of these in one village in particular, and the effect on village life has been subtle but profound. For the first time the women in the village have a comfortable, visually protected space where they can congregate and talk while getting water or bathing or washing their clothes. Village life tends to be intensely patriarchal, and there are no spaces for women to meet together outside the home without some sort of male scrutiny, so this was quite

A woman carrying water from a structure created as part of *Nalpar* (2001–) in the Bandhapara neighborhood in Kondagaon, India. Collaborators on the project are Navjot Altaf, Adivasi (indigenous) artists Rajkumar, Gessuram, Shantibai, Kabiram, and Raituram, and local women artists and other community members. Photograph by Navjot Altaf.

significant. Navjot and her local collaborators, Shantibai, Rajkumar, and Geesu, have, over a period of years, effectively remapped the psychogeography of this village.

The water pump work led to another series of built projects Navjot calls *Pilla Gudi*, or Children's Temples. Again, the village children have no place to come together outside the schools and temples, so Navjot and her collaborators designed a series of these structures, kind of secular "temples" for children to meet in. She worked closely with local craftspeople in all of these projects, and that constitutes another revealing layer: rather than treating "craft" as something abject or naïve, she was able to recognize its complex material and symbolic function in village life. Navjot and her collaborators evolved a notion of craft as essentially *plastic*, something that was not simply concerned with worship or the veneration of ancestors but could be mobilized to remodel social protocols and interactions in the village. To produce work of this complexity Navjot had to build up an inti-

mate knowledge of the social space and flow of power in the village,

over a period of years, even as the people in the village had to learn

about her beyond the caricature of the voyeuristic urban artist. The

specific form of the projects grew out of this knowledge and the re-

ciprocal engagement that occurred between Navjot and her collabo-

rators. You can't really distill this work down to a simple calculation

of efficacy: Was a water pump constructed? How often is it used? You

also have to attend to the quality and the form of the social relations,

the circulation of power within a given site, and the ways in which

that power is contested or interrupted or redirected. Consciousness

is being transformed at both the individual and collective level, and

that's really what art's all about.

TF: One of the most influential writers in this field is Nicolas Bourriaud,

the author of *Relational Aesthetics*. When I first picked up the book

soon after it came out in English in 2002, I was very excited by his

ideas. I really liked the way he laid out the notion of relational art,

defined by him as "an art taking as its theoretical horizon the realm

of human interactions and its social context, rather than the asser-

tion of an independent and *private* symbolic space."[6] But I became

a bit worried with his notion that art represents a "social interstice."

Which art, and when? It seems to me that much art fits comfortably

into a commercial system that includes galleries, dealers, museums,

upper-class consumers, et cetera. And when he started talking about

specific art projects, it was less about socially collaborative work than

work that is based on rather safe encounters.

GK: I had a similar reaction. I really appreciate Bourriaud's ability to move

away from the language of object-based analysis. But when you look

more closely at the projects he describes in his books, the majority

of them fall into what I've described as a textual paradigm: the artist

orchestrates an event, arranges people in a space or engages in some

sort of social interaction that is then documented and presented in a

gallery. The position of the artist is really quite conventional in most

of these works, and they retain the traditional rhetorical system of

disruption or provocation. I'm really more interested in collaborative

or collective practices that start to break down the artist's custodial

relationship to the viewer. For artists like Navjot, or Park Fiction in

Hamburg, there really isn't a point at which we can arrest the process

instantiated in their projects, set it apart, and say, "Okay, here's the

work of art." The process often results in the fabrication of physical

On a summer evening in 2009 around 1,300 people showed up at Park Fiction for a screening of *Empire St. Pauli*, an antigentrification film by Irene Bude and Olaf Sobczak. The park's signature palm tree sculptures, designed by local residents, are in the background. Photograph by Olaf Sobczak. Courtesy of Park Fiction.

structures or forms, but these don't necessarily have a privileged role as a locus of aesthetic significance.

The textual paradigm can be very productive, but it clearly doesn't represent the full range of collaborative practice today. I think there are some fairly significant changes going on in current practice involving the strategic rearticulation or renegotiation of aesthetic autonomy. These operate on two levels. First we see a concern with more participatory or immersive practices rather than the presentation of a specularized event. This also involves a shift away from the supervisory attitude toward the viewer that is typical in the avant-garde tradition. And second, there's an attempt by artists to build conciliatory relationships with parallel systems of knowledge or expertise: planning, activism, ethnography, geography, and so on. In the traditional avant-garde approach these sorts of affiliations are discouraged; there's a constant anxiety about art being contaminated or compromised in some way, losing its specificity if it merges too fully with other areas of cultural production. Other professions, other discourses can only ever appear to the artist as corrupt, complicit, or problematic, and the artist's relationship to them can only ever be one of detached skepticism, critique, and appropriation.

TF: These days one reads a fair amount about the meaning of nonphysi-

cal, digital public interaction: sites like Facebook, text messaging, and email. In the wake of these developments, I've heard people talking about the "analog backlash," like the return of the "touch" in painting and so on. So part of the appeal of collaborative practice could be the nonvirtual aspect of it. Actually sitting down and talking to people live, in person, is an integral aspect of almost all socially interactive and collaborative work. Do you think that this historical, social context is an important backdrop for the kind of work we're discussing?

GK: Yes. One of the things that I tried to do in *Conversation Pieces* was to build a theoretical framework for this practice, to identify a concept of aesthetic experience that can mediate between the individual and the social. I think that work was unresolved, but I wanted to at least outline some coordinates. I'm returning to these issues in the book I'm working on now through an analysis of collaborative or collective labor, the haptic experience of bodily proximity, movement, and so on as forms of affective communication. This work definitely touches on issues that come up in the sciences and social sciences around cognition, empathy, and bodily intelligence. I'm trying to work through a rearticulated concept of labor.

I had the good fortune to go to a conference in New Zealand a few years ago that was organized by some cultural activist groups there. Part of the conference was held in a Maori lodge, or *Marae*. There's a ceremony that's involved in entering the Marae — singing, greeting, touching noses, and so on, before you cross the threshold. The effect is to set this space apart; it is subject to a distinct set of social and communal protocols. I found this very suggestive for my research on aesthetic experience. Once you're in the Marae, you eat first, before talking or meeting; hunger must be satisfied so that no one speaks or performs from a position of bodily disequilibrium or lack. This is part of a very important tradition of nonviolent conflict resolution in Maori culture that influenced Gandhi and Martin Luther King Jr. I was really struck by the attention that Maori culture gives to the ways in which people inhabit space and interact collectively, and how the somatic informs cognitive and perceptual experience.

Of course, this level of analysis has really been stunted in the tradition of European aesthetic philosophy. What's the first thing that Riegl and Wölfflin jettison when they're building the foundations of modern art theory? Haptic or tactile experience, which they associate

with backwards "Oriental" cultures still reliant on the reassurance of physical touch and direct contact with the world, as opposed to the advanced Europeans who've learned to master their world through optical distancing and abstraction. There's also a certain bias against the close analysis of physical and verbal interaction in the poststructuralist tradition, running from Saussure's bracketing of speech acts as unsuitable for scientific analysis all the way through Derrida's inverted valorization of writing over utterance. Even Habermas, who would seem to be more sympathetic to this kind of analysis, offers little more than a procedural account of intersubjective exchange. I'm convinced that there's something very important about the kind of somatic knowledge that is generated by collaborative art practice, but it's difficult to grasp or describe. There are definitely productive clues in research in psychology and cognitive science, like Francisco Varela's work or Andrew Light's work in environmental philosophy.

TF: In recent years I have been doing a lot of reading outside the arts. For the most part it's been scientific books about the brain and emotion written for nonspecialists. In this reading I have become increasingly convinced that art criticism tends to leave out a wide range of emotional reactions that occur outside the verbal realm.

GK: There are so many potential areas of inquiry for these questions. It brings to mind the way that trauma is literally stored in the body, the way in which the body "thinks," and the concept of the body and mind as a series of interlinked processes rather than a collection of discrete organs governed by the brain. Emotions are as much somatic as they are cognitive. I think a lot of the artists I'm researching now have begun to recognize, perhaps intuitively, the significance of these forms of knowledge for collaborative practice.

TF: So there's a general loosening up of rigid categories, at least among the artists.

GK: Absolutely. And you know, I think that really hits the nail on the head for me. This is the shift that I was referring to earlier. Artists are opening themselves up to forms of knowledge and insight drawn from other disciplines, as opposed to having a purely adjudicatory or defensive relationship to them. This goes back to the naturalizing of negation or skepticism as the only legitimate forms of critique. This shift is also occurring at the level of institutional protocols. We see overlaps and interconnections with youth work in CityArts' projects in Dublin, urban activism in the artist groups that worked with the

Prestes Maia occupation in São Paulo, and participatory planning in Ala Plastica's work in Argentina or Park Fiction's work in Germany. While Park Fiction adopts a somewhat ironic or parodic attitude toward planning processes in their visual staging, they also transform these processes and apply them in practice. They're comfortable with the fact that there is a zone of indeterminacy or slippage between their art practice and other modes of cultural production. This is where some of the most interesting work is being developed, in my opinion.

TF: Right, and there is also the willingness by artists to seek collaborators in other fields—like Mel Chin's collaboration with Rufus Chaney, an agricultural scientist who put real-world effectiveness into the toxic waste site remediation project *Revival Field* [1990-]. Also, most relevant here is the notion that so-called community collaborations draw on the sorts of knowledge that can be expressed through active interaction with nonartists. Malcolm Miles has written that so-called community members are experts in their own life—that they have a kind of expertise that's inaccessible from the outside, because they've lived in a certain place for a period of time.[7]

But that gets to the question brought up by Miwon Kwon of the appropriation of the voice of the local community, drawing somewhat upon your own criticism in the "Aesthetic Evangelists" article. It is a valid question and important to consider, though it has become almost a mantra with which to dismiss the field of collaborative art entirely.

GK: Exactly. I've gotten a bit impatient with the almost reflexive nature of that critique. When I raised questions about the appropriation of community-based art practice in the mid-'90s, my intention was never to use this criticism to "prove" that it's futile for artists to work collaboratively with communities, public agencies, or NGOs. Unfortunately, over time it's been reduced to this. The fact that some projects are subject to compromise or co-option is used to dismiss an entire domain of art practice. The sad part is that this has had the effect of limiting close readings of specific projects at the discursive, political, and ideological level. There's room for some really good, probing analyses of various forms of institutional co-option, but we don't even get these. Instead we get the same offhand references to the ways that a given project *might* be appropriated to meet the needs of cultural tourism or to give museums some sort of political

credibility. I'm not arguing that activist or community-based work shouldn't be criticized: far from it. I'm just arguing that it merits a far more intelligent and substantive form of criticism than most mainstream critics and historians have been willing or able to provide. I suppose my intention in the "Aesthetic Evangelists" essay was to say that collaborative art practices require very different forms of knowledge and expertise, not the kinds of things that are typically taught in art school. That's why most of the accomplished artists and groups working in this area are generally a bit older; they've had to learn on the job, so to speak, over many years of engagement. Conventional art education is largely irrelevant for this kind of work.

Also, the patronage system for contemporary art has never been more complex. In addition to the traditional forms of support, like private dealers, galleries and collectors, museums and alternative spaces, we have relatively new forms of commissioning associated with the international biennial circuit and art fairs. On top of that there are all sorts of funding systems associated with NGOs, foundations, universities, and other nonprofit entities, along with public art commissions, urban regeneration or redevelopment agencies, and so on. Every single one of these forms of support brings along its own unique opportunities and dangers in terms of co-option or compromise. Given this diversity, it's imperative that we develop a much more sophisticated understanding of the impact of patronage, institutional power, and public policy on art production. The simplistic dismissal of any form of support outside the traditional matrix of dealers, galleries, and museums is simply inadequate at this point. That's no better than the equally simplistic argument that any form of patronage associated with the art market is corrupt, or that art loses its critical power when it's placed in a museum or gallery.

TF: I don't think that simplistic critique of art world patronage gets stated often enough [laughter]. I mean, what is more compromised than the art fair? It's a dreadful environment in which to look at art, in my opinion—it's just about money. If you can stomach that but have trouble with artists who work with a city agency or an NGO, then there is a problem. Don't get me wrong; I work at a museum. I'm not against museums. But there are constraints in any system.

GK: Yeah, any site is going to have its contradictions. Recently I was researching a project in Tanzania by the Danish group Superflex in which they sold biogas digesters to people living in rural areas. The

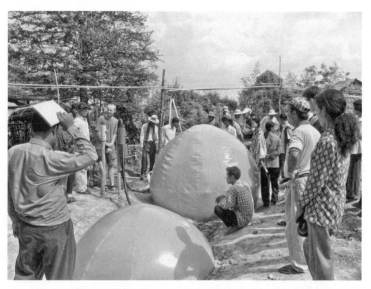

Superflex demonstrating their project to local farmers at the University of Tropical Agriculture just outside Phnom Penh in 2001. Together with Cambodian agricultural students they set up a version of the Supergas system, a simple biogas unit that runs on organic materials. Photograph courtesy of Superflex.

artists present it as a kind of situational critique of the neocolonialist mentality of Danish NGOs working in Africa. In interviews they spend a lot of time discussing the dangers of making the poor dependent on aid and quashing their entrepreneurial spirit and independence by providing clean water and health clinics. They are really concerned to prove that what they are doing has nothing in common with the kinds of things that those paternalistic bureaucrats working for the NGOs do. They even dress up in costumes that are supposed to parody the clothes of colonial administrators: khaki shorts, pith helmets, and so on. The fact that they *sell* the biogas digesters is particularly important to them, since this is supposed to be better than donating them, which would encourage dependence. Aside from the fact that this fetishizing of the market is pretty perverse in the context of a poor African farmer, the critique of dependence has been circulating through the NGO world for years. I contacted some people who actually work for aid agencies in Tanzania, and what Superflex is doing is quite similar to projects carried out by NGOs in the region. The more interesting question is why Superflex was so concerned to

create a separation where none seems to exist. I think this goes back to the defensive relation that artists typically have to other areas of cultural production, the fear that their autonomy will be eroded or violated in some way. For Superflex, the art of this project, I suspect, is based primarily on their attempt to ironically distance themselves from the co-opted machinations of NGOs. Needless to say, this lends itself to a somewhat paternalistic attitude toward practitioners in other disciplines, who can only ever be seen as naïve and unreflective. And this stands in the way of any real productive collaboration between artists and those working in other fields of expertise.

TF: Sure, and the autonomous realm of art is a modernist creation. The history of art, for the most part, is engagement with the pope, the pharaoh, the Medici family, the local government.

GK: It's not uncommon to encounter this naïve libertarianism among artists from the European Union, where it's seen as kind of edgy to embrace the market and attack the welfare state. There just aren't very good models in contemporary art criticism for understanding political transformation. I think some of this can be blamed on the cult of May '68 in the canon of critical theory, which suggests that meaningful change can only occur through an absolute rupture of historical continuity—a single moment that breaks radically with the past and owes nothing to the existing distribution of social and political forces—that only this sort of revolution can hope to outpace our tendency to revert to reifying patterns of thought and action when working collectively. As a result there's very little skill or sophistication in understanding the incremental, capillary nature of political change or the importance of provisional forms of solidarity. My other area of research is the history of American political reform movements. Based on my work in that area, I'd argue that meaningful political change has almost always been a product of temporary coalitions among activists, mainstream political actors, independent parties, unions, people working for NGOs, and mobilized communities. In fact one might argue that more sustained good has been accomplished, in a less destructive manner, through the cumulative effect of incremental forms of political struggle and resistance than through various attempts at total revolution. This doesn't mean that these more gradual changes don't also involve violence, direct action, and protest, and even the threat of systematic crisis. They clearly do,

but they also rely on a less romanticized version of how meaningful change is actually produced within a given social system. The interactions that occur among the state or public agencies, the corporate sector, NGOs, social movements, activists, and artists are extremely complex, and we really need a more realistic model of how they operate.

FIVE SOCIAL VISION AND A COOPERATIVE COMMUNITY

Project Row Houses RICK LOWE, ARTIST,

AND MARK J. STERN,

PROFESSOR OF

SOCIAL HISTORY AND

URBAN STUDIES

IN 1993 the artist Rick Lowe led a group in founding *Project Row Houses*, an organization that has since become an important player in the development of Houston's Third Ward by renovating a series of shotgun houses and translating them into an art and community center; by expanding the campus to provide housing for single mothers; by acquiring, renovating, and reactivating a historically significant ballroom; and by building new affordable housing. An early inspiration for the project was the interpretation and depiction of row houses by the Houston-based African American painter John Biggers. But the original twenty-two shotgun houses on a block and a half were only the start: the organization now extends six blocks and includes forty properties. It is an artist-led nonprofit corporation, but it is also the Row House Community Development Corporation, an affiliated but separate corporation that has designed and built low-income housing units.

In general there is no hesitation in the rhetoric of Lowe and others at *Project Row Houses* to ascribe social goals to the endeavor. The website proclaims that the project is "founded on the principle that art—and the community it creates—can be the foundation for revitalizing depressed inner-city neighborhoods."[1] But it also claims an aesthetic dimension in architectural preservation and innovation, the ongoing creation and presentation of contemporary art projects on site, and, most relevant for this book, the notion that there can be an aesthetic of human development and action. (For further discussion of how this project plays out in the unique environment of Houston, see the conclusion.)

In the following interview Lowe narrates the genesis of the project, starting from an impetus to do something substantial and effective within the African American community. Like many of the examples in this

book, the project unfolded slowly, as did Lowe's own understanding of exactly what he was doing. It was only after the project was under way that he began to understand it in terms of Joseph Beuys's notion of social sculpture.

As in the interview with the artist Harrell Fletcher and the planner Ethan Seltzer (chapter 6), it is interesting to see how Lowe and the social historian Mark J. Stern differ in approach even as their interests overlap. Not surprisingly for an urban studies professor, Stern is interested in measuring social phenomena; he has worked, for example, to develop a "revitalization index." But his observations based on this index are similar to Lowe's in many ways; their methods represent different routes to similar ideas. Even as he speaks the language of the social sciences, Stern is profoundly sympathetic to the arts. As a pragmatic observer of the city who can produce quantitative charts of social networks, he is suspicious of standard measurements of the effects of the arts and argues for an understanding of arts groups as "irrational organizations" that should not be measured by orthodox benchmarks.

––––

RICK LOWE is the founder of *Project Row Houses*, a multidecade experiment in social action, preservation, community development, and public art. He has participated in exhibitions and lectured nationally and internationally and received the 2000 American Institute of Architecture Keystone Award, the 2002 Heinz Award in the Arts and Humanities, the 2005 Skowhegan School of Painting and Sculpture Governors Award, the Lenore Annenberg Prize for Art and Social Change in 2009, and other awards. He was a Loeb Fellow at Harvard University in 2002 and has served in Houston as a member of SHAPE Community Center, the Municipal Arts Commission, and the Civic Arts Program and as a board member of the Greater Houston Visitors and Conventions Bureau.

MARK J. STERN is a professor of social welfare and history and the codirector of the Urban Studies Program at the University of Pennsylvania. The coauthor (with Michael B. Katz and Michael J. Doucet) of *The Social Organization of Early Industrial Capitalism* (1982), Stern cofounded (with Susan Seifert) the Social Impact of the Arts Project at the University of Pennsylvania, which since 1994 has studied the role of community cultural providers in improving the quality of life in urban neighborhoods. In 2006 he again collaborated with Katz on a book, this time a social history

of the United States in the twentieth century, *One Nation, Divisible: What America Was and What It Is Becoming.*

———

The following conversation took place at Mark J. Stern's office at the University of Pennsylvania in November 2004, with follow-up discussions by phone in July 2005.

TOM FINKELPEARL: Can we begin by talking about the genesis of *Project Row Houses*?

RICK LOWE: As I speak about it in hindsight, I can say how *Project Row Houses* evolved and how these collaborations happened. But back there looking forward, I didn't have a clue about collaborative art. I knew that I was interested in work that pushed beyond the boundaries in terms of social engagement, beyond what we call "political art." Early on I was doing art that was political — billboard-size work used as the backdrop for political rallies. It was socially engaged on one level, but there was a leap that I felt like I needed to take to figure out how to make art that wasn't created in a way where the audience stood back, but where they were actually engaged. One sure way to engage people is to find something bigger than you are, beyond your capacity, and it forces you to build some kind of relationship to others to move the project forward.

I was interested in issues of low-income African American communities — how to contribute, using creativity, to help transform some of the conditions of the environment. Blight was a huge issue. I was also thinking about the community brain drain. Everybody's always leaving, and nobody's coming in. I thought of myself as a part of that brain drain. The resources that I had accumulated over time were not going back into the neighborhood. So how do you pull those things together?

The first step in the collaboration was with a small group of artists. I had interacted in groups before, but not with the specific purpose of trying to figure out how to address these issues in a low-income African American community. Once I hooked up with those artists — there were seven of us — we began to explore the possibilities for bringing our work into the community, and that was exciting for me. But no one had the know-how or the energy at the time to figure out how to build a structure through which we could make

ourselves available. I was the most active in this community, so it kind of fell on my shoulders to figure it out.

MARK J. STERN: The character of the engagement with the community?

RL: Yeah. To figure out a situation in which we could bring our resources into the community.

TF: Rick, when you say "the community," are you talking about Houston's Third Ward?

RL: We were talking about how to do something in an African American community in Houston, not any specific place. But I was thinking specifically about the Third Ward because I was doing volunteer work there, and I had done these installations there at this little place called SHAPE. The name was one of those acronyms that didn't exactly fit: Self Help for African People through Education.

TF: Were you already living there at that time?

RL: No, this was in 1990 and 1991. I was living on the west side of town. As we started to think about this, I was on a bus tour organized by SHAPE with a group that was looking at dangerous places, places that needed to be torn down and dealt with. We passed these little shotgun houses, and that was the first time I thought about the houses—you know, the scale of the houses, and how as artists we could utilize those houses as a way of reflecting something to the community. Of course, in the beginning we didn't have resources or the long-term vision of the collaborative process that could build an institution or create systems with sustainability. We were just thinking about doing some kind of guerrilla art project that would happen and then we'd go away.

As time went on in my researching possibilities in the area, I came across Joseph Beuys and his idea of social sculpture, which he defined as the way in which we shape and mold the world around us. This was interesting as a potential kind of work. And there was something about those houses that was hauntingly reminiscent of John Biggers's paintings. Biggers was a senior African American artist in Houston who died three years ago. I started looking at Biggers's paintings and trying to understand the houses from that point of view, until I realized there was a possibility there that went beyond a temporary act of guerrilla art. At that point I realized it was going to be something that was way beyond me as an individual, bigger even than the seven of us artists, so I started planting the seed and telling people what the possibilities were.

Rick Lowe (left) with the artist Dean Ruck in 1993 during the beginning of the renovations and rebuilding of *Project Row Houses*. Photograph by David Robinson. Courtesy of *Project Row Houses*.

MJS: So was there an "aha" moment? Or did the idea build over time?

RL: There were a couple of "ahas." The first "aha" was simply seeing the houses with this community group. We were talking about tearing them down, and we all agreed that this would be the correct course of action. But after looking at Biggers's work and really thinking about it, I drove to that corner again one day and looked again, and all of a sudden I thought, "Aha! Wow! Look at that."

MJS: There's a value there.

RL: Yes. I just remember standing there. It was a rainy day, and the roofs get a little purple and it's a beautiful sight. So there was enough of an indication that something was there that I was able to drag people over there and talk. And the other artists got involved and excited as well, which gave me more confidence to talk about it and be enthusiastic.

MJS: Interesting. You know, before I was working in the arts, I was essentially doing research on urban poverty. One of the things I was working on in the early '90s was an essay that argued that the idea of the underclass was about reinforcing boundaries between "us" and "them." The way I got involved with looking at the arts was around the fact that too many people were wanting to tear things down.

There are all these neighborhoods in Philadelphia that people only look at as deficits—that are defined just by the negative. But there are all these other dimensions of those neighborhoods that get obliterated when we just apply that negative label to them. Part of our work in the arts was to say that there are resources and assets in these neighborhoods that are invisible or below the radar, and seeing these assets was our motivation. So it's interesting that at the same time, in the early 1990s, your engagement came out of thinking about what these neighborhoods were like, but also reflecting on the objects themselves. The houses themselves were part of your motivation.

RL: Right. And it's also about not only thinking about it abstractly. As creative-minded people, we all do that. We all look probably ten or fifteen times a day at something and think about what it could be, what values may be underneath. But then there's that other difficult step to actively engage and try to uncover and reveal those things in a way that moves either yourself or other people to action, and that's the difficult part.

TF: Rick, quite frankly, you may look at things ten or fifteen times a day and see potential, but that is a tremendously optimistic outlook. Others might look ten times a day at the problems that the city presents and get depressed. But even for the most optimistic and active person, as you say, there is a difference between seeing potential and activating it.

RL: It's frustrating for artists like myself who enjoy doing that, when you can't make this kind of work happen in other places and other environments, because you can only take the first step. You can only look at it and use that creativity to envision what the possibilities might be, but there still has to be that other level of really tangibly tearing into it, pulling things out, bringing things to it to make the value actual instead of just latent or conceptual. It's frustrating when you can see it so clearly but can't make it happen. I have had situations where I can see the potential, but I can't pass that understanding to the people in the community. It's a struggle to empower others to be able to see it. That is where the collaboration, the coalition building comes in.

But with *Project Row Houses* it was so easy, for some reason. Once the core of seven artists got excited, we went to DiverseWorks, which is an alternative art space in Houston, and talked to people

there and dragged them over to see, and they got excited. They were the ones who gave us the idea or planted the seed that it could be sustainable and not just a one-time project. So from them it went to the NEA. We drafted a proposal talking about how we were going to rehab these old houses and bring artists in from all over the country to do work in this low-income African American neighborhood, and so on. It was kind of a far-fetched proposal at the time, but there was a quality about it that resonated with people quickly. The folks at the NEA saw something interesting, so instead of throwing the proposal out when they realized we hadn't even gotten any kind of agreement on the property, they sent us a letter stating that they were interested in the proposal, as a way of giving us leverage to negotiate with the guy who owned the property. You know, they actually became participants, in a sense. The owner was an architect living in Taiwan. Once I was able to fax him a letter from the NEA saying that they were interested in the project, he became interested, and we got a lease-purchase agreement.

We were able to start with a small group of artists—basically the seven of us and a few others from the DiverseWorks circle—to clean and clear the site. And then folks from the neighborhood started coming. At this point, as I said, I had no idea how to go about building a collaboration, to reach the goals. But the one thing that was very obvious was that if we were going to do it, it wasn't going to be just us doing it. It was going to take a broad group. During that time I started to really see my role as an artist as trying to uncover the meaning of the place and creating opportunities for people to give that meaning a place to live within the project in reality. And so it went from children in the neighborhood to church groups, museum groups, corporate groups, and a wide range of other professionals with technical expertise, from architects and historians, to attorneys, to people who conceptualized programs. For sure, all the programs of *Project Row Houses* didn't come from me. They came from inviting people who are really good at developing programs—giving them the space to be involved and see what the possibilities were.

MJS: So there were really two kinds of engagement: a community engagement that was about involving people who lived in that physical place, but also an engagement process that brought in folks with whom you wouldn't necessarily work as an artist, but whom you needed to actually make it happen.

Amoco employees from across the United States participating in the first large-scale volunteer effort at *Project Row Houses*, organized by Amoco Torch Classics, a program for the corporate Olympics. This effort renovated the exteriors of sixteen houses in 1994. Photograph courtesy of *Project Row Houses*.

RL: I see that duality all the time, especially in terms of the audiences for *Project Row Houses*. There is the need for people inside the community to benefit from what we're doing on a service basis. But at the same time we realized that *Project Row Houses* was also intended for people outside the community to participate, to benefit from the opportunity to interact in a different kind of environment. For example, we'd have a group from the Mormon Church come and do a volunteer day. Some of these folks wouldn't otherwise have an opportunity to be engaged on a grassroots level with low-income African American folks working on something that is a positive experience. There's that engagement that both sides benefit from, the service part, but also the resources coming in from outside.

MJS: This relates to the work we've done in Philadelphia in terms of explaining to the funders how community arts work. There's this assumption that, when you say "community art," it works like community health or community development. There is a common notion that community art centers should essentially serve their local area, like you could draw a line around whom they serve. And one of our big findings was that most of the audience for community arts

programs in Philadelphia comes from outside the neighborhood in which a given center is located. Originally the arts funding programs were upset about this observation. But if you're an artist and your only engagement is within this limited geography, you feel like there's something missing.

RL: Yes.

MJS: Part of our lobbying in Philadelphia was around saying that "community arts" doesn't mean grandmothers with coloring books in their front yards. We're simultaneously about community activity and serious art. And if it is about art, then people involved with it don't want to say, "I just do it between Third and Fifteenth Streets." It's been simultaneously trying to figure out how these networks operate — and how you get this depth within community but also the connections across a region, or across an entire city. Empirically trying to figure that out has been a challenge. It's been trying to explain to a wider audience that one of the unique values of community arts is that they simultaneously can engage local communities and networks of people that are nongeographical.

RL: That's true. I think people are missing the point when they say that you can't really talk about community-based art in a critical sense because it's just about that community. I mean, if it's community-based art, from my standpoint, it's a community-based activity that's trying to identify some kind of higher order or existence of activities that is not only beneficial for the folks inside the community but should be of interest for people outside the community if they want to better understand the elements that create life and vitality within these communities.

TF: Rick, have you ever seen the charts that Mark has made that visualize the web of interconnectivity in community arts activities?

RL: I haven't.

TF: They look like spider webs. We're looking at a couple of them here. Mark, can you explain what we are looking at?

MJS: Well, these are really two network diagrams we've done based on work we were doing on community arts. For the first one, we interviewed fifty-five artists and asked them about organizations with which they had connections. No big surprise — you can see the average artist had connections with five different arts organizations over the previous year. The chart gives you a feel for both the range of the networks and the fact that there are these connections people don't

Institutional networks 1997 **Institutional networks 2000**

Mark Stern's research has shown that the nonprofit arts sector can help build social networks. This graphic is a visualization of how networks grew in a Philadelphia neighborhood over a three-year period, and it is these charts that Stern and Lowe discuss in the interview. 2002. Courtesy of the Social Impact of the Arts Project, University of Pennsylvania, and Mark Stern.

even know they have. The other drawing is of institutional connections for ten arts organizations we were following, connections with other kinds of organizations, both arts and nonarts. We did another survey this summer of artists in which the whole sampling strategy was based on getting one artist to refer us to other artists. The study was based on developing networks of artists. I think we ended up with sixty-five different contacts coming out of just one artist who referred us to three people, and those three people referred us to nine more people, and those nine referred us to twenty-seven, and so on. One of the big emphases of this work has been these vertical and horizontal networks and the recognition that you've got to have both to do what we call community building—which is building out within a community, and building from the communities out.

RL: Was there a connection between the diversity of the connections and the success of the institutions?

MJS: You can see that certain organizations aren't as likely to have crises, either because of luck or because they've created networks that bridge resources, like the link you made with the Mormon Church. One of our big "aha" moments was when we ran into this group of essentially faith-based community arts programs that just had a certain vitality to them. We realized that they were Roman Catholic–based. And in town—I don't know if this is the same everywhere—if you're involved in the Catholic Church, you're embedded in a network that crosses boundaries, that links suburbs to the city and

spans communities. For example, Norris Square Neighborhood Project up in Kensington, a low-income Latino area, can easily connect with eight or ten suburban Catholic colleges and universities. When they call on students from those colleges, there's a set of resources that they can pull into the neighborhood based on the preexisting community. Other organizations are more intentional in terms of saying, "We're going to build this network out."

RL: I know a lot of smaller, particularly African American groups that are really trying to control their identity, and so they don't allow too much verticality in terms of the way they reach out. There's a certain kind of limitation in terms of resources and the connections they make. It becomes very insular in the way they allow themselves to be seen and talked about. They limit their social networks; they don't allow anyone to be critical of them, because, you know, they're within their own little sphere of activity. But when you start going more vertical and going out, it kind of forces that organization to look critically at itself. That's one of the things that arts and culture can bring to community-based projects — that kind of verticality.

MJS: Right. And boundary pushing. The boundaries between groups are shifting and complicated.

RL: I deal with that all the time in terms of how to allow *Project Row Houses* to maintain an identity as an organization that's African American–centered but, at the same time, exposed and open to cultural views and outlooks from all over. And I see that some African American organizations are somewhat resentful of that.

TF: Some organizations are based on a horizontal interconnection first, as I think yours is, and others are based on a top-down structure first, and then reach out to the community. The top-down structure starts with a well-connected, rich, politically savvy board of trustees that oversees the activities of an executive director, who in turn manages a staff who might choose to work with local community groups. This is different from an organization born from and based on a horizontal coalition.

RL: Yes, this is certainly a different way of working, and I think community-based collaborative art can reflect these two structures as well. There are artists whose most significant contribution is connecting the art world to the community rather than fostering the interconnections within the community. I'm not completely against that idea, because I think there is some benefit in creating work

that's about educating on a grassroots level. That's an important way of working. But my inclination, my sensibility, is about helping create collaboration and interconnection among the core populations that I'm working with, but in a way that maintains and reinforces the importance of the vertical connections.

MJS: In our work we discovered that the one unique feature of cultural engagement is that it really operates across boundaries of race and ethnicity and also across boundaries of neighborhoods. Based on our analysis of participation, we've established that people from outside poor neighborhoods who are involved in the arts of those neighborhoods are a key component of overall civic participation. It's precisely those neighborhoods that have high levels of this cross-participation across boundaries that, over the course of the '90s and into the early twenty-first century, have done better in terms of poverty reduction and population growth. We have a measure that we call our revitalization index, which combines population growth and reduction in poverty. There's a fairly significant correlation between neighborhoods with a lot of this outside participation and positive numbers in that index. The vertical connections are critical simply because of the lack of resources in these neighborhoods, and you need to get those connections up to different social classes and particularly to different institutions. Now, I will say that the character of the connections between more established cultural organizations and community-based ones is, in our view, a weakness in terms of the overall cultural system, at least in Philadelphia. Those connections are overlaid with tensions around social class, race, and ethnicity, and that seems to be a barrier. That is an area where we really see a deficiency in terms of the overall network or ecosystem of culture in Philadelphia.

Part of the new urban reality is that diversity is connected to vital neighborhoods. It used to be that you saw mixed neighborhoods as essentially an indicator of some problem. Forty years ago in Philadelphia mixed neighborhoods were considered mixed from the time the first African American moved in to the time that the last white person moved out. Today it's different. Now people see diverse neighborhoods as a key part of the city landscape. We can demonstrate in neighborhoods that arts activity is the leading indicator of diversity, and that those together are also the indicator of neighborhoods that are undergoing revitalization. That's on a more abstract

level. But it is connected to the fact that arts programs are able to take a particular place and draw resources and people from all over the city. Don't get me wrong. It's not a panacea in the sense that all you have to do is put a couple of arts programs in a poor neighborhood and it'll be transformed.

TF: It's my impression that by far the most diverse place in the Third Ward is *Project Row Houses* — economically, racially, and professionally. You might bump into an architect; you might bump into a kid in an afterschool program. Rick, you live there and I don't, but when we drove around the Third Ward it didn't seem like a particularly diverse neighborhood.

RL: Yes. Mark's right in the sense that one of the ways that arts and cultural institutions add value is by providing an opportunity for people to come and contribute to a neighborhood's diversity. So much development of urban neighborhoods is being driven by land values, and it's causing a demographic shift. So the question is, do we have to allow the shift in demographics to take place as it's happened in the past, where one group comes in and the other moves out, or can we create opportunities for a kind of staying period for this diverse population?

MJS: It gets complicated, because in a certain way *Project Row Houses* both becomes an engine for change in the neighborhood and attempts to be a stabilizer of that process.

RL: Yes.

MJS: Can you simultaneously cause property values to go up and also structure the program so that people who are in the neighborhood have an opportunity to stay put? Is that part of your agenda?

RL: Well, the rise in property values in the Third Ward probably would have happened with or without *Project Row Houses*. The neighborhood would have been earmarked for gentrification because of its central location. Before we came in, the Planning Department had already replanned the property as if the houses were gone. So something was going to happen with or without our intervention. We could have taken a different approach and said that we would take a stand to fight gentrification, any kind of diversification, any kind of change. We could have been more horizontal in our community building. And you know, there are still people in the community who feel that way. But I knew it would be a losing battle, and I also just felt that seeking diversity was the right thing to do — in

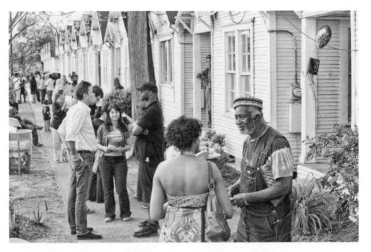

Jesse Lott (far right), one of the founders of *Project Row Houses*, speaks to Regina Agu, an artist from Houston, 2010. In the background left Hadeel Assali (facing camera), founder of Houston Palestine Film Festival, talks to two visitors. Photograph by Eric Hester. Courtesy of *Project Row Houses*.

the sense of trying to instill a community based on desegregation culture.

MJS: Our research showing that neighborhoods with lots of arts organizations tend to see their poverty rate go down over time immediately raises the red flag of gentrification. But I often say that there are five neighborhoods in Philadelphia that have been hoping to gentrify in the last thirty years. There's kind of this New York or Chicago model of gentrification, where overheated gentrification in really hot cities destroys communities. But there are a heck of a lot of cities where gentrification happens over a period of thirty or forty years if it happens at all. Jane Jacobs talks about gradual versus cataclysmic change.[2] You've got to have slow change. If you don't have *any* change, the neighborhood's really in trouble. So the choice isn't between the way things have always been versus overnight change; the issue is, can you ensure that the process of neighborhood change has some duration?

RL: That's right.

MJS: In Philadelphia now there are places where people are saying, "We want a diverse neighborhood, and we're really going to build collectively to get that." But there are probably more neighborhoods

where it has just sort of happened. South Philly is the classic example. It used to be that South Philly was predominantly white, and if an African American family moved across the line into a white section, there would be a cross in front of their house or rocks through their windows. Then, over a fifteen-year period, the Asian American population started increasing. It wasn't like, "Oh, great, the Asians are here!" There was some tension, but changing it from a black-white issue to a three- or four-race issue complicated it enough that at least the first Asians weren't getting rocks through their window. They helped blur the boundary. Now we're working with an African American group on the traditionally African American side of South Philly. The folks who run the community arts center are Catholic, and their parish now is maybe 40 percent Vietnamese and 20 percent Mexican alongside the African American congregation, and it's stretching them.

RL: That's a really good point, that there is some middle ground between things staying the same and a total community makeover. I'm interested in creating a social collaboration to extend that period of transition to allow for all kinds of social dynamics in the process. I like the notion of the triangulation that occurred in South Philly with the introduction of the Asian Americans. Every place has to move on one way or another, whether it's through decay or some kind of positive growth experience. The key is just how we interact within that space of development.

MJS: Artists can't do everything, but they can help with diversity. They can complicate a process that comes with a lot of pressure to flatten and simplify. Like the tendency to just put the label on a "decaying" neighborhood. I think there is a fit between arts diversity and contemporary cities. A lot of the assumptions about what is valuable in a city and how to visualize a city are up for grabs now. It's a particularly important time for the role of art and artists in cities—not only because this makes for hot cities that rich people want to live in, but because all the residents of a city are looking to come up with new value, or value in different places. I think that this is a particular point in the history of American cities where the artists have the ability to challenge categories and provide a space where there can be ambiguity, where neighborhoods can be complicated. This seems like a unique moment. In Philadelphia up until fifteen years ago, if you tried to violate the color line, you were going to be sub-

ject to violence. And there's nothing like violence to uncomplicate an urban transition. But we're at a different point now, where people are willing to try out diversity, both intentionally and by happenstance, and that provides an opportunity for artists to be inserted into urban community life in a way that's really good for neighborhoods.

RL: I've been working on this idea of what role artists and arts and cultural organizations should play in terms of community development. This is part of a project with Miguel Garcia at the Ford Foundation. Market developers' interest in community development is profit-driven. They don't care who gets served; they don't care who's paying. And then you have community development corporations, which do have an interest in who gets served by the development. Now, *Project Row Houses* has a CDC, but what role does it play? As an arts and cultural institution, *Project Row Houses* has the role of trying to look into what values come out of these developments from a human standpoint: What does the development project mean? The CDC says it needs to serve low-income populations, but what does it mean if a development serves low-income populations in relation to market development of high-end real estate? I want to explore what it means and create opportunities for meaningful dialogue. To me this is where arts and cultural institutions come in from a different angle.

TF: Would you say that the diversity at *Project Row Houses* is partially created through collaboration? *Project Row Houses* has attracted all these different kinds of people who have different expertise, different socioeconomic and racial backgrounds, et cetera. But even in this collaborative community spirit, all the vertical and horizontal interconnectivity, there is one person at the center who is particularly important as a catalyst for the interconnection. You are the instigator. It is usually one person who has the "aha" moment and then gives the opportunity to everybody else to be interconnected in all these different ways.

RL: I think the way that a project develops will often look like the person who instigated it. If I had dropped out of *Project Row Houses*, or if I drop out in the future, the kind of diversity that it expresses will certainly shift. There would be different people with different notions of what kind of diversity is necessary.

MJS: We've tried to emphasize that the networks operate on a differ-

Housing designed by Rice Building Workshop, Rice University School of Architecture, 2006. These buildings were designed by students and built as low-income rental housing. The low tan building at the far left is now the *Project Row Houses* Laundromat. Photograph by Danny Samuels. Courtesy of *Project Row Houses*.

ent level from organizations. *Project Row Houses* is a combination of what Rick brought to a situation, how Rick was embedded in social networks, and a certain kind of luck to pull it off. When you look at community arts projects in Philadelphia, I wouldn't say as a group they're successful all the time. Probably a third of them are in financial crisis right now, and a third of them are having arguments between the executive director and the artistic director. Someone once said to me that artists are good at dealing with adversity because 90 percent of the stuff you try is a failure, so you don't get discouraged easily. And one of the problems is that funders are not really interested in failures. So *Project Row Houses* is one success. In Philadelphia we have Lily Yeh—everyone knows Lily from the Village of Arts and Humanities, a community-based arts organization that she founded in 1986. She was a professor at the University of the Arts in Philadelphia. The Village's mission was to use the arts as a strategy for community revitalization in the immediate neighborhood, which was a poor African American neighborhood in north Philadelphia. Her chief strategy was building public art installations and sculpture gardens in parks in the neighborhood. In a sense part of it is luck when you get a person, a setting, and resources coming

together to create a success. One of the drawbacks of this happening in the arts is that there's this notion of genius out there. We tend to take the geniuses and sort of draw a circle around them and say, "Wherever that person goes, there must be genius happening." But talent is just one of the ingredients.

TF: In fifth grade we were studying crystals, and one assignment was to make a supersaturated solution by adding lots of sugar to boiling water—more sugar than water can hold at room temperature. Then we put in a piece of string and let the solution return to room temperature. Sugar crystals formed on the string. This is a metaphor for what you're saying. If the situation is right, crystals form on the string. There would be no crystals without the string. So when the social situation is—

RL: Saturated with possibilities.

TF: —then if the right string goes in there, you get *Project Row Houses* or the Village.

MJS: And artists are occupationally trained to take risks. Rick and his collaborators saw the situation as a set of opportunities that an investment banker or someone working in the CDC wouldn't have seen. So the contribution of an artist in that situation, I think, has to do with seeing the world differently and also being a risk-taker of a certain kind.

TF: Yes, and it is important to stress how little people thought of the site of *Project Row Houses*. Far from recognizing a supersaturated solution of possibility, the establishment was getting ready to clear the site.

RL: I would also like to add that I think we live in a time and place in which, when you talk about art, you're talking about some kind of product—even in terms of community-based art. There needs to be a product to point to, whether it's a successful community-based project that's sustainable or a short-term project. But another part of me is rooted in this idea that there is a certain value in community-based projects that just explore and ask questions. That in itself can be a successful process that may not result in a product. It can allow questions to be put on the table that have not been asked before. It becomes, in its own way, art for art's sake—asking the questions for the questions' sake, not for the sake of the product. Would that satisfy a funder?

MJS: It's so funny, I find myself falling into the same role that traditional

art producers fall into sometimes — a role that I'm critical of — when they say, "Well, I can't explain it; that's for the critics. I just make the work." So here I am saying kind of the same thing, "Well, I just want to go through this process and do it. I can't explain it" [*laughs*].

We got started on our work in reaction to the economic impact of the arts movement that was trying to reduce all of the value of the arts to the multiplier effect in terms of restaurants and tourism. We were saying that this flattened the arts, didn't take into account the depths of art's potential for transforming communities and improving the social environment generally. I think as you get a feel for that depth, you can actually come up with ways of measuring that allow you to represent it to a wider population. You're self-consciously trying to say you can do a community arts project that has a social mission, but also an aesthetic, emotional aim. *Project Row Houses* has that kind of depth, and I find that really impressive. Maybe part of the artist's thing is to have strands that you're always trying to pull together in the right form. And the challenge is, how do you, at a particular moment, pull them all together in a way that really works? I always wonder why one person can write one great novel and then eight bad novels. When all of those things fall into place, you have something wonderful. When I hear you reflect on Biggers's paintings, there's a sense of ambition that isn't something you can reduce to a twenty-slide PowerPoint presentation. That's part of the cultural challenge in terms of how you relate to the community development types. If you lay that out in particular settings, they'll say, "Oh, God, we have an artist in here! Why are we talking to this artist?"

RL: I have heard that IKEA determines a price for a product, and then they have their designers design to that price. You know, to make sure that the product is affordable. Anybody can design something nobody can afford. So put the economics first. And when most people engage in a discussion of value — not just in the arts but in other community work too — it starts from the notion of economic impact. At the beginning I wasn't smart enough or educated enough to know that that's what I was supposed to do with *Project Row Houses*. One of the challenges is to know that in reality economics is a big part of it, but to not allow that to guide the development of the work, to keep other principles at the forefront. Oftentimes too a lot of the creativity is spun out in resistance to the economics, because

you can't afford the standard way so you have to do it differently.
And those spin-offs are really where the juicy, exciting stuff happens,
for me.

TF: Mark, you have said that using an economic model for these arts
organizations isn't often the most apt, that it's more like a social
movement.

MJS: Sure. The dominant model that's used to judge organizational suc-
cess in the arts conforms to orthodox organizational standards like
economic stability, successful marketing, clarity of the staff organi-
zation, and stability or moderate growth. A social movement model,
on the other hand, is built around the motivation of people involved
in the group. In fact we've called a lot of these community-based
arts organizations "irrational organizations," because they lack those
more orthodox benchmarks of well-being, but they essentially make
up for that in the motivation and engagement of the staff and the
participants. It's our experience in working with arts organizations
that these irrational assets are probably a better standard by which
to judge their success than orthodox organizational standards.

Part of the reason we got into making this distinction was that
there's a tendency on the part of policymakers and funders to think
that unless an organization grows and becomes more orthodox, it's
not succeeding. While growth and development are desirable out-
comes for some organizations, that shouldn't be our only standard.
If an organization is on mission and providing the services that were
its goals, it doesn't have to meet these kinds of standards of growth
and development — you know, a kind of upward-mobility model —
to be judged a success.

SIX PARTICIPATION, PLANNING, AND A COOPERATIVE FILM

Blot Out the Sun HARRELL FLETCHER,

ARTIST, AND

ETHAN SELTZER,

PROFESSOR OF URBAN

STUDIES AND PLANNING

HARRELL FLETCHER is one of the better-known artists in the United States who operates in a socially cooperative mode, yet his work is uncharacteristic in a number of ways. First, his cooperative gestures are often interactions with a single person, not a group or a community. Fittingly, *Blot Out the Sun*, the subject of the following discussion, included the cooperation of many actor-participants, but it could be seen as a collaboration between Fletcher and one person, Jay Dykeman. Second, Fletcher's work includes a heavy dose of deadpan comedy. In general he undertakes projects of such breathtaking simplicity that humor is just below the surface, whether he is working with a youngster in Brittany to realize in bronze his vision for a public artwork, personally returning a rug to the man who manufactured it in India, or literally spotlighting everyday objects that were already present on a street in Portland, Oregon.

What is common to all his projects, be they comical or more overtly serious, is the attention to small details and the method of taking simple gestures to (or beyond) their logical horizon. For example, in the participatory website Learning to Love You More, created by Fletcher with the artist and writer Miranda July, assignments were posted for anyone who cared to follow them.[1] The tasks were quite simple, such as "Assignment #50: Take a flash photo under your bed" (though more detailed instructions ensured some consistency in the contributions).[2] On the website there are 550 under-the-bed photos, making for an oddly compelling chronicle of an unconsidered, invisible site in the home. It is the accumulation of many thousands of mundane slices of life that is the essence of the project. As the critic Jon Davies put it, "Placing quotation marks around the everyday to both appreciate and critique it is a current that runs through Fletcher's work. . . . [His] entire practice comes down to di-

recting attention to—or as he puts it 'pointing at'—the ordinary."[3] The question often arises whether the humor in Fletcher's work is at the expense of the participant-collaborators. Fletcher argues here that it is not, that he takes the voice of his partners seriously, often doing little more than fulfilling their stated desires. This position is reinforced in the following interview with Jay Dykeman.

In this conversation Fletcher is paired with his Portland State University colleague Ethan Seltzer, an urban studies and planning professor. In some ways their participatory practices could not be more dissimilar; if Fletcher's are often absurd and narrowly framed, Seltzer's have long-term, practically irreversible consequences for an entire region. There is no question that Seltzer's brand of planning takes the voice of the community participants seriously as he outlines how Portland sought public input in the creation and redesign of the city's Urban Growth Boundary. (It is interesting to compare the context of Portland, one of America's most rigorously planned cities, to Houston, a city without zoning, and the site of *Project Row Houses*; see chapter 5 and the conclusion.) Seltzer's practice would be found toward the top of Sherry Arnstein's "Ladder of Citizen Participation"; it finds the answers to fundamental regional issues through participatory democracy. The goals of Fletcher's projects, on the other hand, are exasperatingly evasive, which often seems to be the very point. But the two find common ground in their trust in interactive process and participation, even if the stakes are so different.

———

HARRELL FLETCHER is a professor of art and social practice at Portland State University in Oregon, where he helped found the social practice concentration in the Fine Arts Department. He has worked collaboratively and individually on a variety of socially engaged, interdisciplinary projects for more than fifteen years. His work has been shown at museums in the United States and Europe, and he was a participant in the Whitney Biennial of 2004. Fletcher has work in the collections of the Museum of Modern Art and the Whitney Museum of American Art.

ETHAN SELTZER is a professor of urban studies and planning at Portland State University, where he teaches interdisciplinary courses dealing with themes of regions, planning, and place. From the beginning of his career he has been interested in public participation; his dissertation at the University of Pennsylvania was titled "Citizen Participation in Environmental

Planning: Context and Consequence" (1983). He has published widely on planning, often collaborating with his Portland State urban studies colleague Connie Ozawa. He is a past president of the City of Portland Planning Commission.

TOM FINKELPEARL: Harrell, can you tell us about the project *Blot Out the Sun*?

HARRELL FLETCHER: *Blot Out the Sun* was made in 2002, soon after I moved to Portland. I received a grant from the Regional Arts and Culture Council to produce a series of small-scale temporary projects. Around that time a friend told me that a man named Jay Dykeman wanted to have a movie made at the gas station he owns. The station is located in the southeast quadrant of Portland. It's in an area that's pretty diverse and a little down and out. And it's an independent owner-operated gas station. So I decided to go and talk to Jay, thinking maybe this could be one of the projects for the RACC grant. I just stopped by one day and asked him if it was true that he wanted a movie made, and he said that it was. I told him I could probably help him realize his idea, and he seemed really excited. So I asked him, "What do you imagine this film to be like?" He told me that his idea was that the film be based on *Ulysses* by James Joyce — which wasn't what I was expecting. I don't know what I was expecting, but that certainly piqued my curiosity. On his recommendation I went and bought a copy of *Ulysses* and started reading it, and then I met with Jay and his employees a couple of times. We went out to lunch together and talked about the project. He explained to the employees that this was going to be an okay thing for them to do — that they should feel free to take a little time off from work to help me out. They were a bit skeptical, but he was very positive. He explained *Ulysses* to them and to me and what he saw as a connection to the gas station. He saw the station as a place filled with activity, with lots of different characters coming and going all the time. To him this was similar to the novel. He saw this particular spot in Portland, Jay's Garage, somehow as the center of the universe. At first I thought I would just use that idea in a general way and make a documentary based on the gas station. But that was really hard to do. I found it difficult to capture this idiosyncratic, interesting material on the spot — especially because the grant period was a limited amount of time.

So I switched gears and decided to actually use text from *Ulysses*

Jay Dykeman was the co-initiator of *Blot Out the Sun*, a video adaptation of James Joyce's *Ulysses* for a gas station in Portland, Oregon, 2002. Here he presents a brief introduction to the project. Video still courtesy of Harrell Fletcher.

and to ask the people at the gas station—the employees, customers, and people who were just wandering by or waiting for the bus there—to read lines from the book. These were direct quotations read from cue cards, on camera. From these quotations I would construct a condensed film version of *Ulysses*. So I read the whole book and spent a lot of the time being really confused by it, as I think most people are when they first attempt it. I was consulting with Jay periodically on what his thoughts were about it. He brought in a books-on-tape version for his employees to listen to, including commentary trying to explain Joyce's symbolism and the stylistic changes. So we were all getting familiarized with it at the same time. Then I went through and highlighted passages that I was intrigued by and wrote them out on cue cards, in chronological order, although they would sometimes include a line from one page and then another line from twenty or thirty pages later. These little scenes were then videotaped at the gas station with all these local people reading the lines. That was then edited into video that's a little less than half an hour long.

The video was projected at night at Jay's Garage, on a big white wall [adjacent to the garage] that Jay had envisioned for the screening. It was the wall of the apartment building of my friend who had told me about Jay's idea in the first place. All the people who had

taken part in it were invited back to watch. I had taken down their contact information, and I had given them invitations to the screening as I was shooting the video. About two hundred people showed up to watch the projection. The mechanics and Jay spoke after the screening, about their experience of being part of the film. After that Jay made copies of it on VHS and handed those out to his favorite customers, and also played it in his waiting room for people waiting for their car to be repaired. Somebody who happened by during the screening worked at a film festival in Olympia, Washington, and nominated the film for the festival. Jay and some of the mechanics came up for the screening and talked afterward at that too. Since then it wound up being shown in a lot of locations, including the Whitney Biennial in 2004. It continues to be shown periodically both in film festivals and in exhibitions, and it is on YouTube (not posted by me).

TF: You had employed some similar strategies in earlier projects, like *Some People from Around Here* and *These Fine People*, in which you experimented with the notion of visibility.

HF: Yes, I think *Blot Out the Sun* grew out of some projects I had started doing almost ten years earlier, in 1993, in Oakland, California. But with those projects I was trying to draw out something that was specific to the people themselves—just pulling out culture that was already there and then trying to make that more visible. I was collaborating with another artist, Jon Rubin. We opened a sort of neighborhood gallery that did projects just about people and places in our local area. We did shows about a rug merchant, garage sales, a big cement boat that someone had made, an apartment courtyard garden, et cetera. All of the shows wound up also being about other things in incidental ways, like gentrification, celebrity, war, history, community, and other topics. *Blot Out the Sun* was the first time I worked with something that came out of a canon of high art. *Ulysses* is interesting to me because it is about common people and because it can be appreciated by nonacademics as well as academics. In any case this was a departure for me. I had done a previous project that involved making a re-creation of a *Star Trek* episode with a *Star Trek* fan, so that was probably the past project most similar to *Blot Out the Sun*.

TF: When you start dealing with a high-culture icon like *Ulysses*, there can be a kind of inherent humor based on the incongruity of the setting, especially a gas station.

Blot Out the Sun (2002) elicited the participation of the workers at the garage, but also motorists who happened to stop by. A canine passenger inspects the camera. Video still courtesy of Harrell Fletcher.

HF: Right.

TF: There was a full range of folks who participated; some are clearly the mechanics; there are people who have stopped by; there's some racial diversity, perhaps educational diversity; and so on. Some people seem to stumble over the lines, while others seem to be well versed in how to express that sort of text. I am wondering, did you anticipate the humor? Did you see some danger in that humor?

HF: I don't think I set out to make a humorous piece, because the idea of using *Ulysses* was actually suggested by Jay. I think it would have been different if I had thought it up, if I had decided to take this obscure, high-art text and have people who you wouldn't expect read it. If I had gone in with that game plan, then it would be more likely that my intention was humor. But I was following Jay's lead. The humor was just a residue of the process.

TF: When you showed it at the gas station and subsequently at festivals and museums, did people perceive it as humorous?

HF: There are definitely spots where people tend to laugh. But starting back in 1993 I had been making these works that were done for a specific site, and the participant was always there when the work was viewed. This increased a certain sensitivity for me. I wouldn't want to make a piece that was making fun of people because those were

the people I worked with, and they were the people watching it with me. So we were sharing in it. I always have made that a cornerstone of how I work, to be very sensitive so that no one I work with feels like they are being made fun of.

TF: There was also humor sometimes when people exceeded your expectations—the nicely turned phrase from the unexpected voice. Last week I was watching *Blot Out the Sun* on my computer, which must have been very different from standing at the station watching it projected, in a group that included many who participated in the film. I would imagine that the first time you showed it, people were saying, "Oh, there's Fred" and "That's me!"

HF: Right. It was celebratory, and there was a lot of applause. People had no idea what to expect, and most of them were astonished and happy about it.

TF: In contemporary cooperative art there's this range of participation, from projects in which a group creates the structure of the interaction to, let's say, an event in a museum, where the participant just walks in and has some food in a social setting. This might be called the range from socially collaborative work to relational art. *Blot Out the Sun* is an interesting hybrid. On the one hand, it is unusual in that the initial idea wasn't yours, Harrell. It was the brainchild of Jay, your community participant partner. Often an artist has an initial idea, and the details are created in concert with a group. This was the opposite. Still, though the initial idea was his, he might never have imagined executing his notion so literally.

HF: Right. He really liked the idea of doing it with the cue cards, for instance. He bought into the whole thing, really, because it was *his* idea that I was facilitating and augmenting. When I would approach customers who had just driven up to get gas and ask them to read some lines, they would oftentimes look to Jay to see if it was all right, because they knew him. He would say, "Yeah, do it. This is a filmmaker guy. Go ahead and be in his film. He got my approval." That made a lot of people more comfortable. You know, I just did a project up in Victoria. The institution I was working with made me get release forms, which created a very different dynamic. At some level, by asking for these release forms, I felt like I was suggesting that I might be doing something wrong. At the gas station I didn't get any release forms. I was going to work with everyone who participated, and if

they didn't like something they could tell me and I'd take it out, or we could change it as we were doing it. It was more on the level of friends working together than a business contract.

TF: Watching the film, I was reminded of the piece you did with the kid in France, in which you took his drawing of a turtle and made it into a public artwork. I was thinking, Be careful what you say around Harrell, because he might execute your idea in public.

HF: You're referring to a piece made during a residency at Domaine De Kerguehennec in Brittany. The kid was Corentine Senechal, an eight-year-old who lived near the sculpture park. But I didn't just execute his drawing. I worked with him for two years to realize that project. He was involved in all the phases. He made models, learned about contemporary art, got to pick the site. He had meetings with the director of the sculpture park to negotiate aspects of how it was produced. He went to the foundry where it was fabricated, helped install it. He was there for the opening.

TF: Nonetheless the authorship of these projects at some level is still Harrell Fletcher's. There's a consistency of sensibility in your work. And there is some humor in the projects—you take a pretty simple idea to an extreme.

ETHAN SELTZER: Harrell, do you agree with that? Because I think in a lot of ways this is very purposeful on the part of the participants. In both pieces we are talking about, you weren't just screwing around; it was very real. Young kids take things very literally. And Jay was on a quest; he was like Ulysses himself, right? His mechanics too took the risk of being exposed in a way that they might not have been comfortable with, yet they took it very seriously.

HF: I always approach these projects with seriousness. Also, if I'm talking about those projects in a lecture context, I do it with a completely straight face. I don't want to suggest to anybody that something is supposed to be funny. However, I will grant that while I approach it with seriousness and I present it with seriousness, there is almost always a level of humor; it sort of happens naturally without me pointing to it. As you said, Tom, there is humor in surprise, a delightful humor, as opposed to a sarcastic or cynical humor. I'm completely happy that it's there. Lots of things that are serious can also be really funny. I feel like what makes my work funny is that I'm taking it very seriously, so I sort of agree with both of you.

ES: That's kind of it in a nutshell. If you try to make it funny, you're prob-ably putting your ego on display. If it's nothing but the facts, there may be a whole lot less ego —

HF: Which for me is also a relief. I don't think my work is egoless, there's definitely ego there, but there are aspects to putting myself out there that are really uncomfortable to me. It is more comfortable for me to say, "Didn't Jay come up with a great idea!" or "Didn't Corentine come up with a great idea!" than to say, "Aren't I funny? Didn't I come up with a great idea?"

ES: Right. What communities do, they do collectively, by definition. Otherwise it's just a bunch of individuals. So being associated with something like *Ulysses* at Jay's Garage means being associated with a community. If there's humor, if there is accomplishment and enter-tainment, and if there's some kind of statement, it's a statement on the part of this community, which is not typically the way art gets made.

HF: Right.

TF: I'd like to switch gears and ask a couple of questions related to some of Ethan's research on Portland, specifically related to his articles on Portland's urban growth boundary and regional planning there.[4] I have not been to Portland for many years, but when I was last there, I was struck by the abrupt transition from city to country, from density to farmland. It seemed like there was no sprawl: you went from rows of town houses to open land on the other side of the street. Virtually no suburbs! Can you talk a bit about Portland and the planning pro-cess?

ES: First, although the transition from urban to farm is very legible here, we do have both sprawl and suburbs. You'd feel right at home! How-ever, we have done some things differently here than in most other U.S. metropolitan areas, and we have achieved some notable results. I think there are a bunch of reasons for this.

Portland is a place of many small things. We don't have an impov-erished South Bronx or an affluent Long Island. We have lots of little units that are scattered around. Rich people live next to poor people. It's a pretty fine-grained mix; you're not in one kind of environment for long before you get to another. That also holds for jurisdictions. We have lots of very little cities, and we use the term *city* pretty loosely out here. Portland, with 560,000 people, and Johnson City, with 460 people living in a trailer park, are both considered cities by the State

of Oregon—as is everything in between. A city of 25,000 is a big city around here. By the same token, one hundred acres is a big development, but that's remarkably small compared to many other regions our size. Because of all these little pieces, when you start trying to figure out how to deal with something like urban growth on a metropolitan scale, you're constantly crossing boundaries that have been constructed to give single units authority. Boundaries are about control. So, at least from an institutional perspective, one of the really difficult things is coming up with better, more effective strategies for crossing boundaries. That's something Portland's been working on for a long time. We've had a regional government here that's unlike any other regional government in the nation. It was established in the 1970s by a vote of the people, to better coordinate what these jurisdictions were doing with each other, and to address issues like transportation, planning, urban sprawl, and the preservation of farmland. This has happened in other places around the world, but it hasn't happened in the U.S. in quite the same way.

It's also worth noting that climate and ecology have created a really abundant landscape. Early settlers didn't need very much land to sustain themselves and to produce enough to be part of an export economy. In fact this is one of the oldest continually inhabited places in North America—there have been ten thousand years of human habitation here. There was a very complex and developed trade between this region and others on the part of Native Americans, because this was such an abundant place. When Anglo settlers came, they were farm families rather than industrial extractors of natural wealth, at least initially. We've always been a place where people chose to live well rather than get rich. There are better places to go in North America to get rich. When you look at the structure of this community, we have lots of little businesses and few big ones, and what that means is that politics, social life, and cultural life are really up for grabs. The do-it-yourself movement and the local music, art, food, and book scene have a really strong foothold here because we're not dominated by large institutions that owe their existence to corporate forms that would help sustain those institutions over the long haul. There are pros and cons to that. I grew up in Minneapolis, which has the Dayton Hudson Corporation and Foundation, now the Target Corporation and Foundation. That kind of large-scale philanthropy has supported the Walker [Art Center] and the Minne-

Video capture from Harrell Fletcher's *Blot Out the Sun*.
Video still courtesy of Harrell Fletcher.

apolis Institute of Art and the symphony, which are all great things. One of the consequences of Portland's not being a corporate town is that we don't have that kind of corporate philanthropy. While it's ridiculously easy to start things here, it's also incredibly hard to sustain them. It's the bitter with the sweet.

If you ask people why they like living here, it's because they like their neighborhood but also because they're an hour and a half from a mountain and an hour and a half from the ocean. It is a regional sensibility. They have a sense of quality of life that goes well beyond the neighborhood where they happen to live. That has ultimately defused the worst territorial impulses on the part of local government. They can't address the needs of their constituents if they only think in terms of their own boundaries.

Finally, innovation tends to occur in the margins, and we're a marginal place. We're not a world city; we're a secondary city in the U.S. We haven't been saddled with the expectations that go with being well known and recognized beyond a local scene. If you go to other places in the world, and you say you're from Portland, Oregon, they might give you a quizzical look and you have to say, "We're between San Francisco and Seattle." That may be changing, but it's changing in a good way right now in that it's tied to things that are authentic to this place.

TF: Is this regional approach, particularly the urban growth boundary, a

contentious issue? What about the farmers who own property just outside the growth boundary—wouldn't they sue to make it possible to maximize their property's value, perhaps by building a development of luxury homes instead of growing blueberries? Is this highly contested given Americans' obsession with property rights?

ES: Yes, this is always an issue, and the eternal struggle in this nation between the rights of individuals and the collective needs of communities will always be a flashpoint. When it comes to planning, there are two ends of the spectrum. One is the let-her-rip end of the spectrum, where the community has little say about what the individual property owner can or cannot do, epitomized by Houston, Texas, which has no zoning. (By the way, they do have regulations; it's a misperception that there isn't any control there. It's just not exercised publicly through zoning.) Houston is held up as a place that lets the market rule. It's a libertarian sensibility—the notion that Ted Kaczynski is fine out in his Unabomber cabin as long as he stays away from a mailbox. At this end of the spectrum, whatever individuals do adds up to what happens, and that's regarded as good. At the other end of the spectrum is the idea that there is a public or community outcome that is far more important than the sum total of individual activity. Those kinds of places tend to be like fascist states, where the individual citizen has no say about what's going to happen. Or, alternatively, there is the utopian intentional community where there is no property and there are no exclusive relationships, only people living in community in the purest form.

Portland doesn't fit on either end of this spectrum. This is America, right? Even here in Portland, property is a big deal. But in comparison to many other places, we respect the notion that some outcomes are simply too important to leave up to the market or the impulses of individuals, and one of those has to do with the preservation of farmland. Why did we take such seemingly radical steps to preserve farmland? It was the heart of the Oregon economy back in the 1970s, when those regulations were created through pressure from farmers and environmentalists joining together. It's like Detroit protecting the auto industry. Farming and forestry were the reasons Portland existed in the first place, so we took some extraordinary protective actions that I'm not sure we could take again today if we were starting from scratch. It's very contextual. It's kind of like doing *Ulysses* in Jay's Garage. If you did *Ulysses* at the Queens Museum, it would not

be the same thing. I bet even if you used the exact same cue cards, people wouldn't laugh at the same points.

TF: You have written about various opportunities in the planning of Portland for public comment. There was a series of propositions open for comment that could increase the growth boundary, decrease it, or keep it the same. This participatory process is an interesting counterpoint to cooperative art projects. As in a lot of these art projects, the premise of the question, the structure of the participation, was a given. For example, the notion that the public must be consulted, the basic structure of property rights, and the very notion of a growth boundary are all presupposed. You are not just asking the public, "What should we do about Portland?" Rather you are seeking comment on the disposition of this growth boundary at this point in history. Do you also ask the open-ended questions?

ES: We do both. But the boundary is a good example. There are a lot of reasons to ask people about something as mundane and boring as the urban growth boundary. Now some of us think it's remarkable and fascinating, but for most people civic participation is a leisure-time activity. It's what you do after you get home from work, after you deal with the dog, play with the kids, talk with the spouse, pay the bills, watch *Survivor*, *Lost*, and *Gossip Girl*. Only then you think, "Oh yeah, it's Tuesday night. I'm going to a meeting about the urban growth boundary." But we really need to ask people about these issues, because ultimately they're going to have to pay for whatever happens next and live within a certain sort of urban context. If you expand the urban growth boundary it costs the community in the form of services; if you hold the urban growth boundary where it is, it potentially costs the community because of the density. Nothing is free. I bet you could say the same thing about Harrell's art projects: participation creates both opportunity and cost. When Harrell was talking about his participatory projects earlier, I was thinking about the risks and ethics of participation, also about the way that our planning and his art making start with questions, posed by planners in one case, and artists in another. The question becomes the catalyst for what ultimately gets called the product.

TF: But the risks and ethics must be very different in planning, because you are inventing a set of physical and social spaces that people have to live in for the rest of their lives.

ES: Actually, I don't think that's entirely true. In both cases you are putting people, their place in society, and their prospects for the future on the line. In planning we potentially affect many more people than Harrell does with his projects, but in both cases the lives of real people are affected. This is a high bar for both endeavors, or should be. One of the key reasons why we engage in participation is that the future is fundamentally unknown. So the question that arises is, What can we do to be as smart as possible about the future? It turns out that the only way you can be smart about the future is to get as many people involved as possible. It's like the parable of the seven blind men and the elephant. The future is the elephant, so a lot of different perspectives are needed to get some sort of general perspective on it. It doesn't mean that you're going to be right, but you're going to insulate yourself a little bit against the profound uncertainty that comes with trying to act on behalf of something you know nothing about: what is going to happen tomorrow.

TF: In one of your essays, Ethan, you cited several motivations for seeking participation in the regional planning process: it's a way to find more ideas; it's a way for the participants to have ownership in the plan; and it offers the cover of democratic legitimacy to the project.

ES: Yes.

TF: Harrell, what do you think about those three values of participation: more ideas, ownership, and cover of legitimacy?

HF: The first two are definitely true for me. The third one is kind of mixed, of course. You know, when I was in the interdisciplinary MFA program at California College of Arts and Crafts, for the most part we were taught to follow what I call the studio-gallery model: artists working in a studio creating their own works as a solo individual and then hoping those objects would be shown and sold in a gallery. That was the model I was taught in school. The fact that I was doing work with other people, nonartists, creating work that often was not an object—all those things were originally perceived by art audiences and other students as being questionable and *not legitimate*. Fortunately those practices were eventually seen as interesting and legitimate by some art centers and by grant makers and public art commissions. I found a support system. But there also has been a powerful constituency that has had the opposite reaction to my participatory work.

TF: So an artist could not seek cover in participation in the studio-gallery

context. But there is a different history of American public art where community input is seen as an important legitimizing component of a project.

HF: Right.

TF: Of course *Blot Out the Sun* was not the sort of public art project that would require community review. You decided to make it an interactive, cooperative project.

HF: Yes, and I've done the other kind of projects with required community review, and they were a lot more difficult. Because *Blot Out the Sun* wasn't permanent, I wasn't held to so many rules, regulations, and approval processes—I was able to function like an artist in a studio who gets to make decisions independently, even though I did it in a public setting with some public funding.

ES: I think this is an interesting comparison. If I were to go up to my cubicle and make a regional plan by myself, I'd be fired! As a planner, if our process is not profoundly participatory—including being able to attribute specific words used to express ideas to various participants—we're screwed. That's why I'm so intrigued by the work that Harrell does, because it's coming from a place that planners can never go, but still relies on participation that's voluntary and creative.

HF: I really want to use specific words or ideas from participants—so that people can see themselves within the project—but out of choice rather than obligation.

ES: Right. And it wasn't that long ago that planning chose not to involve anybody. It was a couple of guys in a room who decided where the highways went. Robert Moses, of course, is often held up as the exemplar of top-down nonparticipatory planning. In Oregon we have an expectation that there will be participation, and that requirement for participation is statutory. It is interesting how different the art world is.

This gets back to a question you raised before, Tom. Expectations are that you will not participate in art, which means the pressure is off; it's no big deal. Conversely, does it really matter if you participate in planning? Does it somehow mean more? I think we regard culture as something that serves as an immutable backdrop, when in fact it's always being formed; it's always evolving. So if people don't participate in art, then not only what does that say about the culture, but even more, what does it say about the way the culture evolves? Why would we think this work would be valuable? For example, what

if people looked at *Blot Out the Sun* and said, "Well, this is exploit-
ative. It is harming these mechanics because they're not as articulate
as those college-educated participants."

HF: There is the potential of harm. For some people, taking those risks
isn't acceptable. For me and various other artists, we think it is worth
it to take those risks if they are taken in thoughtful ways. But in the
art world there is not a code that you're supposed to follow; there's
no way of knowing what the nature of your interaction might be
when collaborating with the public. You're a rogue each time you
work on a new project.

ES: If you live in a society where nobody takes any risks because of a per-
ception that there may be potential harm around the corner, noth-
ing evolves. Or if it evolves, it evolves in a degenerative way. So in
art, participation is not giving cover but taking a risk. When people
participate in planning, they're participating often on behalf of very
ethereal principles. Think about your children, or your children's chil-
dren. It's not at all concrete. Participation really raises fundamental
questions: What does it mean to live in a community or a society?
What does it mean to live a life? Now, we never talk about it in those
terms publicly, because that's verging on religious or spiritual—it's
too far out there. But there are people who talk about the way in
which participation in these processes does yield benefits that have
little to do with reasons for the processes in the first place. For ex-
ample, a participatory planning process is not just about soliciting
ideas; it can also help create an environment with more social capital,
stronger bonds of trust and reciprocity among community members,
in addition to arriving at a plan.

TF: In my reading it appears that Oregon is a high social capital environ-
ment, which enables the participatory process, which builds more
social capital, and so on.

ES: Yes.

TF: So the regional plan reflects the desire of the citizens for a certain sort
of social space, and the rules that they adopt to reflect this value help
reinforce certain social habits and behaviors. Do you think it sort
of cycles on itself—that a strong social capital environment fosters
strong participation in the plan, and the plan creates an environment
that creates more social capital?

ES: Yes, absolutely. We have a very intentional civic culture, and it re-
inforces the notion that with group participation, doors open. We're

also a big little place, or a little big place. A lot of business here is transacted on a first-name basis. People wear jeans to the symphony. It's very comfortable, and I think that's kind of emblematic of the fact that people do not feel like they've got to present themselves in a cartoonlike way to get respect.

TF: That seemed to be the case at Jay's Garage. Watching *Blot Out the Sun* I got the sense that there was a relaxed atmosphere. The regulars were flowing through, although this filming was not their everyday interaction. Still, this sort of project might be much more difficult in a place like many gas stations I have visited in New York, where there is probably less trust to draw on.

HF: That might be the case, but I've worked on participatory projects all over the world and I think you can always find a way to help people feel comfortable enough to collaborate in some way or another. But it is true that some places seem more open to that sort of thing than others.

TF: Ethan, do you see the gas station as a characteristic site in Portland?

ES: Yes, though that said, I think there are subcultures everywhere. There are all kinds of examples of places where people are regulars, and that isn't unique to Portland. What's a little bit different here is that civic and institutional life isn't managed or dominated by large hierarchical corporate forms. This is a city of subcultures that can coalesce in a way that doesn't work so well in places where, from the outset, the way that participation is going to unfold and decisions are going to get made is hierarchically structured.

TF: Ethan has written that the regional planning of Portland, and hence the city itself, is *not* an experiment; it's an intentional result. In your art, Harrell, it seems like there's a lot of experimentation.

HF: Yes, but there is a difference in the experimentation I engage in as opposed to that of studio artists. When their work is shown, it is the result of experimentation in the privacy of their studio. My experimentation is going on in public and is often seen; it becomes visible. Artists in the studio can keep fooling around like scientists in the laboratory. When they finally get to the point where they decide that the work has become successful, that it is ready for people to see, then they go public. In my case it all happens in real time, right there in the open. Also I guess I don't think of it so much as experimenting because it has to happen. There's very little time for me to make changes to try this or that other way. It's just sort of built into the way

I work. Maybe it is more like the way you design an urban growth boundary; it's going to be there. It's not going to change the next day; there's going to be a whole big process to it, and the public will be involved.

ES: The reason why I said it's not an experiment is that people made those decisions because they thought it was the best thing to do on behalf of this place. It wasn't so that people in Cleveland or Phoenix could see what happened if somebody tried it.

HF: For me, when I was in graduate school, a sculpture professor said to me — and it sounds kind of corny, though it has been profound for me — "Don't worry about sculpting the sculpture. Worry about sculpting your life, and the sculpture will fall into place." The way I interpreted that was that I need to make sure I am leading the life I want to live. That was quite different from what most of the faculty said, which was more or less to make the object the highest priority, without worrying about how it came into being. Of course I was more influenced by the first position. I do projects because I want to live in a world in which those projects happen and to enrich my life by doing them. In a basic, selfish sort of way, I want to see them happen because they're interesting to me to have as part of my life. This is not so far removed from the planner or participant who lives in Portland: you want to see the city become a certain city. You want it to be a city that has streets and buildings and parks and urban growth boundaries that operate in a certain way because you live here. I travel around and do projects in a lot of different places, but I like to think that while I'm there I'm trying to make that place an interesting, participatory environment. All I have to do is these little interventions to make that happen, and that makes it a more interesting place — at least while I'm there, for myself.

TF: So you are sculpting a bubble that you're living in. Ethan, through your participation in planning, and teaching planning to the people who are going to plan your region, you're also creating a larger bubble.

ES: It's nice to live in a city your kids want to come back to. I think in the end Portland is populated by people who have made the decision that they want to live here — sometimes in isolation from what they're going to do here. It's because the nature of this place is not world domination. Every city has lots of little spaces and lots of little zones, places in between where things could happen. I mean, Harrell

could do the kind of art he's doing in any city in the world, I think, because there are always little spaces in cities that you could fill up with something. But Portland is the kind of place that encourages people to fill the voids, not to stand back and watch someone else fill them.

TF: Harrell, how does the social impact of your projects figure into your assessment of them? I have asked a number of people this question: If you did a project in which you interacted with a group of homeless people and at the end of the day, several in the group had housing, would that make it a successful art project?

HF: In order to answer that I have to take a step back and talk about my idea of what art is. My sense is whatever anybody calls art is art. It's transitory, because things that aren't seen as art can later be called art and vice versa. There's no intrinsic thing that is art, there's no way to test for it, it will always be a subjective assessment. My belief is that if you call yourself an artist, then what you make is art, or if the viewer says that something's art, then that is art. All it takes is that intention.

So, coming from that point of view of what art is, if my intention was to find housing for those homeless people or if I was doing some other project with them and as a result of doing that project they wound up finding housing, and they *wanted* housing, then I would consider that a successful art project. I actually have some experience with that specific scenario, in the case of two different individuals. There were two projects where people actually got housing, but I didn't really define those projects as my art — partly because they weren't commissions, and I normally work on commission. They were more like situations I stumbled on, but still I guess I now think of them as part of my practice as an artist.

TF: I have heard about those cases, where you became an advocate for an artist, and you introduced them to the art world. But I didn't know that it was not defined as a "piece" by Harrell Fletcher, because it seemed somehow consistent with your practice. Could you tell us about those scenarios?

HF: Well, they are not "pieces," but I do feel like what I did is part of my practice. I used all the same abilities that I use in any other projects that might seem more easily attributed to me. My work as an artist is pretty broad, so it could include those kinds of activities as well, I suppose. In one case I met a woman named Veda Epling in San Antonio, Texas, who was color-highlighting all the passages in a

Bible. Some of the pages looked amazing. I spent time with her, and we made digital prints from her Bibles. Those were shown in a gallery, and some sold to a museum. She got the money from the sales and was able to get housing. In another case I met a man named Michael Patterson Carver here in Portland, in front of a grocery store. He was selling drawings of protests that he had made. His drawings were also totally amazing, but in a very different way from Veda's Bibles.

I asked if he would like to show the work. And he said he would, so I arranged for a group of about ten drawings to be shown at White Columns in New York. And from there it just kind of took off. I had to continue to arrange things, and I also had to deal with transfers of money from galleries to him, because he didn't have a checking account. But he went from living in a tent in Forest Park and selling his work on the street to living in an apartment here in Portland, and then moving to a boat and living off an island in British Columbia, then living in Mexico and traveling around. He wound up winning an Altoids Award, which I had nominated him for. As part of that he got $25,000 and he flew me to New York to be at the opening with him at the New Museum. All that happened within one year from the time I met him.

You know, I walk by lots of people who are showing work on the street, and I don't respond to the work, so I just keep on walking. I'm not someone who's always on the lookout to help a homeless person. Yeah, I'd love it if I had that ability, but I don't. In these cases I was just actually looking at the work and seeing artistic value — as I would for work I saw in a museum. They happened to be showing on the street, and I felt like I needed to help promote it and put it out there in a more visible way.

TF: You are saying that this was simply an aesthetic response to two artists' work, and I would understand this better if you were a different artist, but in your case a significant part of what you do is catapult people's ideas to their logical, or illogical, conclusion. Certainly this is a part of what you did with *Blot Out the Sun*, but even more so with the kid in France.

HF: Right.

TF: But what you are saying is that you were interested in promoting their creative output and that their emergence from homelessness was a welcome but unintended consequence?

HF: What I mean is that I was first responding to the work itself, which I happened upon—I wasn't looking specifically to do projects with artists who were homeless. But because I became excited about the work and was also intrigued by the people and their situations, I instinctively wanted to help promote their work. It was interesting to see how well it was all received in an art world context. I find it satisfying to break down the walls between the art world and the public, and the fact that both Veda and Michael wound up getting some money that allowed them to get off the streets was great too. I liked them both as people and wanted the best for them, but I also realized I had a limited ability to help them, so I just did what I could as someone with resources in the art world. In both cases I tried to be as thoughtful as possible while working with them and their situations. I think they were both happy with the results.

ES: In planning and art there are positive and negative consequences that can be judged, right?

HF: In art they are still subjective.

ES: Yes.

HF: Even in urban planning, some people will love the fact that new highways were created and some will not.

ES: Sure, and we're still arguing about that. But in the case of your work, aside from the social consequences, is it only recently that we are even able to see it as art, and can say whether it is good or bad art? And because of the assertion that it is art, and the expectation, actually the reality that we do regard it as art, we've got to think about what it means for this art to be "good" or "bad"?

HF: Sure, but that was true also of the Impressionists and other artists, like Duchamp. They were not considered artists by some people, and then their work was incorporated into the canon and was seen as an acceptable practice.

ES: That relates to a problem for planning and for plans: When do you declare success or failure for a plan? If you're dealing with hundreds of years of human settlement in a place, when do you declare that what you decided to do on behalf of the future has succeeded? The culture is always in flux, right? Perhaps one success is the breadth of what is now considered to be fair game in planning. I mean, if planners are only considering where to put highways, then we could never deal with issues like homelessness. There's a vast number of

intertwined elements that we would associate with a really livable city. Achieving a more complex vision of planning is something of a success. Perhaps the same principle holds true for art. As a nonartist, there is a lot I do not understand, but the participatory aspect seems very exciting to me. I feel close to it.

Blot Out the Sun JAY DYKEMAN,
 COLLABORATOR

JAY DYKEMAN is the owner of Jay's Garage in Portland, Oregon. Not simply a place to fill up your tank, Jay's Garage is an old-fashioned service station where you can have a tire changed or get an engine job. The establishment is a busy crossroads; it took nine calls to find a time to interview Dykeman after he had agreed. He was always out "saving a car," pumping gas, or simply speaking with a customer. Jay's Garage was the first station in Portland to offer B99 biodiesel fuel, though Dykeman told a reporter that it was as much a business decision as an environmentalist gesture; he saw a market in the area for the product.[1] As in the film *Blot Out the Sun*, Dykeman speaks with a great deal of enthusiasm and clarity.

———

The following interview took place in February 2011. Tom Finkelpearl was in New York, and Jay Dykeman was in his garage.

TOM FINKELPEARL: How did *Blot Out the Sun* come to happen?
JAY DYKEMAN: Well, I always wanted to do a movie and put it up on the wall here at the station. Harrell and I had a mutual friend. I think the person who made the link was a woman named Miranda July. She lived in the apartments next door for a time. I used to know her pretty good; I went to a couple of her performance art pieces here in town. I didn't really have any preconceived notions of what the film was supposed to be like, except that it should be based on James Joyce's novel *Ulysses* and take place here at the station. I couldn't quite figure out how to get from point A to point B. Harrell came up with the idea, which was very clever, of taking salient points from the book, writing them on big posters, and then holding them up out of camera range

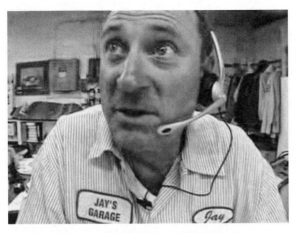

Jay Dykeman reading from cue cards in *Blot Out the Sun*, 2002.
Video still courtesy of Harrell Fletcher.

for people to read. That was a good delivery system for this kind of venue, so to speak. We went to breakfast or lunch a couple of times and he schemed that up. He's a clever guy.

TF: Why *Ulysses*? Is there something about Jay's Garage that reminds you of the book?

JD: Oh, very much so. Well, I'm not very literate, but it was just the way Joyce describes the events that happened to those people on that day and the far-reaching thoughts that went into these little actions — if that makes any sense. So the flow of the book and the flow of life reminded me of the station. I may be getting too metaphorical here. It's one of those seminal books. If you're supposed to read the hundred greatest books, that's on the list. With a book like that, you know, the first time you read it, you just kind of plow through it, but you just have to revisit it. I have some CDs, a thirteen-part recording, where this guy goes through the book with you. If I'm at home doing bookkeeping and the pump checkouts at night, sometimes I'll put that on. You know, Joyce was just so smart. He could put a lot of information on a page. So that's how I got tangled up in that.

When I first met Harrell and we went out to breakfast, I told him that I have always viewed my station as the center of the world. Because it is the center of *my* world, I just assume, why wouldn't it be the center of everyone else's? You know, it's a melting pot down here. We are in the middle of this industrial area, just on the approach to

the bridge going into downtown. One day at the service counter we had five different languages going on. It's just a wonderful, interesting place to be. Different nationalities come through—Asians, full-on Muslims, and all are welcome.

TF: Was there any difficulty in getting people involved?

JD: No. That was easy, easy, easy. We just asked them if they would like to do it, and almost nobody said no. That includes the people working at the station and the customers.

TF: Those people in the film who drove up to the station, were they people you knew?

JD: Sort of half and half, you know. I've been here a long time, and I know a lot of people who come through here, but some were just strangers. They just took to it immediately. Absolutely.

TF: How long did it take to make the film?

JD: He had carte blanche. It took him all summer.

TF: Did you invite them all to the screening?

JD: Yes, as much as we could. We got the information about the screening out there in advance, and the people who were interested stayed in the loop. The screening was a blast. There were a lot of people here. You know, it's just a corner gas station. But there were a hundred people at least. We have a bus stop right here on the corner. People saw the activity and they would get off the bus. They'd wander over to see what was going on and sit down and wait for the screening to start. We opened up one of the bays and we kept the bathrooms open. Harrell got up on a ladder and put draping over the streetlights to keep it as dark as possible. We got a laptop and a projector, and when it got sufficiently dark I got up there and made a little speech, and Harrell got up and made a little speech, and the lights went down and the projector went up.

After the screening we just kept playing it on a monitor in the station. We still do on occasion. I took the VHS tape and I had DVDs made, and I keep a bunch of them in my desk. I still give out the DVD—gave one out on Monday. We have a poster up from when we made the movie. Most people think it's pretty charming, clever. A little confusing, but they still enjoy it. That's the idea, it's to be enjoyed.

TF: What about Harrell going off and showing it in other places?

JD: I think that's *wonderful*. Everyone should see it. There's a lot of energy in that film. Just take a look at the hands on that one old mechanic.

A mechanic pauses from his work in Jay's Garage as he reads lines from cue cards in Harrell Fletcher's *Blot Out the Sun*, 2002. Video still courtesy of Harrell Fletcher.

That guy has probably wrenched well over ten thousand hours. Then that other guy, Greg, makes that monologue about kissing and whatnot. There's a lot of energy, real energy.

TF: Who do you think was the producer or director of that film?

JD: Well, I think the credit should go to Harrell. I wasn't just the fly in the soup, but he was the one who would come around, and no matter how busy we were he would just kind of muscle his way through. What he had to get, he would get. It was my idea, but I don't think it would've happened without Harrell. And I'm not sure it would have happened as well with another filmmaker. He was absolutely the right person for the job at the right time. He is persistent!

TF: There is a feeling of Portland as I remember it that you get from the movie—people stopping by, a friendly atmosphere.

JD: Absolutely. You know, most people live in Portland by choice. I am here from Chicago. Harrell is here from somewhere else. We put up with the sloppy weather because of the smart people and the general ambience, the alertness, and the arts. A lot of coffee shops. A lot of good microbrews around. It's a smart, pleasant way to live. And it's a good place to bring up a family.

TF: You are an independent gas station?

JD: Yes. There aren't that many independent gas stations left anymore anywhere because of the barriers to entry. But we have been here a

long time. My youngest boy works with me here now. He's twenty-six. He appears to have a passion for it. When he's ready, if he wants, I'll just give him the keys and keep truckin' on. My job in life is that when you come in here I want to make sure you get where you're going. We close at seven, but if you come in here at five of seven and you've got a flat tire, I am going to get out there and do what I have to do to help you get home. That's my personal creed or motto or whatever.

TF: Did making the movie affect the community of the station?

JD: It was a very energizing thing to have happen, to see yourself up on the big screen like that! We're just little guys down here; that was almost empowering. For me personally, you know, what a thrill! I had my wife and kids out there and my dog. When I gave my little speech I was holding that dog. I am a very average person. For average people who don't really get out of themselves, what an opportunity. That's one thing we like about artists: they have the ability to get out of themselves. Most of us can't do that. I run a gas station. So for a few minutes we were getting out of ourselves, and that was really thrilling. The people who are in that film still talk about it. To dedicate your life to being perceptive with all the things that can derail us, to stay on track and stay focused, that's very admirable. Harrell is like that, and Miranda. They are doing well, and they earned it.

TF: You might have another idea for a film?

JD: Yes. I talked to Harrell about that the other day. I said I'd like to do another one. We're going to get together and I'm going to come up with two or three different books and see if we could collaborate on it. I've always liked A. A. Milne. It is on the other end of the spectrum from James Joyce. *Ulysses* is pretty deep, needless to say. But *Winnie the Pooh* is a charming story. You know, doing another film with a book is what I know. I'm not a filmmaker, and I don't even watch a lot of movies. I tend to like Asian movies, like Korean movies and Japanese, and the old standards. The last movie I watched was *The Ruling Class*, with Peter O'Toole. So I'm going to come up with a couple of ideas on my own, new ideas, and see what Harrell has in mind, then see if we could slug something out in the middle and see if he wants to make a nuisance of himself again!

Cátedra Arte de Conducta TANIA BRUGUERA,

ARTIST

IN RECENT YEARS there has been a wave of art projects that mimic or reinvent structures of education: art as school, school as art. In this book no fewer than four pedagogical art projects are discussed at length: Mark Dion's *Chicago Urban Ecology Action Group* (chapter 2); Wendy Ewald's *Arabic Alphabet*, with students from I.S. 230 in Jackson Heights, Queens (chapter 8); Brett Cook's project at the Packer School in Brooklyn (chapter 10); and Tania Bruguera's *Cátedra Arte de Conducta* in Havana, discussed in this chapter. Perhaps students are natural targets for collaboration, as they are well organized in schools and somewhat flexible because of their youth; but it is exactly students' vulnerability and lack of voice that progressive pedagogy seeks to address by rebalancing power in the educational setting.

As discussed in the following interview, *Cátedra Arte de Conducta* was born from Bruguera's profound disappointment with the reception of a work she created for Documenta 11 (2002) in Kassel, Germany. Although her project there had been a critical success, she returned to Havana frustrated, wanting to find a way to incorporate a process of thinking into the visitor's experience of her work. Soon she came up with the idea of a multifaceted, interactive, participatory school, an experiment in pedagogy with the goal of fostering a new generation of less commercialized, more politicized artists in Cuba. The *Cátedra Arte de Conducta* opened in January 2003. In its ambitious scope and its critical self-awareness as an institution, Bruguera's school bears a close resemblance to Rick Lowe's *Project Row Houses*, which was also born of disappointment. In an interview conducted in 1996, Lowe described his profound disenchantment after an artwork he had created for a show in Houston, about the lynch-

ing of a young African American man, ran up against what he saw as the impossibility of forging a deep connection to the subject matter in the museum context. This experience drove him out of the art world and in a direction that eventually led him to found *Project Row Houses*.[1] Bruguera and Lowe's projects are emblematic of the formation of so-called counter-institutions. While Lowe seems to have embraced the notion of building an institution by incorporating as a nonprofit, hiring an executive director, and even adding the bureaucratic layer of a community development corporation, Bruguera resisted when she saw the success of her project and its potential institutionalization, and closed down the project after seven years. Both Bruguera and Lowe point to Joseph Beuys as an influence. Like Beuys, who butted heads with the bureaucratic structure of education in Düsseldorf, Bruguera negotiated an uneasy relationship with the institution of the art academy in Havana.

Without making any explicit references to progressive pedagogy in this interview, Bruguera echoes the theories of both Paulo Freire and John Dewey. She sees education as a site for creating collectively and developing human social potential, not simply acquiring information. However, it is important to note that her school was in fact quite rigorous, with hundreds of meetings and thousands of hours of work for its members. Though almost nothing was technically required, the members were expected to do far more work than a typical student in an American master of fine arts program.

———

TANIA BRUGUERA is an interdisciplinary artist working primarily in what she calls "behavior art," performance, installation, and video. She has participated in numerous biennials and has created works for the Tate Modern, the Pompidou Center, the Stedelijk Museum, and other museums across Latin America. She studied art both in Cuba (at Escuela de Arte San Alejandro) and in the United States (at the School of the Art Institute of Chicago). In January 2011 she moved to Corona, Queens, to initiate a long-term project related to immigration, sponsored by Creative Time and the Queens Museum of Art.

———

In December 2008 I observed a workshop at the Cátedra Arte de Conducta *conducted by the Polish artist Artur Zmijewski, which consisted of the members of the school creating a video loosely based on Dziga Vertov's film* Man with a

TOM FINKELPEARL: If we could start at the beginning, what were your
motivations in creating this project?

TANIA BRUGUERA: It was a combination of things. First of all, when I
was at ISA [Instituto Superior de Arte], studying toward the termi-
nal degree in art here in Havana, between 1988 and 1992, there were
no performance art classes. I had to discover performance on my
own. Since then, I always had it in my mind to teach performance in
Cuba. Then around ten years ago I was with a group of Cuban art-
ists in Venezuela at a residency in Maracay.[2] One day we were talking
about the state of things in the arts in Cuba, thinking what we could
do to improve the situation. At one point we addressed ISA, an insti-
tution that had once been led by Cuban avant-garde artists and was
regarded as a place that had seeded the best projects of the younger
generations, but at that moment it was without leading artists as pro-
fessors, and the institution, relying on this tradition, was a stop on the
cultural tour for foreigners, who could buy the work of the students
with high hopes or as a souvenir at very cheap prices. So we started
thinking, maybe as a joke, that we should establish our own school.
This conversation was at the back of my mind four years later when I
started the school, and the first people I asked to be professors were
those artists.[3]

These were the contextual impulses, but, most directly, this project
was born as a consequence of participating at Documenta 11 in 2002.
Although my piece had some sort of success in the exhibition, in the
press, and it was even bought by a museum in Germany, I came back
with some dissatisfaction. The piece I did was part of a series in which
I try to work around the political imaginary of a place. Specifically
Untitled (Kassel, 2002), using the reference of the Nazis, was a reflec-
tion on our historical responsibilities at times when the events are
not so clearly read as a collective consent. The piece worked among
other things with the idea of a live action that existed but was some-
how not visible. The problems of the negotiation of the visible and
the invisible in art is a recurrent aspect of my work.

My disappointment was in relation to the disjunction between the
political process that I wanted the audience to go through and how
little time they had to spend in the piece. I came back thinking that

I needed to change the use of time in my work, the time required to experience it. I wanted to situate the thinking process within the work and not outside it. I started thinking about appropriating the structure and the resources of power as my medium, as my material. Instead of representing them, I wanted to put them in action; that would be my work.

Simultaneously I was disillusioned with the way international success had become such a prominent goal for artists in Cuba. Art was becoming foremost a source of income, and artists were becoming a new social class close to the bourgeoisie. The Cuban social and political reality had become more a reference to sell authenticity than actually a place from which to propose productive dialogue.

TF: At that time there was also an infusion of American collectors into the system, no?

TB: Yes, it was at its most visible peak during the Havana Bienal in 2000. Huge buses filled with American collectors and trustees from museums arrived in streets where in some cases no tourist ever stops; they were enthusiastic and excited, moving from house to house, under a very tight schedule where they saw, I don't know, five, six, seven studios a day on top of the exhibitions part of the Bienal around the city. Of course ISA was part of their route. It was crazy. And they came for, like, half an hour, forty-five minutes max, if you were lucky. It was: arrive, look, buy, let's go to the next one, leave, repeat.

TF: And Cuba fever was felt in New York. Everyone was talking about Cuban art and the Cuban market.

TB: From the other side of that fever, in Cuba, there was a ton of interest in the idea of an art market and how to be successful in it. New jobs appeared: assistants, dealers, artists' managers, art historians working for artists on their texts, people specializing in the building of crates and shipping. It was almost as if we were playing a game, the game of becoming capitalists. Money earned had an impact. But I knew, because I have seen it before, that such enthusiasm is short and moves very quickly from one center of attention to another. A friend of mine was speculating how long it would last before the art of maybe Vietnam or Ethiopia caught the attention of those same fervent aficionados of Cuban art.

Some artists in Cuba began to imagine what was wanted from them, from their art. Pleasing the foreigners involved another kind of process of social engagement as well as another kind of censorship.

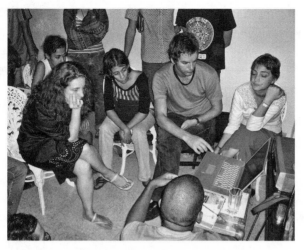

A workshop at *Cátedra Arte de Conducta* to create artworks based on idiomatic phrases that could serve as a dictionary of Cuba for foreigners, taught by the Albanian artist Anri Sala in 2005. Left to right: Ana Olema, Tania Bruguera, Jeanete Chaváz, Anri Sala, and Martha Perera. Photograph by Loraines Gallego. Courtesy of Studio Bruguera.

TF: So at the outset of this project there were two things on your mind: disillusionment with commercialization in Cuba and the snapshot mentality of the biennial circuit exemplified by your experience at Documenta.

TB: I wanted somehow to propose another artistic reality, to go back to thinking about the social use of art. I didn't think I could enter into a productive conversation on that subject with the artists involved in this fever. But what about the younger generation? Education is the number one medium through which the state creates change in society, long-term change. So as I was looking for political structures to work with, I said maybe education is where I have to go. Spaces for discussion were almost nonexistent at that moment. To open a space for discussion as an art piece was a political gesture.

I also thought from the beginning about this as a long-term project. I was thinking a minimum of five years, playing with the ways in which socialist economies are planned on *quinquenios*.

TF: Did you actually write a five-year plan?

TB: Oh, no. I wanted to keep the possibility of readjusting the strategies. The other thing that was very important for me was that while I was

using the form of an institution, I didn't want to become one. Over time the structure became more and more clear. And this is something that I became nervous about: the fact that it could be *too* clear. I was creating a space for discussion, and in order for that to happen I also needed internal contradictions.

The way the structure worked at the beginning was by trying to find ways in which we could work with behavior as an art material. The first year, I identified some issues to be dealt with in performance and social and political art and tried to find a specialist in each area; for example, since performance artists often have to deal with legal issues, we invited a lawyer to explain the perspective of the law on the rights of an author and so on, and since performance art is often seen as an event that creates a media impact, we invited a journalist who taught a workshop on the idea of the construction of the truth within the media machine. I wanted all of us to be prepared with the tools and the methodology of those other practices.

Another thing I wanted from the beginning was for the project to be mobile. The classes happened at different locations, at different times of day, and were different lengths. I wanted to generate a situation that spread around the city, making this piece an unavoidable work of public art.

TF: But a lot of the activity unfolds in this house we are sitting in, which was your grandmother's home, a ground-floor apartment with a courtyard in old Havana.

TB: Yes, where I've lived since 1987. I actually used my house before for some of my performances and for some exhibitions. At the beginning I thought we would just use one room. But now a second room is the library; a third room is where sometimes participants stay over when the discussions run too late. The kitchen is a collective space, and sometimes we cook and eat all together. They get here and they feel like home. It is a situation of trust and respect. One example is the library: they check out books, and we never had a lost book. This is also part of the education. The education is not only on how to do a better art piece or on the latest theoretical concepts, but also on how to create collectivity. Behavior is not only a material for the artworks, it is also part of life, and as such it has to be functional. It's a project about art, but it's also important to make them good people, good citizens.

TF: How did you decide on the name *Cátedra Arte de Conducta*?

TB: Well, I was doing my MFA in performance at the School of the Art Institute of Chicago [1999–2001], and I found that I couldn't identify with the perspectives on performance that I was being taught. Even though the term *performance* is very rich, it was identified by people outside the art world as related to theater or the performing arts instead of social gestures in the public sphere through art. It also seemed, at least in academia, as if over time the term had acquired its own expectations and specificity. I came from a different tradition of what was political and what was performative. Why should I call it *performance* if my practice was going to be done in Cuba? Also there were other terms used, like, in the U.K., *live art*, and then there was *body art* and so on. I didn't know what to call it, but I just knew I should not use *performance*. But even before all that, I had to deal with the political implications of identifying what I was doing with an English word.

One day I was telling a friend about my first job experience, where I ran a sort of art program at a juvenile detention center, a reeducation center, or, as it was called, a school for kids with behavioral problems. They were ages six to sixteen with some delinquent past and usually a very bad environment at home. That type of school is called *escuela de conducta*.

TF: The school of conduct?

TB: Yes, the school of or for conduct, or behavior. *Conducta* in Spanish has two meanings: the social ones and one that implies conduction, conduit, transmission. After I graduated, in June 1992, I started working at the escuela de conducta, and in September of that year I started at the ISA as a professor. So on Mondays, Wednesdays, and Fridays I had these kids with behavioral problems. Tuesdays and Thursdays I had the ISA art students. I wasn't satisfied with either world, and for a long time, in my mind, I wanted to put them together. One day, talking to this friend, I said, Yeah, in the escuela de conducta I was doing *arte de conducta* — art of behavior. It was kind of a joke, but I kept the name.

At the same time I was doing research on Latin American performance. I was beginning to see that a consistent thread throughout all the work I was looking at was the social gesture. I wanted for sure to do art that is political and social. When you say *performance*, you do not always connect immediately with that. But if I say *conducta*, it is unavoidably social, because behavior is what society uses to commu-

nicate and to judge; it is society's language. So I thought that would at least assure that the conversation was going to focus on the social.

TF: Do you refer to the young people in the program as students?

TB: No, they are called members, or participants, or artists; I go back and forth on that. I want to treat them as young artists and avoid the student-professor power relation, as the young artists will soon be on the same professional platform that we are. Of course, the project is my responsibility, but I try not to be present all the time and to be open to what is needed by their work at each moment, so that the dynamic between them and the program can develop organically. The participant-observer theory from sociology, which I use in my work, can be valuable. Also, I called the visiting artists not professors, but *guests*.

I'm interested also in not having a stable way in which things are called; things change and we need to be faithful to that.

TF: Okay, members and guests. I know that in Cuba most institutions are government-run. What's the bureaucratic relationship to the state?

TB: When I came back from Documenta, I had been outside Cuba for the most part of the previous two years, and when I began talking to people about doing a school, they were all telling me that it was legally impossible and that I had lost touch with reality here. Then, by chance, I was with my partner at a dinner, as the spouse. I started talking to the spouse of the person who made the invitation. We talked about my work and about teaching, and I said that it was a shame that ISA was doing so badly at that moment. She asked me more about that, and I went on and on, complaining. As I was a bit obsessed with the project of the school, I told her about that, and she asked me about the ideas I had. At some point I finally asked about her, what she worked on, and she said that she was the dean of ISA [*laughs*]!

TF: Ouch!

TB: Yes, but it was really good. We're still really good friends, because we were very honest and straightforward from the beginning and because we connected at a personal level first and then at the institutional one. And she said, "Why don't you come back to teach for us if you have all this criticism?" I said to her, "I will only go if you give me my own department, my own *cátedra*." I didn't want to go, so I asked for the impossible. But she said, "Okay, send me a proposal on Monday." And she accepted the proposal. It all happened very fast. The fact that I had just returned from Documenta made it easier.

With this opportunity I had to reevaluate the project I had in mind, and I realized that it was perfect because it would be more real. It would be a critique from the inside of the institution, and also the project would be evaluated by the actual educational parameters. What could have been a lack of resources on their part worked perfectly for my project. They were renovating the school, and there were no spaces available, so I situated the project in my house, as I had intended from the beginning. They had no money to pay the professors, which made me more independent in terms of who I would invite to teach, because I was away from the bureaucracy's scrutiny and economical control. Plus, because ISA is a government-run educational institution, we had a legal umbrella to do public events and bring foreigners legally.

TF: I'm here legally in Cuba with a proper visa myself because of your association with ISA.

TB: Yes.

TF: Are the members doing a course of study at ISA as well?

TB: One of the characteristics of this project is that we accept participants from any background. Some are ISA students, some ISA alumni, some San Alejandro high school students,[4] but we have others who study architecture, cinema, dance, music, theater, art history, philology, sociology, civil engineering, writing—but more important, each year we have at least one participant who has never studied nor practiced professionally any form of art. While this project is for the study of political art, there are a series of elements that are the guidelines of the project's political direction that are not only discussed but implemented in the dynamic of the project. One of them is Joseph Beuys's idea that everybody can be an artist. Another one is about who shapes and enters the discussion around the public landscape. The way people know about this project is from ear to mouth, rumor, which is one of the elements we have assumed as the documentation of this as an art piece. Usually the members tell others, who they want to enter the discussion, about the program. Although the average age is twenty, the range is from sixteen to thirty-nine, which creates a very rich environment in terms of the expectations people bring to the discussion. Officially participants commit for two years as active members. They commit to come five days a week every week all year around, except for a few weeks during summer vacation, for two, three, four hours every afternoon. It's very intense. Each

year we officially accept eight members plus one art historian. But we usually have about eighteen people, because some of the graduates still come; some people tag along; professional critics and artists sometimes come when they are interested in the specific guest of that week. And the groups overlap, which guarantees that the knowledge is passed from one group to the next without having to restart with the same subjects or to repeat the discussions. It is a very good way for the newest group to catch up with the previous one because there are no levels. They are all at the same level.

I created two structures simultaneously: one that is real and one that is symbolic. They are flexible and respond to the needs generated in the project and the context. The symbolic structure is the one where I'm reproducing the recognizable elements of an educational program, which I install but do not respect. For example, to enter the project one has to go through a selection process in front of an international jury that chooses the best candidates. But once the workshops start, I let in anybody who wants to attend. For me it is very important not to create an elite group. And although the studies are advertised as a two-year commitment, some do not stay the whole time, and many continue on much longer. It is a natural process: when they outgrow the program, they leave. This can seem like chaos from an institutional point of view, but it guarantees the intensity and urgency that is the main educational tool I work with here.

TF: How many guests would you have in a year?

TB: One per week during the program, so around forty a year. The range of practices of our guests goes from the ones in the arts — critics, curators, artists, dealers, studio managers, et cetera — to historians, sociologists, mathematicians. . . . We go from very practical professional preparation to the most abstract ones. Two weeks ago we had a person from Spain who runs a production company for art. She told them about her experience with artists' projects from that side of the spectrum and let them know what would be the best way to prepare drawings for projects, how to develop the ideas from the production point of view, and so on. The members should be professionals as well as dreamers. They know how to make a CV, how to set a budget, how to conduct research, but also how to walk the road toward utopia.

Because we do two exhibitions a year, we invite one curator per semester. The curator walks with the artist from the initial generat-

ing of the ideas for artworks to their production and finally the exhi-
bition. It is a very close process of collaboration between artist and
curator. The curator also meets with the participants together, and
they discuss as a group the ideas for the show. The exhibitions are
only on public display for one day, actually for just a few hours. The
exhibition is not about the work but about the creativity generated in
that collaboration and about the moment it generates while in public
view. That is the main reason it is in display for so short a time. Later
some have reinstalled the works generated for these events in more
traditional exhibition setups.

Every artist who comes for a workshop is either politically or so-
cially engaged, so it's either a public art artist, a political artist, or an
ex-socialist artist, because I'm interested in talking about what kind
of political art we can do during and after Cuban political and ideo-
logical transitions. Each guest provides an assignment for the mem-
bers to be done during the week. For example, Dan Perjovschi asked
them to create a daily drawing of what happened to them that day.
At the end of the week they put together the drawings as a book, and
each participant got a copy.

TF: Can you give a couple more examples of artists who come for work-
shops?

TB: There is a wide variety of approaches. Dora Garcia, an artist from
Spain, did a workshop called "Rumor, Rumor." She came with the
notion to start and spread a rumor. During her workshop they talked
about how rumors work in Cuba, and the group decided to create
a strategy to spread the rumor that the European Community was
giving grants to Cubans who applied to start small businesses. In
order to start the rumor, one member had to call the minister of for-
eign relations and say, "I'm calling about the grant from the Euro-
pean Community. How do we apply?" And the person on the other
end would say, "What are you talking about?" The member: "Haven't
you heard?" The bureaucrat: "No, I have heard nothing. I will have to
get back to you tomorrow." It was creating an invisible thread in rela-
tion to the generating and accessing of information, something that
is very controlled in Cuba.

 Christoph Büchel gave a five-hour lecture about his work that I
think is almost a piece in itself, and for the workshop he decided to do
a performance. He was here during the elections, and he proposed to
give a prize to anyone from the workshop who was first in line to vote

Participants listening to an artist talk by Christoph Büchel during the first day of his workshop in Havana, 2008. Seated next to Büchel in the center is María Teresa Ortega, one of the two long-term translators for *Cátedra Arte de Conducta*. Photograph courtesy of Studio Bruguera.

in their neighborhood. Five people from the workshop got in line at 5 a.m., were the first to vote, and got the prize, which was a very expensive bottle of Cuban rum and a book about Cuban politics provided by Christoph.

Stan Douglas came twice and each time gave a workshop on editing. He produced his piece *Inconsolable Memories*, which he showed at the Venice Biennale in 2005, with the assistance of one of our participants, who told me that in the one week of experience with Stan he learned more about video and how to approach art than in one whole year of studies at ISA.

For me it is important that the assignments from each workshop can develop into full art pieces so that the participants generate art from those moments. Artists have very different strategies, so it is important that each week the participants witness different, sometimes opposite points of view about art and its social role, so they can be confused by it, and from that they can work on recognizing what elements they identify with, and then develop their own ideas about how that relationship can work.

Very consciously I decided from the beginning to not talk about my own work to the participants. For me it was very important that everybody worked out their own artistic identity, and I know how

vulnerable people can be when they are in the middle of a process of constant deconstruction of their ideas and how easy it is to seek approval by going into the collective comfort zone. I even stopped showing in Cuba during the existence of this piece. My piece was *Cátedra Arte de Conducta*; it was ongoing and present, but it was about them. I even decided at one point that I needed to be away, physically, from the project. That is a very important aspect of all my long-term projects, which is the transference of the project to other people. The participants gained more and more control.

But back to the workshops. One of the best examples was one given by a journalist: "How to Construct the Truth." Her assignment was about how you can claim something that is not true, how can you construct something that's not based on truth and make it totally believable, through the techniques and tools of journalism.

TF: You know the word *truthiness*?

TB: Yes, from *The Colbert Report*. Believable data. The credibility of something that is totally false.

TF: So now, the school ends at the end of this academic year?

TB: The workshops end now, in December. Artur Zmijewski is the last one.

TF: Oh, this is the last week!

TB: Well, the project is on the verge of becoming an institution—it has too fixed a format, it's too clear to people, and too comfortable. The goal of this project, which at the beginning nobody thought was possible, was to fulfill some of the broken utopian dreams. It was to make the statement that things are possible, to fill a void. Now the best thing to do is to *create* a void, to create desire, so the participants feel the need to create their own utopias, their own projects to fill that void. For artists working with the creation of institutional forms, the most challenging aspect is to know when and how to stop it. The closing is just as important as the beginning of such projects. And sometimes to do what people do not like is actually the right thing to do. The need for a good educational system was not solved with my project; that is something that has to be part of a collective effort, of a common desire for change. Now it was time for new generations to do their work, to take over.

TF: In one interview you said that you were tired of critiquing structures; you wanted to create structure. What do you mean by that?

TB: That's correct. I'm not interested in talking about the existing structures but in creating new ones, to see art as the space to create new

models. My problem is with the sustainability of those structures, because I do not think it is the role of the artists to run those structures but to create them in order to propose it to others — understanding that they would have to run them for long enough to make clear their functioning and goals to those taking it later. So that means that an artist is a catalyst who has to understand that their work will undergo formal changes once it starts functioning in the realm of the real. It is important that the artists keep their critical distance with such creations, and that can best be done when the project is not ours anymore. The artist has to always be vigilant, because you don't want to *become* an institution. You are using institutions as a form, as a social discursive structure, to create a new reality; it is just a strategy. The problem is when the artist gets trapped into the benefits of being part of or even being an institution, or when they become more interested in the work to survive as an institution, to gain public certainty and approval, than to keep it open to risks. In this case the structure I created was becoming a fixed form, a structure that repeated in cycles; there were specific expectations toward the project. I did not want to work on the construction of a past — the school founded by Tania Bruguera — but for the here and now. I was trying to prove that art can be part of the social and political everyday-life changes, and those fixed experiences are the opposite of it.

For two years I thought about ways I could pass the project on to others to continue, but any imaginable idea was linked to the origins of the project, and that for me was very problematic. The way I decided to end it was by giving the members more visibility and hopefully some professional good start. I will be curating a show during the Havana Bienal that will be a five-year résumé, a documentation of the project through the members' work. Each day I will include one guest from the ones we had during these five years. The show will be a daily program. Every day in the gallery there are different artworks, different performances, different video programs. It's going to be pretty intense. I wanted to keep the concepts we used for exhibiting work during all those years, with a duration of just a few hours, only one day. I did not want the burden on the members of doing a super-piece but to see it as an ongoing process that we will show. I want them to still think they can be trying stuff out even if the Havana Bienal is the main event in the arts in Cuba and it will have a

Food created by a *Cátedra Arte de Conducta* participant, 2003. Responding to a cultural question posed on the radio, diners were invited to a no-cost meal at a home restaurant (*paladar*), for which participants had created new edible dishes. Photograph courtesy of Studio Bruguera.

lot of visibility for them and their starting art careers. I really want to pursue the freedom of risk.

TF: You've used the phrase *useful art*. What do you mean by that?

TB: Art has never been enough for me. Art can have two phases: the one where you see something and show it to other people and the one where, after that collective recognition, you do something with it, you apply it. I'm having a lot of problems right now with contemporary art because almost everything stops with that first phase, which could be identified as research. I am against the influence of the Duchampian gesture that has defined contemporary art practice for so long: taking the urinal out of the bathroom. After that it seems that the condition for something to be art is its uselessness. At the beginning of the twenty-first century we should go with a different model of doing art, a model that integrates human activity and everyday life in a different way. For me that is to create art that works simultaneously in different dimensions, including a useful dimension that does not eliminate the intellectual, contemplative one. I would like to work on activities that provide a practical resource, while you are thinking about them at the same time. Why do you have to have a split between thinking and doing?

TF: So rather than take an object out of the flow of life, you want to create art in the flow of life?

TB: Instead of taking something from life to become something you look at, I produce something in the art world to be used in society. In *Cátedra Arte de Conducta* we worked a lot on the idea of useful art, and many works were generated from that perspective. One example was the work of Nuria Güell, who is one of the only four foreigners we had during all the seven years of the project. She has a privilege that most Cubans do not have at this moment: legal access to the Internet. Her work consisted of selling Internet service, putting up an announcement for those who wanted Internet. She gave it to people who responded in exchange for their everyday survival shortcuts for living in Cuba. This project shows the state and conditions of life in Cuba at this specific moment; it works on a symbolic level. It makes you think, it makes you feel, but at the same time there is something real happening. People are really using the Internet.

Adrian Melis did a piece where he bought stolen wood from a guard at a wood factory and used it to build a booth for the guard, who was doing his shifts unprotected from the wind, from the rain, from the sun. The guard now has a booth that protects him, and we can witness through Melis's piece, a video, the state of the relation between the legal and the illegal and the normality of how people go around the law to survive in Cuba.

For one show Javier Castro proposed to give his space to neighbors around the gallery as storage. Because people live in such small places here in Havana, sometimes they have to live with all these boxes and clutter. But for the month of the exhibition people could bring their stuff and store it here while they were fixing their house or painting it or moving to another one, or just to enjoy the space they gained. It's not solving their problem forever, but it does for a period of time, and it proposes a model while exposing this pressing problem. It is very directly symbolic *and* useful. These are all examples of works functioning perfectly and independently in each world.

TF: Do you think that the school itself has a use?

TB: I think so. It is symbolic; it reminds us of what is missing in that context, what can be done. But it is also a fully functioning educational project, one possible model for the study of political art. But I'm not totally satisfied with it, because I'm working for and with artists. That's why I have decided that my next project will be with

and about immigrants. I mean, I'm super proud of the members of the project, and most of their work is with and for nonartists, people from the street. They themselves are actually working on the borders of the social and the artistic. Still, I have doubts about art itself, as a medium. And I have doubts about artists as a class, as a social group.

TF: Yes, but imagine there's an art project, and as a result of the project five people who were formerly homeless now have an apartment. Does that make it a successful project? What if the artistic nature of that homeless project was extremely simplistic, with no nuance and complexity to the design?

TB: There are two points of view from which to look at it. In terms of its usefulness, the example you present is successful. In terms of it as art, we should see the ways in which it was elaborated and presented, the path by which it showed the internal contradictions of such a social situation and its strategies to educate us onto a new reality. To be solely useful doesn't make it good art. Commonplaces and clichés are in every art form, especially when they become a trend. For me a successful example of useful art should show the doing and the thinking simultaneously, an unthinkable reality that is real and functioning in front of your eyes. It is when you stand in the exact point where past and future meet. When you can satisfy the expectations of two very different demographics: those who are expecting a highly elaborate, intellectually complex, and problematizing project and those who are directly involved in the project, the ones for whom it has to *work*, truly. There should be a balanced tension between the literal and the figurative. When I say you have to please those people who work with you, or who are part of the work, or the material of the work, or the goal of your work, I'm not saying you have to give them what they want. I'm saying that you have to be able to show them that your proposal is better than whatever they had before, that it solves their problem in a better way. It is a negotiating process with both audiences. And there is a moment in which one should not care anymore if it is art or not.

TF: How would you evaluate the success of an individual workshop or the school as a whole?

TB: From my perspective, the way to look at the failure or success of the school is through what happens after the member leaves. The work of art is the process of the school, but the result is another process that starts after they leave here. The measure of success is how long

the person is able to produce work that is not following the pressure of the art market or the art world but responding to their own desires and ideas about what art should do in society. The success of a workshop likewise. When a guest leaves, are the members stimulated, do they have a series of questions they still want to find the answer to?

The goal of this project is responsibility. It is its burden. For me the success is that they are good and honest artists but also good people. The project hopefully will work in their education in art but also as a civic element of a society.

TF: I have been thinking a lot about the idea of reciprocity recently. You can give without expecting anything in exchange; you can give and expect a balanced and equal return; or you can give and expect more in return, which is called profit. These are referred to as positive, balanced, and negative reciprocity. You have spoken about positive reciprocity—your own idea that you will not expect anything from the members—and you have spoken about the mutual reciprocal support in the community.

TB: Well, the problem with that proposal is that you are working with economic terms. The way I think one should think about reciprocity is not with concepts related to owning. For me reciprocity is creating a project for someone else under that person's conditions, adapting our initial ideas to their needs. There are some art projects using reciprocity where it seems that the gesture responds to an intellectual self-gratification, even bringing benefits to the people involved, whether they want them or not, that's problematic. Sometimes there is a disconnection that transforms and treats those people solely into [or] as objectified art materials. The satisfaction one should get from reciprocity is the exercise of going outside oneself.

TF: Still, in this project and others in this book, I see the establishment of networks of back-and-forth exchange. When you say you have created a community, that could mean this exchange, the notion that I'll help you with your sound editing if you do the camera work for me, which seems like reciprocity.

TB: The mistake is in the use of *if*. It is not, "I do this for you *if* you do this for me," it is just, "I do this for you." The point is that each person should say the same. It is not a quid pro quo. Maybe person A is helped by person B, and later person B gets help from person C and D, and person A is helping person C. It's not a two-way street; it's a place

The Spanish artist and *Cátedra Arte de Conducta* participant Nuria Guell (right) legally marries a Cuban man (center, name withheld), 1999. The groom was selected by a panel of *jineteras* (Cuban slang for female sex workers) on the basis of a love letter contest for Cuban men wishing to emigrate. Photograph by Mauricio Miranda. Courtesy of Studio Bruguera.

in the middle, where people meet. It is knowing that you will have support, and things are not seen as debts or gains but as joy.

I always say that I wanted to provide a safe environment, safe but tough, safe because we were based in trust and honesty, not because it was easy. It is a system based on professional admiration, which each person has to work hard to get from the rest of the group.

TF: So this might fall under the definition of altruism or generosity. You give something without expecting a return, and the group generates a community through the sort of reciprocal give-and-take that creates ties.

TB: It's not even about giving and taking; it is about being proud of the work. That pride is in the place where two or more people encounter each other. It is a place that neither owns but both enjoy.

TF: In our discussions here you have mentioned the principle of trust in regard to the relations in the project. I see it here, in the structure and the flow of interactions. But I don't think that your other work is based on creating a relationship of trust with the audience.

TB: [*laughs*] You're right. To be honest, it's an anomaly in my work. I think that may be because I am working with the structure of an insti-

tution, a social structure, a pedagogical one, instead of a single event where I have less time to get to my point. My goal with *Cátedra Arte de Conducta* was to generate a collective discussion, and trust is an important part of creating that environment, especially if the subject of that discussion has to do with the political, and if it is held in Cuba.

Part of the trust is the ways in which I tried to protect that discussion. I was working really hard to give total freedom to the participants in terms of the kind of work they wanted to do, politically speaking.

Sometimes social projects get a lot of pressure from the art world, which obscures the original goals of the project, and even made them change, so I decided that the *Cátedra Arte de Conducta* project would be divided into two moments in terms of its visibility: While the actual pedagogical project was happening, active, it would not have much exposure, just to the people involved in it—participants and guests. Once it is finished, inactive, the participant's work would be more visible. Only once the project is finished can it be seen, can it be defined.

TF: So there is trust within the group, and you mentioned the notion that the members are peers, or will be.

TB: Yes, we know each other very well, and there is a set of ethics we respect, including that idea that we are all equals, even if some have more experience in this or that. It's a very healthy environment, a very honest one, which makes it possible for us all to learn from each other.

TF: How does that state of mind correspond with, let's say, some more aggressive side of your work?

TB: When we do crits, we can be really intense; we interact really critically. I think aggressiveness in this project comes across as all that they have to challenge in terms of their ways of thinking and the demands and expectations, in the group, toward their work.

TF: Is it possible that you have a different relationship with the perceived audience at a museum, whom you don't mind metaphorically slapping in the face, versus the members here, who are not the audience for the work but members of the creation? Your goal for these members is to—

TB: Transform.

TF: Is the goal the same in a museum—to have a transformative effect?

TB: That is a different scenario. While the participants of *Cátedra Arte de*

Conducta are both the audience and the work, their attitude as audience is an active one; they are open. In the museum, yes, you have to metaphorically slap people in the face so that they wake up and open to ideas of why they should interact with art. Those audiences in general are used to going to the museum to enjoy, to have a pleasant Sunday with their family, to get away from their reality. Maybe the aggressiveness gets codified in a way that is clear to them so they can get out of this mode. Maybe the school is about doing the same thing, but it is not as visible because it's stretched over a longer period of time. In my work aggressiveness is a resource, not a goal. I found that through some sort of aggression, people go back to their animal instincts, they can become animals — social animals, of course — and when they are in this state, I can go back to question what is their role in society. In the school project we are all clear that we are constructing citizenry.

TF: There is the question, of course, why is this art? Is it simply because you are an artist and call it art?

TB: Saying it is art "because I say so" doesn't work anymore. I mean, Duchamp is getting more and more obsolete. In this project art is in the transformation process for the participants; it is in the visualization of a discussion for the audience; it is in the proposal of a new model of collectivity.

I have created a space that fulfills people's desire and has generated others. But I think this piece is and is not art at the same time. Those categories are mobile. Or maybe it is not art but what is generated from it is art — for example, the work of the participants or a moment of appreciation from the viewers. Or maybe it is art because it is a gesture that has implications beyond itself. But either way, I don't think art should be a definitive condition. It should be a transitional condition, a condition one enters into and exits from.

TF: Well, perhaps if you define something as art, you allow it to exist in a way that it didn't exist before. Like, for example, if you didn't call your school an artwork, it could not have gotten the exposure in the Havana Bienal.

TB: The condition of being art does give you a set of privileges you do not have in other areas of human work. People will be paying attention, looking for something other than the evident. I have worked with these possibilities provided by art, but not for this project. The school's presence in the Bienal responds more to the need I had to

A public artwork on a city dumpster by a *Cátedra Arte de Conducta* participant, Yaima Carrazana, 1999. The ironic counterslogan "Todo en Orden" (Everything is in order, or Everything is okay) mimicked government social propaganda and was anonymously removed almost immediately. Photograph by Maylin Machado. Courtesy of Studio Bruguera.

provide a closing gesture to all the years of work and to provide the participants with a better professional place from which to continue.

In other cases, like *The Stroll of the New Man* [2007], I actually worked on the professionalization and recognition of someone as an artist in order for her to travel outside of Cuba for the first time in her life. That was using the privileges Cuban artists have. She participated at the Göteborg Bienale, where I was invited. During the weeklong installation time she was there with her boyfriend, who is also an artist, on vacation, taking photos and experiencing another place as tourists. Then we installed all the photos in the show as well as the objects she bought to bring back to Cuba.

TF: So their trip—what they acquired on their vacation—became the installation?

TB: Yes. I used the condition of being art as the acquisition of privilege. Art is a space that you create where there is a different set of rules, maybe the ones you would like to see in place. Art has the power to change the rules—why not use it?

TF: What about questions of ethics? Do you think that there should be ethical considerations in the use or evaluation of art?

TB: Sometimes ethics are one element of the artwork. In social art pieces

one is trying to establish a new set of social rules, and that involves ethics. But ethics should not become morality. The ethics applied to this kind of work should be generated in and by the project's own dynamic and needs. I think art has to be unethical sometimes, as well as to be illegal sometimes too, precisely because those are the elements questioned. The audience, instead of rejecting it automatically, should try to understand what is the social proposal they are looking at.

A natural reaction by the audience is to see if a project did good or bad to the person, assessing the humanitarian aspect of it as the substitution for ethics. I think it's important to do good to people. But the audience has to be trained for the suspension of the ethics, like in the suspension of disbelief, so you can enter into the piece and then let it reveal the proposal of ethics it comes with. And then you can confront the work. If you come with your own ethics, you will not enter the work; you will be totally stopped in front of it and will not engage in the conversation proposed.

TF: Would you say that one of the roles that you're looking for is that opening up of ethical judgment?

TB: Art can be a temporary establishment of a new reality; an alter reality, transreality, parallel reality. Part of what some social projects can propose is precisely that: it is the possibility of analyzing and imagining another set of ethics. Ethical judgment is an important part of social and political artwork, so opening to it seems like a must.

TF: You have been living a lot of the time outside Cuba since around 2000. Has this changed how you work here?

TB: It has certainly changed the conditions in which I can work in Cuba: it has given me more privileges.

TF: What about collectivity? Is that a part of the culture here?

TB: Yes, it is a practical necessity as well as an ideological regulation.

TF: Do you feel that your Cubanness has anything to do with your collaboration here?

TB: Very probably, yes, that indoctrination of the collectiveness and the social responsibility.

TF: Walking around Havana the last couple of days there is a crumbling feeling, like it's on a gradual, slow-motion, decades-long journey to dust.

TB: I call it postwar. Like it has been bombed, like materialized ideology.

TF: Yet it is here in the Cuban context that you chose to build something,

a complex structure over seven years. Do you think there's any influence of the environment here, building in the midst of decay?

TB: I see your point. I suppose I was tired of coming and having to live in that reality. I needed to create my own reality, and to show myself that it was possible. Also, at the time I started the school, the private restaurants, taxis, home rentals were beginning to be allowed. Why couldn't we propose that process with social institutions? I was not advocating for the privatization of education but for the expansion of the process of proposing a different option to the one offered by the government, the one that was fifty years old.

TF: By building the school from scratch, you were not reforming an institution; you were forming it. In some ways this echoes the difference between reform and revolution. I would guess that sort of rhetoric is common here.

TB: I like the ideas around revolution, more than around reform. But I built the institution based on observations of other institutions, so it is also a comment on those existing experiences.

TF: But there's a difference between taking on an institution and creating a new one.

TB: The problem here is that the right to build—institutions or anything else—is not of the people. The right to build is taken by the government. The same happens with the use of words like *reform* and *revolution*; they were socially copyrighted by the ones who won in 1959. So the gesture of building something is in itself a political gesture.

TF: Some artists who work in a similar vein say that their gesture is the starting point, but the work of art is the relationships created. But those relationships, of course, have other actors and authors and members.

TB: Remember that my first work was, literally, redoing Ana Mendieta's work. So I'm really interested since the beginning in this. Regarding the *Cátedra Arte de Conducta* project, in South Korea, at the Gwangju Biennale, I produced the school as a work. Nothing was authored by me except the gesture to tell the curator that I was going to give my space to the participants and to curate the space for their works to be seen. It was very difficult the first day. Journalists from *Art in America* and *Artforum* were coming to see this place, and I had to talk about everything but "my" work. So it was a test, for me, as an artist. I had to change my role quite a bit. I'm not only the facilitator; I'm not only the professor; I'm not only the friend; I'm not only the promoter. But

this is exactly what I wanted to do. I want to disappear through exposing other people. Definitely authorship is an important element in this, one that I like to think about and hopefully challenge in my work. The political aspect is not only in the gesture or in the relationships, but in the consequences of the gesture.

Cátedra Arte de Conducta CLAIRE BISHOP,

ART HISTORIAN

CLAIRE BISHOP is one of the leading writers on the topic of participatory and collaborative art. She has championed art from Latin America and Eastern Europe and has tended to support the tougher, less consensus-oriented practices, often writing critically about art that has a straight-forward social agenda. Her position is sometimes contrasted with that of Grant Kester. A clear example of their divergence is the contrast in how they assess the aesthetic status of the dialogical encounter. While Kester embraces art in which an ongoing dialogical exchange is *itself* the aesthetic gesture, Bishop argues in the following interview that Tania Bruguera needed to finish the *Cátedra Arte de Conducta* before it could be evaluated as a work of art.

In addition, consistent with her suspicion of socially instrumental goals for art, Bishop downplays the importance of Bruguera's interest in producing "good citizens" in favor of mapping the social and art onto one another. However, Bishop creates a conscious double standard: institutional critique or institution building means something quite different in Cuba, where there are fewer functioning institutions than in the United States and Western Europe. So while she might interrogate the power structure of an art school as art project with a certain degree of suspicion in a Western sociopolitical context, she sees it differently in Havana, where institution building outside a governmental setting has been so difficult.

———

CLAIRE BISHOP, an associate professor of art history at the Graduate Center of the City University of New York, is the author of *Artificial Hells: Participatory Art and the Politics of Spectatorship* (2012) and *Installation Art: A Critical History* (2005) and the editor of *Participation* (2006). Her essays

have been perhaps even more influential and controversial than her books, particularly "Antagonism and Relational Aesthetics" (2004) and "The Social Turn: Collaboration and Its Discontents" (2006).

———

Bishop has followed Tania Bruguera's work for a number of years and visited Cátedra Arte de Conducta in 2009. Prior to this interview Bishop read a transcript of my interview with Bruguera. We met in New York to conduct a follow-up conversation in Bishop's CUNY office in October 2009.

TOM FINKELPEARL: I know that you have been resistant to this question in other contexts, but do you think that Tania Bruguera's *Cátedra Arte de Conducta* is a work of art? And if so, in what sense?

CLAIRE BISHOP: I have endlessly debated this with Tania. When she gave me the opportunity to go to Cuba and participate in the project, I really wanted to go, because I was interested in how she was going to frame it as a work of art. While the project was happening I understood it to be a service to a younger generation. I asked her, "Why do you need to call it a work of art?" Can't it just be something that Tania Bruguera does in Havana, related to, but more experimental than, her teaching at the University of Chicago? Isn't this just her way of doing an art school in Havana? And even if it is an art project, it's not autonomous and self-organized, if that were even possible for an art school. It's a two-year module that students can choose to do while they are studying at the Instituto Superior de Arte. It's got a very clear relationship to the ISA, and she needs that relationship in order for it to function—for example, to be able to invite people to Cuba.

Later I said to Tania, "For this to be a work of art, you have to finish it. It can't be ongoing. And most of all, you have to think about the form in which it is relayed to a public who are not its participants." For me that's when the project can become a work of art. It has to be communicable in some way, rather than existing as pure presence. This brings us to another debate that I continually have with myself about the difference between community art and contemporary art. The difference is one of audience: Is the audience taken into consideration? In a discussion at Tate Britain last February, I asked Tania, "Why is *Cátedra Arte de Conducta* a work of art?" She couldn't really answer me. I said, "Okay, I will answer for you. I think that it

is a work of art because you've authored this project in a particular way. What is at stake is that you have put your name to this, and it fits within a trajectory of other pieces that you've done." (Actually, this debate became very interesting, because the New York collective 16Beaver were there, and it turned into a blazing argument between them about whether or not Tania was exploiting her students, and what it means to end the school, because they felt strongly that you can't just drop your collaborator-participants; you have an obligation to them. We all disagreed on that.)[1]

TF: Tania and I discussed how calling it a work of art gave it a different status, latitude, or access—for example, allowing her to present it at the Havana Bienal and the Gwangju Biennale in Korea. An art school would never be presented in these biennial contexts, but Tania's school as art could be.

CB: But she was calling it a school a long time before she thought of exhibiting it. In my opinion, she has managed to make it a work of art through the ways in which she has exhibited it. However, I've got a feeling that the Korean presentation in 2008 wasn't as interesting as the Havana Bienal in 2009, which was fantastic—changing the display every day, with a high-intensity, fast turnaround, so it mimicked the structure of the course itself through its mode of exhibition.

TF: When I was there in Havana, my perception and experience of the project were framed by the idea that this was a work of art by Tania Bruguera. I saw her relationship to the participants, to the site that she created, to that apartment in Old Havana, even the spare design of the classroom, as a set of artistic gestures and aesthetic decisions.

CB: Well, most of those decisions seem to be practical. It makes more sense to have the center of activity in Old Havana rather than fifteen miles out of the city center surrounded by a former golf course, which is where the ISA is based. It is more convenient, and interesting, to be in the heart of the city, where the students can come and go twenty-four hours a day.

TF: Perhaps, but I accepted the physical, psychological, and practical aspects of the school's enactment as part of the work of art.

CB: But this comes down to the question of what we turn to in order to compare and speak about this kind of project as a work of art. I know that I respond to such dematerialized, antivisual projects in the terms handed down to us from Conceptual art. For example, I am always looking for the structure and ideas underpinning it. So for me, this

is a project that lasted six years in which artists, curators, critics, and other disciplinary specialists were brought to Havana to teach workshops to a fluctuating group of students. The aim was to produce a generation of young artists in Havana who would be able to engage critically with the social and political environment in which they find themselves, as well as being able to represent themselves to external visitors, international curators, or whoever was interested in their work in a way that would bridge a local and international vocabulary. They would be aware of the problems of the international art world wanting something of them, wanting them to fulfill a certain image or role.

TF: I would add that another primary goal was to foster a group of artists oriented toward a less commercial practice. Tania said that she would deem the project a success if it prepared the students for the world and equipped them with the tools to create socially engaged art. This sounds more like what you are describing: judging the school on the outcome after it closed, not on the basis of the ongoing interchange.

CB: Yes, that was a good answer by Tania. I was glad she said that, because I was thrown by your comment on the aesthetics of the space—it overemphasizes the process, whereas I think she is more invested in the resulting situation.

TF: I think you are agreeing with Tania on this point, and I am disagreeing with both of you. I tend to see it as an aesthetic process as well as a product—a performance and an artistic residue. Also, the result is not only a set of artworks and exhibitions but also a set of tools with which to engage the world and a set of behaviors that are enacted over time. The process does not end with the closure of the school or the opening of an exhibition; it continues to create its own meaning through the ongoing use of the tools that have been acquired by the participants. So I would say that there is no final "resulting situation." Rather the result or residue plays out in a variety of social contexts over a long stretch of time.

CB: Still, when it's exhibited you have to judge it as an artwork. This is a big problem with the current trend for schools as works of art. I have increasingly come to think that they are totally incompatible formats to map onto each other. The criteria of education are not the criteria of a work of art, and when you try to apply one to the other it skews both of them in an unproductive direction. That said, the friction between the two can still be interesting, just as good activist art, archi-

tectural art, research-based art, or any liminal practice can be, rubbing up against two systems, trying to find a new space between two methods.

TF: In the interview Tania discusses how she had created an art school but also a school of behavior, a school about how to create collectively, how to become a good person or a good citizen. What about that idea, that part of the school's pedagogical intent is citizenship?

CB: I think that is one of the project's least interesting aspects. I am wary that it makes the project banal and moralistic, because *all* education should cultivate that kind of citizenship. Becoming a good citizen is what happens en route to learning other things; it doesn't need to be made the focus. Her school works in two directions, however, because, as she pointed out in the interview, being a good citizen might involve misbehaving. I am surprised that she brought that up, because it was not something I've heard her mention before, and it seems that it isn't necessary for understanding the project or why she is doing it.

TF: Then why call it the School of the Art of Behavior?

CB: Because she is trying to find an alternative to the word *performance*, to set in motion a specifically Latin American term and a set of ideas that it creates, rather than importing the inadequate history of performance from the West. I like very much that the name comes from *escuela de conducta*.

TF: Yes, she is very clever linguistically.

CB: Very smart. Compelling art is often about this kind of good linguistic branding and conceptual precision. The school is about behavior. Tania has always stressed that behavior carries a normative dimension. It's how we judge people in society. My preferred reading of the project is to de-emphasize the good citizenship aspect and think instead about conduct as the way you carry yourself, the way you are in the world and produce art through this state of affairs. You can't read the project in this way without understanding how Tania is trying to map art and social behavior onto each other. She is always trying to do these two things simultaneously, to produce something real and symbolic at the same time. But I am very resistant to talking about art in terms of its being good or interesting just because it produces good citizenship.

TF: In terms of the philosophy and structure of education, I know you read Jacques Rancière —

A *Cátedra Arte de Conducta* participant, Mauricio Miranda (left), speaking with Rirkrit Tiravanija (center) about his proposal for the magazine *Ver*, published by Tiravanija, whose workshop solicited sounds and images for a special issue on Cuba. Glori Linares (right) is translating. 2008. Photograph by Loraines Gallego. Courtesy of Studio Bruguera.

CB: Although not without a critical distance.

TF: How would you compare Rancière's work, particularly *The Ignorant Schoolmaster*, to the liberation pedagogy of Paulo Freire as a source or influence for the *Cátedra Arte de Conducta*?

CB: I've often thought about this, because Rancière never mentions critical pedagogy; he never mentions Freire, whose work is more interesting and more useful in thinking about social art projects like *Cátedra Arte de Conducta*. Rancière's primary concern is equality, and this philosophy of equality is a response to his former teacher, Althusser, who understood education as a transmission of knowledge to subjects who do not have this knowledge.[2] This concern with equality runs through Rancière's critique of Bourdieu and French sociology, in *The Philosopher and His Poor*, and his writing on nineteenth-century workers and their interest in literature, in *The Nights of Labor*. It is the common thread throughout all of his writing. *The Ignorant Schoolmaster* is a way of continuing this in response to particular changes in the French educational system in the 1980s, so it doesn't really function as a practical tool for implementing a philosophy of education. But "the ignorant schoolmaster" is a very catchy phrase, and it is very appealing to use it in artistic contexts, because it conjures a provocative image of the artist.

For Freire, the teacher is not a repository of information who deposits this wisdom in the mind of the student—in what he calls the "banking" model of education—but neither is he "ignorant." What I like in Freire is his acknowledgment that even when you stress equality and transparency, so that the students are conscious of their position as historical subjects capable of producing change, you can't deny the teacher's position of authority. It is a fantasy to think that this authority doesn't exist; the point is how you use it. You can't just pretend to be one of the students. I think Freire applies much more to *Cátedra Arte de Conducta* than Rancière does.

Another important question for me is the degree to which interdisciplinary projects actually do work within both disciplines rather than falling into a refugee space where no one really pays attention. Is *Cátedra Arte de Conducta* an experimental model of education on education's own terms? It always seems too easy for artists to assert that their education project is disrupting hierarchies without acknowledging that this is already a tradition within education. Moreover upheavals in education's own history are synchronous with artistic upheavals (such as postmedium specificity and participation) in the late '60s. When art starts working with other people as a medium, it is perhaps inevitable that art and education start to have more of a relationship, since these questions of equality and empowerment are interrelated. So is *Cátedra Arte de Conducta* an experimental model *within* education or a good solution to the problem of how to get international visiting lecturers to Cuba? We would need an expert in critical pedagogy to answer that question.

One thing that I found interesting regarding the teacher-student relationship in Havana was that Tania was, by local standards, earning a lot of money in another context and could use the slippage between financial systems—U.S. dollars, Cuban convertibles, and *moneda nacional*—to finance a school herself. For example, she could easily afford to take everyone out for dinner after an event; using moneda nacional, it doesn't cost more than $20 to feed twenty people. But in the West I have seen how people with money and connections have so much power, especially over students. Nobody would want to challenge such a person. I was concerned that she was producing a group of uncritical acolytes because of the economic advantage she has in that context. Even if she is doing something very good with that money, it is still a potent form of power. So on the last day of

my teaching I sent Tania out of the classroom because I wanted to ask the students about these concerns. They were all absolutely adamant that that didn't make any difference: "Oh no, we think of her as a colleague." I realized that being brought up under communism had made them see the relationship very differently; they had none of my cynical skepticism.

TF: Tania acted with a great deal of restraint while I was there. When she was in the classroom she participated mostly as a facilitator, arranging video equipment or transportation.

CB: She was different during my week, which was very discussion-based. She talked, and she talked a lot. Everyone did, to the point where even the translator gave up translating and joined in the discussion while I was left hanging in a language void! But the larger point I want to get at is something that I am struggling with continually: the insufficiency of Western criteria for analyzing projects from socialist or ex-socialist countries. Take, for example, Pawel Althamer's work in Poland, which I like enormously. It seems to require different criteria of judgment from the ideas that we default to applying to artists in Western Europe and North America. Althamer does a lot of educational or educationally oriented projects, such as his *Einstein Seminars* [2005] and his work with the Nowolipie Group, which are very civic-minded.[3] Some of them are complete failures visually, but experientially there is often a Dadaist dynamic of subversive eccentricity created through the insanity he builds around him. I often wonder whether I need to rethink my emphasis on a visually forceful result, especially in relation to artists from former socialist countries.

TF: In the socialist context of Havana, Tania built an institution—or a semi-institution that she took apart before it became too institutional—in a city that is slowly crumbling, a city in an authoritarian state where, as she notes, only the government can build institutions. Do you think that building can be critical, or does critique need to be deconstructive?

CB: It is what Maria Lind has called "constructive institutional critique"; the most recent generation of artists manifest their interest in critique by creating alternative institutions.[4] This leads to another instance of the paucity of Western art historical terms for describing the artistic situation in Latin America and Eastern Europe. Institutional critique requires functioning institutions for you to critique. If you haven't got these institutions to critique, then the intelligent

alternative is to build your own, and I really admire those people who have done that. This often leads, in my view, to more interesting art than is produced in the West. There is such a surplus of resources in North America that there is less energy and less urgency about the production and display of art.

So yes, critique doesn't have to be negative, and I am interested in the constructive modes of institutional critique that have arisen in the last ten to fifteen years, but I also see an important difference between critique in Western and Eastern Europe: the latter is frequently still about art, offering inventive solutions to an institutional absence. For example, the Slovenian collective IRWIN has produced a book of art history called *East Art Map*, which charts a comparative history of Eastern European art. They have also been instrumental in forming Arteast 2000+, a collection of Eastern European art for the Moderna Galerija in Ljubljana, in order to secure this work for a local context at a time when Austrian institutions are voraciously buying up this history. That is also constructive institutional critique, but it is done in the name of art and art history; it is not claiming to be social change. We could compare this with pseudo-institutions in the West, which are inter- or transdisciplinary in focus. For these projects, the association with art seems to be a question of expediency above all: access to funding and to a certain kind of limited visibility. Tania's project is about changing a generation of artists; it's not about forging community, improved housing, campaigning for prisoners' rights, et cetera.

TF: Yes, but Tania also says that "art is not enough," that she is interested in "useful art," and the use tends to be outside the realm of the arts. In our discussion she gave three examples of useful art: the guardhouse at the lumberyard made from stolen wood, the provision of Internet service for Cubans by a non-Cuban artist, and the artist who lent his exhibition space as storage because Cubans have so little space.

CB: It's funny that she gave those examples. I think that they are interesting only within an array of projects that can conjure the ethos of *Cátedra Arte de Conducta*, since they fit rather nicely together. On their own many of these students' projects don't yet hold up. However, there are some projects by her students that are less useful but much more interesting, in that they give you access to the social and cultural conditions of Cuba while also playing with legal loopholes. One of my favorites is by Celia and Yuni, a couple who are buying

Given the opportunity of one minute free of censorship, a speaker with a dove on his shoulder, flanked by two people in military uniform, addresses the audience at the Havana Bienal in 2009 in Tania Bruguera's *Tatlin's Whisper #6*. Two hundred disposable flash cameras had been distributed to the audience. Photograph courtesy of Studio Bruguera.

and selling grave plots—the only type of private property you can acquire in Cuba. The idea that they are buying and selling absences is very poignant: private property as a negative space, which you can only inhabit when it's too late, when you're dead. But this project doesn't have a *useful* dimension. Rather it maps the real and the symbolic onto each other in a sly and mischievous fashion, using social systems as a medium, as well as anticipating the full-scale capitalism that is surely only a few years off in Cuba.

Also, I confess that I think none of the students do useful art as well as Tania herself did in the 2009 Havana Bienal with her performance *Tatlin's Whisper #6*.[5] In this piece she seized the framework of the Bienal as an opportunity to provide a public function: an hour's freedom of expression, in which audience members had access to microphones and a podium for one minute each. The setup was highly constructed, since those who went to the podium were flanked by two military personnel who placed a white dove on the speaker's shoulder. It functioned very powerfully as a performance *and* as a brief window of free speech.

TF: Yes, *Tatlin's Whisper #6* looked intense. Fifty thousand people have watched the video on YouTube, and the commentary, which is mostly in Spanish, is very political and for the most part passionately posi-

tive, though there's a scary undercurrent of right-wing American anti-Castro sentiment.

 Tatlin's Whisper #6 was carefully designed. The uniformed guards and the visual structure of the stage and the podium formed a frame for this moment of freedom of speech. I agree that it was probably better realized than much of the participants' work — though I haven't seen a picture of the guardhouse made from stolen wood, and it is conceivable that there is a kind of architectural or sculptural interest to it, in precisely how the artist uses the wood to build the structure.

CB: But it's interesting that Tania never mentions that aspect of the work. You're right, the visual realization is important. The artist needs to think about how the house is built and whether something else can be alluded to through this structure. However, I do really like the phrase *useful art*. Tania and I have had lots of conversations about this, and she has finally won me over — but only if the usefulness is a corollary of the work rather than its raison d'être.

TF: This is where we disagree. I don't see why the usefulness has to be separated out, considered only a corollary of the work. When an artwork like *Tatlin's Whisper #6* is enacted or created through a participatory, cooperative process, then the elements — the participatory structure, the temporal process, the visual and contextual frame, and the social consequence — seem to me to be interwoven. By the way, I wouldn't say that this is the case for all art. For example, if an Impressionist painting is used on a poster by a housing advocacy group, and they are successful in preventing some foreclosures, then I would certainly call that success's relation to the artwork "corollary."

 In our discussion Tania and I touched on an issue contiguous to reciprocity: trust. There was a distinction between some of her projects that are based on trust and others that are not.

CB: It's a good distinction, because her long-term projects, like the school, are absolutely about trust, but her other works temporarily invite the audience's trust and then throw it back in their faces. For example, the piece she did for Performa 07, *Delayed Patriotism*, involved asking audience members to pose for a photograph with an eagle; in the background was a portrait of a dictator, which they did not notice until afterward, when they saw the photo. I don't know if you could call it a betrayed trust, but in this work a position of narcissistic comfort is snatched away from viewers when the setup is revealed to them: they have been framed.

Holding an eagle and standing in front of a photograph of Mohammad Rezā Pahlavi, the former shah of Iran, an audience member at the Bronx Museum films himself while being photographed in Tania Bruguera's *Delayed Patriotism*, 2007. In this project audience members were photographed in front of images of dictators who had come to power with the aid of the United States. Photograph courtesy of Studio Bruguera and Bronx Museum.

TF: The process of building a community around trust with the participants at Tania's school is not only at odds with some of her very tough and aggressive projects but also opposed to what I assume to be your position based on your writings.

CB: You are probably referring to my critical response to relational aesthetics, which I outlined in "Antagonism and Relational Aesthetics" in *October* in 2004. People have wanted to turn that essay into a total system of thinking about art, where antagonism becomes a criterion of what's good or bad in social art, but that approach doesn't work. It was a good method for the particular task of dismantling Bourriaud's ideas, but that is not an indicator of my preferred criteria for all art. I've got much more critical distance on all four of those artists now [Rirkrit Tiravanija, Liam Gillick, Santiago Sierra, and Thomas Hirschhorn]. My current problem is how to address social art outside a Western context. The more time I spend in South America or Eastern Europe, the more confused I am about what my criteria are or should be, because I simply can't map these criteria onto them; they are just not comparable contexts and histories.

TF: Interesting. I sympathize to a large extent with your critique of the political claims of relational work, but I want to ask you what you

Representing Spain in the Venice Biennale, Santiago Sierra paid non-European men to have their hair dyed blond. Most of the men were street vendors in the areas adjacent to the Biennale. *133 personas remuneradas para teñir su pelo de rubio (133 persons paid to have their hair dyed blond)*, 2001. Courtesy of Santiago Sierra and VEGAP.

think about an alternative reading of a project you describe in your essay, namely Santiago Sierra's *133 persons paid to have their hair dyed blond*, from the 2001 Venice Biennale. For the piece, Sierra paid a group of 133 local street vendors, mostly immigrants from East Africa, with some Chinese and Bangladeshis mixed in, to have their hair dyed blond, and invited some to sell their wares in the Spanish pavilion of the Biennale. I like this as a project of Sierra's because it is startling but not abusive; the hair will of course grow back to its natural dark color, and it did not seem humiliating. The vendors became more visible on the street, and some were invited inside, crossing the social and economic borders imposed by the art context. You describe the unease of the situation of the vendors within the pavilion, but I was also struck by the possibility that there could have been a dialogue between the vendors and the art world visitors. Would it have made a difference one way or the other to you if such an interchange had taken place?

CB: My gut reaction to that is that it is the wrong question to be asking of

the work. I think Sierra wants that punch of misidentification, which is certainly what you get as a viewer. When you are in the Venice Biennale, chugging through the great intestine of the Corderie, you are just looking and looking and looking. It doesn't occur to you that the art will talk back. I think Sierra wants you to look at the vendors, and he wants them to be objectified. That cruelty is also its aesthetic punch and, in my view, exactly what he is aiming for. At the time that I wrote "Antagonism and Relational Aesthetics," I was operating with a very North American *October* magazine idea of the "critical" work of art, which I've now got more perspective on. I am teaching early-'90s art at the moment, actually 1989 to 2001, and I think there is a different relationship to the critical in Europe than there is in North America, particularly in France. In part this has to do with not having to address Greenberg, which in the U.S. in the early 1980s gives rise to the dilemma of critical or complicit postmodernism. The French don't have this relationship—instead they have Lyotard, who produced the influential exhibition *Les Immatériaux* at the Centre Pompidou in 1985, and especially Baudrillard, with his dizzying embrace of mediation, and this is why there is a really interesting generation of French artists in the 1990s for whom the critical is simply an operative vocabulary for what they do.

TF: One of the arguments I am making in the book is that the American context is unique because of the artistic, social, and political framework that we are mired in here. We are living in an extreme form of self-oriented individualistic society, though perhaps we are now in a mild recovery mode from the most reactionary set of federal administrations, which obsessively valorized the individual over the collective—including economic policymakers who placed their faith in the aggregation of rational choice by self-interested individuals. To do something cooperative in this social context has a different meaning.

CB: Yes. I need to work on describing more precisely what I think that different meaning is. Perhaps it can only be clarified through comparison. When I look at Scandinavian or North European artists working collectively, I always feel a slightly melancholic tinge to the work, because it goes hand in hand with the decline of the welfare state—the final shreds of a dream are being clung to, a dream that is already slipping away. In the U.S. this dream didn't really exist in the first place, so there is a different tone and aspiration to socially oriented work.

TF: I argue in the introduction to this book that the contemporary move

toward cooperative action in the United States is not just in art and education. If you read the work of progressive American urban sociologists or city planners in the 1970s and '80s, they sound strikingly similar to Paulo Freire.

CB: I think you know that I am still more interested in Freud and the consequences of repressing negative and destructive instincts. I still find the Freudian framework incredibly persuasive and very beautiful.

TF: But there are a lot of scientists and social scientists who are beginning to question Freudian pessimism. Of course, they grant that humans are aggressive and competitive animals, but they want to add to this picture the notion that we can be exceedingly and uniquely cooperative. This sort of interpretation is making its way through whole sectors of academia and political action.

CB: Yes, but you also need to question whether or not this is progress. At exactly the same time that you have artists endorsing participation, you also have New Labour endorsing participation to reinforce their social-inclusion agenda. At the moment I am reading Luc Boltanski and Eve Chiapello's 2005 book *The New Spirit of Capitalism*, which describes a third spirit or phase of capitalism, one that has internalized two critiques that arose around 1968: the "social critique," for more social justice, and the "artistic critique," for more autonomy and creativity.[6] The latter is manifested in demands for more autonomy at work, less alienation, feelings of participation and inclusion, being consultative and self-motivated, being satisfied and fulfilled by work—all these were taken on board by business in the late 1970s, and we are now living with the consequences of this adaptation. The third spirit of capitalism has also given rise to networks rather than hierarchies: people work around the clock, and we never detach ourselves from our email, because we feel invested in our work in a different way. *Participation* is really a key word in the new spirit of capitalism. So I am wary of simplistic oppositions of individual to social, and selfish to collaborative, because capitalism has already internalized and cannibalized these distinctions. Of course, in the great scheme of things nothing has really changed: a few people have all the money and many don't have much. The question now is how the production of capital has shifted in its methods. As a result of this, art has to be more complex in its ambitions instead of merely ameliorative.

EIGHT A POLITICAL ALPHABET

Arabic Alphabet WENDY EWALD, ARTIST,
AND SONDRA FARGANIS,
POLITICAL SCIENTIST

WENDY EWALD'S cooperative project *Arabic Alphabet* is a case study of
how world events can intervene in the meaning of an artwork. The travel-
ing retrospective *Wendy Ewald: Secret Games* opened March 16, 2003, at
the Queens Museum of Art, and the response was generally positive.[1] In a
review in the *New York Times*, the critic Ken Johnson particularly praised
the early photographs, in which Ewald got the children started as pho-
tographers and encouraged them to document their environment. These
shots were taken by the kids while Ewald was absent, and they are among
the best-known collaborative artworks of the 1980s. They propelled Ewald
to a MacArthur Award in 1992. Johnson praised the rough-hewn nature
of the kids' photographs, calling them "blurry and formally off-kilter,"
"strange, scary, funny, often wrenchingly sad," "fiercely unflattering," and
"pictures of almost terrifying emotional candor."[2] He particularly liked
a sullen portrait called *Mommy and Daddy* by Martha Campbell, which
he thought was "as heartbreaking as anything by Diane Arbus." Johnson
clearly preferred this work to other cooperative projects in which Ewald
herself takes the photos because he felt her craftsmanship tends to render
even scenes of poverty "picturesque."

One of Johnson's least favorite works in the show was the *Arabic Alpha-
bet* project, a newly commissioned work created in collaboration with
a group of students from I.S. 230, a middle school in Jackson Heights,
Queens, a neighborhood that had been transformed by the immigration
reforms of the mid-1960s. Jackson Heights is staggeringly diverse, with
large South Asian and Latino immigrant groups mixing in with economic
exiles from Manhattan and a substantial, multicultural gay and lesbian
community. As narrated in the following discussion, in this project Ewald
asked for student volunteers to create an Arabic alphabet, using images

to represent each of the twenty-eight letters. The result would be based on free association, like a Rorschach test: What image does a given letter bring to mind? Ten Arabic-speaking students who had emigrated from five countries—Egypt, Jordan, Algeria, Morocco, and Lebanon—signed up, and over the course of several months they created photographic images with Ewald that were then blown up to banner size and hung in the museum's largest gallery. As is the goal in a progressive pedagogical setting, the teacher-student relationship was reoriented. Ewald created the basic structure of the collaboration, but the content needed to come from the students because she does not speak Arabic, nor could she imagine what each letter might evoke. In Freirian terms, Ewald's problem-posing approach allowed teacher and student to become jointly responsible in the learning process and artistic product.

On March 20, 2003, four days after the Queens Museum opening of *Secret Games*, the U.S. military commenced its campaign in Iraq. That week the *New York Times* launched a special section titled "A Nation at War," in which an article on the *Arabic Alphabet* project appeared on April 7 under the headline "A Single Alphabet Bridges Children's Two Cultures." Along with the curators, the museum's education department had arranged Arab Family Day on the occasion of Ewald's show, and the *Times* reporter Corey Kilgannon covered the event, speaking with a number of the student-artists and their parents. The article dwelled on the peaceful nature of the imagery, in contrast to the violent depiction of Arabs that was saturating the media at that moment. "I can't watch it anymore," Ahmad Alrefai, twelve, was quoted as saying. "All you see is kids dying and bombs killing people over and over."[3] The *Times* article touched on the generational divide, exemplified by clothes and language. Alrefai, who emigrated from Jordan when he was four, was accompanied that day by his mother, who was wearing traditional clothes, including a black hijab. Like the other parents there, Alrefai's mom was pleased that the project linked the kids to written Arabic and showed another side of Arab American life. Ewald was mentioned in Kilgannon's article, but it was Alrefai who was photographed in the installation; he was featured over Ewald, now that the project had moved off the art page into a section that was covering the war.

This contrast in coverage was telling. The art critic focused on the artist, while the cultural reporter focused on the broader political context. Most artists working in a socially cooperative mode report that their work is usually not covered by art critics, and when it is, the coverage often questions the aesthetic value of the work, particularly if there is any hint of

social harmony. So the art critic favored the "terrifying emotional candor" of the "fiercely unflattering" work in the show, while the cultural reporter documented the positive reception by the participants and their parents.

——

SONDRA FARGANIS, the founder and former director of the Vera List Center for Art and Politics, is presently the director of the Wolfson Center for National Affairs at the New School in New York City. She is trained in both political and social theory. From her dissertation on political movements in the mid-1960s to her current scholarship on cultural elites, she has concentrated on the relationship between theory and practice. She founded the Vera List Center as a public space for the discussion and debate of ideas integral to that intersection. While still at the Vera List Center, she appointed Wendy Ewald to a senior fellow position.

WENDY EWALD is a conceptual artist who has collaborated with communities in the United States and around the world for more than thirty years. She has been artist in residence at the John Hope Franklin Center at Duke University and a senior research associate at the Center for Documentary Studies, also at Duke. She has had many solo shows of her collaborative photography and was included in the Whitney Biennial of 1997.

——

The following conversation was recorded in New York in the summer of 2004 and refined and reconfigured over the next two years.

SONDRA FARGANIS: At its core your work over the last twenty-five years has centered on the idea of collaborative art. You have collaborated with children in many different places — Appalachia, Holland, Colombia, South Africa, Saudi Arabia, to name a few — using your skills as both a photographer and an educator to enlarge the imagination of students, most often so that they can create a work of art that represents their sense of self and community. I work as a social and political theorist and want to engage you in a conversation that will juxtapose your art with my theorizing. This notion of collaborative art brings up a joint interest you and I have: the intersection of art and politics. Give me the specifics: When, where, and why did you want to do the *Arabic Alphabet* project?

WENDY EWALD: I usually work with an idea over time. The *Arabic Alpha-*

bet is part of a series of alphabets that represented a loose cross sec-
tion of language in America. Like most everyone I know, I first en-
countered written language in children's alphabet primers. Looking
back, I now see that the words and visual examples used to represent
letters reinforced the worldview of the middle-class white girl I hap-
pened to be. A shiny new car, say, illustrated the letter c. My father
ran a Chevrolet dealership in Detroit, so that one seemed especially
apt for me. As a child, I assumed that this congruence between writ-
ten expression and one's own experience of the world held true for
everyone.

But as the United States has become increasingly diverse, the cul-
ture of our schools has remained much the same as in my childhood:
white middle class. And the language sanctioned in the classroom is
an extension of a white middle-class ideal, just as it was in the '50s.
The words taught in school constitute our society's official language,
and unless we master the intricacies of it, our chances of making
more than a marginal living are alarmingly small.

I began to hear disturbing stories from English as a Second Lan-
guage teachers in North Carolina, where I work. They talked about
the bad treatment their students sometimes received from other
teachers, who assumed that because the children didn't speak Eng-
lish well they were stupid. Those stories made me think about using
photographs to teach language. I decided to make pictures, with the
students' help, to illustrate the alphabet. In this way children could
influence the images and meaning of an alphabet primer—in effect,
make it their own. I wanted not just to mend an educational system,
but to see our language(s) and our children as they actually are in the
world.

I had already created three alphabet projects: a Spanish alpha-
bet with Latino children in North Carolina, an African American
alphabet with children in Cleveland, and an alphabet with white high
school girls in Massachusetts. For years I'd been thinking of working
with students to create an Arabic alphabet. I'd been aware that our
relationship with the Arab world was going to become a key issue
in this country. I just didn't expect it to become an issue in the way
that it did. I'd been interested in how people in Arab and/or Islamic
cultures would make photographs. In 1992 I'd worked with young
people in Morocco, and in 1997 in Saudi Arabia. Then in 1999 I did

a project with an Islamic school in Raleigh, North Carolina. At that time I became concerned with children who are growing up as Muslims in this country and what they face on a day-to-day basis. Now, as war with Iraq became imminent, the project felt urgent, and New York post–September 11 seemed the right place and time to continue the investigation.

SF: You're asking us to think of the philosophical import of the ways in which language structures our perception of reality. I see as well the historical and political sense of the importance of language. Your turning to Arabic was right historically and artistically. Historically we had entered the era of globalization, and artistically, working with this community added another dimension to your earlier work. So even if the events of September 11 had not occurred, a compelling case could be made for this new body of work. Your artistic impetus met a historical moment in Arab American relations.

WE: Yes, though for me, this was a continuation of a collaborative project that I had been working on for years. In the fall of 2003 I looked for a public school in the borough of Queens that would allow me to work with Arabic-speaking students. It was very difficult because school policy was to protect their Arabic-speaking students from any outside meddling, or even identifying them as such. The USA Patriot Act had prompted a roundup of Arab Americans for questioning or confinement, often without legal representation. But also, I think, in truth, school officials didn't want to take on a project that could be controversial, that could identify them as a school with an Arab population. It might have required work to accommodate the project comfortably and safely. We needed a school that was open and considerate of the diversity of the students. We asked maybe five or six schools. At last a forward-thinking middle school principal, James Bongino, arranged for me to work with ten students at Intermediate School 230 in Jackson Heights, Queens. He was interested in art and was adamant about giving kids the opportunity to work on this project. I sympathized with the other principals' protectiveness, and to be fair, even if they knew my objective was noble, the project could always be misconstrued. But I realized that by hiding their students, they were, in effect, denying them the opportunity to express themselves as proud Arab Americans.

The first day I went to I.S. 230, a couple of teachers seemed un-

comfortable with my working with Arab American kids. They asked me why I was not working with the Jewish kids, or with the Colombian kids, who make up a large percentage of the school population.

SF: There are several different kinds of politics here. Are you saying that the teachers were really asking what's so special about the Arab kids? Or maybe I'm hearing that wrong?

WE: Well, I think it's more than that. They were asking why we were singling out the Arabic-speaking students in light of what was going on politically. Once we got started, it was clear the Arabic-speaking students had never before had the opportunity to meet as a group, and then, during Ramadan, the Muslim month of fasting, they were especially happy to hang out in the darkroom together during lunchtime; otherwise they would have had to sit in the cafeteria watching the other students eat.

The first day I gave them permission slips to take home to their parents describing the project. To my relief, I found the students and their parents were eager to participate. But then it took some juggling on the part of the assistant principal to fit the project into the school schedule. We had to pull kids out of class to participate, which created resentment with some classroom teachers. Fortunately the students felt privileged to be part of our project, and I had a strong ally in the art teacher, Maria Bonilla, who understood our commitment to the project and created a home for us in her art room. Later she led field trips to the museum and arranged for us to hang an exhibition in the school.

Our first activity was to split up the letters of the alphabet among the students and to choose words that started with the letters. Then we made photographs that represented the words. Finally, the students wrote the letters and words on the negatives.

While all the students spoke Arabic, some were fluent; others knew just a little from hearing it at home, and the words they used were not necessarily the same. They had emigrated with their families from Egypt, Jordan, Algeria, Morocco, and Lebanon. There is a great deal of diversity, country to country, in the language. We had to decide whether to honor that diversity or to use classical Arabic. In the end we took the advice of those who said we would want anybody who is Arabic-speaking to recognize our alphabet, and used classical Arabic. The students had to ask their parents to help them find words. The parents were happy because they said they

At the temporary studio set up outside I.S. 230, a student participant, Hussein Osman (right), poses with the artist assistant Pete Mauney (left, pointing). Wendy Ewald is under the camera hood. Participants depicted words starting with each letter in the Arabic alphabet, in this case the letter *alif* and the word *amr* (command). *Arabic Alphabet*, 2003. Photograph by Aaron Diskin.

wanted their children to maintain a connection with their language and culture. Unexpectedly it became a family project. Later I asked an Arabic-language teacher to check the students' work. Interestingly this teacher became an arbitrator of what was correct and what was not.

SF: This appears to have been a project where you have had more collaborators than other projects.

WE: It was definitely a community collaboration.

SF: An issue of concern is who your collaborators are and how much you must use their input—how much you owe them. I sometimes worry about the loss of artistic expertise. Might it not be the case, I'd ask, that the artist has a critical consciousness that the collaborators might not have? Might it not be that the artist is not out for power but for some version of the truth? What happens to the artist's expertise in the process of making collaborative art? If collaboration is marked by a diversity of perspectives, might it encourage disunity of the finished project? I am particularly struck by generational diversity—where adults, with a heightened political consciousness, present a sharp contrast to the naïveté of the children, for whom

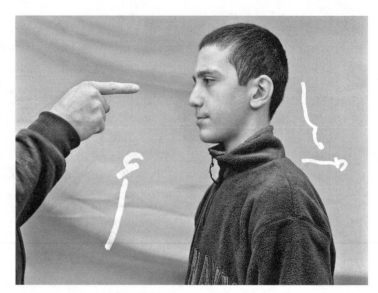

The image for the word *amr* (command). Arabic letters were hand-drawn by participants on the color negatives. This image appeared as a banner and in the book *American Alphabets*, where it was accompanied by an example of how to use the words in a sentence, in this case, "The teacher commanded the student." 2003. Photograph by Wendy Ewald with Hussein Osman.

this project is a joyous, expressive artistic activity. In Jackson Heights the sense of self was understood by the older Arab Americans in the community, articulated much more carefully than the sense of self as understood by the youngsters. In the best sense of the term, the adults were more discerning collaborators. In your project the parents were quite articulate in seeing a larger political agenda.

WE: I think the parents' and the community's agenda is always present to some degree in the children's work. In this case the adult's role was more visible. Perhaps because there had never been an Arabic-language project in the school, the parents were immediately interested in having their kids participate. In this case I would also hesitate to say that the children are naïve to the political agenda of their community. I think much of my work attests to that fact if you look below the surface. After we hung the work in the Queens Museum, we brought half the school to the exhibition, some three hundred kids. It was the first time one of the girls who'd participated in the project had seen the installation. She went on to say that she'd been embarrassed about being Palestinian but that through the project,

she'd become more comfortable with who she was, to the extent that she felt proud. She could be both Palestinian and American.

SF: It's fascinating to see how an arts-based project tells us about people's views of America. It would be much harder for a social scientist using traditional interview techniques to get as clear a statement as you offer on the need to balance cultural identity against citizenship. This philosophical assessment, by your young person, is a statement of what the political theorist Charles Taylor calls "the politics of recognition."[4] Taylor's is the cutting-edge work in examining multiculturalism and its ramifications for theory and politics. While many think of toleration as a form of respect for the Other, the progressive shift since the '60s is to recognize the identity of others and ensure free expression of their distinct identity. For Taylor, toleration per se is not enough. These parents are exemplifying Taylor's point that we must move beyond toleration, which assumes the expediency of the Other, to "recognition," which assumes the Other's worth. I appreciate the way a philosopher like Taylor takes one through the importance of recognition for the sense of self. Your focus on the child as viewer-creator of his or her identity adds another dimension to the theorist's articulation of this problem. The parents cut through theoretical discourse on toleration to show how, in moral terms, recognizing the distinctiveness of people matters. Your collaborative work and some of the most important work in political theory are grappling with a similar set of issues. Built into the very notion of socially collaborative art is "recognition of the Other," giving moral status to the Other. This sort of intersection of art and politics is exactly what we had in mind when we started the Vera List Center at the New School in 1992.

WE: When most Americans think of the Arab world, we automatically think of Islam, though not all Arabs are Muslim. By working with students who speak Arabic in Queens, my idea was to talk about the language, not to talk about Islam. Through language the students were able to present a synthesis of Arab American experience. I feel that the project went beyond stereotype. Ahmad, an eighth grader who aspires to be an airline pilot, chose the word *jar* (neighbor) for the Arabic character *jim* because "it means something like kindness, which is what people must show in the world." He also chose *fekr* (thinking) for the character *fa* because, he said, "It's a good symbol. It represents me. I'm a good man because I'm smart." Later Ahmad

wrote his words in the graffiti-like font he'd seen on the walls all over his American neighborhood.

But I want to get back to your question about diluting one's artistic vision if you involve others in making decisions. I think my collaborators' involvement is integral to the meaning and aesthetics of the art. I make small decisions all the way through, as any artist would, but so do my collaborators. If I don't give them space, the finished piece won't have the same depth or visual interest.

A lot of times the kids come up with ideas that I never would have imagined. As an artist, I understand these are good ideas. For example, Omar, who was one of the youngest kids, chose *diminish* as his word. I had no idea how we were going to make a photograph illustrating *diminish*. But he had the idea to use cups. The two of us started laying out plastic cups from the cafeteria, and eventually we came up with a pyramid shape. Later, when he drew his letter and word on the negative, he drew a line through the cups, separating some from the others—that is, diminishing the number. In that case the concept was definitely driven by him. I was just helping him make it visually literate.

SF: As I see it, you are always able to resist the temptation to impose an "Ewald vision" on the art project. You don't see it as simply your vision; you want to be part of it, but you want collaboration, not imposition. It seems to me that underpinning your kind of work is a challenge to address the question of what belongs in a museum. If you invite parts of the community to assist in the making of art, then it's not simply their art-making activities that constitute art but also the very invitation at the beginning of the process.

WE: Yes. As an artist, I set up the structure so that the students' ideas can surface. Moreover I have to choose projects that I think make a difference to the community from which they come. But it's a struggle for me because I'm interested in having a good product come out of it. I am working as an artist—that is the bottom line. And I make mistakes, but I can usually see those mistakes and pull back from them.

My voice obviously begins the project. I decide whom I'm going to work with, which group of children. Then it becomes a collaboration with the children and with the partner institution I'm working with. I want to fulfill some goals of the institution so that the work has a life afterward. A school might want me to work with a particu-

lar group of children. In this case I wanted to work with children who spoke Arabic.

SF: Are there any instances in which you would say to one of your collaborators, "I don't think that's a good idea"?

WE: Yes. There are technical challenges. It's very hard to stay still for the time it takes the shutter to open and close, so, for example, they couldn't hold something in their hand without support.

SF: So something is almost *objectively* the case that, irrespective of your intentions, it's just not going to work.

WE: Right. We would then discuss a solution or an alternative.

SF: Is there ever a moment when, either with this or other projects, you see the child — who's now the collaborator — photographing in a way that you know could be better? Are you ever tempted to intervene, and do you always resist the temptation?

WE: I can usually. Once the kids and I are together, I explain what we're going to do. I've figured out step by step how to get from the first meeting to the end product. I have a plan, but it may change. For example, when we started the alphabet, I gave each kid two or three Arabic letters. They had to write a list of words beginning with those letters. At that point they're choosing the words. Then we had to figure out which of the words could be photographed; I had to have some sense of how I could make a picture out of their choices. Then we narrowed it down and often tried two or three things. Emmie brought in flowers to illustrate the word *zahrat* [flower]. First she chose a red backdrop to set the flowers against. Then we talked about where she wanted the flowers and if she wanted anything else in the frame. If she hadn't had an idea, I might have started by giving her suggestions. She asked another student, Hussein, to work with her. She directed him to hold the flowers so she could look through the camera with me. Later we agreed that it looked interesting with his hand because you expect a feminine hand with flowers.

We worked at our makeshift studio on the sidewalk outside the school. I shot with a 4 x 5 camera on a tripod. We had lights set up to flash as the shutter was released. We used stands to mount our different-color backdrops on. The students' choice of color backdrop was often interesting. For example, Mohammed's word was *misery*. He wanted red for the background because he wanted the intensity of that color. He had worn his Algerian sweat suit for the picture. We were trying to figure out how to represent misery. I think he had the

A crowd gathers for a public event in the largest gallery at the Queens Museum of Art. Hanging above is *Arabic Alphabet* (2003). Translations were placed on the walls adjacent to the banners. Photograph courtesy of the Queens Museum of Art.

idea of slumping over. I looked through the camera and asked him to move a bit to the right and took a Polaroid. We looked at it together and discussed if more of his neck should be showing and if the angle of his body was correct. We were happy with what we saw, so I took the final picture.

SF: The viewer really has this wonderful task of looking at this picture with care and trying to deconstruct it. It's not simple.

WE: Once the negative was developed, Mohammed wrote the letter and the word with a colored marker on the surface, which is a complicated process. When you write in color on a color negative, you don't readily know what color it will be in the print. We had to learn something about layers of color and how to manipulate them.

SF: Are there any pictures you took in which you were at loggerheads with your subjects?

WE: There are always pictures that I am less interested in, which can be difficult because I have to show them. Most artists don't face this problem. When a photographer takes pictures that intend to show a reality, she is already collaborating with the world. I think collaborative art is another form of photography, photography that can be

more revealing than documentary photography. I think it's a bit more honest, for example, than if I had simply photographed these kids in Queens, making a statement about them rather than with them.

SF: I think there is value to a documentary that is seen through the eyes of the artist, the filmmaker, or the photographer. But collaborative art wants to bring the view of several actors into the artistic endeavor. A method of understanding referred to as phenomenology in my trade has a very strong moral dimension, especially in the hands of a great social theorist like Max Weber. It demands that the observer not impose his or her view on the world, because that view is only a part of the game. The observer has to see the world through the eyes of the people she is trying to understand. You are, for me, a kind of living embodiment of Weber's phenomenology. You are not simply giving your view, but asking what the world means to specific, socially situated kids. It is bad theory and bad politics to shut out opposing viewpoints, because one will never be able to work with social actors unless one can see the world they're coming from. So there is something in phenomenology, although perhaps not as overtly as in your work, that speaks to this collaborative endeavor: the subject — here, the young person — having his or her views articulated with another — here, the artist.

Let me explicate further. There is a critique of positivism or objectivity that says that the outside observer cannot access what's going on, as if there is an objective world out there that is clear and present. So how *do* we understand the world of the person being observed? Do we imagine ourselves into the world of the Other and report on that world as the Other has seen it? There is a relationship between collaborative art and a form of social theorizing that puts the emphasis on the social actor and understanding the world of the social actor as the social actor sees that world. Phenomenology is deeply moral, even though we don't usually think of it in those terms. If theory is to have a moral dimension, it has to see the world through the actor's eyes. It reminds me of your work, which says that we have an obligation to give dignity to the actor or viewer. One way of giving dignity, or what Charles Taylor would call "recognition," is to say that we are trying to understand what actors think of the world or why they behave in the world in the way that they do. We are trying to see the world from their perspective. Only when I see the world as you do

might I be able to tell you the implications of what you see, and you may then want to change what you see, but it would be immoral for me to tell you what to see.

The alphabet projects are not exclusively seeing the world through young people's eyes, because you're not just giving them a camera and saying, "Take the picture," and letting it go at that. You've already told us that you're an artist and you know certain things — not because you're morally better but because you're more experienced at this moment in life, particularly in the technical side of photography. I believe that in collaboration you have to have trust in the Other, which you don't have to do if you're an isolated artist reporting only to yourself. There must be mutual trust. Your authoritative perspective uses expertise or knowledge or experience to help the child reach his or her goal. *Collaborative* embodies this notion of giving a voice to the Other or sharing a voice with the Other.

We have another issue, of course, which is what to do with this vision of the world. Do we just stop at the level of understanding? Or do we use knowledge to effect change? You, the artist, have to decide how you're going to deal with the visions presented to you by the young people you are working with. What if they want to articulate an image that you find troublesome, that you find classist, racist, or sexist? Do you get them to alter their vision?

WE: As far as I'm concerned, change begins with acknowledging what exists. When I'm involved in somebody else's world, I don't hold all the cards. They're sharing their ideas and skills with me; I'm sharing mine with them. Later on we'll see if what we made makes sense, artistically and morally. I would encourage us not to use an image that could be exploited or misinterpreted by an outside audience. When I enter into a collaboration with someone, I feel it's my responsibility not to put them in a light that is embarrassing or damaging. But there is room for problematic images. For example, Nicoline, an Afrikaner girl I worked with in South Africa, photographed a black man going home from work as an example of what she didn't like about her community. She had made a portrait of him across the fence surrounding her yard. He was out of focus and looked menacing. When I questioned Nicoline about her use of the camera, she told me her mother said, "Well, that's how black people turn out in photographs." I thought the photograph was a brilliant portrayal of her racism, but I didn't show it in South Africa. I was concerned that

she didn't understand how the image would be interpreted in her own community, and given the context, she would have been hurt through her collaboration with me.

So much is happening as I'm taking the pictures that I often don't see as clearly as I do later. I might have to reshoot to make the intention clearer. I'm also teaching the students to do everything, so there are many layers of the process. Ideally it would be great to tape-record every time I shoot, because I don't have time to ask Mohammed, for example, "Why did you choose to wear your Algerian suit and slump over as you did?" Once I know the answer, the picture has another layer of meaning for me. I hope the viewer can experience those layers of meaning, maybe not in a conscious way, but the multilayered process has a kind of veracity that another process might not have.

SF: Did *Arabic Alphabet* meet with accommodation or conflict from the museum or the school?

WE: I had hoped to make the images as placards in the subway. I loved the idea that someone on the train would look up and see Arabic script, and instead of seeing an inflammatory word like *jihad*, he would see the word *neighbor*, for example, and an image of two children shaking hands. The subway placement didn't work out for logistical and financial reasons, so I decided to construct an installation of the *Arabic Alphabet* that would convey the experience of literally walking through language. I had the images printed on fabric. The negatives had to be digitally scanned in preparation for printing them on four-by-eight-foot translucent silk banners. The machine we used was a state-of-the-art Heidelberg scanner, but the initial results looked odd: the digitized faces of the Arabic children were ashen, drained of color. When we tried to correct the color, the machine overrode our input. Finally we came to understand that the scanner was programmed to produce Caucasian skin tones. It took us some time to debug the machine's bias and achieve the right hues.

We were going to hang the banners from the thirty-foot ceiling in a large two-story space in the Queens Museum. First we had to decide how to hang them. I took the kids to the museum so they could see the space. Then we made a model with tiny pictures that could be moved around. The students each made their own configuration. In the end the kids played a part in deciding how to install the piece. I wanted to have a key to the language, so the viewers could under-

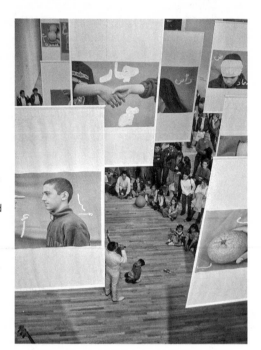

Throughout the run of the *Arabic Alphabet* show there was a series of events, often centered on one or two of the countries in which Wendy Ewald had initiated collaborative projects. Here a Cinco de Mayo celebration in 2003 brought in a large contingent from the local Mexican American communities. Photograph courtesy of the Queens Museum of Art.

stand and pronounce the Arabic words. We had to decide what the order of the letters was going to be. Were we going to do it in Arabic fashion, right to left, or in Western fashion?

After hanging the banners, we invited the students' parents and other members of the Arab community to attend a celebration, which happened to coincide with the U.S. invasion of Iraq. The crowd stood around under the banners and talked about how important it was to see their language honored this way; they wanted the world to know there was more to Arabic than what they normally saw. The students and their families said they took tremendous pleasure in the affirmation they felt that day, as if, just for this moment, solidarity could face down the horrors of war.

SF: Surely your audience, as with any work of art, doesn't necessarily understand it in all the dimensions that you, the artist, understand it. It is wonderful when your intent is understood and appreciated.

WE: I think my intent is also to challenge an existing situation.

SF: To create a project that would enable us to understand something about the reality and the diversity of the Arab American community?

WE: Yes. I try making the work so that I bring people along with me,

people who might have very little knowledge of the Arab American community and who are afraid. In this case I wanted to look at how we saw the language of what we were calling "the enemy" and to put it into a larger human and cultural perspective. Whether there was the war with Iraq or not, this was the intention. I also wanted to give those kids, who were now being seen as the enemy, a chance to talk about who they were through their language.

SF: What I really find fascinating about your work and about artists like you is your use of the visual for a political objective that is far more nuanced than conservative critics of art allow. Those who say, "Art should not be political," are as limiting for me as those who say, "Art is only political." I think it's much more nuanced than either of those two positions suggest. You as an artist are dealing with some vision rooted in reality, and your aesthetics can help get you there. As I hear you, the political objective you've spelled out is to say, "There is within the United States, or in large parts of the United States, an assumption that Arabs and Muslims are all of one piece. I have a political objective, which is to help show, through this project, that that's not the case." You want to give voice to those without power.

WE: Yes, I hope so, but I have trouble with the expression "giving voice." The people I work with already have a voice. Often we don't listen.

SF: For me, teaching is helping people get the tools that will enable them to see which blinders have been put on them, by whom, and how to get those blinders off. It's not to give them answers, but rather to give them the tools to be unhappy. Teaching for me is not about happiness; it's about consciousness. Its purpose is to help students see the public dimension of their private identity. I tell my students, "I would love you to come back and assure me that no one can pull the wool over your eyes."

Let's look at this collaborative art issue from another angle.

An interesting aspect of the Queens show, which was a gift to us from the *New York Times*, was the fact that the show became overtly political with the article in the "Nation at War" section. It was framed for the viewer as a show that could help us understand our foreign policy vis-à-vis the Arab world. It would be a different kind of review in the Arts section of the paper. So in what sense do you see the actual show being changed by that first article?

WE: When the article came out in the *Times* it really gave the show a sort of form. The reporter was present at the Arabic Family Day discus-

sion and met the students. His article focused on the kids' experience of being Arab Americans during a time of war, as opposed to the earlier review in the Arts section of the *Times*, which focused on my work as a whole. Also the "Nation at War" piece pointed out how the work we'd done presented a synthesis of Arabic and American cultures, whereas the review was fairly dismissive of the *Arabic Alphabet* as a political polemic.

SF: It would be interesting to know if people knew about that article when they came to see the show. I wonder if they came to the show already knowing that this was a very different kind of show, perhaps a political show. There certainly wasn't any kind of boycott of the show; it had good attendance, and my recollection is that the kids and the families involved in the show were faithful from the moment they realized this was an important endeavor. Did the children or the parents of the children read the review in the *Times* and comment on it?

WE: Yes, they were pleased, but it would be interesting to know what they think now that the politics have changed. *American Alphabets*, a book of all my alphabet collaborations, will come out soon. I'll have a chance to get in touch with them. That could be an opportunity.

SF: So it would be fair to say that in some sense the show had an artistic and political objective, as well as an artistic and cultural dimension. In its artistic dimension the show was an extension of your earlier work that dealt with language and alphabets. You have always seen language as a way of getting at a certain aspect or culture.

WE: This project, however, doesn't fit the media pattern. It was great to get the article in the "Nation at War" section because, at that moment, people needed to know what those kids thought.

But I also went to Chiapas right before the Zapatista rebellion there, and I was in South Africa right before the government changed. I found the timeliness of my projects didn't really change how widely the work was seen. It's more complicated than publications are used to showing. It's not dramatic or polemical. It shows day-to-day life in a crisis situation.

SF: An objective of yours was served with the timing of this show. The message of the show was that there's a big difference between the Arab American community and the 9/11 hijackers. And yet in the minds of large parts of the population, it's the same, and the anti-Arab or anti-Muslim sentiment of the country comes from an erroneous view that you, as an artist, want to counter. And here before

you is a body of work that shows a diversity, in the best sense of the
term, of the ordinariness of the people.

WE: I was disappointed, though. We offered the alphabet installation to
institutions free of charge, but it's been hard to find venues for it.

SF: It's possible that hesitant people would say we don't now need a pro-
Arab show. They would say that we're at war with this enemy, even
though the whole point of the show is to suggest a rethinking of that
view. Your images are on the side of peace and empowerment rather
than on the side of war and victimization.

WE: Along those lines, when *Secret Games*, my retrospective exhibition,
opened at the Addison Gallery right after 9/11, on the cover of the
invitation was a veiled Saudi woman. And the museum held a meet-
ing to try to figure out how to respond to questions from the press.

SF: The museum put the image on before 9/11 and was now confronted
with an image that meant something else. Pre-9/11 it was a striking
image, but after 9/11 it became —

WE: Menacing. At the opening I happened to stand next to the big por-
traits I'd made with women in Saudi Arabia. I remember feeling lost.
At that moment I understood that many of the images in the show
could be interpreted entirely differently from when I'd made them. I
realized how little I could control, regardless of my intention.

SF: Let me return to the question of voice. In this model of collabora-
tive art, there is what I would call not an authoritarian voice but an
authoritative voice; that is, the parties are not in some sense equal.
They may be morally equal and they may be equal before the law and
they may be emotionally equal, but they are not equal in the sense of
knowledge of the situation. You have a certain expertise — perhaps
not because you're privileged or white, but simply because you have
been trained to be an experienced artist and you're an adult. Your ex-
pertise gives you an authoritative voice. An authoritarian voice uses
the power it has, which you have in this situation because you have
the equipment, the show at the museum, and if you walk out of the
project it's over. You would have no need to defend your choices
other than the basis of authority. An authoritative voice is one in
which you have to be able to defend your choices when asked on the
basis of reason, and in that sense it's negotiable. The importance of
the shift to recognition is that acknowledgment is made that poli-
tics — and might we add art? — is not about objectivity or neutrality
or impartiality but what can be called "involved artisanship." This is

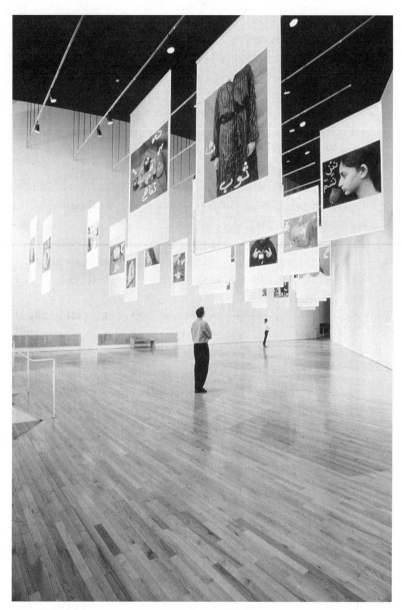

Each of the letters and images in *Arabic Alphabet* (2003) was printed on a four-by-eight-foot translucent silk banner and hung in the Queens Museum's main gallery. The installation was designed with the students using a scale model of the space. Photograph courtesy of the Queens Museum of Art.

beyond valuing a plurality of ideas but has to do with sharing legitimate space. This is the politics of recognition, this is our culture, and we would like it to be seen in its best light, and this could be a way of doing that. This notion that it's going to cause us grief is your rationalization of or politics about them. When you have this kind of political atmosphere in which people are more attuned to looking at the political aspects of art, how is that softened by the art of being collaborative?

WE: Oh, I think it is tremendously [softened]. I think choosing the alphabet also softens it — something that's very simple, childlike, and that can't hurt us. I think the aesthetic softens it too. If the kids were to organize something themselves, it might be considered overtly political.

SF: If we see your work as an art project with an expert, I think it softens the show. It's not a white woman of privilege doing a solo show, but it's a polished professional working with Arab American children.

WE: It does go both ways. When I was doing the project *Black South, White South,* when we showed the work, one teacher said, "God, how did you have the guts to do that?" And then she said, "But you know, if I tried to do that, I would be castigated for being so political because my skin is so dark."

SF: Are you a pure, unadulterated outsider, an expert who has no hidden agenda other than to work with these children to produce this work of art?

WE: No. It's interesting to think what would have happened if we had put those pictures on the outside of the building or on the subways. After having met with the families, I can only think that they would have applauded that.

SF: Perhaps the most important issue facing the world today is multiculturalism or the politics of recognition, the need to recognize diversity. So let's go back to Charles Taylor. He argues that there is a preferred group of people in society prepared, because of deep-seated feelings of morality or politics, to tolerate others. But he wants to get beyond *tolerate* to *recognize.* Perhaps your collaborative practice goes beyond the *toleration* of Arab American students. Given the context in which we are living — in Queens, in America, in this moment in time — the project asks us to recognize these kids. This is accomplished not through a diminished or compromised voice but rather a shared voice of the artist and her collaborators.

NINE CROSSING BORDERS

Transnational Community-Based Production, Cooperative Art, and Informal Trade Networks

PEDRO LASCH,
ARTIST,
AND TEDDY CRUZ,
ARCHITECT

IN THE FOLLOWING INTERVIEW Pedro Lasch and Teddy Cruz discuss their approaches to transnational issues in their work. Both Lasch and Cruz traverse a number of worlds in their traditional practice (Cruz designs buildings; Lasch shows his artwork at museums) as well as in academia and in civic and community activism on both sides of the Mexican-U.S. border. Lasch's work is socially based, with projects ranging from festive gatherings to multiplatform social communication, artworks created through interaction, and political paintings. He has been particularly interested in mirrors as a mechanism for literally "creating a more reflective form of communication," as Michael Rakowitz wrote in *Artforum*.[1] This interest has played out in such exhibitions as *Black Mirror/Espejo Negro* at the Nasher Museum of Art at Duke University in 2008, in which the viewer was consistently reflected and included in the work, and a participatory mirror-mask performance with Mexicanos Unidos de Queens in the basement of a church.

Likewise Cruz merges social practice with more esoteric pursuits. He is known as a theorist of transnational urbanism, which he puts into practice in the work of Estudio Teddy Cruz. As Nicolai Ourousoff wrote in the *New York Times*, Cruz "has spent the better part of a decade strolling through Mexico's bustling border towns in search of inspiration. Where others saw poverty and decay, he saw the seeds of a vibrant social and architectural model, one that could be harnessed to invigorate numbingly uniform suburban communities just across the border."[2] While this observation has necessitated a bit of explaining by Cruz to his clients (no, he does not intend to make Hudson, New York, into a "derelict shantytown"), it crystallizes his intent to study a wide range of sources and apply what he has learned across regional and national borders. Just as Robert

For the design for Hudson, New York, Estudio Teddy Cruz drew on diverse architectural inspirations, including informal and transnational forms. 2008. Rendering courtesy of Estudio Teddy Cruz.

Venturi and Denise Scott Brown had learned Main Street a generation earlier, Cruz is intent on gathering lessons at the border. But Cruz is looking for more than new architectural forms. As Jennifer A. Gonzalez has written, he "begins with the premise that human environments are to be actively produced, not merely encountered."[3] He is interested in understanding the social aesthetics of space, how people can participate in their environment, how the local intelligence of communities can form their space, and the interdependence of use and form. The language of use, so controversial in the fine arts, seems natural in his architecture.

In the interview both Lasch and Cruz express their respect for informal modes of exchange, informal building, and informal social relations. For both of them, the zone of the informal economy is a site for creation, a place where counterpublics creatively invent their own forms of cooperation. Echoing the sentiment of Tania Bruguera (chapter 7), Lasch notes that cooperation is often not a choice but a necessity in the third world;

lack of resources can lead to shared resources in Mexico and in Mexican American communities. That said, Cruz does not necessarily embrace the notion of the "Latin Americanization" of American cities as outlined by Mike Davis. Rather he sees opportunities for a reinvention of aesthetics and architecture in models that cross borders—the creation of new hybrid models, not the importation of social norms from the south.

———

PEDRO LASCH is an assistant research professor of visual art at Duke University. He was born and raised in Mexico City and holds degrees from Cooper Union (BFA) and Goldsmiths, University of London (MFA). Lasch has produced projects internationally as an artist, researcher, educator, activist, cultural organizer, and producer of social interactions, games, and temporal rearrangements, at both alternative and mainstream venues. He has been active in 16Beaver Group in New York and other collectives, as well as various grassroots immigrant organizations.

TEDDY CRUZ is an associate professor in public culture and urbanism in the Visual Arts Department at the University of California, San Diego. Born in Guatemala City, he received a BA from Rafael Landivar University Guatemala City, a BA in architecture from California State Polytechnic University, San Luis Obispo, and a master's degree in design studies from Harvard University Graduate School of Design. He has taught and lectured in various universities in the United States, Latin America, and Europe. He is the principal of Estudio Teddy Cruz in La Jolla, California.

———

The following interview took place in fall 2009. It started as an email exchange and finished as a live conversation with Teddy Cruz and Tom Finkelpearl in a hotel room in New York and Pedro Lasch joining via Skype from London.

Part 1: Email Exchange

TOM FINKELPEARL: Pedro, can you tell us about your *Tianguis Transnacional* project?

PEDRO LASCH: I began the *Tianguis Transnacional* series in 2004. It consists of ongoing material productions and social exchanges, and fundamentally it is defined by a steady exploration of the complex aesthetic, social, and political manifestations of informal trade. The

projects pay particular attention to the materiality and social networks of the so-called informal economy within current processes of globalization, seen through the prism of colonial and postcolonial histories. Because of the focus of our conversation, I will here only address two projects in the series, *Prototipos para estructuras informales* (Prototypes for informal structures) and *Sonido Tianguis Transnacional*, both of which started in 2004 and are still ongoing.

Prototypes for Informal Structures involves the design, elaboration, and production of a new kind of joint for the easier, quicker, and more compact assembly of the ubiquitous street-stand structures we see in most megalopolises of the world. These structures belong to the history and contemporary practice of informal trade, broadly known as *tianguis* throughout Mexico and the Mexican immigrant population of the United States. The word *tianguis* is a Nahuatl (Mexican indigenous language) word that has survived five hundred years of aggressive U.S. and Spanish colonization. In the process it has undergone very meaningful transformations. A crucial word in the pre-Conquest times of the trade-based Aztec civilization, it simply meant "market," the equivalent of our global "shopping malls." In contemporary Mexican Spanish, however, tianguis has become a prominent synonym of informal trade, illicit street stands, and so-called black or gray markets. My project and its associated design, production, and testing processes intentionally functions as a vehicle for conversations and collaborations among individuals and groups who rarely get to interact in creative ways because they find themselves on opposite sides of the formal and informal, the mall and the *tianguis*. Collaborators include informal tradespeople (*tianguistas*) and any other users of these stands, cultural producers, industrial designers, and mechanical engineers, as well as intellectuals and activists who engage with the topics of globalization, informal economies, and social structures in general. Mechanically the new joints attempt to solve very real problems for the tradespeople who transport, assemble, and disassemble such structures on an everyday basis. As a formal construction and aesthetic manifestation, they also stress the importance of contemporary network theory, physically fashioning a collective understanding of some of the most complex architectural and social structures that connect and constitute transnational informal markets. The implications of an improved street-stand joint may

seem quaint or less evident in the United States, where street trade is strictly regulated and pushed back to the least visible areas of the social fabric. In countries such as Mexico, however, the implications are enormous. There entire metallic subcities and architectural assemblages appear and disappear every day, like snails that come out of their shell by day and retreat to it at night. These metal subcities also bear close ties with the grassroots urbanism that architects and thinkers like Teddy Cruz have theorized and found so inspiring in towns like Tijuana, as well as many of the favelas, shantytowns, and *barrios populares* so abundant in the global network of growing cities and megacities.

TF: Can you tell us how you interacted with the tradespeople in developing the prototypes?

PL: My interactions with users of such metal structures date back to 1999 and consisted mostly of conversations. At that time Mexico City's Commission of Art for Public Spaces recommended the execution of my *Sculptural Proposal for the Zocalo*, a project that would reassemble on the country's main square, called Zocalo, a three-hundred-ton steel scaffold that for nearly a decade had been keeping alive the city's most important cathedral right next to it. The *Zocalo* project was greatly inspired by many dialogues with workers who assemble and disassemble scaffolds and metal structures on a regular basis in the old downtown of Mexico City, a place that has been sinking for centuries. Through these dialogues, initially focused on the life and death of buildings and their memory, I was soon involved in long-term conversations with the manufacturers and users of all kinds of metal scaffolds and street-stand structures, including those addressed by the *Tianguis Transnacional* project. The mammoth scaffold of my *Zocalo* project was in fact subversively planned as a monumental nod or public conversation piece for the downtown tianguistas, whose individually smaller yet collectively gargantuan metal structures have been regularly displaced by police and prevented from occupying the main square by a chain of repressive governmental regimes dating back to 1512, the year of the Spanish conquest of the Aztec capital of Tenochtitlan.

My numerous conversations and physical interactions with tianguistas over the years have led to a very clear structure. Between September and November of 2004 I built six complete sample street stands for *Tianguis Transnacional*, including the special joints and all

A prototype based on the most common street vendor stand in *tianguis* markets, including the modular joints that make it adaptable (at the bottom). Pedro Lasch, *Prototipos para estructuras informales* (Prototypes for informal structures), 2004. Photograph by Pedro Lasch.

the other modular components that make them so adaptable. Soon thereafter I began sharing the sample assemblages with various tradespeople. Participants would get a free street stand in exchange for sharing their experiences and suggestions with me. (While relatively cheap, standard metal structures for street stands can be too expensive to rent or purchase for tradespeople at the bottom of the social scale.) To test the prototype stands—a constant stage for predictable and unpredictable interactions with or without the presence of the artist—I decided to invite as partners six different kinds of tradespeople on the basis of *what they sell* (raw meat, vegetables, flowers, toys, electronics, DVDs and CDs); *where they sell* (six neighborhoods spanning Mexico City's enormous urban area, including rich, middle-class, and poor areas); *how they sell* (indoor stand, outdoor stand, assembled daily without permit, assembled daily with permit, assembled on varying sites, assembled on semipermanent sites); and lastly, *how I connected with them* (direct personal contact, second-degree contact, third-degree contact, through anonymous calls in tianguista networks, through political leaders of both offi-

cial and unofficial tianguista organizations, through various random methods). Unfortunately, while in the last five years enough participating tianguistas have used the prototypes and shared their desires and recommendations with me to elaborate what I think could be a final modular joint and stand, the actual production of it has had to be delayed until the project has sufficient capital for the joints' mass production. To fulfill their radical potential, the joints must be as functional, reproducible, anonymous, *and* cheap as the standard screws one can buy at any hardware store within our globalized economies. The necessary collective or individual capital to produce such a joint, and the effective access to a social network that may distribute it for daily use, will most likely remain the most ambitious aspect of this work in progress. But even if they never reach their utopian potential, these one-inch-square metal joints will have served as the central node for many unlikely and surely worthwhile conversations and collaborations in the popular markets, academies, and art contexts of Mexico, the United States, and other parts of our formal [and] informal world.

TEDDY CRUZ: As you suggest in your narrative, intervening into the complexity of these informal systems is a huge challenge, mainly because the intervention here cannot be a singular "thing"; it wants to "distribute" itself across a huge range of registers, spanning social, political, economic, and cultural domains and material practices. One particular topic that comes to mind in the context of the *Tianguis Transnacional* project is the way in which your process attempts to insert itself in the midst of formal and informal, legal and illegal dynamics. On one hand, the actual metal joint will amplify flexibility and efficiency of deployment, etc., but behind this piece there is a process, a research that has taken you into dialogue with tradespeople, particular sectors of performance of the informal market, zoning regulatory guidelines that deny these typologies. It is this process that I find fascinating about the project, and in some way I am thinking it would be great to make it part of the project's representation. Mainly because, as an artistic practice that attempts to encroach on underutilized public space, reorganizing particular official limits in the city and the social networks that self-regulate, your operative material seems to be precisely this array of conditions. So this question of how to integrate research and product recurs here: how to bring to the fore the complexity of the process of negotiation

across stakeholders, official institutions, and the political economy of the informal. These questions come to mind because the story of your project is very compelling, and it is the agency of its narrative in connection to the "joint" that can help us as audience transcend certain reductive interpretations of the potential of the informal in redefining the terms of the city.

Up to now the informal has had a "bad face" for planners and politicians, not to mention those who complain that the tianguis are a disgrace to the city. You and I and people interested in the role of the informal density, economy, and material practices know that the need to acknowledge these ephemeral, improvisational, entrepreneurial practices in the contemporary city is essential in order to speak more intelligently about sustainability, socially and economically. Yet the opposition remains, across the board, between the formal and the informal, the planned and the unplanned. Is this project an opportunity to dynamite this opposition and operate in the midst of their very conflict? Is the actual metal joint an excuse to produce new critical interfaces across these divided agendas?

PL: Your point is crucial, and very encouraging, to say the least. I love the image of the project blowing up the distinction between the formal and the informal, opening up more space to operate between them. To picture the broad range of ripple explosions implied here, it might be worth laying out two specific scenarios. In the realm of aesthetics or art theory, such dynamite would shake up the isolationist and colonialist tendencies of U.S. and European institutions and social circles. Formalism, as well as its accompanying notion of the *informe*, has continuously served to prevent non-U.S./European artistic and cultural realities from becoming visible on a global scale. This making invisible is particularly tragic because the erased experiences and experiments tend to be much more relevant for the diverse contexts in which the large majority of cultural producers in our world operate. In our second scenario, the more immediately consequential world of law and politics, we could understand the elimination or softening of the distinction between the formal and the informal as a recognition of the rights of the twelve million undocumented immigrants in the United States and many more worldwide. Whether we call it an international workers' movement, an amnesty, a legalization process, or immigration reform, the point here is that the fictional formula that separates the formal (citizens and legal immigrants) and the

informal (undocumented immigrants) is always blind to the broad range of conditions and realities that exist between the two. One of the key arguments behind *Tianguis Transnacional* is that most of our existence, regardless of our social class or cultural background, cannot be reduced to the narrow constraints of formality set by Western art history, international and national law, and the state's census and taxation systems. Between the legal and the illegal lies the legitimate, and this is the space where the tianguistas set up their stands.

In terms of your suggestion that the research, history of exchanges, related urban zoning issues, and other interconnected parts of the project should become part of the work's representation, I could not agree more. I have already tried to work in this direction, but the scale of a project such as this one is daunting and inevitably creates a need not just for collaborative investigation but also for collaborative representation. In architecture and urban planning it is assumed that the architect works with a team, and perhaps because of the medium scale and longer history of so many firms, labor relations tend to be stable and easier to understand. In art the pervasive myth of the artist working alone in the studio keeps creating all kinds of difficulties for those of us who like to work with others. On the one hand, we are faced with the exploitative structures of unpaid and uncredited labor that are the norm in the contemporary art world, its galleries, and museums. On the other hand, we compete with the extreme specialization of roles and solid union representation of Hollywood, TV, and mainstream media, neither of which is applicable to a medium-size and necessarily flexible work like ours. Between 1999 and 2003, when I founded and directed various experimental education programs with the title *El Arte, el Cuento y los Cinco Sentidos* (Art, storytelling, and the five senses), I specifically worked with students and community members of indigenous areas of Mexico and immigrant neighborhoods in the United States on a set of solutions to these dilemmas. Grassroots self-representation, experimental pedagogy, and authoethnography helped us create the broader forms of representation you are talking about as a byproduct, while they simultaneously helped demythologize the role of the artist as sole "presenter" and "representative" and avoided at least the most exploitative labor relations of the cultural sector. In terms of our topic at hand, the *Tianguis Transnacional* and its representation, I actually think your work and practice is a fantastic model of what the project could become,

so rather than saying more at this point, I will turn the question back to you.

TF: But first let's talk about your second project in the *Tianguis Transnacional* series, *Sonido Tianguis Transnacional*. Can you elaborate on what *sonidero* culture is? Where has it arisen in the United States, and how did it migrate from Mexico?

PL: The direct relations between the first set of collaborations with tradespeople and this second one may seem oblique at first but are actually deep and diverse. *Sonido Tianguis Transnacional* focuses on collaborations with *sonideros* or *sonideras*, a kind of DJ or MC that has risen to prominence in the last few decades. Sonidero/as have become the main cultural producers of the same populations who produce and sustain the informal markets and street stands. They are also the cultural and social bond, the messengers that connect indigenous, undocumented, and migratory populations across regional, national, and transnational vectors. The *equipo de sonido* (sound equipment), or *sonido* for short, is to this project what the street-stand joint was to the first project I spoke about: a simultaneous structural glue and analytical device for a complex material and social assemblage. Basically the sonidero/a is the person or company who owns and uses sound and light equipment, often assembled on elaborate and highly portable scaffolds, to throw private and public dance parties. As is the case with many popular cultural manifestations, the history of the sonidero movement is highly contested, so my extremely brief summary here should not be taken as an authoritative version. To many people, the movement was born in the 1950s working-class neighborhoods of Mexico City, particularly the barrio of Tepito. While fifty years later some sonideros like La Changa or Condor have become so popular that their performances fill entire arenas — their fees being too high for any working-class individual or family to hire them for a party — the large majority of sonideros still exist as a cheaper option to the more expensive and much desired live band. Sonideros play music from their record collections in the intimate spaces of working-class *vecindarios*, or mass housing complexes. They also perform on streets that are temporarily taken over by people who have no access to any other space for entertainment or dancing, much like the tianguis is assembled with or without permit, or day laborers gather every morning to be found by their temporary employers.

Musically speaking, while most sonideros play cumbia, salsa, and other Afro-Latin genres, their musical repertoire is as diverse and adaptable as their audience. In terms of its visual culture, I believe that the exuberance, talent, and complex visual culture of the sonidero movement (their logos, posters, flyers, videos, websites, hand-drawn messages, etc.) makes them the direct yet unrecognized heirs to the much-revered historical Mexican *prensa y grabado popular* (popular press and print). While many artists nostalgically insist to this day on using linoleum cuts for what they think is a popular press, sonideros have long understood that Internet cafés, websites, and Photoshop flyers are the real popular artistic media of the day. For the purpose of my *Tianguis Transacional* project, a crucial feature of the U.S.-Mexican sonidero networks, also a much loved and hated one, is that at these extremely loud parties there is an almost constant *talking over the music* by the sonidero. Words spoken over music with the mic and various sound effects may include the sonidero's brand name, announcements of all sorts, political messages, but most important, hundreds of messages that sonidero fans bring to the DJ booth on little slips of paper so they are read out loud by the sonidero for someone in particular. Within a migratory perspective, these messages take on an enormous social dimension, as DVDs and CDs of recorded sonidero parties are sold and distributed in a grassroots transnational distribution system that reaches both the towns of origin and destination of the mass migrations from Latin America to the United States in the last three decades. This way a man in Queens may buy a DVD of a party that happened in his hometown of Cholula, Puebla, because he knows his mother attended or may have attended the party and sent a greeting to him through the voice of the sonidero. Younger or less famous sonideros go back and forth between only a few towns in the United States and Mexico. More established or famous sonideros can cover various states and countries in their sociogeographical scope. In either case they are among the few who respond to the great need for fun, love, and dancing in an extremely difficult immigrant experience, and their communications always go in both directions, symbolically and literally uniting families across increasingly deadly borders for several decades. They have also played key roles in the U.S. immigrants' movement. During the massive rallies of 2006, for example, hundreds of thousands of protesters reached the streets of Chicago and many other places be-

cause for weeks on end sonideros had played the role that radio hosts had taken in other parts of the country, like Los Angeles, spreading announcements about the rallies and the anti-immigrant Sensenbrenner legislation at their parties.

I could speak volumes about why I find sonidero culture so relevant and fascinating, but for the sake of brevity I will move on to describe the physical functioning of the collaborations in my *Sonido Tianguis Transnacional* project. The work as a whole is centered on a platform or booth that, along with video and sound players, serves as an ever-changing repository for the gradual accumulation of materials gathered by local sonidero artists and fans. The core of my work in the project has been to identify interesting sonidero social networks and invite them to share their materials in contexts unknown to them. A crucial role of mine as artist and cultural producer here is also to create connections where there are none, establishing links across social spheres that tend to remain separate, such as the informal and undocumented, the artistic and the academic spheres. The materials we collectively accumulate include posters, flyers, statements, pamphlets, journals, CDs, and videos. All of these materials are accessible to visitors throughout exhibitions in traditional and nontraditional art venues. Every time the work moves to a new venue, the archive grows in relation to local and transnational migratory networks. The space where these productions are displayed also becomes a stage and DJ booth for local sonidero/DJ gatherings (*encuentros sonideros*) and dance parties organized in coordination with the exhibition.

So far these multimedia productions have happened in three chapters, with various transnational DJ networks and dozens of collaborators. It may be tempting to cut or shorten the following list of collaborators in the context of this publication, but the list here plays multiple representative and material roles. Changing or eliminating selected names would threaten the very core of the project, as recognizing one's coproducers is key in my view to the aesthetics and ethics of cooperative art practice. *Chapter 1: New York/New Jersey* happened between March 12 and July 8, 2006, at the Queens Museum of Art. Participants and co-organizers included the Arts and Social Justice Youth Program at QMA, Mexicanos Unidos de Queens, Onda Sonidera and Javier Juárez, and La Chula Baby (Laura Moreno) as well as sonidero artists from New York, New Jersey, and Mexico, among

them Diego Medina, Internacional Sonido Latino, Los Nukiis, Sen-
sación Fanny, Vikingo, Club Son Poquitos, Disneylandia, Ursus
Candela, Mercurio, Dania, Genesis 2, Magia Americana, Monarka,
Maxter Mix, Super Lucky, Caña Brava, Carismatico, Vicencio Mar-
quez y CMV, Baron Dandy, Machely, Marville, DJ Karissma y Juan
Vidal/Producciones Azteca. *Chapter 2: Tepito/CENART/Mexico City*
took place at the Centro Cultural Lagunilla-Tepito-Peralvillo and
the Centro Nacional de las Artes, Mexico City, on October 19 and
20, 2006. Participants and co-organizers included Transitio_mx 02:
Grace Quintanilla for Fronteras Nómadas el Festival Internacional
de Artes Electrónicas y Video del Centro Nacional de las Artes, Fun-
dación BBVA Bancomer y la Fundación Cultural México-Estados
Unidos de América, A.C., Mariana Delgado and Fran Ilich for
Proyecto Comunidades Transnacionales, Marco Ramírez for Cen-
tro Cultural Lagunilla-Tepito-Peralvillo, Roberto Martínez and all
the members of La Fraternidad Universal de Sonideros de México,
Carmen Jara, Onda Sonidera and Javier Juárez (New Jersey), Chula
Baby (Laura Moreno), Rogelio Silva Pallén y Producciones ANIMA.
Sonidero artists and scholars included Catherine Ragland, La Pequis,
Duende, Corimbó Chambelé, Tropical Caribe, Timoleón, Estereo
Mofles, Exitos, Cristalito Porfis, Son Latino, Yesga, Maravilloso,
Ciber, Enigma, Continental 2000, Caballero, Disco Móvil Tauro,
Master Denver, and Lupita La Cigarrita. *Chapter 3: North Carolina*
happened at the Arts Center, Carrboro, North Carolina, throughout
the month of March 2008. Participants and co-organizers included
Los Artistas Collective at the Arts Center (Carrboro), University of
North Carolina, Chapel Hill's Music Department and 2008 Festival
on the Hill, Duke University's Program in Latino/a Studies, Chula
Baby (Laura Moreno), Hermandad Sonidera, and Andrés Maqueda.
Sonidos, DJs, *clubes*, and scholars included Kelley Tatro, Catherine
Ragland, Bandolero, Travieso, Cumbiambero, DJ Taz, Enigma, La-
tido, Maracay, Consentido, Cobra, Forever, Junior, Tazmania, Cango,
Genesis 2, Pachanguero, Titanes del Sabor, Ilusión, Sibaney, Emi-
grante Latino, Rey Horóscopo, Ritmo y Son, Club Reyes de la Pre-
Salsa, and Club Son Poquitos.

TF: Can you tell us how you collaborated with the sonideros, organiza-
tions, and scholars on the projects?

PL: The nature of the collaborations has been as diverse as the soni-
dero networks themselves, but basically I have in all cases started by

A couple dancing in a mixed crowd of hundreds at El Centro Nacional de las Artes in Mexico City in the closing *sonidero* party of the Electronic Arts Festival, Transitio 2007, co-organized by Pedro Lasch. Photograph by Pedro Lasch.

making sure that I have a confirmed "official art venue" before I invite any local sonideros or scholars to participate in a new chapter of the project. The legitimizing power of such institutions is key to my project. Sonideros have long suffered from low self-esteem as cultural producers, not just vis-à-vis popular live bands and lip-synching pop celebrities, but also toward middle- and upper-class artists of all sorts and breeds. Contrary to many class clichés and expectations, for example, house and avant-garde, as well as pop electronic music, were introduced by Mexican sonideros and *discotecas móbiles* (a variant of sonido) to rural populations in the '80s and '90s long before these genres were established among the middle and upper urban classes through official radio stations. And while Tijuana-based Nortec as well as other groups from a more "professional" class have gotten much of the credit for the fusion of electronica and rural folk genres, sonideros have also been at the forefront of such experimental genres and their related technical savvy for decades. There has been little to no recognition of the sonideros' visionary labor and contributions in the institutions that write and archive the history of art and culture. For these and many other reasons, the first step for me is to share with a given set of sonidero networks any access I

may be given to the props and stages of the traditional and sanctified spaces of traditional art, as well as the often deceptively open and liberal venues that claim to celebrate contemporary social art practice.

I am in no way proposing a philanthropic Robin Hood model here or a feel-good collaborative art practice where for one day the artist finds the servant a seat at the table in the mansion. I simply cherish the notion that artists may take seriously the pleasure and responsibility of putting themselves and others in difficult yet intensely creative situations. If artists like Santiago Sierra use their work and social status to publicly exacerbate the social schisms between exploiters and exploited (always, curiously, on the territorial and discursive ground of the exploiter), I see the bulk of my collaborative proposals and projects as a chain of workshops to collectively produce tools and experiences that help us better understand our social relations and hopefully also create new kinds of social exchanges in the process, all the while confronting and including the tensions in society without falling into the extremes of always cynically excluding the same populations or celebrating them in their absence through a naïve utopianism. In the case of *Chapter 2: Tepito/*CENART*/Mexico City* of *Sonido Tianguis Transnacional*, for example, the rigid codes assigned to the racial and cultural signifiers of the postcolonial Mexican social hierarchy were intentionally frustrated by demonstrating and enacting the potential porosity of originally opposed cultural venues and their surrounding neighborhoods. (A daylong workshop and contemporary art event was held at a community center in the working-class neighborhood of Tepito *before* inviting everyone there to a grand popular sonidero party attended by about two thousand people from all walks of life in the exclusive and fortresslike Centro Nacional de las Artes of Mexico City the next day.) The collaborations were also based on switching and confusing the conventional roles of artistic and intellectual authority. (At the events I co-organized with Mariana Delgado and Marco Ramírez, all the public stages, academic podiums, and DJ booths were simultaneously shared by sonidero artists and promoters like Fajardo, Roberto Martínez, and Carmen Jara, as well as new-media artists like Fran Ilich and scholars like Catherine Ragland and Néstor García Canclini.) While it was at times incredibly chaotic, this mixed format certainly has helped create many of the most tense and exciting dialogues or experiences of this event and others like it. In this context

a panel may be as performative, quirky, and radical as any other contemporary artwork. In the most recent chapter, in North Carolina, I also unintentionally discovered a positive refinement to the mixed exhibition-panel-party format of the previous two chapters. Through years of creating these platforms for collective experimentation, I have finally accepted that the only way to prevent artists, academics, and intellectuals from speaking and behaving as experts even in front of people whose experiential knowledge far exceeds ours is by keeping us in the minority. At the North Carolina academic panel, for example, we had six representatives of different aspects of the sonidero movement speaking along with three scholars, myself included. It was my favorite sonidero panel so far. I am not sure, however, if this "minority rule" runs both ways, as I would probably hate to see a sonidero party taken over by academics, cultural critics, and contemporary visual artists.

While I generally love it, my only growing frustration with doing this kind of work in a context as grand and official as Mexico City is that through much of my experience in such settings, when artists refuse to take on highly spectacular and visible modes of artistic provocation such as Sierra's, their playful role can easily be subsumed and stifled by their function as bureaucratic organizers, fundraisers, and logistical mediators. An additional discouraging fact to those of us motivated by the search for deeper or more lasting exchanges is that the art market, as well as its connected biennial circuits, increasingly promotes those artists who jump across continents producing one social spectacle after another, often but not only through a so-called antagonistic art practice. While I actually support the use of provocation as a means to social discovery and transformation—and this practice is anything but new in art—the problem with many of these artworks is that in their aggressive pursuit of press on the artist and the organizers, they too often create irreparable damage to the social bonds that other people have been building with great care over long periods of time. Having said that, it is my view that we should not get distracted by the success afforded this kind of art. Not only should we not let their screams spoil our music, but to put it in Brecht's terms, I'd rather avoid making art whose main function is to decorate large sinking ships.

TC: I find your research of and practice within sonidero culture to be very compelling examples of process-based works that emerge from the

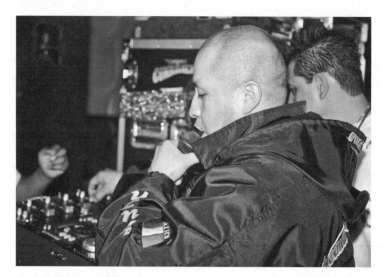

The DJ Joaquín Huerta (also known as Sonido Super Dengue) speaking over the music in typical *sonidero* fashion at the Arts Center, Carrboro, North Carolina, 2008. This insistent talking is a transnational communication system. Photograph by Pedro Lasch.

understanding of the ethical knowledge embedded in a particular community. It is clear that these projects amplify artistic intervention as an excuse to produce experiential platforms for social exchange and in so doing reorganize many of these cultural and political economies in order to produce new synergies and new methodologies to democratize information. One question that comes to mind again is: How is this knowledge being documented or translated beyond the event itself? Can an actual artistic language emerge from both the research and the event itself? It seems a relevant question to ask, mainly in the context of how the project becomes a tool to further disseminate the sonideros as a sort of GIS (geographic information system) of sociocultural flows (and beyond) that can allow the emergence of new sustainable practices and artistic agency.

PL: In the case of my collaborations with sonideros and their networks, the issue of representation is relatively simple. Unlike tradespeople and other groups who participate in the broader *Tianguis Transnacional*, sonideros are very conscious and proud of their artistic and cultural contributions. My collaborations with them should be seen mostly as an effort to establish useful links and work collectively on

useful translations across media and languages. What I am trying to say is that the best forms of representation I can think of visually, musically, or culturally already exist, and they are an integral part of sonidero culture itself. But your question seems to be pointing in another important direction. Basically I think the sonideros and their networks already have impressively sustainable practices and solid artistic agency. The idea of opening contemporary art circuits to them is surely to democratize these circuits, as you say, but it is mostly because contemporary art museums and cultural institutions need to pay attention to what sonideros and people like them are saying and doing. It is hard to find a working-class or immigrant neighborhood without its healthy number of DJ or sonidero representatives. Sadly, few of these neighborhoods' inhabitants know where any of their contemporary art institutions are, if any even exist. My hope is that artists and art institutions can learn from the sonideros and make themselves relevant beyond the already tiny and always shrinking public of contemporary art. We need to reinvent our art production systems so that they are not based on artists and curators being independently wealthy or on museums having to fundraise for millions with corporate givers or political figures. To do so we will need the knowledge gained by several generations of sonideros and their fans but also many other and very different kinds of cultural producers.

TC: Yes. As the artist in our time is also the designer of new conditions — and in this sense I personally do feel that this type of work benefits from the artist's role as logistical mediator — these new conditions can generate new institutional frameworks. This project's research and process opens these questions: Can artists and their contingent interventions into public domains help conceptualize alternative regulatory and economic policies benefiting transitional uses, anticipating and choreographing formal and informal interactions? Can the work produce new urban spaces defined by alternative scales of infrastructures (the micro) that intentionally support the unpredictability of these informal dynamics, negotiating the boundaries that separate public and private domains? Can these alternative modalities of public space also include economic support systems? Too many questions, but I cannot avoid perceiving in the comprehensiveness of the *Tianguis Transnacional* project a larger "operational diagram" that reorganizes and redistributes all these categories.

A poster designed by Producciones Alexander (Mexico City) for the final *sonidero* party co-organized by Pedro Lasch at the Arts Center in Carrboro, North Carolina, a key destination for Latin American immigration in the United States, 2008. Logo design is a key element of sonidero culture. Photograph by Pedro Lasch.

Part 2: Live Conversation

TF: Teddy, over the last two days we participated in the first Creative Time Summit on public and political art, where you presented your work. In light of all those discussions and the email conversation we had with Pedro, can you start our live conversation with a few comments on the informal? Do you see any risks in dealing with this realm of inquiry?

TC: Well, many people ask me, are you suggesting that your process is all about "the people"? I think this applies to Pedro's work as well. Lately there seems to be a suspicion from particular art criticism sectors about social practices that use people as material, suggesting that this is not art but social work, a bunch of do-gooders using people as props for projecting socially responsible art. I am at odds with this late defense of art for art's sake. I believe that, in our time, the autonomy of art needs to be questioned and that an expanded notion of art practice needs to be produced where artists can be the facilitators of new socioeconomic relations. The nuance here, though, has to do

with the nature of the engagement of people, of mass agency. More than using people as a symbolic prop for social practice, the image of the multitude, I am interested in operational dynamics: How does a community perform? What is behind our work is a desire to engage the translation of such operational dynamics into sustainable artistic practices. At the center of this desire is the need to translate the invisibility of the informal into new political and economic urban frameworks. This translation of the *procedures* of the informal as opposed to its *image* is what needs to be amplified. This is what I am truly interested in investigating in order to rethink what we mean by socioeconomic sustainability. Making some of these hidden performative dynamics visible, however, potentially puts at risk the magic of their clandestinity. This has been a critique whenever I mention dealing with these processes where social participation, volunteerism, and sweat equity can be translated into new economic policies that encroach on the rigidity of current exclusionary top-down lending systems. What I am suggesting is not to retreat into modes of representation, typical of the visual arts, but to *perform* the act of representation. In other words, not to focus on *what* to represent, but on *who* is to be represented, as Bruno Latour has pointed out.[4]

Many people in the neighborhoods that have become sites of my investigation are in a sense illegal. The hidden value of their everyday practices need not be exposed fully, but can be translated and represented by mediating agencies such as the many nongovernmental community-based entities operating at the level of those migrant neighborhoods. In this case Casa Familiar, the nonprofit where I am working in the border neighborhood of San Ysidro, serves the role of interlocutor, facilitating the translation of the socioeconomic intelligence embedded inside the community's informal transactions. It is important to point out the role of these agencies and their collaboration with artistic practices in producing tactics of translation that can make the informal, bottom-up urbanism particular to these environments into the device to transform top-down institutions. Their task is to incrementally formalize such invisible dynamics, making them sustainable in the long term, while camouflaging their very clandestine nature. All of this is a risk worth taking.

TF: The joint that Pedro designed has representational value. How important is it that it be put into practice as a practical object?

TC: My critique of the conditions of public art or art in general is that

At Political Equator 3, a cross-border mobile conference, Teddy Cruz (speaking at right) discusses the border in *Visualizing the Evidence of Coexistence*, Estudio Teddy Cruz, Center for Urban Ecologies, 2011. Photograph courtesy of Estudio Teddy Cruz.

there has been this overpowering and at times dominating role of the metaphorical. It seems to me that in many ways all that we are able to do is to represent or translate the issues of concern today, to raise awareness of the crisis into a kind of metaphorical image or object. But very seldom are we able to produce the methodologies that can allow us to transcend the problem and encroach on the conditions of power that produced it in the first place, changing the very structure of such institutions. I am interested in how the world becomes more operational, less embedded in systems of display and more in processes of production — in new conceptions of citizenship. Yesterday at the conference, Tania Bruguera said, "Let's restore Duchamp's urinal to the bathroom."[5] At some point the conceptual can illuminate a problem, but in art we are not able to really think of the processes that can produce new possibilities of *acting*. I am interested in finding a more functional relationship between artistic research and intervention and the construction of the city.

PL: I agree with a lot of what Teddy is saying. It is a little bit of a paradox that all these visual artists should be engaged in social processes. They have visual practices but, like me, they are also skeptical of what the

visual can accomplish. For example, I have taught a graduate seminar at Duke University for the last four years called "The Poverty of the Visual," and one of the things we examine is how, within certain social practices, visuality creates the largest traps. As people who love visuality, who love visual tools and visual media, how do we not fall into certain traps for the kind of political representation that Teddy's talking about? I feel it is a terrible shame that functionalism has such a bad historical reputation. Otherwise I would be happy to call myself a functionalist artist. Particularly with projects like *Tianguis Transnacional*, I prioritize function over image even if I am at the same time obsessed with formal fragments. I just think when you put certain things in the art context, people are very quick to focus only on the visual surface, because the art market always requires innovation, and it is the visuality that provides that innovation. So, yes, the work should be judged not only on its symbolic or visual basis but on how it actually functions in a given society. I am very frustrated with the hermeticism of certain art practices. For the art to escape this hermeticism it has to at least try to go beyond the symbolic.

TC: It is interesting because, at least in terms of architecture, if we were talking about this in the '80s it would sound awfully pragmatic and technocratic. Everybody was pursuing the allegorical dimension then, the role of poetics in shaping space and the city, formal attitudes; it was all about this autonomy of the formal. As we have been discussing, there is an ongoing polarity between the autonomy of architecture as a formal artifact versus the more relational, infrastructural dimension—where architecture is a device to get to something else, a support system that facilitates critical interfaces across complex relationships. Particularly in our time, there is a need to go beyond the symbolic, without of course losing its interpretative potential, but somehow grounding it in a deeper way within the drama of the everyday. But the point is that art has become almost useless, meaningless in terms of present sociopolitical and economic realities. For me it is essential to suggest that a foundation of artistic practice today can involve facilitating and producing new relationships across institutions, communities, and jurisdictions. Instead of simply speaking of political art, artists can construct the political, anticipating modes of action in transforming stagnant and exclusionary political and economic structures. So behind the need to restore Duchamp's urinal to the bathroom, as Tania said, there is the desire

to reclaim a notion that has been forbidden in the field of architecture: function, the functional connection between art and the everyday. The joint project for me, Pedro, was literally and figuratively a piece that opened the possibility to produce this connection. A minimal gesture for maximum effect, the piece produces these combinations of assembly; it is a functional device but simultaneously symbolic of the need to produce connections across these sectors.

TF: So the *use* of the joint is not only in the creation of more efficiently built informal markets, but in the crossing of boundaries in the process of the project, the complexity of social relationships necessary in navigating the design process. Even without the final moment in which you walk into a market that is made with the joint, there could be success in the relational process.

PL: Yes. The idea of the joint actually being produced at a massive scale in all these markets is hopelessly utopian, and I am aware of that. While I will continue working toward that goal, I think that the more modest function of the joint that you just described is as important. And those functions are in fact inseparable. The many years of work I have spent on this have produced the idea of the joint, but the premise has produced dialogues that are unimaginable outside this process.

I love Teddy's idea of the "contamination of the large by the small," because I think we have to find words and ideas that escape this notion of the formal and the informal, or maybe even the functional, because it has gotten such a bad reputation. So this idea of the small polluting the large is one way to escape both functionalism and the divide between the formal and informal. In a way, when we start using these terms we fall into misunderstandings and debates that are long past. Even where our practices might be innovative, the words haven't caught up yet.

TC: Yes, through this notion of "contaminating the large by the small" I am thinking that there is a need to speak of the informal in more complicated ways. In the context of today's discourse, the informal continues to be pushed aside. I mean, whenever we are restructuring or thinking of the city, we only think of infrastructure at a very large scale. In my mind the issue is to what degree the notion of infrastructure can be embedded in the informal, because infrastructure as an idea has to do with temporalities, with managing the flow of diverse forces in the city. Infrastructure is not just a freeway to handle the car traffic or a bridge. This kind of singularity of purpose of infra-

structure needs to be questioned, and we need to open up a conception of infrastructure understood as a differential system, negotiating and calibrating the large and the small, absorbing and supporting the kind of temporal social and economic dynamics embedded in informal economies and densities at the scale of communities. Of course that is very difficult to visualize for planners, because the task of translating this into physical terms sounds too fantastic. How can infrastructural surfaces modulate temporal conditions? So if the informal can be supported, what forms of the infrastructural conditions would allow that? What I mean in many ways about the contamination of the large by the small has really to do with these ideas, mainly in southern California, where I work, the capital of oil-hungry selfish urbanization, made of a super-size-me urbanism. The future of urbanism here depends on tactics of adaptation, transforming the large with the small. It has to do with strategies of encroachment into the largeness of its homogeneous sprawl. So this has to do with the question of how to inject programmatic complexity into normative urban development, but at the same time this pixelation of the large by the small has to do with the need to reconfigure property: how to produce different conceptions and categories of ownership, subdivided in smaller parcels; gradations of collectivity between public and private; and so on.

I love what you said in Bogotá, Pedro, about the social content of a sculpture, that a sculpture can be a social artifact. Similarly architecture can produce a language that makes those social relationships, programmatic relationships, transparent. The language of architecture does not need to be conceived a priori in terms of a formal device, in terms of its external formal aspects. It emerges from the process of negotiating programmatic contingencies. In other words, I am wondering again how a building, an artifact, becomes a trace of social exchange or of circulation through and across the complexity of this sort of programmatic differential.

This sort of thinking can remain abstract, of course, to the institutions of urban development. So I joined the Center City Development board of directors in San Diego because I wanted to test some of these ideas in the context of actual political debate. I was tired of hearing that they were going to be building plazas downtown to respond to the need for public space. The discussion I was trying to push was that what is important besides the shape of the plaza and

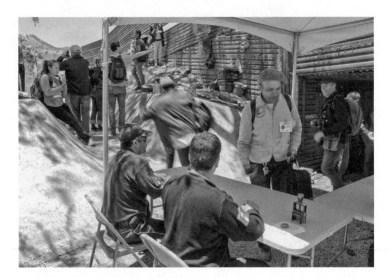

For Political Equator 3, Teddy Cruz invited participants to walk through a culvert built by Homeland Security to be met on the other side by Mexican Immigration. *A Border Crossing*, Estudio Teddy Cruz, Center for Urban Ecologies, 2011. Photograph courtesy of Estudio Teddy Cruz.

how it is going to be decorated with nice landscape and sculptures in order to call it public space, is in fact the tactical public programs that can surround it. In order to respond to the One Percent for Art, developers usually just hire the Jaime Carpenters of the world to come and put nice glass sculptures in their lobby or on the park instead of using that one percent to provide infrastructural raw space to public cultural institutions or grassroots arts organizations. If this was the case, the many community-based art practices that were homeless in downtown San Diego because of the inflated real estate bubble could have been brought into the mix of new development in order to inject cultural programming into those small parks, attracting different audiences from the communities around downtown. This relationship of program to space, of economy to space, to activate a different set of relations, this is what we are all talking about: how to design systems that amplify the proximity of what has been separated, calibrating relationships across different publics. That is the tactical aspect of the work.

TF: When you talk about the development of plazas in San Diego, I am reminded of Mike Davis and his discussion of the Latin Americaniza-

tion of American cities north of the border. Do you think that there is legitimacy in this sort of discussion to the different habits of sociality, and how might that be reflected in your work or the perception of your work?

TC: I think we need to shift the language. Many of us working on these issues tend to be forced into a niche, into certain categories that are very one-dimensional. In my case, people in architecture tend to call me "the shanty guy," and they think what we are proposing is to have farmers' markets and Mexicans everywhere, filling the plazas with the messiness of slums. I think that this Latin Americanization of the American city should speak less of packaging cultural identities through aesthetics only, but instead should be a way to consider how immigrants have begun to retrofit the American neighborhood with alternative economies, modes of sociability, and informal densities, providing the pathway toward the radical transformation of exclusionary zoning and lending.

PL: I am not sure about the term *Latin Americanization*; it is fascinating for sure—there's probably a whole other book there to be worked on. But in a book on cooperative art practices I could note that, out of necessity in many Latin American countries, in fact in third world countries in general, there are healthier social habits *because people need them to survive*. This might be too bold a proposition, but one of the ways I read the growing importance of social practices in contemporary art in Europe and the United States is that the third world is finally transforming the first world's art discourse. Most people read performance as an avant-garde U.S. [and] European art practice. I actually think of performance as Europeans and Americans finally understanding that the large majority of the world's art production has always been ephemeral and ritualistic and participatory. It is crucial to understand the contemporary interest in social art as part of a longer global history and not simply as a new period of the Western avant-garde. The implication of those different readings is huge.

TF: I think I agree, but I'm not sure Teddy does.

TC: No, I do. But I am thinking about this *Latin Americanization* term again, and the need to question it a bit in order to avoid falling prey to the politics of identity that have ghettoized this type of research. I talk often about immigrants retrofitting older neighborhoods in San Diego. As they plug in illegal densities and economies, they begin to pixelate what has been a homogeneous monoculture and mono-

program into a more complex interweaving of social and economic conditions. Many people who work with these notions of culturally specific urbanism end up focusing only on the iconographic vision, the way that cultures have moved in to install a different character and aesthetic sensibility. While this is essential, more fundamental is the possibility to uncover the hidden value of such pixelation, what this pixelation *does* to the neighborhood. The political economy of these neighborhoods' transformation is as essential an issue as what the buildings look like, in terms of identity: how immigrants build illegal granny flats to support an extended family; how small businesses replace car garages, encroach on alleys to produce informal economies in the shape of street markets, and blur private and public boundaries as they share resources, et cetera. These transactions and negotiations of boundaries are stronger than any kind of project of beautification that the iconographic reading tends to focus on, particularly because they are the basis for the possibility of long-term socioeconomic sustainability.

The evaluation of these different readings of a neighborhood's identity is essential at this moment of crisis, when we are searching for new models of possibility. As I mentioned before, these informal dynamics can truly become the device to produce a different idea of zoning and economy. I am interested in the idea of the immigrant neighborhood as a political unit from which new economies can emerge. So getting back to what Pedro was saying, yes, let's bring the performance of the territory back into our practice, because the territory is already performing. These environments are performing in particular and valuable ways. In this context it is not only the Latin Americanization of the American city that seems to be of interest here, but the whole influence of Latin America at this moment. No other continental sector in the world at this moment can compare to Latin America's political and economic reconfiguration of the last years. This is the only place in the world where entire governments are reorienting their gaze away from American-style globalization and instead seeing the potential of social networks and informal economies as the basis for constructing the contemporary city. While the architecture avant-garde flocked to Dubai and China in the last years of economic boom to build its dream castles, some of the most interesting projects having to do with flexible infrastructure,

From the Global Border to the Border Neighborhood, Estudio Teddy Cruz, Mark Gusmann, 2004. Estudio Teddy Cruz learns from the improvised and ingenious spatial tactics of the border neighborhood. Photograph courtesy of Estudio Teddy Cruz/Giacomo Castagnola.

new social and cultural institutions, and urban systems integrating formal and informal dynamics and mediating the large and the small were occurring in Latin America, in Medellín, Bogotá, and Curitiba. In my mind it is not the Latin Americanization of the American city, but how the strategies and tactics of governments and activists in Latin America begin to present a kind of reference to lead to change. This cements the idea that at this moment it is in places of scarcity, not places of abundance, that we will find some of the best practices and models of urbanization. In that sense the Latin Americanization of the United States should be seen as a phenomenon that shifts the discussion toward the best practices, the best models of urbanization that continue emerging somewhere else out of a condition of socio-economic emergency.

TF: How does this notion that the best practices are found in unconventional sources influence your work?

TC: The most essential inspiration of my work is the idea that the creative intelligence of the communities of practice I work with is already

embedded in those neighborhoods. *It is already present.* As architects and artists, we can become the sort of cultural pimps of such reality, facilitating the contact and translation with and of such intelligence. A question I always have: As artists, how are we the initiators of new agency? I want to imagine that we can be the ones initiating new institutions, new sustainable practices.

Unburning Freedom Hall and The Packer School Project

BRETT COOK, ARTIST, AND
MIERLE LADERMAN UKELES,
ARTIST

IN THE MASSIVE CATALOGUE for the exhibition *The Spiritual in Art: Abstract Painting, 1890–1985*, Donald Kuspit declares, "The 'spiritual' is a problem concept in contemporary art," pointing to what he sees as a seventy-five-year history of purging spiritual meaning from abstraction as the art establishment moved toward a more materialist practice, as exemplified by the paintings of Frank Stella.[1] Yet while the show and publication lamented the mainstream art historical disregard of spiritual trajectories, they were also symptoms of a changing climate. As Michael Brenson pointed out in his *New York Times* review, the show coincided with a set of other exhibitions in 1986 that began to unravel traditional readings of the progress of twentieth-century art. He saw *The Spiritual in Art* as a "direct challenge to the picture of modernism that has been painted by the Museum of Modern Art," by presenting an alternative to MoMA's "Cézanne-Picasso-Matisse axis."[2] There has been considerable water under the bridge since the mid-1980s, and, confirming Brenson's intuition that a shift was under way, the spiritual in art seems to no longer be "a problem concept"—even if parts of the art world remain reluctant to openly discuss it.

In the following interview Mierle Laderman Ukeles and Brett Cook address their well-developed spiritual practices. We discuss Ukeles's mammoth installation and site for dialogue at a museum and Cook's mindfulness and community-building project at a school. There are significant similarities in their projects: they emphasize repetition to encourage reflection and, as part of a cooperative system, ask a large number of participants to make small gestures and seek to reveal with their participant-partners that there is something larger than the individual. In Cook's work certain elements emerge more or less directly from practices of

mindfulness and meditation. Like Ernesto Pujol (chapter 3), Cook sees an unproblematic relationship between his personal spiritual practice and his art: it is all of a whole. There is a bit more ambivalence in eliding the two for Ukeles, who commenced her work in the intellectual climate of the late 1960s and early 1970s, which was somewhat cool to overt spiritualism. Systems aesthetics, feminist practice, and public art are not known as hotbeds of spiritualism. In other contexts Ukeles has created works that deal explicitly with Jewish themes, and she is happy to talk about Jewish spiritual sources, but she feels that the label "Jewish artist" is reductive, just as Lee Mingwei feels that being called a "Buddhist artist" sets a limit on his work's effect.

Both artists describe bringing their toolkits of engagement to the process. For Ukeles, this meant calling in the sanitation and fire departments to get started. For Cook, it meant certain graphic techniques as well as a set of mindfulness exercises. Ukeles's means and her materials are typically utilitarian, and her spirituality is often best expressed through collaborations with bulldozer operators. Cook, on the other hand, speaks of positive seeds of compassion, mindful creation of peace, and treating each person as irreplaceable. This overtly spiritual style mixes with his educational background and political bent, but it is expressed by an artist who has come of age at a time when he could be relaxed in his spiritual vocabulary.

———

BRETT COOK created a series in the 1980s of "nonpermissional" public works with spray paint that were somewhere between street art, graffiti, conceptual art, and colorful pointillist portraiture. He began to show in galleries and museums in the late 1980s, continuing his interest in aerosol art while building out the complexity of his cooperative practice. His artworks are often created through participatory, contemplative, and creative exercises that draw on his background as an educator and artist. Like Pedro Lasch (chapter 9), Cook often uses reflective materials such as Mylar as a way to bring the participant and the viewer into the image.

MIERLE LADERMAN UKELES is a pioneer of American social practice, having produced influential feminist works beginning in the late 1960s and important public artworks starting in the 1970s. In 1969 she wrote a manifesto titled "Maintenance Art — Proposal for an Exhibition," in which she assumed the role of "maintenance artist." In 1976 she became the un-

salaried artist in residence at New York City's Department of Sanitation, starting her work there with *Touch Sanitation*, which involved shaking hands with more than 8,500 workers in the department. Since that time she has created scores of public performances, museum exhibitions, and public artworks, often on themes of the environment and labor.

————

In May 2006 Ukeles and Cook recorded a discussion with Tom Finkelpearl in New York. The transcript was emailed back and forth from the East to the West Coast for a year and a half, taking its final form in fall 2007.

TOM FINKELPEARL: Let's start by each of you describing a single collaborative project you have worked on.

BRETT COOK: I would like to describe a project at a K-12 school called Packer Collegiate Institute in downtown Brooklyn. The school was interested in my work as an art maker and aware of my background in education, and they contacted me to help them cultivate community around cultural diversity. Packer is an independent school that considers itself intellectually and politically progressive, but it is a *private* school. So despite many wonderful efforts to nurture diversity, there are inherent challenges, like high tuition and the small school population, that support a culture of separation. The first questions that crossed my mind were: What are the aspirations of the community I am being invited to work with? What is it that the students, faculty, staff, parents, and caregivers need? What do the participants aspire to be? How can a creative project transcend class and culture to model the ideas of our interconnection? Initially my contacts at Packer were sending me school press, admissions documents, teaching materials, and evaluations for context. They had recently finished a multiyear assessment of their school, everything from its academic programs to operational budgets, and these findings deeply informed my understanding of the community and what would best complement everyone's health.

From the outset I aspired to listen to and act with the Packer community's desires and diverse input from the participants, rather than act on what I felt was interesting to me alone. The task of repairing a door is a good metaphor. Let's say I have to repair a door, and the tool that I am most comfortable with is a hammer. A ham-

In the courtyard at Packer Collegiate Academy, participants trace projections of student-drawn images on a community portrait. A picture of people in the process of drawing these images had already been projected from a Brett Cook drawing. Paint, pen, and acrylic on wood. Packer Collegiate Institute, Brooklyn, New York, 2006. Photograph by Brett Cook.

mer may not be the best tool to use. The problem might be better served by using sandpaper to make the door fit better. Or it may be best to use a screwdriver to take the door off the hinges. My process really starts by listening for the need and initiating conversations that help bring this out. From there I begin to ask, not how do I bring my tools to this project, but what are the tools that this particular collaboration demands? Through the information they had given me about Packer, months of writing back and forth and phone conversations, we were able to clarify what this need was and collaboratively craft our process.

And so our dialogue came to the idea that I would meet the students in their Carol Shen Gallery. The gallery has shown Picassos and some teachers' work, and it functioned as a traditional gallery separate from the flow of the school. Students occasionally visited the gallery with classes, but it wasn't a space they were intimate with or spent time in.

We began by scheduling all 942 students to work with me in the gallery space. The theme for our meetings was "What am I made

of?" I introduced the project through a teaching from the Viet-
namese Buddhist monk Thich Nhat Hanh. The suggestion is that if
you look deeply enough at a flower, you can understand it's made
of the sun because the flower needs the sun to grow, and you can
see that it's also made of clouds because it needs water to grow.
I would ask the students to continue telling me the things that
the flowers are made of, and inevitably it would be apparent that
flowers are made of many nonflower elements. I then asked them
to write about what they are made of. While some students were
literal in the descriptions of what they are made of—I am made of
bones—others expanded into more abstract things that they were
made of, like feelings or emotions.

Based on their "What I am made of" sentences, each participant
made art pieces on mirrored paper. These reflective creations might
have included clouds or trees or a Yankees T-shirt, and because of
the material, when we looked into them, we would see ourselves.
This exercise was the beginning of modeling the idea of intercon-
nection. With some of the older students, I used the metaphor of
the United States, whose population is largely made up of non–
United States elements. My underlying notion was to try to help
the students recognize themselves in each other.

Meanwhile, I took photographs of them working and later made
drawings from the photos. After digitally scanning some of the
images, we used acetates to create projections that an expanded
participant community of students, parents, faculty, and care-
givers traced on fabricated walls in the school's main courtyard.
We projected on a beautiful Brooklyn spring afternoon with food
and music. So the event itself became this episode of community
building where many different folks worked to touch the present
moment together. It was also another moment where participants
were reflecting back on what they were made of as they re-created
larger versions of other people's drawings. I think there is profun-
dity in this idea of repetition, and this event was one of many re-
curring facets or practices of this project.

When I think of a spiritual practice, I think of it as an opportu-
nity to cultivate an open-heartedness in myself, so that I can know
my own true nature and at the same time try to share what's best
in me with other people in the world. But it is a practice, and it's
something that I think improves with exercise.

Two students (right) in front of their portraits being colored by participants in *The Packer School Project*. An image of the girls appears in the upper right of the mural. Throughout two days much of the school community participated. Oil pastel on acrylic paint pen and wood. Packer Collegiate Institute, Brooklyn, New York, 2006. Photograph by Brett Cook.

Therefore many parts of this project were experiences of repetition, where people could practice contemplation or mindfulness or reflection together. This was a bit of a challenge for the community because, like so much of our society, it's a very vertical, competitive, and academic culture. A lot of these students are aspiring to attend Ivy League schools and then proceed to professions that are not built on notions of co-activity but are much more about individualism and independence. So even within the fabric of the school I got the sense that there was a certain kind of disconnection. People at Packer were preoccupied with what they were doing. The projection day was an unusual and meaningful episode where, regardless of how old they were, regardless of their status as faculty or students, everyone was working together in what was, in the end, also a party.

The day after the projection, students, faculty, and caregivers came together again and colored the walls with pastels. Some students colored within the lines of the drawings that they had made the previous day. Some participants decided to draw other things;

we intentionally left spaces open so that people could add what they wanted. We included students' writing and four blank large mirrored elements—again there was the repetition of this idea of reflection. At the end of the day, in the main public social space of the school, we were left with a large public document created initially from students' writings and drawings on mirror but expanded by and reflecting the hands of the community.

While the coloring was taking place, I took more pictures of the courtyard process and made drawings from those photographs. We then transformed the gallery again. First the gallery had been turned into a studio-classroom in which the students and others made their mirror pieces. Then we covered the walls in colored paper and projected more images from the mirror pieces, writings, and two images of people coloring the outside walls. Those two projections were ten feet high and thirty-six feet long.

The next day was titled the Day of Reflection. Participants started out doing exercises based on the methods of Jon Kabat-Zinn, who started the Stress Reduction Clinic in Worcester, Massachusetts. He uses accessible, general language as architecture for people to build a practice of mindfulness and meditation that is most typically associated with Buddhism. In this instance my method was slightly different from Kabat-Zinn's. I started by inviting everyone assembled, students, faculty, and staff, to close their eyes with their hands up until I placed something in their hands to hold. I asked them not to talk, to try to sit still, and to feel what I had given them. I asked, "Is it hard? Is it soft? Can you tell what it is? Does it bring back any memories to you? After holding it for a while, smell it. Does that bring any memories? What kinds of reactions do you feel from this exercise? Then just hold it on your lip and see if it causes any sensations." Then I had them chew it thirty times. And while they were chewing it, I was asking them to chew it very slowly, and think that this raisin (which they had recognized by now) started out as a seed and someone had to plant it, care for it, water it, and fertilize it. After some years, when the vines were ready to bear fruit, someone had to collect the grape by hand, and someone had to dry it, package it, process it, put it in a truck, and drive it across the country. And when it had come across the country, I had to go to a store where it was for sale and buy it. By this time most of the people started to swallow the raisin, and then I

Faculty, students, and staff eating raisins in the gallery as part of a mindfulness exercise in *The Packer School Project*. An image of people coloring the mural in the courtyard had been drawn on the left wall by Brett Cook. Packer Collegiate Institute, Brooklyn, New York, 2006. Photograph by Brett Cook.

asked them to feel it going through their body. What did it feel like going through their body? It feels like sugar, like energy.

TF: Was this a conscious loop back to the first question: What are you made of?

BC: It is repetition—creating a space where people practice pausing or reflecting on themselves in a way where they get in touch with what they are made of. One of the things that came up in people's sharing was that they seldom made time to stop and reflect on how they were living or what they were doing or how they were linked to each other. There is a Buddhist teaching that within us there are positive seeds and negative seeds. Some of the negative seeds might be fear, envy, anger, or resentment. Some of the positive seeds might be compassion, happiness, or love. I remember many times in my life I have nurtured my negative seeds and they grew strong because of ways I was with people, things that I ate, or things that I read about. And like any plant that grows stronger, it becomes difficult for other seeds around it to grow. So a part of these repetitions made the question "What am I made of?" famil-

Faculty, students, staff, and community members at the opening celebration of *The Packer School Project* coloring in the image of the people drawing in the courtyard. Throughout the event audio recordings of a community assessment of the project were playing. Packer Collegiate Institute, Brooklyn, New York, 2006. Photograph by Brett Cook.

iar. And part of the repetition was to nurture positive seeds within everyone involved—in this case the seeds of mindful breathing, deep listening, and reflection.

The Day of Reflection was an invitation to look deeply and meditate on what had happened so far from their perspective as participants. Each person recorded their reflections by responding to five specific questions, either as drawings or writings or through a recorded interview. The questions were:

- What does the gallery exhibition feel like?
- What does it feel like to be asked, "What are you made of?"
- Where do you see yourself in this project?
- What did it feel like to draw what we are made of and to color together?
- What have you learned by being involved in this project?

At the end of that day we were left with a transformed gallery that highlighted their words, drawings, and involvement in the project, through photo documentation of the process. There was

TEN SPIRITUALITY AND COOPERATION

a table with the five books of written reflections and audio of the students' reflections. From the beginning of the project a group of the older students filmed the process, and they made a video that was also playing in the space.

The next day was another day of reflection. Students and faculty were brought to the doorway that opened to the courtyard that was now framed by the large, collaboratively colored panels. It's an oval courtyard, and the participants walked out in two lines — one went to the left, one to the right — and as they curved around to the other end of the courtyard they began to pass each other in silence. It was another opportunity to reflect on what they had done, who their community is, and experience yet another exercise in recognizing difference while seeing themselves. While some of the participants may have seen it as a walking meditation, some of them may have thought it was just another exercise in educational assessment [*laughter*].

MIERLE LADERMAN UKELES: How long did this walking take?

BC: Maybe fifteen minutes. Then the final night was the exhibition opening. Students, teachers, administrators, family, and friends came to the gallery and colored the drawings on the walls, added to the reflection books, and saw the documentation of the process in the photos and video.

At the opening the director of the school said the project was the most inclusive and multidisciplinary experience that they ever had. It involved all ages from the lower, middle, and the upper schools; it involved the director of the school, the groundspeople, parents, caregivers, and faculty. From the beginning of the project I was looking for ways to deconstruct the hierarchies at the school. There were barriers of age, language, employment, class, and culture, creating this false assumption that some of us are somehow separate. Therefore much of my process was just trying to treat every person as gifted, treat every person as irreplaceable, and honor every person's contributions as important.

In any case the piece continued to live after the closing date and continued to change because we left the pastels out. And people did go back because there was connection from their involvement.

When I think about collaboration, I think we all have different expertise, so in certain areas a fourth grader can have much more expertise than I do because they go to that school. At another mo-

ment, if it is about creating a container for collaboration or reflection, that might be something I have more expertise in. My contribution included developing the conceptual structure of the project, but it also included artistic production and technical decisions. Once we identified the needs, I proposed many of the tools—oil pastels, mirrored paper, raisins—the scale of the works, and methods of documenting the process. These are decisions based on years of experience and practice.

TF: Another thing you bring to the project is the notion of mindfulness, repetition—kind of a Buddhist overlay?

BC: Well, yes, I do have a history with Buddhism, but I am also a Hindu and Christian and other things. I've found that mindfulness occurs in many different ways within various religious and spiritual traditions. Raised as a Catholic, I can remember practicing types of mindfulness through prayer. As a person who studies shamanism, I can recognize aspects of mindfulness in *temescal* and some of the rituals I experienced while I lived in Oaxaca. As a yogi, I recognize mindfulness in my daily asana practice. As a Buddhist, I see mindfulness as coming from a broad and long tradition, which some describe as a method of cultivating awareness. And in a secular way awareness is healthy. Mindfulness is something that creates peace; with more awareness I am more conscious of decisions that I make to not hurt myself and other people. I think that kind of awareness can also be tangible: I have grown more aware, more in tune with what's happening in the classroom, in the workplace, in the neighborhood, in the world.

TF: Thanks, Brett. We can go into more depth on these issues in a bit, but let's turn to Mierle now and hear about a collaborative project.

MLU: I want to talk about a work I did in Los Angeles between 1995 and 1997 called *Unburning Freedom Hall*. I was invited by the Los Angeles Museum of Contemporary Art to be in a group show organized by Julie Lazar and you, Tom. The premise of the show was to deal with issues of public culture in the museum. A question was to be raised: Can the museum be a site for creating public art? This is a pretty radical notion—perhaps it was more radical in 1995 than now. It was exceptional because the project was not to be situated in the public programs or education wing of the museum, but in the main galleries, in the art space proper. I came to Los Angeles from New York City. I had never been to Los Angeles before. I

didn't come with images in my mind of the famous "Hollywood" sign or the movies; I came with the image of 1992, of the uprising. I learned that it had been the worst civil disturbance in the history of the United States. One doesn't think of L.A. as being the center of the civil rights struggle, yet the most destruction from racial hatred had happened in Los Angeles. I found this both fascinating and frightening. I wanted to deal with issues of urban fire and of the possible destruction of the city. But I didn't want to deal with this subject frontally, as if I'm pointing a finger at L.A., because I felt that would be a kind of insult — a person coming from outside, the New Yorker coming to Los Angeles, to say you have this big problem. Furthermore it's a problem not only in Los Angeles, but all over the United States.

So this is what happened when I arrived at the first meeting of the artists, the curators, and some museum people. We gather in a building of the museum called the Geffen Contemporary, an old industrial building that has a great floor load, which automatically makes me love the building because you can bring trucks inside! Also the industrial garage doors all around the building open all the way up to the streets, so you can bring in many trucks at the same time. When I talked about certain magnitude of tonnage, it didn't make people nervous the way it usually does. They didn't get all shook up; they could handle it. Then I walked farther inside, and there was a tremendous amount of light coming from up high from multiple skylights; the sunlight was just flooding into this huge space. It transfixed me. I had come there thinking about 1992, how I might deal with this. And standing in the pool of light, I blurted out, "This is a place to unburn Freedom Hall." I wasn't planning to say that. It just came out of me.

Now Freedom Hall was a story sitting in my head for many, many years. I learned about it in a film produced and directed by Louis Massiah, a key documentary filmmaker in Philadelphia who had featured my work in his 1985 film *Trash*. He showed me this new film for Philadelphia public television called *The Bombing of Osage Avenue*. The bombing of the title was a tragic chapter in American history, when the government actually dropped bombs from the air onto a residential neighborhood in Philadelphia on May 13, 1985, while trying to evict an African American black nationalist group called MOVE from a house they were occupying there.

The result of this frantic military action aimed at one house was a
fire that burned down and destroyed sixty-one houses in a long-
established African American middle-class neighborhood, killing
eleven people in the process. In his film Louis made a comparison
between this contemporary event and what happened more than a
century earlier in Philadelphia by telling the story of Freedom Hall.

This is the story. In 1838 there were three groups of people that
could not rent a room for a meeting—even though Philadelphia is
a city that contains many of the icons of American democracy, like
the Liberty Bell and Independence Hall. The groups were women
seeking a vote, African Americans seeking full freedom, and abo-
litionists seeking the end of slavery. So they got together and de-
cided to join forces. The groups organized a public subscription
and got two thousand people to donate $20 each, and they built
their own place for their own meetings. Its name was Pennsylva-
nia Hall, but they called it Freedom Hall. Its sole purpose was to
be a temple of free speech. What got me about the place was they
completed it with the finest furnishings and draperies, materials
of the same quality as Independence Hall nearby. With great am-
bition, they were creating a place to last, a place to plan the future,
believing their vision was what America could be. They opened the
building on November 14, 1838, shifting back from the joint action
to pursue each group's individual goals. The women had a confer-
ence, the African Americans had a conference, and the abolitionists
had a conference, all in the same place at the same time. But the
very day that it opened, a mob gathered outside and started throw-
ing stones and breaking the many windows of Pennsylvania Hall.
The people inside were very frightened. They went to the mayor.
They said to Mayor Swift, "You've got to help us. The mob is not
going away." He said, "I will help you, let's go back." He went with
them to Pennsylvania Hall. He said, "Let's cancel all the meetings
tonight and calm everything down." They accepted it. Each group
cancelled all their meetings. They left the building and handed him
the key. He locked the door. Then he turned to the mob and said,
"You will be my police." Guess what happened? The mob burned
the building down. Freedom Hall had lasted for four days. It was
burned on November 17, 1838. They did not rebuild it.

So I thought I would try to rebuild a coalition as a solid support
system and ask its members to help open the project out to the

public at large. I wanted to create an invitation: Let's unburn Freedom Hall. To me, art has a magical capability to rewrite history, to play it again, hoping it can come out right this time.

What is my coalition? My coalition is about the city, because I am attached to the notion that our city is our common home. I'm very urban, and I see the city as an ecological entity. The density of the city is a good thing; it conserves a lot of energy. If you can work out the relationships among the people, you don't waste a lot of space and other resources. Yes, the city can be our home. That's where I started from. I felt that in 1992 in Los Angeles, a fundamental crisis had occurred, way beyond material losses. The social contract itself, the basis of the city, had been ruptured. Because of that rupture it was up to the people in Los Angeles to make a fundamental decision, as if starting over, to say whether they were going to keep the city. That means the public needed to make a decision that they were not going to keep burning it down.

Now, who knows how to keep the city? Who are the models? The first people that I invited into this coalition were sanitation workers, who I believe represent the first cultural system of the city; without sanitation workers, you can't be in the present. The job of sanitation is to remove yesterday, so that when you emerge in the morning, you are in the present; you are not walking around in yesterday. Second, who keeps the city open? The street maintenance workers. They clear the way so you can move throughout; you are not stuck. And third, who keeps the city? The firefighters, because they protect you and save you. These are the three groups that form the basis of the social contract that underlies our common home. Without these workers willing to do endless work, we can't have a city. I wanted to make it manifest that all the rest of the citizens are dependent on these three groups; we are already in a coalition with them. And then I also added high school kids and their teachers, because I felt that if we're looking at a story going all the way back to 1838, I really want to project its meaning forward into the future. How do you project something into the future? You do it through children, the next generation. I wanted to ask each of these groups how to unburn Freedom Hall. They would set the stage. Then I could invite in everyone else.

I asked people to make offerings that are *Unburnings* for an artwork that would end up in the museum. I never defined *unburning*.

Ever. I felt that I would tell the story that came from within me, but because they are in Los Angeles, because they lived through 1992, I cannot tell them about those fires. They lived them. It was for them to express if they chose to. I could provide materials and vessels to hold the offerings and the promise that this will become part of a huge environment in the museum that they can participate in.

In the spirit of the original coalition, I grew the artwork out of five kinds of collaborations. The first was a collaboration with the museum itself and with city officials. I insisted that because the story I was dealing with is part of reality, I needed to push this re-created story to operate in a zone of reality, so it had to occur in a real work time, and it had to take place in real workspace. It's not about a leisure-time activity; it's not something you make when you are all finished doing your real thing. I wanted to penetrate reality itself. Since these are the people who make the city and who keep the city, for them to create *Unburnings*, to shift history, it has to occur in their zone of reality.

I went back to New York. I went to the commissioner of the sanitation department, where I am artist in residence. I asked him to write a letter on my behalf to his counterparts, to the Los Angeles commissioners of sanitation, streets, fire, and the head of schools—to say we know Ukeles, and she is not some lunatic. We trust her. We've done very large works with her. Would you please cooperate with her? They all responded yes. Then I began the detail work with the museum's curator, Julie Lazar. Together we went into negotiations with the city. At first it was very, very tough to say to the sanitation department, the streets department, and the fire department, "We want you to give us time in your real workday"—to do what? To make art. And we also want to set up art studios right next to the firetrucks in the firehouse and the street maintenance trucks in the yard. That is the real work time and real workspace.

The negotiations with the fire department were the toughest, you can imagine, because the fire department in 1992 had its own chapter. There was almost a war between the fire department and the police department. The fire department felt abandoned by the police, from whom they needed protection. People in the fire department turned off the truck's lights when they went to put out a fire. Why? Because people were shooting at them. Perceived as representatives of the city, regardless of their helping role, they were

seen as the enemy. It was a very, very difficult moment. So an artist is coming to try to deal with this subject? You can imagine the fire department was not too happy about opening up the whole subject all over again.

However, as luck would have it, the day Julie Lazar and I had a meeting with the head of the fire department was the same day that the women firefighters had brought a class-action suit against the department for discriminating against women. The bosses at headquarters had just been beaten up by the press along with the newly litigious females in the department, and who walks in? A woman curator and a woman artist. I remember these guys in the fire department glancing at us in the strangest way as we entered. At first it sounded like they were getting ready to cancel our meeting. Exhausted from the media zoo, they understood that these two women coming in were asking for things that would play out in full public view—and they caved in. They said, "Whatever you want, just whatever you want." I insisted on going to several firehouses, not just one, and being able to come back more than once, so that I wouldn't simply ask people to be creative on the spot. So I could tell them the story of Freedom Hall and there would be time for it to settle in. "You can make these at home. Think about it, and I will be back." This repetitive access was a very important element.

The facts of the piece after all the negotiations with four public agencies were as follows: I made twenty-seven journeys to different work sites around the city, starting in South Central L.A., the epicenter of the events of 1992, and then widening it out. The city donated 690 work hours for this project, which is really significant. We worked with 301 city workers in these different places. Five schools and one art center gave 961 hours of learning time.

The second collaboration was with the recycling industry. I selected glass as the main material for these reasons: glass is transparent; glass is ubiquitous; glass is a classic recyclable. Glass can start out as a vessel, be used or broken, go into fire and not be destroyed; rather it can come back to be what it was: a jar to be used again. I wanted to use glass in all its manifestations: as liquid melting in the fire, as whole glass formed into jars and bottles, and as glass that's shattered, which at tremendous scale can become a mountainous pile like sand and gravel and the earth itself. The good part about glass is it can last for thousands of years. The bad part

Installing *Unburning Freedom Hall*, Los Angeles Museum of Contemporary Art, 1997. Front left to right: front-loader, recycling truck, conveyer belt to pour glass and create the mounds. In the center Mierle Laderman Ukeles consults with the manager of the recycling yard and an art handler from MoCA. John Bowsher, MoCA installation designer, is in the background. Courtesy of Ronald Feldman Fine Arts.

about glass is that physically it's not flexible; because it is so brittle, it can easily shatter. I liked the complexity of the material: so strong yet so vulnerable.

Through negotiations with L.A.'s recycling industry and luck in meeting the right directors and employees who were interested in public culture, in my particular piece, and in public outreach, I got a huge donation, actually a long-term loan for the duration of the exhibition, of 540 tons of glass from a local recycling facility near the museum. That is over one million pounds of shattered glass. I was thrilled because this particular museum, sited in this old industrial building, could really handle the weight. They also committed to allow me to direct the compositional placement of the glass into mounds using the same heavy machinery that they use in the glass recycling yard. We were, in effect, to create a mobile recycling operation in the museum.

The third collaboration was with city workers and students outside the museum. With virtually all the staff from the museum's education department we set up art-making studios in sanitation

Members of the City of Los Angeles Department of Transportation Street Maintenance Division making the *Unburnings* after roll call from 6 to 7 a.m. The studio was set up in the truck yard. *Unburning Freedom Hall*, Los Angeles Museum of Contemporary Art, 1997. Courtesy of Ronald Feldman Fine Arts.

and street maintenance yards and fire stations that opened at 6 a.m. For my first visit I gave the workers the same kind of illustrated presentation that I give in universities or museums, only when I showed other works that involved service workers doing work like themselves yet living in New York, England, Holland, or France, it had a special resonance. Then we talked about making *Unburnings*. I invited them to participate and promised that whatever they made would become part of the work in the museum. I invited them to either make the art at work when I would return or make it privately at home and bring it in. The deal was that we could have an hour of work time, but the time was from 6 to 7 a.m. Actually it made a lot of sense. That's when people gathered in the yards to begin the first hour of work. When I came back for a second visit, we set up large studios right next to the firetrucks and the asphalt trucks and inside in the sanitation sections. We provided transparent vessels, simple ones: pickle jars, mayo and olive jars, and many kinds of materials.

"They'll never do it," the bosses said. Well, during these journeys around the city, they made 720 *Unburnings*. Here are some *Unburnings*:

A little bed with a pink stuffed satin quilt and a gray pillow built inside a big mayo jar — the bottle becoming a landscape. In front of the vessel is a sign that reads, "People dream in a bed. But less fortunate people don't have a bed. So I am offering this bed. This way everyone in the world will dream in a bed. (Not a poem) MARVIN GARCIA." He was a high school student in South Central L.A.

Another: A firefighter called E.Q. was killed in the line of duty. The captain explained to me, "His brother, also a firefighter here, still can't talk about it." This brother, the creator, never spoke to me, but he heard the story of Freedom Hall and he heard my invitation for him to participate. During my second visit to the firehouse, on the counter of the firehouse kitchen, he gently set down an incredible *Unburning* and walked out. No words passed between us. Up against the inside surface of one side of the glass vessel was a memorial card with a picture of his brother's funeral with a long line of attending firefighters. On the other side of the vessel, the other side of the memorial card showed a close-up of the deceased firefighter, Leroy McKnight, a huge smiling man, looking like he hadn't a care in the world. In the center, standing up, was Leroy McKnight's glove. It is a really big deal for firefighters to give up their gloves, because that's what protects them going into the fire. Written in big black letters on the fawn-colored leather glove were the letters E.Q. He was so strong, everyone called him Earthquake. Nested deep inside the shelter of the glove was his Bible. The creator's response to my invitation was to give me an offering with his deceased brother's personal Bible and his name glove to be part of the art. I have no words for that. That's what art represented for him. Art gave his brother a chance to be honored in the city to which he gave his life, not a name on a plaque, but through an artwork for a big museum. I don't know if he, the unburner, was an art lover, but he believed that the artwork and the invitation to place this artwork in the museum was a sufficient way to truly honor E.Q. With this *Unburning*, people can feel that art has enormous significance.

And finally, the sanitation worker I call "the guy on the threshold." I love these people who stay on the edge. He never came into the space during my visits to his garage. At the last moment he plunked down his *Unburning*: his work glove twisted and twisted, writhing against the confines of the glass vessel. "Put some color on

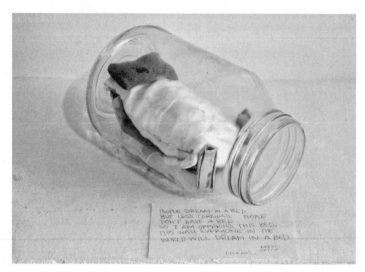

Marvin Garcia, a student at Los Angeles South Central High School, created this *Unburning* for *Unburning Freedom Hall*, Los Angeles Museum of Contemporary Art, 1997. "People dream in a bed. But less fortunate people don't have a bed so I am offering this bed. This way everyone in the world will dream in a bed. (Not a poem) MARVIN GARCIA." Courtesy of Ronald Feldman Fine Arts.

it," his super said. "It's so dull." "Nope," said the sanitation worker. "That's my art." And he walked out.

In one of the high schools there were over a hundred students, which was pretty frightening. We set up a huge array of materials, all free for the taking, like a giant swap meet, in three classrooms. The students went shopping from room to room. Contrary to what the teachers said would happen, they made so many *Unburnings* that we had to stop them from making any more and shoo them out. It was like a fountain of making. Also, in three schools I asked for and got permission to light a fire in the courtyard of the school. I wanted to push the complex nature of fire, the notion that fire can be controlled and fire can be healing, not just destructive. Many of these kids came from South Central L.A. and had personal experiences at home and at school of the events of 1992. I asked them to think of things that they hated and write them down on a piece of paper and burn them.

The fourth collaboration was with visitors to the exhibition inside the museum. All of these *Unburnings* were brought into the museum and placed in large tall shelves. On some of the shelves,

small monitors played my videos tracking and listening to many of these same people talking about their *Unburnings*. After they were in place, twenty-eight tractor-trailers brought in the 540 tons of crushed glass we had borrowed. The challenging task of choreographing the twenty-eight trailers' rising hoppers so they didn't crash into the ceiling struts and yet dumped their entire payloads—without crashing into each other—was performed by an old-time expert recycling-yard super. He conducted the trucks as if they were an orchestra. After that an on-site recycling yard was set up with conveyer belts. Directing this traditional pile-making operation, I made a series of huge mounds that formed a kind of landscape surrounding an empty space in the center. The biggest mound was three hundred tons by itself. In one area, working intensively with one bulldozer operator, we slowly constructed a series of smaller mounds from the ground up—he working so delicately that he was shaking off sheer veils of individual morsels of glass from his blade. We worked so closely, it was if we were one continuous entity: me, him, the dozer. He told me that, despite the fact that he had worked in a recycling yard for the past ten years, he had never seen his material like that before.

In the open center of the mounds was the Hearth. At the entrance to the Hearth, a monitor with headphones showed my video work that included the story of Freedom Hall and my invitation for people to participate here. Suspended just over the Hearth was a symbolic yet functional table, a floating circle of glass, a form of perfection, yet imperfect and incomplete because the glass surrounded an absence: it had a hole in the center. It was made of one-and-a-half-inch-thick plate glass covered with a skin of quarter-inch cobalt-blue stained glass. This table was suspended thirty-six feet from the ceiling and cabled to the ground. Sixteen specially commissioned chairs surrounded the table. It was the Peace Table, a place for visitors to join the revived coalition that I tried to create, by making their own *Unburnings*.

Off to the side I made another small steel table with a glass-phalt top for any two people who wanted more privacy. I hoped that people who entered the installation would be inspired by the hundreds of offerings collected on my journeys around the city, now surrounding them; select a vessel, take a seat at the table, join in, and continue to make *Unburnings*. This happened beyond my

expectations. Over a thousand *Unburnings* were made during the four months of the exhibition at MoCA, March 16 to July 6, 1997. These were mounted on the shelves daily. By the end there were so many *Unburnings* it was difficult to find a place for them on the shelves.

And then the final collaboration was what I called a gathering of Peace Builders. The museum helped me write letters to people in local communities it had identified all over Los Angeles. We asked them to please nominate the most important local Peace Builders in their community. More than a hundred people were nominated. I hoped the museum would allow me to have a peace talk every day, or every week, or a hundred peace talks. I had reached an institutional and budget limit here. We ended up with eight peace talks — eight different ways to think about peace at different scales: Conflict Resolution; Inner Peace; Peace and the Land; Environmental Neighborhoods; Peace, Home, and the Family; Peace and Interreligious Coalitions; City Work as Peace Building Work; Multiculturalism and Neighborhood.

They were all held around the Peace Table floating in this landscape of shattered glass. In a strange way the scale of the Peace Table shifted with each talk; sometimes it seemed huge, and sometimes it became intimate. But throughout I was trying to set up a situation where these questions would rise up like the peaks of glass. Could this gathering in the city lead to wholeness, or would it be shattered once again, as it was in Philadelphia? What are we going to do? Are we going to get together, or are we going to keep burning down the city?

One of the peace talks was about conflict resolution. A very tiny woman came in carrying an offering that she had made and sat down at the table to lead the peace talk. She began by talking about her own *Unburning*. Her name is Marcia Choo. When the whole thing blew up in 1992, she simply went out in all the chaos and created something called the Asian–African American Peace Coalition. She did it herself and gathered her friends. She told me that she lost twelve pounds within the first week. It was agony, with terrible confrontation between the Asian communities and the African American communities, both of whom were living and working in the same area. Her response was to say, "This is ridiculous. We have to work this out." In the museum at the table she said, "I

Museum visitors observing one of eight peace talks in *Unburning Freedom Hall*, Los Angeles Museum of Contemporary Art, 1997. Present were the MoCA curator Julie Lazar and the artist Mel Chin, along with around forty participants. Photograph by Lyle Ashton Harris. Courtesy of Ronald Feldman Fine Arts.

have had a knot in my chest for five years, and it's unknotting itself, right here at this peace talk." I almost fainted. It was so amazing to me: here is the woman who in the middle of hell had succeeded in creating an effective peace coalition and yet something in her wasn't resolved. It was art, the freedom in the art invitation that enabled her to let it go. Her sister, sitting at the opposite side of the table, burst out crying and said, "Marcia, I never was able to tell you how much I admire you."

TF: Can you talk a little about the religious and spiritual dimension of this project?

MLU: To make this piece I had to stay in Los Angeles for a really long time. I was very lonesome, and it was hard. It was still scary even though I've done this sort of work in a lot of places over many years, where I didn't know what would happen with the strangers that I was inviting to create the work with me. Every time I went into another sanitation garage during *Touch Sanitation* I found it really scary because I don't know the people and they don't know me. I can do this work all week, but then I withdraw and don't work on the Sabbath. Brett talked about reflection, taking time for reflec-

tion. I do that one day every week. We prepare food at our home in advance, then we turn off the house phone, the cell phones, and the computer, and you can be in a state of being—that's Sabbath. So here I am by myself in L.A., walking home from synagogue on a Sabbath, and I'm asking myself, What are you doing? I'm asking this even though by this time the piece was almost two-thirds done. What is this about? Why all this tonnage? Why do you have to go through all of this stuff with people you don't know? Why glass? Why jars—mayo, pickles, and olives? Why call the jars "vessels"? Why shattered glass? So many questions, yet I have been so utterly committed to this thing as it was on its way to being finished. And then! No answers. Rather, another story suddenly pops up in front of my face. I recognize this story, like, "Oh, so it's you! You're here!" It is a story from the Kabala, a Jewish mystical text about the creation of the world, that is always living in me.

Here is the story: In the beginning everything was perfect, perfect vessels, and the Divine was everywhere. Everywhere was the Divine. In an act of love—was it loneliness for us?—the Divine did something called *Tzim-tzum*, which means "constriction." The Divine constricted the Divine, so that there could be room for life, for human life. But in that act of love, a move of constriction, a blazing fire broke out. It was so strong that the vessels could not contain the fire, and all the vessels shattered. The pieces of the perfect vessels fell, spread out all over the world. Each had an outer husk of the trauma of rupture, even evil, but inside there was a spark of divine light. Every single shattered morsel, all over this world, is filled with divine light. That is a metaphor that every person in the world is filled with the divine light. And our job in the world, the work of the world, is called *Tikkun*: to bring the vessels back again, to repair and to re-create them. This story is part of me. I love this story so much because there is so much hope in it: pure vessels, fire, shattering, evil covering divine light, hidden light, and our power to restore. So walking down the street on the Sabbath, I thought, That's what I'm trying to do! Repair, restore, rebuild through this world of glass. The immense mounds of shattered glass can come back as usable vessels only through our work together, and strangely through putting them back into fire that can also shift to destruction. How shocking the closeness of what I had tried to do and this story. But it is not as if I set out to *illus-*

trate the story when I was invited to be in the show; I wasn't even
aware that it was operating in me. But I find it very curious because
it resonated so strongly.

TF: And you never mentioned this to anybody at the time. I was one
of the curators of that show, and I never heard this until now. You
know, I have noticed a reluctance on the part of artists — less so for
you two — to acknowledge the spiritual basis of the works or to talk
about it in public.

BC: I have heard the Buddhist writer and scholar Robert Thurman
speak about our society as spiritually bankrupt, where we are un-
able to see things through a lens of spirituality. And yet so much
creation comes from the place that could be called divine. Divinity
is a metaphor for creating things that are bigger than us or connect-
ing to something that is bigger than ourselves.

MLU: When I call a city our common home, I'm already projecting an
image of something bigger than individuals. I think you could say,
as Robert Thurman says, that the society is spiritually bankrupt.
But I believe that you can never, never, never thoroughly know
about another human being, any human being, what another
human being can create. I have been utterly amazed by people. But
I think that art can do this. Art can create a situation where a person
feels someone is listening to them, or there is a receptivity. That's all
they need, and an outcome and an offering of huge spiritual depth
is possible.

TF: Well, according to all the polls, America is a country of very reli-
gious people. But the art world is very hesitant to talk about spiri-
tuality.

BC: This may be an issue of semantics, but religion and spirituality to
me are two different things.

TF: You can be spiritually bankrupt and still have a lot of religious
people in the country?

MLU: Oddly [*laughs*].

BC: I think it's true. I agree with Mierle that spiritual potential is in all
of us. I think spirituality manifests regularly, but I don't think we
have a lot of practice in being awake enough to witness it.

MLU: When you talk about practice, you can have aspirations for any-
thing, but to make space for practice, trying things, trying them
again — that's work. I have a fanatical devotion to the notion that
it's through work that we can work things out. I think that's close to

spiritual practice. It's not something we can just say, but we can try to open up possibilities in which you are safe to try and try again.

BC: And I would say a part of my practice has cultivated less preoccupation with authorship or ego. As a member of a culture ruled through hierarchy and a profession deeply rooted in objects from one master, the sharing credit with others is an ongoing personal transformation. A single expert or individually divine object becomes slippery when the art is made by a bunch of kids, literally by their hands. With more awareness of the conceptual rigor and value of an inclusive process, there is still the ability to recognize individual contribution, as well as the irreplaceable contribution of everyone involved, and the subsequent results are greater than any one.

TF: I have been to Quaker meetings through my son's school, Friends Seminary, and at the meeting there is literally nobody in charge. The whole community is equal; anybody can get up and speak his or her mind on any topic. Of course, there is a strong group dynamic that determines the sorts of issues people bring up. I feel that the Quaker meeting is an interesting comparison for socially collaborative practice. In both of your descriptions there are collaborative elements and there are noncollaborative elements. The Quaker meeting has its parameters: it takes place in a specially designed space, within a group of "friends" who are dedicated to principles such as nonviolence, at a particular time and day, including the famous reflective silence, et cetera. In the projects you described, as the artist you created spaces for community interaction. But the conceptual, physical, artistic, spiritual spaces in your projects were carefully created by you to set up the interactions. Within the context you then asked the pregnant question, and let the interactions begin. Right? You both had a question at the beginning: "Will you help unburn Freedom Hall?" and "What are you made of?"

MLU: That's true.

BC: In Mierle's project there was so much work even before the moment in which you ask for the *Unburning*. The final object wasn't how you started talking about your process. You started talking about Freedom Hall to categorize or frame the question. I think this sort of initial intensive setup is critical in my own creative process as well.

MLU: I think that the pregnant question is actually a way for the artist to

start with an idea and then take it outside your own ego and move it into the public sphere. Even though you've identified the first move, the answers reside outside the ego of the artist. However, there are authoring moves, directing moves, judgments that I don't hesitate to make because I feel that's my job as the artist. For example, when the museum staff brought in materials from their art education program to make the *Unburnings*, I literally threw out 90 percent of what they brought in, because I thought it was pushing a certain specific material agenda onto the people.

BC: There is skill in the crafting of a question so that it can be embraced broadly, so they can make it their own. And another part I think is choosing materials that people feel comfortable with. How can I choose something that inspires the people I'm working with? In my case none of the students or even the art teachers on the faculty were familiar with mirror paper, so the material alone was exciting to them as a springboard to go from.

MLU: Why do you use the reflective materials?

BC: Among many reasons, mirrored surfaces are engines of introspection. They are a literal representation of reflection. Through two dimensions mirrors reflect ourselves and our interconnectedness with all things.

MLU: It reminds me of a piece I made called *The Social Mirror*, in which I covered the body of a New York City garbage-collection truck entirely with mirror, so that it actually captures people on the street within its garbage-truck frame. And there they are. But it's not just you. It's others. The reflectivity and transparency are real, spiritual materials.

TF: Mierle, there is a saying: Why is it that Jews always answer a question with a question? Answer: Well, what do you think?

MLU: [*laughs*]

TF: There is a Jewish tradition of dialogue, endless discussion, like Freud, the talk doctor. I'm talking about a culture of Judaism, not the religion. Freud was the expert active listener who created a structure to help you talk through your issues and arrive at your own realizations, to uncover your own injuries, by asking the pregnant question. The analyst and the patient could be said to be collaborating on the cure. This is not unlike the aspirations described in both of your projects. But specifically, Mierle, do Freud and his status as a Jewish intellectual have any meaning for you?

Mierle Laderman Ukeles, *Unburning Freedom Hall*, Los Angeles Museum of Contemporary Art, 1997. Materials: 540 tons of recycled crushed glass; twenty-five-foot-diameter cobalt-blue stained-glass suspended table; sixteen plywood chairs codesigned with Robert Wilhite. Video and shelves for *Unburnings*. Photograph by Paula Goldman. Courtesy of Ronald Feldman Fine Arts.

MLU: Well, let me back up a bit. As a practicing Jew, like Brett as a practicing Buddhist, I'm very involved in repetitive rituals, repetitive practices. It links me to the repetition of natural cycles, like the cycles of the year and other life cycles in the natural world. This places me in the world, with the world, and with time — six days to work and one day to withdraw for reflection and for simply being and, as a prayer has it, "soaked in, saturated with joyfulness": the Sabbath. I know what time sundown is because of the Sabbath beginning and ending and how it changes every week throughout the year. Most urban people I know don't have a clue when the sun goes down. On the other hand, as a contemporary artist, my tradition comes out of the twentieth-century avant-garde, which is linear, not circular or repetition-based. I have a way in my life to build systems, to love ritualistic repetition. That's not dialogue, though — not from my Jewish practice. You know, I did a piece in the Tel Aviv Museum where I made a table out of a bulldozer bucket as the base and a garbage-truck hopper side as the top, cleaned up and repainted, of course, and people sat around this table and talked to each other

about how to fix the environment. It was a small model for my proposed table for six hundred people to sit on top of Hiriya, Israel's biggest landfill, which had just closed. I was thinking that maybe six hundred people could figure things out about the environmental crisis, if you just give them a chance to talk to each other. I don't know if I believe that anymore, by the way. The art world in Israel is relentlessly secular, religiously secular, one might say, where anything specifically Jewish is nonkosher in the art world, so to speak—like how you described the art world here in the United States. But this TV art critic said to me, "Your dialogue, isn't that like the old-time yeshiva where they sat there rocking back and forth, learning the Talmud again and again and again? Isn't that what you are trying to do with that table?" Tipped off beforehand that I had a ritual Jewish practice, he was determined to put me in a cartoon box. I was really determined not to get trapped in this predigested stereotype that I am "only a Jewish artist." I felt that he was trying to close down my creativity by locking me into a cliché. So I responded on TV with, of course, a question. I asked him, "Do you know that in Native American culture there is a practice that you don't make a decision unless you check its validity up to the seventh generation afterward for the effects of the decision?" And my choosing to talk to people through the issues came from the Native American tradition, not Jewish [laughs]. I actually believe that. I didn't want to get locked up in this tiny box he wanted to put me in, resisting the fact that there is a wonderful image of unending dialogue and freewheeling discussion from the process of learning in the Talmud. So this whole subject is a little fraught for me.

TF: Brett, is meditation part of your creative process, part of your preparation?

BC: The simple answer is yes, but describing meditation in my process and preparation is not so simple. Your question makes me think of Thich Nhat Hanh again. He has a great teaching that says if you want to make something about peace, lead a beautiful peaceful life, and then what comes from that life will be peaceful. So, to that end, I engage in a variety of contemplative practices that cultivate a life that is creative and peaceful. Cultivating peacefulness prepares me to be more peaceful.

MLU: I think I heard that you're beginning with yourself, in relation to

your work, to live a peaceful life as much as you can; that's the first modeling, actually. A work starts there and opens up to include other people. Well, you are better and more peaceful than I am!

BC: I don't think of myself as better or worse, only as someone deeply committed to peace as a practice. I think of it as a spiritual practice because, as I said before, it's attempting to cultivate my own wisdom and open-heartedness so that I can come to my true nature.

My way of being is going to affect what we make together in a collaborative project. But I can't make anybody else learn. I can't make anyone else act in a different way. I can, however, change my own actions, and this affects our relationship. That is the idea Martin Luther King calls the "Network of Mutuality" or what the Lokota people call *Mitakuye Oyasin* — this idea that we all are interconnected, so that things that we do in our lives are affecting everyone around us.

MLU: I believe art is about freedom. Once you start telling people what to do, you've lost a possibility for creativity. The tricky part is being very clear about who you are, what you are offering, what you are suggesting, and then what are you opening up. I agree with you about finding common ground. I was able to move things forward in the sanitation department after years of listening. I like finding common ground. You know, my kids say I can find something in common with just about anybody. But what I want to ask you, Brett, is what happens when bad things happen to you? For example, what if there are too many egos that you are coming up against? And they're simply not going to let anything happen, not let anything be created? I've had a lot of experiences like that in the last few years that are difficult.

BC: Well, by way of answering, here is a well-known Taoist story. There once was a farmer, and his horse got away. The whole village said, "It's so terrible your horse got away. You can't plow your field, and you're going to starve to death!" The next day the horse comes back with six wild horses. The villagers say, "Oh, you are so lucky. You have all these horses. You are such a fortunate man." The next day his only son tries to break in one of the wild horses and instead breaks his leg. "Oh, so terrible," the villagers say. "You are old. Now your only son is injured. You don't have any help. You can't take care of your field. You are going to die." The next day the emperor comes with his army to enlist all of the young men to go away to a

war, but the army can't take the old man's son because of his broken leg. Often in my life I would like to say something is good or bad. The story suggests that things are not really good or bad, they just *are*; the good or bad comes from our own judgment. In my collaborative work I try to cultivate being more open and flexible—to give control to other people and let them make decisions. Sometimes those decisions are not the decisions that I have planned. But inevitably there is a longer story, like the farmer and the horse. If there is something I want to be attached to, I try to let it go. If I email you with an idea but this is not how you want to express yourself, rather than putting my ego on it I try to retract it and change my perspective. What else can we do? What is another way that we can express ourselves together? Dialogue with empathy is another part of the craft of collaborative practice that takes one outside of the object alone and outside oneself.

MLU: And you could recast your original creative fire or notion into something equally good and equally powerful? It is not diluted?

BC: I think you said earlier that you want to highlight the spiritual power in people in a way that you can't even imagine. Often my collaborators show me an entire universe of ideas that I never previously imagined—when the collaboration is carried out skillfully. And it's not to say that I haven't had episodes where I didn't handle it skillfully or where I did try to force an issue. I continue to evolve through my collaborative experiences, and that helps me create new collaborative experiences that do not alienate people and, at their best, relieve suffering. I might have to redirect my ideas or concepts during the process, but I think being able to incorporate those changes into the project is one of the skills I've consciously developed in working this way. And that is why, when I am looking at a huge collaborative project like you made, Mierle, there are countless conceptual considerations that I can appreciate in its process. As a collaborative artist it makes me imagine what an incredible amount of craft, flexibility, and openness it takes in you to go to these different settings and engage with different people and give them the space to express themselves.

MLU: The flip side is dealing with idiots who don't want something—actually who don't want *anything* to happen [*laughs*]. There are people in this world who have negative seeds. They do not want to take a risk for themselves, and they do not want things to grow.

The grave challenge, as I grow older, is not to let their negativity become toxic and dominant, but to keep countering it.

The most delicious part is, as you say, to go to these different settings and engage with all these different people by creating a process, a structure, a situation, and the space in which others have a chance to be heard, to express themselves both individually and working together, to become transparent enough to show their immense power to create transformation in the world—just like the original builders of Freedom Hall. What am I saying here? Deep down, I have a sitting faith that if you work to pry reality open to let freedom come roaring in, most—well, many, many people are already ready to move in there. Why, they have been waiting for the chance!

BC: It goes back again to the idea of challenging myself to be more peaceful if I want the world to be peaceful. If my objective includes peace in the world, would I cultivate a more peaceful world by being violent toward another person? Nonviolence can be disarming. The people I most admire in the spiritual, political, personal, and artistic spheres create inclusive models of being and work. They help me move toward the world that I want to see in my own work and life.

The Seer Project
LEE MINGWEI, ARTIST

THE MERGER OF ART and life was a major concern for the pragmatist John Dewey in the early twentieth century. Joseph Beuys had post-Fluxus ideas in mind in 1973 when he wrote, "Every living being is an artist."[1] Rick Lowe had more of a community political agenda when he said, "We can approach our lives as artists, each and every one of us.... If you choose to, you can make every action a creative act."[2] But others see spiritual roots for the aesthetic life. For example, in *Buddha Mind in Contemporary Art*, an anthology of essays tracing the influence of Buddhism in recent American art, including the Buddhist roots of John Cage's and Allan Kaprow's practice, the art critic Kay Larson writes, "The Buddha at his awakening saw that all beings have Buddha nature. Thus we are all artists expressing our true nature through the ongoing minute-by-minute activity of composing our lives out of the flux, out of the floating world."[3]

Suzanne Lacy is an important link between the older generation of artists like Kaprow and a younger set including Lee Mingwei. Lacy was one of Kaprow's feminist students who added a more explicitly political dimension to his art-into-life performance practices. She takes the same sort of tack with her own Buddhism, speaking of how an active composition of life and art can also have a political dimension: "For the engaged artist ... attempting dialogue and collaboration within a nexus of social relations is fraught with issues of individualism still unchallenged in the visual arts, creating contradictions that do not exist in the same way for the practicing engaged Buddhist."[4] According to Lacy, the "not-knowing" involved in the sharing of authorship goes with the process orientation of an art that unfolds in life.

Lee Mingwei is one of Lacy's better-known students, and despite his

ambivalence to the label, he has often been identified as a Buddhist artist. Part of this label may simply come from his upbringing—he grew up in a Buddhist home in Taiwan—but, as Lee might point out, we do not label Joel Shapiro a Jewish artist despite his recognizably Jewish name. Lee says that when he is interviewed in Mandarin, his Buddhism rarely comes up, and he sees the label as incomplete. Still, it must be acknowledged that he has consistently created works with spiritual references, from the *Letter-Writing Project* at the Whitney Museum (1998) that asked the audience to bow and kneel, to the *Bodhi Tree Project* (2008) in Queensland, Australia, which involved planting a cutting from the sacred Bo tree, under which the Buddha gained enlightenment, on the museum's grounds. Indeed Lee is one of the featured artists in *Buddha Mind in Contemporary Art*.

In 2003 Lee created the *Seer Project* at Harvard University, a project organized by Teil Silverstein in the Office for the Arts. Along with Lee, Silverstein searched for volunteer "seers" who would be willing to offer one-on-one sessions to expand participants' consciousness through dream interpretation, psychic ability, and tarot: "The artist will consider religious and folk traditions (I Ching, etc.) that address our desire for understanding and reassurance in the face of the unknown."[5] The resulting interactions between "seers" and "seekers" took place in a specially constructed room without Lee present. It is hard to situate this project on the spectrum from the scripted encounter to socially cooperative art. For the most part the *Seer Project* was an intracommunity interaction; most of the participants were from Harvard University. But the work is not exactly scripted by Lee, either; he simply set up a framework. In this sense Lee has a very light touch, and his goal is subtle inner transformation, which is not as explicitly social as many of the works in this book.

———

LEE MINGWEI was born and raised in Taiwan and moved to the United States during high school. He received a BFA from California College of Arts and Crafts and an MFA from Yale. He has shown his work internationally at museums and in biennials from Asia to Venice.

———

In October 2009 I interviewed Lee Mingwei in his Lower Manhattan loft. I asked him to respond to the interview with Ukeles and Cook, and then we spoke about one of his own more explicitly spiritual projects.

TOM FINKELPEARL: Before we get to an in-depth discussion of your *Seers Project* at Harvard, I would like to ask you to comment on the discussion between Brett Cook and Mierle Laderman Ukeles. It seems to me that Cook was fairly comfortable identifying the spiritual aspects of his project, while Ukeles has resisted the label of "Jewish artist." Where do you see yourself on this sort of continuum?

LEE MINGWEI: For me, ideally, I would like to do my work without any label. Obviously I cannot stop people from seeing my work in a certain spiritual light, but I am actually grateful when critics do not mention spirituality as a basis for my work! I always see myself as a spiritual person, but I never see myself as a spiritual artist. There was an early article by Kay Larson in the *New York Times* under the headline "Transforming Death's Wound: A Healing Art" that identified me as a Buddhist artist.[6] I had just graduated in 1997 and my show at the Whitney was in 1998. So I was extremely excited and happy to see my work written about, but it was uncomfortable. It seems like an easy way out for Western critics to put me in that spiritual genre. It's like if an Italian artist goes to Taiwan and the review just says, "Here is a Catholic artist." The *Times* article focused on the *Letter Writing Project*, in which visitors are invited to write a letter, maybe to a deceased or absent loved one to say something that they always wanted to say but never did, and they can seal the letter to be sent or leave it unsealed for other visitors to read. There are three simple booths for writing the letters, but each booth requires the visitor to assume a different position — like the three positions in Buddhist meditation: kneeling, sitting, and standing — so it is natural that Larson would connect that back to Buddhism. But that was only a part of the project. I don't want my work to be seen only from that point of view because I think there is so much more to it. I am Taiwanese, and when people see my work they will automatically use the word *Zen*. But it is just one part of me. My interviews in Taiwan or other reviews in Mandarin rarely get into this part of my practice, maybe because in Taiwan a lot of people are comfortable with the spiritual part or because there is nothing odd there about coming from a Buddhist family.

TF: In the work at Packer, Cook is clearly employing practices that could be called Buddhist.

LM: Yes: inner awareness and reflection. In his piece he seems to be

teaching the students practices of mindfulness. I have not done that in my projects, because it's the participant's own decision either to be mindful or not; it is the participant's own responsibility. If they are not inspired to be mindful when they experience my work, that is completely fine, and if they are, that's great. You know, if I ever see a museum show and the wall text tells me what to think, I probably won't go in that direction.

TF: Well, he wasn't telling the participants to be mindful so much as he was engaging in exercises that could inspire mindfulness as part of the process of the project.

LM: Yes, I understand. I am not criticizing his work, just mentioning a difference. In my work I am hoping that the concept and the physical environment will provoke mindfulness or introspection. It is completely up to [the participants].

When I set up a piece, I create rules of the game that can be more or less restrictive. There is no specific script, just general guidelines and a space. If you believe in this particular environment that I set up, then you are welcome to come. I think there is a built-in self-checking system, a sifting system in my projects. People who are not interested in this or who do not believe in this particular encounter won't participate. People don't generally resist the projects, because they would never be there in the first place if they did not choose to come. It is a self-selecting process.

TF: Yes, this is a big difference. At Packer, Cook was working with a pre-existing community. So he set up a series of interactions within that environment.

LM: And he was working toward a product: a show. With my projects I tend not to do that. It's often a very ephemeral project, and there is no collective result at the end. It is often a one-on-one experience with a one-on-one result, like the *Sleeping Project* [in which a participant, chosen by lottery, spends a night alone with the artist in the exhibition space, chatting and sleeping]. And the "result" is mental. Often there is no documentation. The artwork, for me, is the very individual experience of the people who participate, and every one of them is completely different. That experience is the premise of my work, the inner transformation that the viewer undergoes after this experience. When people experience my work, it's that activity that triggers the inner transformation, and that's the artwork. I actually think that this is the same for a painting by Picasso. The physical ob-

ject is not the work of art. It is the interaction with the viewer, the experience, and the personal transformation.

TF: I don't think Cook would argue with that. His show at the end was more the residue of the interaction. There was not really an audience for the show beyond the participants, since he included the entire school. In Ukeles's project, she created a setting for interaction. There was that beautiful blue table and the opportunity to make *Unburnings*, but there were also the organized interactive moments, the peace talks. Still, both of them created objects or inspired objects to be made.

LM: Yes. I see my practice more in terms of dance. I use time and space as my medium to create an experience. When the time is over, there is nothing. When you go to see the stage, it is just a stage. When you go to see the *Letter Writing Project*, it's just the booth, until you enter, until you trigger that mechanism, which is the event. Ukeles and Cook are often in the middle, directing the piece. I do say to the audience, "Here's what you could do." But I often disappear from that very central interaction because intrinsically I am a very shy person. I feel very uncomfortable being at the center of attention. Sometimes people say I am a performance artist, but I do not see it that way. For a performance there needs to be an audience. In some works, like the *Dining Project* [in which Lee serves dinner to one participant each evening in the exhibition space], I am present, but it is in a private situation. There's no audience. The only audience is myself and the actual participant. This is a difference between my work and that of many other artists, including Cook and Ukeles.

TF: Tell me about the *Seers Project*. How did it come about?

LM: The *Seers Project* was a response to an invitation to come for a residency and then to create a project for the Office for the Arts at Harvard University. I thought it would be interesting to look into the extremely left-brain institution that is Harvard, to look into the people and find any who think of themselves as seers. I didn't really define *seers* exactly, because it is really not for me to say, "You can only participate if you fulfill this exact set of rules." I left it a bit open.

TF: What were you expecting a seer to be?

LM: My expectation was that people would come who have a particular talent in feeling and hearing people's pain and therefore can be a source of relief. I know, it almost sounds like a therapist. The people who came forward did have a particular kind of healing ability, and

Participants, called "seekers," waiting to enter the private space (right) to speak with a "seer." Harvard *Seer Project*, multimedia interactive installation by Lee Mingwei, 2003. Photograph by Anita Kan. Courtesy of Lee Mingwei and the Office for the Arts, Harvard University. Commissioned by the Office for the Arts, Harvard University.

some of them could tell the future for the people who came to see them. That is different from a therapist — and it was free! We put out a request, and within about two weeks we had fourteen or fifteen seers who were mostly professors, students, Ph.D. candidates. It was interesting that they were all women. It was the same when we did the project later at the Whitney Museum. However, the seekers, the people who came to seek council with the seers, were a mix of men and women.

We kept it anonymous. I think anonymity was important for this project because it was at Harvard. There was one professor in the sciences who taught a very technical subject but also considered herself a healer. She saw the two as the same. In Western society, when you tell people you are a seer, people look at you thinking, "Are you serious?" The Harvard community is not about fortune-telling or healing, so I think it took a lot of courage for the seers to participate in a project like this in public. I wanted these people to feel that they are welcome even within the Harvard community.

I was being kind of naughty. I wanted other people to acknowledge these people, to understand that maybe someone has talent in

quantum physics but also in healing. It is actually a project about looking into institutions. I was looking for different sorts of people and interactions, people who were hidden. For me that was the theme of the project. I could have done a similar project looking for transgendered people in a very rigid social environment, looking for a group of people that's not obvious but that's willing to come out and share their identity and talent within a confined, highly protected space.

I designed a site for interaction that almost looked like a yurt or a lantern made of shoji screens. Inside there was a table with two chairs. There were chairs outside for people who were waiting. A seer was sitting inside, one per day, and she would welcome the people who wanted to come interact with her face to face, but they only saw her upon entering the enclosure. The project took place in Memorial Hall on campus, which has the feel of a Gothic church. It has beautiful windows; the atmosphere was very spiritual. The space for interaction, the enclosure, was in the transept. Memorial Hall was created for the members of the Harvard community who died in the Civil War. One of the seers walked into Memorial Hall and did a forty-five-minute cleansing ritual with the seekers there. Afterward we asked her why she did it, and she said she felt there was this very powerful energy collected at the rose window when she first walked in — male students who had died in the Civil War — and she wanted to let these spirits know that she was there not to take their place but to learn something from them and from all the other people who came here. It was an indigenous American Indian ritual. She had this burning bundle of sage, and she was chanting. I think the waiting seekers just accepted it as part of this particular sphere.

Each seer would meet up to twenty seekers per day for fifteen to twenty minutes each. I never observed the interaction of the seer and the seeker because that was only between them. But I did see the before and after. I was there to talk to all the seekers, and I also had an assistant who helped me. Both of us were there to facilitate those experiences, because the people who came out often wanted to talk. And it was often very dramatic. Most of the people came out kind of stunned; people would come out crying. It was different for the seers. In some cases the seekers came out more relaxed than before they went in. People did not know what to expect, so some went in agitated and came out relieved. All the seers were from the Harvard

Lee Mingwei (left) speaking with participants who waited between twenty and sixty minutes to enter the private space of the *Seer Project*. Lee was present to greet seekers and answer their questions before and after their meeting with a seer in 2003. Photograph by Anita Kan. Courtesy of Lee Mingwei and the Office for the Arts, Harvard University. Commissioned by the Office for the Arts, Harvard University.

community, but some of the seekers were from the greater Boston area because the *Boston Globe* did an article on the project just after it opened and there was still time to sign up.

Later I was invited by Debra Singer to present the project as part of the Whitney Biennial. We put the enclosure up in the lobby of the Altria building, where the Whitney had their branch. It was a very different room, but the experience was similar. The biggest difference was that at Harvard many of the seekers were students, while at the Whitney many were artists.

TF: What led you to this subject? Did you have any previous experience with seers?

LM: A bit. When I was growing up in Taiwan, there were shamans in Taoist temples and rituals related to the spirits of different gods. They became the conduit of the heavens, so people would go and ask them for answers. One of my uncles was a Taoist. I went with this uncle to the temple, and it was a bit of a scary experience. But that was not my upbringing. I grew up in a Buddhist family—more specifically Chan, which is the Chinese version of Zen Buddhism—but

also attended Christian school. Some of my artist friends have an interest in fortune-telling, but I somehow have no interest in that at all. The *Seers Project* was more about challenging an institution such as Harvard with this particular issue. Also I think because I was a biology major, the spiritual part of me was kind of hushed up when I was younger.

TF: What made you confident that there would be enough seers in the community?

LM: I was quite surprised myself. I really have to give credit to Teil Silverstein, the curator who took on this project. She could have just said, "What are you *thinking*?" But she just said, "Okay, this is good," and started working on the wording of the invitation to participate. But I don't really think of the project as spiritual art so much as in terms of the type of interaction—the category within my artistic practice in which I set out the rules for meeting but I am not present for the interaction. In this way it is like the *Letter Writing Project* in which I set the stage but the participants are on their own, and there is no documentation of the act. I am interested in the interaction, like how the setting can challenge the balance between these two strangers, and how these two people interact with one another with intimacy and respect, and where the boundary is.

TF: For this type of project, what would you say is the art: the setting, the rules, the interaction, or all of these?

LM: That's always a big question for me when people experience my work. I think for the *Seers Project* the artwork lies in the very spontaneous interaction between these two strangers within a very confined space and time. They don't interact in a way that is completely open. They interact with each other within a set of rules. There are reins. For me, the art lies in this very ephemeral interaction; as I said, it's almost like a dance between two strangers. Still, it was important for me to be there at Memorial Hall. I was a little concerned that it might be taken just like a fun-fair event. With the *Seers Project*, it hopefully will be a bit of a spiritual experience, an interior awakening—probably not immediately but maybe later. One woman came back looking for the seer she had met, wanting to tell her about the powerful dreams she had had over several days. She felt it was a gift from the seer.

TF: As an artist, do you consider those dreams part of your work?

LM: Not in a direct way. I think this is very similar to asking a parent whether a child's achievement is a part of their life. It is, but it isn't,

In the *Seer Project* all discussions within the enclosure were private and were never photographed. The project took place in Harvard University's Gothic revival Memorial Hall, 2003. Photograph by Anita Kan. Courtesy of Lee Mingwei and the Office for the Arts, Harvard University. Commissioned by the Office for the Arts, Harvard University.

or it is indirectly. I often see my projects as my children, and it often has a very clear stage that this project passes in life, and usually it happens in my dream when I realize that this project is in my real life. It's always the same imagery, that a tree is growing from this ground. It is always the same dream.

TF: Your dream reminds me of another project of yours, a project that takes on Buddhism in a more direct manner, through a tree.

LM: Yes, my *Bodhi Tree Project*, which was a commission by the Gallery of Modern Art in Brisbane, in Queensland, Australia. It was for a new building that they were operating. For that project, I arranged for a sapling from the original Buddhist mound, the Bodhi tree in Anuradhapura, Sri Lanka, to be brought to the gallery and planted on the grounds — as a public art project but also as a sacred living object. Buddha was sitting under this Bodhi tree when he gained enlightenment, in Bodh Gaya in Northern India. The original tree was cut down by followers of a movement to eradicate Buddhism, but when

it was destroyed Princess Sanghamitta heard of it. She took a sapling from the tree and escaped the massacre and destruction herself, and went to Sri Lanka. The tree in Sri Lanka was planted in 288 BCE. The reason why the high priest in Sri Lanka allowed the museum to take a sapling was that I explained to him that in our contemporary times, most people see the museum as a sacred site. We planted it last year. Last time I saw it, it was about two feet tall. Two weeks ago somebody phoned and told me that it's about ten feet now. It's growing very fast.

TF: What is the nature of the commitment to the tree as a sacred object? Would anybody be allowed to take a sapling from it?

LM: Good question, because it is also a work of art that belongs to the Gallery of Modern Art and the Queensland people. I heard that an institution on the West Coast wanted to take a sapling from it, but I am not sure what happened, or how I feel about that, especially because it is only two years old and to take a sapling probably wouldn't be a good idea. You have to wait a while. They grow to four thousand years old, so you could wait.

TF: Do you think that the tree can become a religious object in the museum?

LM: It depends on who is looking at it. Next to the tree there is a sitting area. They have a very unobtrusive plaque explaining the history of this tree. If you do not read it, it just looks like another tree. The curator at the gallery found an interesting Taiwanese Buddhist community in Brisbane. It is a very large community, and they were very interested in taking on this project; they introduced me to the high priest in Sri Lanka. When the sapling arrived and it was time to plant it in the ground, this community created a whole-day ritual for the blessing. The Buddhist community of that particular temple came. So now they will come into the museum to bless the tree on Buddha's birthday every year, spiritually taking care of that art project.

TF: By planting the tree you have created a space in a museum for quiet interaction, reflection, and ritual. I know that you have a whole range of references in your work. Is there any direction that ties together some of the strands?

LM: Recently I have been reading a book called *In Praise of Blandness*, which is a central part of Taoist, Buddhist, and Confucian aesthetics.[7] A French philosopher named François Jullien, who studies Chinese aesthetics, identifies the bland as a positive quality that reflects

various Chinese spiritual and literary traditions. I see my work very much in that vein, as something that's very bland: sleeping, eating, walking, and bowing. I mean, how boring could it be? But because of the blandness of the self, it embodies all kinds of possibilities—precisely because it is not specific. We all have our own rituals of eating and sleeping. We didn't go to school to study that. We learned it from our environment, and my work views those things as a basis of a departure that most people can experience on their own terms and their own personal experience. I do not deny the spiritual, but I do not want to be placed only in that category. Maybe I would be more comfortable being called a bland artist.

White Glove Tracking EVAN ROTH,
ARTIST

THE COMMUNICATION POTENTIAL of the Internet is the subject of much debate. Is it a weak shadow of in-person interaction or the source of a vibrant new social space? Is screen time detrimental to social capital, or is it a way to create larger, less-regulated communities? Is the Internet a realization of George Orwell's vision of surveillance, or is it the new locus of communication *away* from governmental oversight? The following interviews with the online artist Evan Roth and the Internet theorist and practitioner Jonah Peretti present the viewpoint of two Internet enthusiasts and open-source evangelists.

Even as the liberatory force of the Internet is beginning to play out across the world, some in the field are having second thoughts. For example, the pioneering artist and computer scientist Jaron Lanier presents a counterargument to the optimism of Howard Rheingold's argument in "Technologies of Cooperation."[1] Lanier has soured on the collective enterprise of the Internet and argues that online, the individual voice is appropriated for the profit of large corporations. Yes, the content on YouTube may have been assembled by the collective work of many, but the profit all goes to its owner, Google. And it is not only the economics of the Internet that make Lanier nervous (as they do Evan Roth), but also what he calls "digital Maoism," wherein the hive mind-set can lead to mob rule.[2] The jury is decidedly still out on these issues. Even if this chapter is in many ways the most up-to-date in the book, it is also likely to become obsolete the most quickly. However, it would not be possible in 2011 to assemble this book without considering online creativity and community.

White Glove Tracking, the project discussed in the following interview, shares some of the interactive practices that characterize many of the

other projects in this book: the artist orchestrates a cooperative structure; participants respond and add their own creativity. Uniquely, however, in Roth's project none of the people ever meet each other; the interaction is all virtual. But the most fundamental difference may be in the intellectual platform on which the work was created. Whereas it seems clear that many of the works in this book are somehow the descendants of the progressive, collectivist politics of the 1960s, Roth seems to be coming out of the anti-institutional libertarian zone of free cooperation that dominated the early days of the Internet. So while the community organizing of SNCC may have laid the groundwork for Rick Lowe, a radical attack on copyright by an anonymous hacker might be a more relevant precedent for Roth. The Internet is a zone far from the art world's obsessive interest in originality; on the contrary, it is a place where status is gained when your code is re-used, according to Roth. He is the intellectual child of the hacker, remix, and DIY circles that inhabited the Internet from the start.

It is incredibly easy to find information about Evan Roth online. A self-published book on his work is available for free at evan-roth.com, and in-deed it is called *Available Online for Free* because most of his work fits that description.[3] To get to his blog, type "bad ass mother fucker" into Google and click "I'm Feeling Lucky," and you're there. A Google search of his name brings you his blog, his website, a cache of his videos on Vimeo, and his Wikipedia entry right away. It's not that Evan Roth is such an uncom-mon name, but no other Evan Roth gets any mention on Google until the third page of links.[4] He's *that* well known online, that good at getting his message out on the Internet.

———

EVAN ROTH received a BA from the University of Maryland and an MFA from Parsons, the New School. He has lived in Brooklyn and Hong Kong and currently resides in Paris. While at Parsons he developed several high-profile projects, including *Graffiti Taxonomy, Typographic Illustration, Explicit Content Only, and Graffiti Analysis*. He was a fellow at Eyebeam OpenLab from 2005 to 2007. Roth founded Graffiti Research Lab with James Powderly in 2005 and cofounded the Free Art and Technology Lab, FAT Lab, a Brooklyn-based open-source technology collective, in 2007. He has created music videos for Jay-Z and the Large Professor, among other artists. His work has been shown at galleries and museums, but most of his audience is online.

The following interview took place at Evan Roth's apartment in Hong Kong in December 2009.

TOM FINKELPEARL: Evan, can you describe the various stages of *White Glove Tracking?*

EVAN ROTH: Well, it started because I wanted to make a video that focused on Michael Jackson's white glove as he performed "Billie Jean." This was accomplished by collecting data that isolated or tracked his glove on a video of a live performance, then using that data in a number of different ways. There were several layers of collaboration on the piece. At the beginning it was a collaborative project with specific people I knew, then it became a collaboration in a general sense with anonymous people online who created the data to track the glove, and in the end the data was released for other artists to create work, who in a sense were collaborating on the project as well.

I think it's important to understand my surroundings when the piece got made. I was in residence at the Eyebeam OpenLab in New York, a creative technology and media arts space started by Jonah Peretti and Michael Frumin, both MIT grads. They got money through the MacArthur Foundation to set up a fellowship program that supported creative people experimenting with technology. The lab was research-based, with the understanding that everything you made had to be released to the public domain, free of copyright restrictions. So if you take part in the fellowship, it is your obligation to release the work created there as freely and openly as possible — meaning source code, "how to" guides, Creative Commons [whose "some rights reserved" approach to copyright allows for the creative sharing and development of ideas], et cetera. So they were not only funding artists; they were funding contributions that could be used freely by everyone. It was in this context that *White Glove Tracking* was started in 2004. It was a great time to be at Eyebeam; the other artists there that year were Ben Engebreth, who had done software modeling for NASA's Jet Propulsion Laboratory; Limor Fried, who is a powerhouse on the DIY engineering [and] hacker scene; and James Powderly, who had experience doing robotics as a NASA subcontractor. Ben Engebreth was my closest collaborator and cocreator on the

project. For *White Glove*, Ben handled a lot of server interactions, data management, and back-end web design.

I sometimes say that I hate art that is based solely on an artist's feelings. However, in a sense *White Glove* started because I just really wanted to make a video that was a black screen with Michael Jackson's white glove moving with the music. I did eventually make that version but ended up not publishing it; it's sitting on my hard drive somewhere. It might be okay on a gallery wall someday, but it's pretty boring to watch on YouTube, which is all that really matters.

To do the project I needed to locate exactly where Michael Jackson's white glove was in each frame of his live performance of "Billie Jean." Gathering the data and tracking the glove was only part of my motivation. If I wanted to simply take the performance and isolate the glove, then there are video editing tools that could have been employed, and someone experienced with motion graphics software could have probably done it in a day's work. But the process was important to me, and I wanted it to become an open system instead of just a video. So this piece became an excuse to experiment with open source and crowd sourcing.

One of my favorite examples of crowd sourcing is the NASA Click Works Project. If you've seen it, then the connection to *White Glove* will be immediately apparent. NASA had all of these aerial photos of Mars and the moon, and they wanted to catalogue the location of the craters. The photos had GPS data associated, but it was too difficult to accurately find the circular shapes of the craters algorithmically in the images. They were in a position where they would have needed to pay highly trained researchers to complete a very simple task that didn't require a lot of training. They just needed someone to look at the photos and identify where the circles are, so NASA decided to take advantage of all the people online who were willing to do it for free. They set up an interface that is really beautiful, where you are presented with a photo of the moon and asked to click and drag circles over all the craters that appear in the image. When you're done, you hit upload. Of course, they're not just taking one data sample; they're getting multiple data sets on every image. Then they can look for numbers that don't make sense and chop off the outlying data, focusing on the middle where people overlap. This is what we did with the *White Glove Project* as well.

TF: Were people intentionally screwing around with the NASA project? Were you worried that they would do the same on *White Glove Tracking*?

ER: This is something we weren't sure about when we initially launched the site. If someone is incompetent or if you have some joker who's just clicking and spelling his name, or worse, it's easy to identify because the chances are low that someone else will be messing it up in the same way or making the exact same errors. Not many people ended up doing that kind of thing, I think because that motivation is not really there—nobody would see the result, you know? It's a lot of effort for someone to log on to the system and start making false data that they can't share with anyone. For the most part the bad data we received seemed to be attributed to user error rather than done deliberately.

For *White Glove* there were about ten thousand frames in the whole video, and we ended up having thirteen different sets of data for each frame before we turned off the data collection tool. Ben was responsible for making sense of the numbers and getting it as clean as possible. For the most part this consisted of queries such as "Are all of the gloves generally in the same place?"; "Are they generally the same shape?"; "If not, how far off are they?"; "Is the glove in a position that makes sense in relation to the preceding and following frames?"; and so on. Based on these results we would decide whether or not to average in the data to the final set. Overall this strategy worked fairly well.

TF: How did you get word out that you wanted people to track the glove?

ER: In order to gain a user base, part of the initial intent of the project was to employ contagious media tactics, a term I believe Jonah Peretti coined. Viral media wasn't an explicit research topic of OpenLab, but generally people were interested in making media that was contagious as a mechanism toward spreading open-source ideas—by creating projects that reach a popular audience and then sneak in open source and free culture, like stealth marketing for the open-source movement. So I wanted to take the structure of NASA Click Works and introduce a contagious element. Of course, NASA does not need to do that, since it has a huge following of people willing to click on whatever they want them to. For *White Glove*, the theory was that we would be able to collect more data if we could create an initial traffic spike and appeal to the top one hundred blogs, which can gener-

ate five to ten thousand unique users per day by publishing a link to the project. We figured if even half of those people clicked one frame each, we would be in good shape over the course of a few weeks.

There are techniques for increasing your chances of a project spreading on the web. I have experimented with this quite a bit and teach a course on it at Parsons along with some friends, called "Internet Famous." Even though the title is a bit of a joke, intended to make sure we don't take ourselves too seriously, the underlying idea is that when you have eyeballs, you have power and influence. We use Oprah as an example. She snaps her fingers and makes best-sellers, for better or for worse. She has influence. When I went through the university system, they were completely focused on the end-of-the-year thesis presentations to a room of fifteen people. I always thought that it was amazing that people were so worried about the opinions of these few people, when there are thousands of others out there willing to give brutally honest criticisms of your work—see the comments on any popular YouTube video. So the idea for our class was to give students an opportunity to think outside the classroom, outside the school, outside New York, outside of the United States. How do you get your work out there? We have studied the juvenile nature of a lot of popular YouTube videos, like "Buttered Floor," which pretty much consist of watching people slip and fall. But these videos have eyeballs, and we try to take what we can learn from them and apply it to content that we are more interested in spreading.

When *White Glove* was going on, I was involved in some experiments along these lines. I was investigating some very specific strategies, including some marketing tricks—as simple as releasing on Tuesday morning or posting work when the editors of blogs are looking, late at night or really early morning. Blog editors are lazy, just like everybody else, and a good trick is to publish your content in a way that makes it as easy as possible for them to republish it. With *White Glove* I released images that were all properly sized to blog format at the time, five hundred pixels wide, as well as easily embeddable animated gifs [graphics interchange format]. If I had it to do over again I would have released an embeddable flash video explaining the project as well. Titling the work is important. In the class I talk a lot about *blog title poetry*. If you read posts and videos that go viral, they often have amazingly well-crafted and expressive titles, with some exceptions, of course. Oftentimes what they've managed to cram into

ten words or less is undeniably clickable. Part of my motivation in choosing the Michael Jackson video was to actively look for content that would lend itself to going viral.

There's a blogger named Jason Kottke who is well known within tech circles. He was the first "professional blogger," or so I hear, the first one making a living through blogging. He's sort of friends with Eyebeam and pays attention to what is being developed there. A lot of bloggers read his blog, and I think he was the first one to pick it up. It didn't surprise me that the project would take off because it had the right mix of popular and technical appeal. Peretti talks about the "bored at work" network. They're ready; they're captivated; they're open. It's not like an art-going audience. At an art opening everything is in place to distract you from the art; free alcohol, beautiful people, obnoxious conversation. A cubicle, by comparison, is an ideal situation in which to focus on art: there are few distractions, the mind is eager to absorb, and you aren't stressed about money because you're on the clock. *White Glove Tracking* had a technical element that appealed to the "bored at work" network, but it also had pop culture allure, similar to the way shows like *Family Guy* use pop culture and nostalgia to get viewers.

What ended up happening was that someone put *White Glove Tracking* on Digg.com, where people share and vote on web content that they have discovered online. Then it got to the front page. If you're on the front page of Digg for twenty-four hours, that is something like ten thousand unique visitors on average. I might only have a handful of those days per year on my blog. In addition, on that particular day, some hacker cracked the code to high-definition DVDs, allowing people to get around the digital rights management. It was a big day on the web in general, and that was the number one story on Digg. Even the *New York Times* was writing articles referencing the story on Digg. At the time it was one of Digg's biggest days, and *White Glove Tracking* just happened to be on the front page as well.

I had no idea how long it was going to take to collect the data, since the whole project was an experiment, but my best guess was that it would take something like three months to get through a bare minimum of at least two views per frame, or twenty thousand actions. In a matter of days, however, we had thirteen runs through the data before we ended up taking it down, because we were thinking, "This is nuts."

TF: Do you know how many people were involved in creating the data?

Over 1,500 volunteers isolated the exact location of the white glove in each frame of a concert video of Michael Jackson performing "Billie Jean." *White Glove Tracking* is an open-source project initiated by Evan Roth and Ben Engebreth with support from the Rhizome Commissions Program and the Eyebeam OpenLab in 2007. Photograph courtesy of Evan Roth.

ER: We had over 1,500 registered users and many more that worked anonymously. Beyond the number of the people involved, it was also interesting to look at how many frames each person clicked. Many would just click a couple, but there were others who clicked almost half of the total frames in the video. The figure I would love to have is the total amount of company money people wasted by participating in the project at work. I think wasted company money is a solid metric for gauging successful media art projects.

The way we set it up is that the data collectors are presented with a still image, a single frame, from the live video performance. On screen are the simple instructions, "Click and drag a box around the glove." In order to sustain people's interest in clicking, the images are not consecutive frames from the video, but rather are selected at random. There was something odd and compelling about viewing the media in this way. The video is shot in the early '80s and was captured from an old VHS tape I found on eBay. For a lot of people it was also a piece

of their childhood. I know for me at the time it was a huge moment seeing Michael Jackson doing the moonwalk; I lost my mind.

I did some data collecting for *White Glove*, and it's not a bad way to waste some time. I know it's better than when I was doing architecture, better than red line changes in AutoCAD.

TF: So if you had thirteen data sets for ten thousand frames, that was 130,000 separate pieces of data by perhaps a couple of thousand data collectors?

ER: Yes, somewhere around there. Ben was in charge of dealing with the raw data, and he looked at several different options for narrowing down all these numbers into one final set of data. First we just averaged all the frames, which was not bad, actually, but it was a little bit jumpy. Then we tried chopping off anything that was beyond a threshold variable, and eventually we got to the point where the data set was matching up with what we expected visually. There are some ambiguous moments where Jackson puts his hand in his pocket or spins, and then the data gets weird; you can tell people were having this internal debate about whether it counts or not. "Does it count if you only see the top?" "Does it count if I know the hand is in the pocket but I can't see it?" But I find those moments interesting and visually very telling of the fact that it was not created by a single person or algorithm. You can see the collective indecision in these moments where the numbers start to jump around.

TF: So it's not just a record for where the white glove was but a record of where data collectors thought the glove was.

ER: Yes.

TF: Have you ever met any of the data collectors?

ER: Yeah, I've had people come up to me after presentations telling me that they were data collectors. And I've had friends do it and get addicted. "I've done a hundred frames and can't stop." But for the most part I did not meet them or know who they were.

TF: Do you have any idea *where* the data collectors were?

ER: That's a good question. We have that data stored somewhere, but I haven't looked at it in a while.

TF: That's a major difference between this project and all the other projects in this book: the lack of a geographic location. While you certainly stressed the importance of the particular time and place *you* were in when the project was launched, the data went out and came

back, was processed, and went out again to a set of unknown locations and individuals.

ER: Yes, and in addition to a lack of geographic location I would also say that the lack of direct communication was also extreme. So many people were involved in the project at various levels, 99 percent of whom I never had any direct communication with, not even via email or IM. For the amount of activity going on and data being generated on the website, I was surprised at how few people I spoke or emailed with directly.

In any case, eventually we got to the point where the data was ready for release. We set up a website that aimed to make it as easy as possible for people to take part in the visualizing of the data. The community we were appealing to at this point was not the general public. Now it was an algorithmic process; to take part in the project from this point forward, you had to know how to write at least a little bit of code. I released it in various formats, like Flash, which is widely used; Processing, which is an open-source visual programming environment that a lot of students and artists are used to; and Open Frameworks, which is a C++ [midlevel programming language] toolkit. The website included the audio track as a separate file, the video track at various resolutions, a text file containing the data, and so on. I also made a very basic program that imports the data and draws a yellow box around the glove. The idea was that people didn't have to worry about the input of the data; that was already done for them. They were presented with an environment where they could open it up and click "compile," and it would draw a yellow box around the glove. Then their job was to make something more interesting than the yellow box. During the data collection process the project attracted a more general participation of slightly tech-minded web users; in the second-round release, however, the participants were a much smaller group consisting of people interested in visual programming.

I made a couple of visualizations just to get the ball rolling— visualizations that I must admit are some of the weakest of the group. In retrospect I probably could have spent more time creating my own set of visuals. However, I was most interested in seeing what others would make and felt a push to get the project released while there was still some residual interest from the data collection process. Because I needed some examples to seed the project I created a couple of visu-

alizations in which the glove leaves trails in various scenarios, and in addition I was playing with the roll-over hand icon of the mouse as the white glove. It was intended to be a very explicit invitation for participation rather than the final creation of the project. It is important to think about the differences between the traditional open-source software culture and what's happening now — which is taking this notion of sharing and applying it to other areas, [such as] remix or DIY. It's not just necessarily about source code; it's about collaboration and openness. There's a big difference in just offering links to download source code and having someone say, "Hey, this is for all of us. Let's make something together." Going through the *White Glove* process, it became clear to me that the sincerity of the *invitation* is equally as important as the availability of the source code. It may seem like a small distinction, but in my experience it made all the difference. The quality of the invitation has perhaps a heightened importance in this project since it was framed within the arts, which is a community in which I find people to be surprisingly worried about issues related to ownership and creativity. Just think of how many times you've heard an artist say, "He stole my idea!" In tech circles people seem much more comfortable with the notion that new things are built on old things; there's less ownership involved. In the arts your status goes up when specific large institutions purchase your individual work for their private collection. In the open-source community, however, status is achieved through freely releasing highly useful code that is widely adopted and expanded upon. It is a gift-giving culture. Status within the community goes up based on the quality of the gift rather than the amount of money people are willing to pay for it.

TF: Interesting. A gift economy that's not a face-to-face community.

ER: It's not face to face, but it is still a system that follows some of the norms of a face-to-face community. People care about how they are viewed in a community, whether it is face to face or peer to peer, and so whether you are bringing a bottle of wine to the party or seeding a torrent file, both are ways of improving your status in a group environment. But the arts don't work this way. People tend to get caught up in what is theirs: "Whose idea was this?" and "Who is the creator?" For this reason I was very careful to make the invitation to participate as clear as possible.

On the second round the new-media art site Rhizome.org, who

supported the project through their commissions program, helped get the word out, and after two or three weeks videos started to come back into my email inbox. Zach Lieberman, who was my mentor and my thesis advisor when I was in graduate school, sent in a couple. I was not in touch with him directly, but he submitted some of my favorite videos. One just keeps the glove centered in the video frame. In another the glove controls the playback speed of the video: the higher the glove is in the frame, the faster the video is playing. But in this project it didn't matter whether the person was a friend or professor or someone who lives halfway around the world. Some of the really nice visualizations were sent in by Jung-Hoon Seo, who studied under John Maeda at MIT.

A couple of months later a video titled *Giant White Glove* was sent in by Tim Knapen, in which the artist simply magnified the white glove throughout the entire performance. It was simple and brilliant both in concept and in execution. It quickly became the most popular visualization, for good reason. The setup is almost perfect for that piece because in the video there are a few seconds of Jackson just talking at the beginning and the glove on his left hand is out of the frame. Then all of a sudden he brings his hand into the frame for the first time and it's *gigantic*. It's a perfect setup for a quality joke. When *Giant White Glove* became popular, more videos started rolling in.

TF: And *Giant White Glove* made sense conceptually. When Michael Jackson started wearing it, the white glove had a big impact. It took on this disproportionate importance—so watching him dance around with this gigantic Pillsbury Doughboy–like white glove on his bloated left hand is both surprising and appropriate in a humorous way. Also, it looks really odd when his right hand or his face comes into the magnified zone of the white glove—really spooky and surreal.

ER: Yes, exactly. I love that video. I see it as related to a project I released several years earlier called *Explicit Content Only*, in which I edited rap songs down to only the curse words. It was a pulp media project, focusing on that one element that is emblematic and then expanding it into something ridiculous. When Zach, who is one of the best programmers I've ever known, saw the giant glove, he was like, "Oh shit, I should have thought of that," which is always the best compliment.

TF: Did you ever meet the artist?

ER: No. I've been in touch with him via email because as pieces were released I was trying to properly archive them with the source code on

Tim Knapen (Belgium) created the most-watched video from *White Glove Tracking*, *Giant White Glove*, 2008. Photograph by Tim Knapen/Indianen.

my server. Things on the web seem to come and go so quickly that I wanted to make sure I had all of the visualizations stored in one place.

TF: In my research for this chapter, I had trouble finding artists who were using the social structures of the Internet to make cooperative work that went beyond the simplest crowd sourcing. *White Glove Tracking* used crowd sourcing but also allowed for creative input by artists at the end of the day. You sent out a call, data came back and was sent out for people to process. It circulated to the Internet participant groups and later to Internet audiences. The complexity of this structure is unusual.

ER: I know what you mean. On some level that was the reason I wanted to do it. I felt crowd sourcing shouldn't just be left in the hands of NASA. But there are other interesting projects. I met an artist in Tokyo named Takashi Kawashima who worked with Aaron Koblin on a piece called *Ten Thousand Cents* that was pretty popular within the new media scene. They scanned a hundred-dollar bill at super-high resolution, broke that up into really tiny chunks, and blew them up. Each chunk was so small that once they blew it up you couldn't tell what you were looking at. And then they made an online drawing tool and asked, for each chunk, "Can you redraw this?" Each drawing would take thirty seconds. So they had all these hand-drawn sketches of tiny parts of the bill. They pieced them back together and had what was essentially a hand-drawn representation of a hundred-dollar bill — as drawn in ten thousand pieces. They did it on a crowd-sourcing site set up by Amazon.com called the Mechanical Turk and paid one cent for each drawing. So they paid one hundred dollars to draw a one hundred dollar bill. You can watch videos of each of the pieces being drawn, or you can buy a print of the overall drawing for one hundred dollars.

TF: Yes. I really do like that project, but it is a rather restrictive structure, not unlike the data collection part of *White Glove Tracking*. The structure is —

ER: Closed. Yes.

TF: —and there is not much question of authorship. *Ten Thousand Cents* is certainly by Kawashima and Koblin, with the participation of an online crowd. This is not a bad structure per se. But *White Glove Tracking* ends up with many different videos "by" different authors. The *Giant White Glove* video isn't by you. You built the structure that allowed it to happen. When I found it on YouTube, you were not mentioned by name, though there is a link to the whiteglovetracking .com site. Tim Knapen, the artist-designer who made the video, took it off his website and posted it on YouTube because his server went down on the basis of all the traffic it was inspiring. Last time I looked, it had 883,643 YouTube views and 2,054 comments. [Traffic spiked after Jackson's death in 2009.] People still look at it every day. The *Giant White Glove* may have had the lion's share of views of the entire project.

ER: Yeah, I would agree with that. I think that's what people usually remember when they think of the project.

TF: In any case, to me the *White Glove Tracking* project seems more faithful on some level to the ideology of open source. A number of artists have used open source without adding any new generally available code. You had an idea and put it out there. If someone now takes the *Giant White Glove* code and uses it to make a giant head video that goes viral, without crediting you or Knapen, that's fine as well.

ER: Yes, I see what you are getting at. And even within my own body of work this project was very different in the sense that I never intended my final output, my visualizations, to be the face of the project. I have worked on open projects in the past, such as *Typographic Illustration* and *Laser Tag*, that have been widely downloaded and utilized, but it was always my use of them that remained synonymous with "the piece." For *White Glove Tracking*, on the other hand, I put very little time and energy into my versions of the final output. I always thought of them as example files. It was actually a bit difficult at times, because I kept hearing this voice in my head saying, "You spent all this time and effort creating this data set and *this* is what you do with it?!" But that speaks to the point you are raising, which is that it was never

The *Laser Tag* project by Graffiti Research Lab (Evan Roth, James Powderly, and Theo Watson) allows graffiti artists to tag large-scale monuments like the Brooklyn Bridge with laser images. 2008. Photograph courtesy of Evan Roth.

about what I was going to do with it. My role was in setting an open system in motion.

I have been on the other side of this coin before as well. Last year I worked on an Internet browser plugin called *China Channel* with two other artist hacker friends, Aram Bartholl and Tobias Leingruber. Our project was a small add-on to the popular open-source Firefox browser, which allows a user to experience the Chinese version of the web. Our plugin was built from an earlier plugin, released in 2006, called Switch Proxy, by Jeremy Gillick, which was a tool for creating proxy connections. *China Channel* did little but remove functionality from Switch Proxy so that it could *only* be used to connect to computers in China, giving the user a real-time experience of what can and cannot be viewed on the heavily censored Chinese version of the Internet. Switch Proxy was created as a tool rather than a politically charged web art project, and it worked well. In the end *China Channel* received a lot of coverage, including in the *New York Times* and on NPR, and I would guess that in nontech circles more people have heard of *China Channel* than have heard of Switch Proxy. I view this, however, as an open-source success story for Jeremy Gillick. I hope he feels the same. Similarly when more people have seen *Giant White Glove* than have heard of *White Glove Tracking* I view that as a sign of a healthy and active open initiative.

For *White Glove On Fire* (2008), Jonathan Cremieux (Finland) created an animated digital flame that convincingly responds to the movement of the glove. Photograph courtesy of Jonathan Cremieux.

TF: But the contrast of the initial intent and the final product seems even greater in the *China Channel* project because the guy who wrote the plugin for Firefox had no idea it would be made into art. On the other hand, your original motivation in *White Glove Tracking* was to make art videos. Still, there is a similar issue of both authorship and credit in both cases.

ER: True. Maybe *White Glove Tracking* authors are hewing too closely to the rules. It would be great to see someone using the data set to buy stocks or something.

TF: You know, I understand how the other artists in this book make ends meet through sales, teaching, commissions, and so on. Even though those artists are involved in cooperative activity, it is not always free. Your description of the exchange involved in Internet communities makes me wonder if there is an economic model for an artist who investigates open source.

ER: This is a big question. In my experience there's not a great funding model for media artists yet. When I hang out with other artists we almost never talk about art; we're too busy trying to figure out how to

Evan Roth made a music video for the rap song "Brooklyn Go Hard" by Jay-Z and Santigold (produced by Kanye West). Using the letters B-r-o-o-k-l-y-n, Roth's graphic program created a portrait of Jay-Z. The video was released as part of the (Red) campaign to fight AIDS. 2008. Photograph courtesy of Evan Roth.

pay the rent. The art world's fascination with rarity and limited availability can be difficult for artists interested in free access and open distribution. That said, my work is definitely more popular because I give it away for free, and because it's popular I get more invitations to give talks, workshops, and exhibitions, which sometimes come along with small artist fees. Even when I have worked in a mainstream pop culture environment, I've had some successes with inserting open-source elements while still getting paid. I had an opportunity to create a music video for Jay-Z's "Brooklyn Go Hard," which was released through the (Red) charity that fights AIDS in Africa and is now available on YouTube. I was able to add a link at the end of the video that contained the source code to download the Typographic Illustration technique used to create the video. As far as I know, it is the first and only open-source rap video to date.

TF: And indeed another person did use the Typographic Illustration to

make a video that is very similar to yours, using letters to draw a portrait of Kanye West, just as your video uses letters to draw portraits of Jay-Z and Biggie Smalls. What input, if any, did you have for the video that uses your graphics program?

ER: I found that video by chance when I was searching YouTube to see if anyone had been using the source code. When I looked recently, I was surprised to see that it has over two million views, which is no small feat—one which I've only accomplished myself once before. What's even more interesting is that this fan video has more views than the original video I created through official channels.

TF: So just as *Giant White Glove* became better known than *White Glove Tracking*, and *China Channel* became more famous than Switch Proxy, your shared code allowed another artist's video to get more attention than your own, at least for now.

Earlier you talked a bit about the nature of online communities in terms of gift exchange. One of the critiques of these communities is the lack of personal connection—the fact that you don't "know" the people who have worked on your projects. This book is about art that's made through social cooperation. In what sense is your project social when you could not identify your cooperators if you met them at a party?

ER: One of the advantages of non-face-to-face collaboration is that I wouldn't even have to go to that party. I could stay home and work! There are advantages to face-to-face collaborations, many of which I have personally been witness to in my work on the Graffiti Research Lab and my time spent in the Eyebeam OpenLab. Having had perhaps an overdose of the one-on-one personal collaborations in New York City for the last few years, however, I am finding my isolated time here in Hong Kong to be equally collaborative but much more productive. In many cases I am even working with the same people but being forced to communicate by email and IM forces your conversations to be more directed. I still tend to meet up with collaborators once every few months, and I do feel that face time often leads to good ideas that result in project initiatives. It is not a requirement, however, and I think there is an argument to be made for limited face time being more productive than excessive face time. I have also found that because I have no local network of collaborators here in Hong Kong, I am more likely to seek out the best people internationally rather than just the people that are closest to me.

For the first time this year I released a project with someone I collaborated with directly but have never met face to face [lowercasekanye]. And the collaborations I completed with people I do know personally tend to move faster and involve less wasted time when we are online. I don't want to imply that working in complete physical isolation is a good thing for a collaborative art practice, and I wouldn't want to do it long term, but, personally, it has made for a productive year.

Part of the reason it has been productive is also that I worked at making it work. Over the course of the last two years I have developed an online network of artists and hackers called the Free Art and Technology Lab. We work together primarily through a private email list and public IRC [Internet relay chat] chat room and publish work together for the public domain in a blog format. But there is nothing magical about working with people online; it still takes a lot of thought and effort to keep it running smoothly, the same as any other social relationship. For the most part, the group is made up of people with whom I have previously had face-to-face personal connections but who now live in Germany, Mexico, the U.K., the Netherlands, and the United States. This is admittedly a very different kind of collaboration from the *White Glove Tracking* project, which involved both face-to-face collaboration, initially between Ben and myself, as well as faceless and anonymous collaboration.

TF: I'm wondering, how did *White Glove Tracking* exist within the open-source communities, and what sort of criteria would you use to evaluate whether it was a success?

ER: My initial goal was just to make a collaborative visualization of Michael Jackson's white glove, so in that sense it worked. I didn't know if I'd be able to gather the data successfully; I wasn't sure if that data could make compelling visualizations; and I didn't know if anyone would care to make them. Had any of those three things not happened I think the project would have been a failure. I definitely feel that there was some success in the project in terms of research, but I wouldn't be as quick to say that it was a successful art project.

TF: Okay, but what *would* make it a successful art project?

ER: I guess my confusion comes from the fact that I'm not sure if it's an art piece at all. People think it's an art piece. I mean, Rhizome funded it; I presented it at the New Museum. Obviously some people think that it's an art piece.

Flocking Gloves (2008) by David Wicks was one of several videos in the *White Glove Tracking* project that used the movement of Michael Jackson's glove to create animated abstract forms. Photograph courtesy of David Wicks.

TF: I think it is.

ER: Maybe so, but I'm more comfortable talking about its function as an Internet experiment and research into collaborative media than I am talking about it as an art piece. Art success is tricky. I'm not sure what it means or who decides, but Internet success, on the other hand, is very straightforward. The *Giant White Glove* video has hundreds of thousands of views on YouTube. We're talking about an open-source initiative that is violating all kinds of copyright laws, and it has more views than some of Kanye's videos. That's a sign of Internet success. I'll wait until you hang the project in the Queens Museum, and then we'll see if it's an "art success"!

TF: Then, if you say it is successful as research, what's the goal of your research?

ER: A main goal of my research and art practice is the adoption or absorption of open-source culture into popular culture. I see this as an essential part of the shift from consumers to creators that is already starting to happen in hacker, remix, and DIY circles.

TF: Is another goal democratization?

ER: Yes. In part it's about democratization, and in part it's about working toward a more sincere approach to cultural production that is

based on personal interest rather than return on investment. I'm not suggesting that free culture should replace the current system, but I am excited to think that it could take up a much larger percentage of the market. The Jonas Brothers, for example, are ROI [return on investment] cultural production, whereas Girl Talk [who releases music under Creative Commons] I view as sincere cultural production. I think there is room for both, but I would love to see a version of the future where the scales aren't tipped so drastically in favor of the Jonas Brothers. We can see this shift happening already in both software, where Firefox is arguably the best Internet browser in existence, and in music, where the *Grey Album*, which attacked a number of copyright conventions, is arguably one of the most influential pop albums of the last five years. And as an artist with aspirations of effecting change in culture, I can't imagine painting pictures when there is an infinitely more effective means of communicating with society. On some level this is very similar to the academic model, where information is shared and built upon, as opposed to the proprietary model, where information is kept secret for commercial gain.

One of the goals of *White Glove Tracking* was to get open-source ideals to look cool to the kids. If these open and free ideals can start to trickle into mainstream culture, then we nurture more creators, have access to more information, and can help build a serious alternative to how we create everything from software to art and music. The problem is that commercial interests are trying as hard as they can to make their version of production look cool as well. If we could get Kanye to stop designing shoes for LV and instead start publishing DIY guides for building the perfect sneaker, then we'd be on the right track. At times I feel like my role in the open-source movement is in the marketing department.

TF: In the late 1960s Garret Harden wrote a famous essay called "The Tragedy of the Commons" in which he bemoans people's selfishness—the tendency to act against the best interest of the group. Others have argued that Harden was wrong and that humans are wired to act cooperatively and for the common good, not in a consistently self-interested manner. I wonder if there is an equivalent in the creation of a new creative commons. Is that what you are getting at?

ER: I think there is still a healthy place for selfishness within the commons, but if we can change people's perceptions of what is cool, then we can use our collective selfishness toward a better end than just

buying more iPods and handbags. In hacker circles status is achieved based on the use and adoption of your gifts. If rappers would start bragging about how many people have downloaded their email client instead of how many cars they own, then even though they are still acting selfishly, at least the world would have a better mail app.

White Glove Tracking

JONAH PERETTI,
CONTAGIOUS MEDIA
PIONEER

JONAH PERETTI is a founder of Eyebeam OpenLab, where Evan Roth created *White Glove Tracking*. According to Peretti, the OpenLab was meant to be a collaborative environment with all of the technical resources available; as Peretti told Gothamist.com, it had everything you would need for your project to blossom, including "electronics benches, a 3D printer, a laser cutter, and workstations for hackers, designers, and artists." But it also had an important philosophical basis in resisting copyright restrictions: "The lab will be dedicated to public domain R&D — our code will be under GPL [General Public License], our media will be under Creative Commons, and we will publish DIY instructions for hardware projects. . . . This approach makes it possible to engage an extended network of collaborators and reach the largest possible audience."[1] Peretti is also well aware of the practices of the art world and interested in finding alternatives to what he sees as a limited and elitist practice based on limiting circulation to the unique and rare art object. In general he is optimistic about the potential of the Internet to democratize culture, contrasting his own public practice to that of pessimistic theorists who are detached from action.

——

JONAH PERETTI, a graduate of the MIT Media Lab, is a founder of Buzz-Feed and the *Huffington Post*. He has experimented with viral media both as an entrepreneur and in the more humorous mode of his spoof site, BlackPeopleLoveUs.com, and the corporate satire email thread "Nike Sweatshop Emails," in which he quizzes a Nike representative about why Nike refused to fulfill his order for custom-designed sneakers bearing the word *sweatshop*.

The following interview was an email exchange during late August and early September 2009. Peretti and I never met, though we were both in New York at the time.

TOM FINKELPEARL: In my discussion with Evan Roth, he talked about the emphasis in his residency at Eyebeam OpenLab on creating work that was relatively free of copyright: open-source code and Creative Commons release of restrictions. I believe you designed that residency. Do you think that the mainstream art world is ready for the sort of sharing culture that is present in the open-source community?

JONAH PERETTI: The Eyebeam OpenLab was designed to create a unique context for creative production. The idea was to combine the freedom of an artist residency, the technical resources of a university research lab, and a livable stipend so artists could do projects full time. But what made the program unique was the requirement that all work be released under an open-source license.

This open-source constraint had a bunch of advantages. Artists could collaborate freely because everyone's work was remixable and shareable. Eyebeam benefited because the organization did not lose all the knowledge created in the lab when a fellow left; their code and media stayed in the building for the next generation of fellows to use. And unlike corporate or academic research labs, the fellows could take their work with them because the IP was public and not owned by the sponsoring organization.

In the end I think we succeeded in creating an environment that supported work that could *only* be created in this environment. Artist residencies lacked the collaborative environment and technical resources. Research labs have great resources but insist on owning the intellectual property. The Eyebeam OpenLab took an open, nonproprietary approach, gave artists total freedom, and fostered collaborations within the lab and around the world.

The logic of the mainstream art world is totally different. At the Eyebeam OpenLab we did projects that got attention in the mass media instead of in elite art publications. We make projects that spread for free on the web instead of creating false scarcity through limited editions and high price tags like the traditional art economy.

A workshop at Eyebeam Art and Technology Center in New York, 2011. The center encourages a collaborative process and requires Creative Commons release of projects developed by its resident artists. Evan Roth created and launched *White Glove Tracking* while at Eyebeam. Photograph by Adrianne Koteen.

That is why the program attracted a new breed of collaborative, web-friendly artists and not established gallery artists.

TF: One of the aspects of the OpenLab that Evan commented on was the inspiration he got from the specific set of people who were in residence when he was there, the in-person interaction. If the point of the lab was largely to create work to be distributed online, why did you need to bring people together in a physical location?

JP: Mostly because you come up with good ideas when you hang out in the same space, eat lunch together, get in arguments, and "waste" time socializing. Also the Eyebeam OpenLab has electronic work-benches, a 3D printer, a laser cutter, and other physical fabrication tools. The LED *Throwies* project is a good example of why it is ideal to share a space. You come up with an idea while having silly conversa-tions in the lab; you have the tools to build the prototype; everyone runs out together to try it in the streets; and then the video and DIY instructions go viral on the web so the world can share in the fun. [*Throwies* is available on YouTube and Flickr.]

TF: The interaction you are describing at OpenLab is the sort of social be-

Throwies by Graffiti Research Lab (Evan Roth and James Powderly) combines LEDS and magnets for impromptu relighting of metal surfaces. New York City, 2006. Photograph courtesy of Evan Roth.

havior that humans have been engaging in over the last million years or so—the contagious social enthusiasm that comes from working closely together. Can you describe some of the differences between the interpersonal excitement of perhaps ten people creating the LED *Throwies* as a group project and the virtual interpersonal interactions that took place among the 150,000 people who viewed the *Throwies* video on YouTube?

JP: Way more than 150,000 people saw the video, because it was on several video platforms before YouTube. But it was the DIY page on instructables.com that really went viral and is closing in on a million views.

More people have heard of LED *Throwies* than have heard of Matthew Barney, Chuck Close, or Cindy Sherman. *Throwies* started as an art experiment, went viral on the web, spread as a DIY project, and mutated as new people became inspired and created their own *Throwies* and *Throwie*-inspired projects. I think the project is a great example of how face-to-face collaboration and virtual collaboration have become seamlessly connected. Groups of people in labs and living rooms far away from Eyebeam meet face to face and design

their own projects based on *Throwies* and then spread their designs online, which in turn inspires more people to do the same.

Of course, most are just along as observers and never actually build a *Throwie*. But even these people are important because they help the message spread and make the projects viral. I call these people the "bored at work" network — i.e., the hundreds of millions of bored office workers who spend half their day IM-ing, Facebooking, tweeting, blogging, and emailing stuff they find on the Internet. Collectively they are a bigger media distribution network than CNN or NBC or BBC. The "bored at work" network made *Throwies* viral, and some small percentage of them actually spent the weekend getting even more involved as creators.

TF: In our interview Evan refers to tapping into this network in the crowd-sourced collection of data for the *White Glove Tracking* project. Thousands of folks spent time at their computers tracking the glove, and they made possible some interesting videos by others in the next stage of the project. In the vocabulary of cooperative art, these passive spectators had become active participants. Do you think that there are implications beyond entertainment for the "bored at work" when they get involved with this sort of viral participatory project?

JP: The *White Glove Tracking* project uses the "bored at work" network to actually get people to participate in the creation of an art project. It is important to be entertaining to attract an audience, but once you have people's attention you can put them to work! The key is to make it fun and easy for the audience to participate by providing simple tasks that the average web user can understand. Collectively these simple tasks add up to something much bigger — in this case the *White Glove Tracking* project.

The popular press sometimes calls this sort of thing "crowd sourcing," and the brilliant theorist Yochai Benkler uses the less catchy phrase "commons-based peer production." You create an entertaining or important project, you get lots and lots of people interested, you design structures of participation so it is easy for everyone to contribute, and then a much bigger project emerges from the collective effort.

In some cases this collective effort really produces something huge. Wikipedia is peer-produced and has grown into one of the biggest websites in the world. Linux and Apache are open-source projects that power more web servers than the competing technology pro-

duced by Microsoft and other big companies. And more recently the so-called web 2.0 movement has co-opted this approach by building commercial ventures—for example, Facebook, Twitter, Digg—that create value by combining the activities of individual users into a larger whole.

White Glove Tracking is a really innovative way of extending this kind of thinking to art production. "The crowd" will never create a brilliant piece of art on its own, so you still have individual artists coming up with the good ideas. But now some of those artists are also designing mechanisms for the audience to participate. This way of thinking is not totally foreign to the art world—conceptual artists like Sol LeWitt and movements like Fluxus produced interesting examples of artists designing rule sets and structures that allowed the public to cocreate the work. But the global Internet and the open-source movement have allowed artists like Evan to push this approach way beyond the art world experiments of the 1970s.

Now a project like *White Glove Tracking* can spread to hundreds of thousands of people through the "bored at work" network, find thousands of contributors who get actively involved as glove trackers, and then provide data, code, and inspiration to several artists to create finished works that they never could have made on their own. The project becomes a global happening that drives distributed collective action and taps into the pulse of pop culture.

TF: In my interview with Evan and in your answers there is quite a bit of optimism regarding the social and communicative potential of the Internet. Do you also see a downside? Is there anything that scares you?

JP: There are lots of problems with the Internet, but it is always better to be optimistic when you are part of the effort to make something better. I think pessimism is the natural disposition of people on the sidelines—which is why you often see overly pessimistic theorists, academics, pundits, and journalists. But if you are part of the action, then you can stay optimistic and inspired by focusing your energy on fixing problems, trying new approaches, and filling in gaps.

The web is open enough that you can actually respond to what you don't like by creating your own alternatives. For people like Evan, that means making the web more collaborative, open, and creative. For me that means starting web companies and building technology to make media distribution more viral and democratic.

TF: When I was considering what online artwork to include in this book, several experts in the field said that there are tons of online projects that employ cooperative Internet communication to create sites, but they usually do not define themselves as art. Evan went to art school and defines himself as an artist. However, in my discussion with him he was hesitant to define the *White Glove Tracking* project as an artwork, and he has created work well outside the art world, like a Jay-Z music video. In your bios that I have seen, you do not define yourself as an artist, but you have created projects that certainly could be called art—like the parody site BlackPeopleLoveUs.com. On the other hand, you helped create the *Huffington Post*, which has had a significant mainstream media impact. Do you think that the artist versus nonartist distinction and the high art versus popular art polarity are being challenged online?

JP: For me the goal is to try to find the center of the culture-making action. That is where I want to be, and I think Evan feels the same way. Where is culture being made? Where can my ideas have a real impact? Where can I influence and challenge the way people think about the world?

There were moments in history when artists were at the center of the action. During the European Renaissance, for example, art was how new ideas permeated the culture. Artists did not just make pretty pictures; they actually spread the big ideas that mattered most. For example, one-point perspective reflected the individualistic, subjective worldview, while naturalistic representation promoted secularism's growth. In the fifteenth century the best way to change the world and spread ideas was to become an artist.

These days even really famous artists do not have that much influence on the larger culture. Meanwhile, creative people engaged with Internet and digital technologies are having a huge impact. Some of these people might call themselves artists, but a larger number use labels like activist, hacker, entrepreneur, designer, geek—or they just shrug and do not have a good title for what they do. But it is clear that if you want to contribute new ideas to the culture, you have a much better shot as a creative web geek than as a gallery artist.

In fact, the word *artist* can even marginalize you to the fringes of culture. To be economically successful as an artist, you need to remove your work from the stream of culture, create false scarcity to drive up your gallery prices, focus on cultivating very rich collec-

tors, and make work that is hard to understand unless it is explained by curators and critics. You can only make money in the art world if you are very skilled at making irresistible collectables for hedge fund managers, business moguls, and trust fund kids. You can also make amazing work that has an impact on the larger culture, but playing the "art game" usually makes that harder, not easier.

This is why I think Evan's work is so interesting. Instead of taking shelter in the art world, he just goes after the stuff that matters to culture and adds his contribution. I was never particularly fond of graffiti, but Evan realized that graffiti artists were the front lines of creative resistance to huge forces that define our culture: branding, consumerism, and corporate speech. So he combined graffiti with new digital technologies like LEDS and lasers. He used the web to distribute videos and how-to kits to millions of people. In the end he created a body of work that makes a contribution right at the center of the cultural action.

Put another way with a different example, the *White Glove Tracking* project is not just *about* how our culture is becoming more networked and collaborative because of the Internet. The project actually *makes* the web more networked and collaborative than it would have been otherwise. Evan is not just an artist expressing himself; he is producing knowledge and sharing the source code and data with the world. That is a big difference, and the web makes it possible. He does not just comment on culture; he actually contributes. I can't wait to see what he does next.

CONCLUSION

Pragmatism and Social Cooperation

A RECURRING THEME of cooperative art and participatory activism is their antispectatorial character. Cooperative art is created through *shared action*, not by active artists for inactive spectators. There is a widely held belief among cooperative artists that something substantial and mutually rewarding can be shaped by opening up the creative process and activating local knowledge and imagination. I would like to turn to America's most significant contribution to philosophy, pragmatism, partly because its progressive model of experiential, cooperative social construction has influenced the development of some socially cooperative art while deeply influencing the American education system. But more important, I turn to pragmatism because it proposes a useful framework for building and understanding antispectatorial aesthetic action in the American context. Indeed, as Cornel West says, pragmatism can be considered "a set of interpretations that attempt to explain America to itself at a particular historical moment."[1] Within pragmatism there is a range of political philosophy, but I am going to focus on the progressive strand of public intellectual engagement that runs from the cooperative social and pedagogical philosophy of John Dewey (1859–1952) to the neopragmatism of Richard Rorty (1931–2007). This is a mantle that has been assumed to some degree by a theorist of the public sphere, Jürgen Habermas (b. 1929), in Frankfurt and the "prophetic pragmatist" Cornel West (b. 1953) at Princeton.

The pragmatists' critique of the spectatorial is twofold: first, they attack the "fictive spectator theory of knowledge" (as West and others call it);[2] second, armed with a social and contextual concept of reality, many of them seek action and engagement over distanced philosophizing. Dewey takes issue with philosophies that postulate a bearer of knowledge "outside of the world." In this flawed view "knowledge consists in surveying

the world, looking at it, getting the view of a spectator."[3] The pragmatists simply don't think that's how truth happens; a detached spectator cannot survey the world to observe a socially independent truth because both the human subject and truth itself exist in a social context. Speaking at Columbia in 1907, William James famously summarized Dewey's view of truth thus: "Truth *happens* to an idea. It *becomes* true, is *made* true by events. Its verity *is* in fact an event, a process: the process namely of its verifying itself, its veri-*fication*. Its validity is the process of its valid-*ation*."[4] All truth propositions are actions that take place in the world. Truth becomes a verb.

So for the pragmatists truth is a process that is historical, contingent, and conditional. It is constructed—for the time being only—through inquiry. In his essay "The Influence of Darwin on Philosophy" (1910), Dewey argues that when we understand the implications of evolution, change replaces a priori, stable truth as the operating principle of the world we inhabit.[5] In this environment philosophers have a newly modest role. They do not uncover eternal truths but test hypotheses. Or, as Rorty puts it, "Dewey thought that the Kantian notion of 'unconditional obligations,' like the notion of unconditionality itself . . . could not survive Darwin."[6] But the lack of unconditional obligations does not suggest we stand on the sidelines and watch social truth reveal itself—there are no sidelines. Dewey sees a more active practice for the philosopher in the wake of Darwin. "In having modesty forced upon it," writes Dewey, "philosophy also acquires responsibility." Now the philosopher must project hypotheses "for the education and conduct of the mind, individual and social," and understand how these ideas "work out in practice."[7] For the pragmatists, especially Dewey, philosophical principles become actions defined through webs of interpersonal transaction because human beings are *social organisms*. "The non-social individual," writes Dewey, "is an abstraction arrived at by imagining what man would be if all human qualities were taken away."[8]

By inquiring into the social formations created by this social animal, Dewey became a theorist of democratic structures of cooperation. In an essay on Dewey's theory of democracy, Axel Honneth, the Columbia University and Goethe-Universitat, Frankfurt, professor of philosophy, points out that rather than looking to the political public sphere for the foundation of democracy (as Habermas does), Dewey looks to the "pre-political" sphere of cooperative action. Honneth writes, "In his endeavor to justify principles of an expanded democracy . . . Dewey takes his orientation not

from the model of communicative consultation but from the model of social cooperation." Dewey's democracy is based not on intersubjective speech but on cooperative action for joint problem solving.[9] This sort of democratic action creates a more fully cooperative *and* more fully individual social being. The individuality of the social animal is not lost in this equation; on the contrary, democratic cooperation gives it a relational context. As David Depew, a philosopher at the University of Iowa, writes, from Dewey's viewpoint, "socially cooperative persons living in a democratic society will necessarily become more highly individuated and autonomous than the isolated and merely reflective egos of class-stratified societies whose alienation is imagined by traditional epistemology-centered philosophies, in which private Cartesian egos inspect little more than the field of their own consciousness."[10]

Dewey's understanding of art is likewise social, and his aesthetics are also experiential, not spectatorial. He is hostile to the notion of the work of art as isolated and eternal, existing outside the flow of social life and contemporary context. Neither should art be segregated in museums away from the everyday life, nor is the aesthetic sphere limited to fine art. Dewey wrote in *Art as Experience* (1934), "The sources of art in human experience will be learned by him who sees how the tense grace of the ballplayer infects the onlooking crowd." He asks you to watch the ballplayer, the crowd, and how they interact—to consider the social, interactive-aesthetic space of the ballpark. The player's tense grace *infects* the crowd, and anyone who has spent time at ballparks (or at the theater) will recognize that the infection of performer and crowd is mutual. For Dewey, the troubling discontinuity of high art and life is reflected in narrow definitions of art and its isolation in museums: "Objects that were in the past valid and significant because of their place in the life of a community now function in isolation from the conditions of their origin. By that fact they are also set apart from common experience, and serve as insignia of taste and certificates of special culture." Just as Tania Bruguera bemoans the influence of Marcel Duchamp's gesture of removing a urinal from the flow of life to make it art, Dewey contends that the significance of objects is compromised when they enter the museum to serve as "insignia of taste." Because of the changes in society in the wake of industrialization, the artist "is less integrated than formerly in the flow of social services," he complains. "A peculiar esthetic 'individualism' results. Artists find it incumbent upon them to betake themselves to their work as an isolated means of 'self-expression.'"[11] This is not a call for collective or political art; rather

Dewey is pointing to the politics of the distribution of the aesthetic experience, a sentiment that is strongly restated toward the end of *Art as Experience*:

> The values that lead to production and intelligent enjoyment of art have to be incorporated into the system of social relationships. . . . What is true is that art itself is not secure under modern conditions until the mass of men and women who do the useful work of the world have the opportunity to be free in conducting the process of production and are richly endowed in capacity for enjoying the fruits of collective work. That the material for art should be drawn from all sources whatever and that the products of art should be accessible to all is a demand by the side of which the personal political intent of the artist is insignificant.[12]

How similar this is to Joseph Beuys, who sees the whole of society as the context for a total work of art. "Everyone will be a necessary co-creator of social architecture," he writes, "and, so long as anyone cannot participate, the ideal of democracy has not been reached."[13] Both Beuys and Dewey see the need for "the mass of men and women who do the useful work of the world" to be integrated into a society that seamlessly includes art in daily life. Indeed they both argue that the status of art is "not secure under modern conditions" that isolate it from everyday experience.

But Dewey was not an early visionary of cooperative art. His taste in art tended toward Shakespeare and Keats. While he was writing *Art as Experience* in the late 1920s and early 1930s in New York, there is no evidence that he was up-to-date on Dada or Duchamp. Moreover, he drew a bright line between scientific inquiry, which creates structures for understanding experience, and art, which is *itself* an experience — even if such a clear-cut distinction seems out of character for a philosopher who was a fierce critic of thinking in dualisms.[14] Certainly he had a startlingly wide definition of the aesthetic. This is a man who viewed the "union of men about a common interest" in the Pullman strike as magnificent *aesthetic* spectacle.[15] Dewey's distinction between art and social function does not represent the last word for pragmatist aesthetics. For example, one of the best-known neopragmatist aestheticians, Richard Shusterman, declines to draw such a line. He contends that "different goods can be deeply integrated. . . . Aesthetic value can enhance an artwork's social function, which in turn can heighten the work's aesthetic experience."[16] In any case Dewey was dedicated to opening up aesthetic experience, in terms of both what constitutes the aesthetic realm and who has access to this sort of experi-

ence. His aesthetic was experiential, consistent with the pragmatist notion of the *socially cooperative process of truth creation*. In order for art to thrive it must leave the ivory tower and workers' relation to production must be realigned, so that they are "richly endowed in capacity for enjoying the fruits of collective work." While this is not an endorsement of art collectively created, it is a reflection of Dewey's radicalism in the 1930s and his aesthetic aspirations for working-class Americans. It was a call to free art from its physical isolation and social segregation within the walls of the museum.

For the most part, Dewey's influence on socially cooperative practice is indirect, though there are important exceptions. Allan Kaprow read Dewey as a philosophy graduate student, and the marginal notes he wrote in his edition of *Art as Experience* show that he absorbed Dewey's understanding of experience. Certainly Kaprow embraced the goal of "recovering the continuity of esthetic experience with normal processes of living."[17] In fact Jeff Kelley argues that Kaprow's absorption of the lessons of *Art as Experience* grounded his work in American pragmatism.[18] Kaprow was an influential figure for many artists and a direct teacher of Suzanne Lacy, who went on to influence many others in the field of cooperative art, including her student Lee Mingwei. Mary Jane Jacob, a pivotal figure in the development of socially cooperative art practice, is a Dewey admirer who told me that she talks about him all the time at the School of the Art Institute of Chicago, planting Deweyan seeds in the next generation.[19] It is unclear how or when pragmatism will reenter the discourse of contemporary art in a major way, but I have begun to hear young cultural producers like the Chicago-based group InCUBATE (the Institute for Community Understanding between Art and the Everyday) cite Dewey as an inspiration.

So strains of Dewey's philosophy continue to make their way through parts of the socially cooperative art world, but it is in American education that Dewey's ideas found their most receptive audience, and his influence in that field has been dominant and enduring. He was a cofounder of the New School in New York and of the American Association of University Professors, and his ideas resonated through the twentieth century in the work of many education reformers, including Theodore Sizer and his Coalition of Essential Schools. Dewey started writing about education in the 1880s. In 1896 he opened the influential (and still operational) Laboratory School under the umbrella of the University of Chicago, in the pragmatist spirit of understanding how ideas work in practice. The notion was

to create a cooperative community, a school integrated into its social environment. The curriculum was based on experiential learning (e.g., understanding fractions by cooking) and designed in a manner more like everyday life than the rigid, rote-oriented pedagogical style that characterized many schools at the time.

Dewey's essay "My Pedagogic Creed" (1897) begins, "I believe that all education proceeds by the participation of the individual in the social consciousness of the race." For Dewey, education was a "process of living," not merely preparation but an ongoing social process. Teachers were to be members of the community, not separated from the students or empowered to simply impart knowledge from above, while the students were active both physically and mentally. Like Paulo Freire, Dewey sought to shed the oppressive conditions that created the passive child, and he bemoaned the shortcomings of education that sees the student as merely "receptive."[20] This sentiment, espoused at the end of the nineteenth century, reverberated through the American study of education in the twentieth. Dewey saw school as a fundamental engine of social progress, and this message had tremendous resonance in the progressive era and beyond.

Throughout this book we have seen projects in which artists take on the role of the interactive, dialogical educator. In the American context this sort of practice is indebted to Dewey, whether consciously or not. And while Dewey did not live to see pedagogic art, he used the metaphor of the artist when describing the integral role of educators in society: "I believe that the art of thus giving shape to human powers and adapting them to social service is a supreme art, one calling into its service the best of artists; that no insight, sympathy, tact, executive power is too great for such service."[21] Like Saul Alinsky's vision of the community organizer, like the dialogical teacher imagined by Freire, Dewey's teacher is neither speaking from above nor simply window dressing for a student-run educational experience. West writes, "In sharp contrast to curriculum-centered conservatives and child-centered romantics, Dewey advocated an interactive model of functionalistic education that combined autonomy with intelligent and flexible guidance."[22] This model of engaged interaction and flexible guidance requires a new modesty, but it also requires "insight, sympathy, tact, [and] executive power" on the highest level. It is *not* personal modesty or a modesty of aspiration, but the modesty of power relations that comes from shared control. It is the sort of modesty that is often required of cooperative artists.

The decline of Dewey's influence (particularly in the arts) after his

death in 1952 can be explained by a number of factors, including the dense prose style that makes much of his work slow going for nonspecialists and his lack of understanding of avant-garde art practices, which made his writing on art seem a bit dated. He also suffered from the inevitable ebbs and flows of intellectual fashion. After the Second World War the high-cultural focus turned toward Europe as, not coincidentally, transplanted intellectuals like Rudolf Carnap and Herbert Marcuse brought the teachings of the Vienna Circle and the Frankfurt School with them to the United States. The Oxford political philosopher Alan Ryan writes that "academic philosophy [in America] became increasingly technical and analytic, while the politically engaged audience that would before the war have read *Art as Experience* . . . now turned to Sartre or Adorno or Marcuse." For some on the American Right, Dewey remained the hated symbol of liberalism in the 1950s, but the Left had moved on, at least for the time being.[23]

Still, if the general tide was turning away, some academics were finding echoes of Dewey's approach in that of the Harvard philosopher W. V. O. Quine and others as early as the 1950s. Even so, Ryan argues, "showing affinities between Dewey's work and the recent technical philosophy makes Dewey respectable but not exciting. Making him exciting has been the project of Richard Rorty, who has recruited Dewey as one of the prophets of postmodernism."[24] Starting in the 1970s Rorty, then at Princeton, began a spirited and influential reassessment of Dewey and the pragmatists, and he did more than anyone else to bring their ideas back into the contemporary transatlantic dialogue. The pragmatists are postmodernists, claims Rorty, "in the sense given to this term by Jean-Francois Lyotard, who says that the postmodern attitude is that of 'distrust of metanarratives,' narratives which describe or predict the activities of such entities as the noumenal self or the Absolute Spirit of the Proletariat."[25] But while the pragmatists join the postmodernists in denying such universalist propositions, there is a significant distinction. Rorty writes, "Dewey was as convinced as Foucault that the subject is a social construction, that discursive practices go all the way down to the bottom of our minds and hearts. But he insisted that the only point of society is to construct subjects capable of ever more novel, ever richer forms of human happiness. The vocabulary in which Dewey suggested we discuss our social problems and our political initiatives was part of his attempt to develop a discursive practice suitable for that project of social construction."[26]

So pragmatism, or Rorty's version of Dewey, is a postmodern discursive

enterprise with progressive social aims. Especially after the publication of *Philosophy and the Mirror of Nature* in 1979, Rorty became an increasingly active voice outside the academy. While never achieving the public eminence of Dewey, he continued the pragmatist tradition of attempting to intervene actively in the public discourse. If, as the pragmatists contend, a proposition exists in the world not as an independent "meaning" but through its use, then it is important to be an active participant in the social definition or public *implementation* of ideas.

If Dewey's social vision of truth attacks a "fictive spectator theory of knowledge," Rorty also grumbles about the spectatorial social status of what he sees as an impotent and isolated academic Left in the United States:

> Theorists of the Left think that dissolving political agents into plays of differential subjectivity, or political initiatives into pursuits of Lacan's impossible object of desire, helps to subvert the established order. Such subversion, they say, is accomplished by "problematizing familiar concepts."
>
> Recent attempts to subvert social institutions by problematizing concepts have produced a few very good books. . . . But it is almost impossible to clamber back down from [these] books to a level of abstraction on which one might discuss the merits of a law. . . . These futile attempts to philosophize one's way into political relevance are a symptom of what happens when a Left retreats from activism and adopts a spectatorial approach to the problems of a country.[27]

In this passage Rorty sought to problematize the practice of problematization by asking who is seeking to subvert what order, and whether in fact there is any *consequence* of the subversion. As a pragmatist he inquires into the "use value" of an argument. How does theory play out in practice? What are the actions that it entails? What relevance does it have to laws? Rorty sought a revival of the American "reformist Left" to replace the "critical Left" that he accuses of merely philosophizing, remaining a passive spectator in the social sphere. He particularly laments the disappearance of cooperation between organized labor and the liberal middle class, partnerships among people who identify themselves as union members, democrats, and socialists.[28] His argument is local and contextual. It is a critique of the weak social impact of certain genres of theory here in America. In his view, not only are all politics local, but all philosophy as well. He says therefore that Dewey's argument for democracy was not an appeal to universal values: "He saw democracy not as founded upon the

nature of man or reason or reality but as a promising experiment engaged in by a particular species of animal—our species and our herd."[29] One might add that "our herd" in much of Rorty's writing is the *American* herd. It is one thing to take a spectatorial philosophical position in a country like France that has had a relatively robust social safety net, and something else entirely to do so in contemporary America, where health care is only the tip of the privatized iceberg.

———

In any case, if one is swayed by the arguments of Dewey and Rorty, how might one read a cooperative work of art through a pragmatist lens?

Consider *Project Row Houses*. If one accepts the pragmatist notion that meaning is contextual, then *Project Row Houses* should be read as a specific response to a local matrix of conditions. *Project Row Houses* is situated in the Third Ward of Houston. During the Jim Crow years the Third Ward was a center of African American community life, both as a residential concentration and as a business hub. Though segregation was abusive and limiting to African Americans, old-timers in the area also remember a vibrant neighborhood built by its residents. Even as Houston's population grew in the 1970s and 1980s, as in many urban communities, the Third Ward saw a decline in resources. Ironically this decline was intensified by desegregation. Just as white flight sapped middle-class energy in many American cities starting in the 1950s, some traditionally segregated urban areas lost middle- and upper-middle-class African Americans to other areas that had traditionally been off-limits, in a kind of regional brain drain. The remaining inhabitants were then confronted with decreasing real estate values and dwindling resources most likely exasperated by redlining, the racially discriminatory lending policies of banks that made it all but impossible to invest in African American communities in those decades. Like many of its sister communities around the country, the Third Ward lost population and experienced building abandonment as crime rates rose through the 1970s and 1980s.

In the early 1990s Rick Lowe and a coalition of other African American artists began talking about what they might do as citizens and creative people to help improve the situation in the diminished Third Ward. After a time they came upon a group of abandoned shotgun houses and undertook their renovation and revitalization as a long-term cooperative art project. Nearly two decades later *Project Row Houses* is a campus of fifty buildings within which a wide range of activities and initiatives are

undertaken, some of which are easily identifiable as art, while others fit more comfortably into architecture, urban planning, or social work. But one of the initial inspirations to create the project was aesthetic in a rather traditional way: a particular *visual* image of several abandoned blocks on a specific day. Lowe says, "I just remember standing there. It was a rainy day, and the roofs get a little purple and it's a beautiful sight" (see chapter 5). And to some extent Lowe could see this beauty and be moved to action because of his appreciation of the traditional easel paintings of John Biggers, a senior artist in Houston who had made this architecture and its use in African American community life a major theme of his work. In fact *Project Row Houses* could be seen as a tableau vivant of a Biggers painting. The oft-repeated underlying principles of *Project Row Houses* come from a close reading of Biggers's paintings, and the project is an effort to bring those principles back to life.[30]

But Lowe's aesthetic vision was *simultaneously* infused with the identity politics and community activism that had engaged him for several years. He used the same social brain, the same creative imagination to see the physical beauty of the site as to imagine how to interweave its artistic, social, and architectural future. He understood how (in Shusterman's words) these "different goods can be deeply integrated." So he catalyzed a cooperative enterprise that translated Biggers's on-canvas vision of a flourishing African American past in shotgun houses into a complex and thriving present in a cluster of reclaimed and renovated buildings. It is an art project that unfolds over years as a stream of events and interpersonal interactions. In preservation circles this might be called adaptive reuse, but it is more than that. It is a political, experiential, and aesthetic resurrection of a site—a new and recontextualized version of a place that is still present in the memories of seniors in the community, a site that was destroyed by the unequal distribution of capital in the postwar American city.

While one can get a good secondhand sense of the project by reading descriptions like the one in chapter 5, the live, in-person experience of *Project Row Houses* is a walk through a physical site that continues to grow, art installations that change several times a year, an architectural venture, a development project, and a social setting. Few of the individual aesthetic decisions have been made by Lowe, but the overall socio-aesthetic vision has been instigated and is best articulated by him. This is a site for the creation and display of art for education, for architectural innovation, and for experimental social housing. One of Dewey's goals was "recovering the

The Unity Circle, a daily occurrence in the Youth Education Program of *Project Row Houses*, an afterschool program (full days in the summer) for youth ages five to seventeen. Children often participate for up to ten years. 2005. Photograph courtesy of *Project Row Houses*.

continuity of esthetic experience with normal processes of living."[31] In *Project Row Houses* this continuity is present: daily life is the art. To a large extent the project accomplishes its goals through coalition building and cooperative action. But it is *not* a self-sufficient utopian community separated from its urban environment. As an active undertaking in the city of Houston, it is also a site of social action and engagement. It is a project that actively tests hypotheses on the world.

Houston is often described as the only big city in the United States without zoning regulations, but it is more complicated than that. In a post on the *Bloomberg Business Week* website, the economics editor Peter Coy describes how a city could get along without zoning, remain hospitable to business, and avoid chaos:

> What is unique about Houston is that the separation of land uses is impelled by economic forces rather than mandatory zoning. While it is theoretically possible for a petrochemical refinery to locate next to a housing development, it is unlikely that profit-maximizing real-estate developers will allow this to happen. Developers employ widespread private covenants and deed restrictions, which serve a comparable role as zoning. These privately prescribed land use controls are effective because they have a legal precedence and local government has chosen to assist in enforcing them.[32]

In this free-enterprise vision Houston's land use is controlled not by po-
litically agreed-to zoning laws but by "profit-maximizing real-estate de-
velopers" with assistance from governmental agencies. This has led to a
freewheeling real estate market, sprawl, and, one might add, low housing
prices. But it also supports the ongoing criticism that when we speak of
free markets in the United States, we are often speaking of markets that
are meant to maximize the utility of a specific class, in this case real estate
interests. Perhaps predictably there has been little resistance to dislocation
and displacement through rapid gentrification in other parts of Houston,
notably the adjacent Fourth Ward. Indeed it is remarkable that an area so
close to Houston's center as the Third Ward has not been comprehensively
rebuilt, given the city's population growth. With the success and expan-
sion of *Project Row Houses* has come the specter of gentrification around
their site—the sort of outcome usually hailed in studies of the arts as an
economic engine. Of course, such gentrification would be anathema to
the core vision of *Project Row Houses*, so they have been active in resist-
ing it by acquiring property through their own community development
arm and through building their own affordable housing. Instead of cri-
tiquing development policies through political art, *Project Row Houses* has
itself become a developer. Lowe told me that speculators infringing on the
neighborhood are an inevitable part of the equation that cannot simply
be wished away. If he hears that people are calling around the community
looking to buy property, he gets on the phone to see whether there might
be a parcel of land owned by *Project Row Houses* that he can sell them at
the right price in order to purchase another lot that has more strategic
significance.[33] Part of the socio-aesthetic vision of the organization is to
keep the Third Ward affordable for the African American and increasingly
Latino local inhabitants. Lowe is not standing by as a spectator, but is fully
engaged in the social sculpting of the Third Ward. Yes, his actions could be
said to be "problematizing the dominant narrative of development" imag-
ined by the profit-maximizing real estate interests in Houston, but *Project
Row Houses* is also actively participating in resisting displacement through
actual real estate transactions.

As noted earlier, Dewey had a wide vision of the aesthetic realm. He
could wax poetic about the aesthetic dimension of the ballplayer's grace
or the Pullman strike. In this frame of mind it is not difficult to imag-
ine the aesthetic contemplation of a street or a neighborhood. From a
visual perspective, we take note of beautiful streets all the time—the con-
fluence of architecture, foliage, scale, and so on—but urbanists like Jane

Housing designed by students in the Rice Building Workshop at Rice University School of Architecture as low-income rental housing for *Project Row Houses*. The first set of newly constructed housing was built in 2004. Photograph by Danny Samuels. Courtesy of *Project Row Houses*.

Jacobs also help us see the aesthetic dimension of the social flow. When she looked at a healthy street, she saw human activity, not buildings. The life of the city, for Jacobs, is "all composed of movement and change, and although it is life, not art, we may fancifully call it the art of the city and liken it to the dance . . . an intricate ballet."[34] Even if Jacobs could barely bring herself to call the life of the city a work of art in her influential love letter to Greenwich Village, *The Death and Life of Great American Cities*, she expressed admiration at the beauty of everyday interactions in a community in a way that went beyond the mechanical urban vision of her day. As the Columbia University psychiatry professor Mindy Thompson Fullilove puts it, "In using 'ballet' to describe the prosaic acts of putting out the garbage and nodding to the fruit seller, Jane Jacobs challenged us to open our senses and our understanding. She was well aware that the scene she described was imperiled by urban renewal precisely because it was devalued by power brokers interested in other uses for the land. Her reframing 'putting out the garbage' as 'sidewalk ballet' created a weapon protecting neighborhoods."[35] This sort of analysis of Jacobs's use of *ballet* is consistent with the pragmatist practice of considering not just a word's

linguistic meaning, but its social use-value. In Jacobs's context, situating everyday social interactions in the realm of art became a weapon to fight the powerful forces that devalued the common flows of the city. If, like Dewey, one is dissatisfied with the isolation of art "set apart from common experience," one can still use the social status of art to reframe the perception of an action, a space, or a neighborhood. This is exactly what Mierle Laderman Ukeles did with her maintenance art performances and garbage-barge ballets in the 1980s, and the sort of weapon that Lowe is using at *Project Row Houses*, understanding that calling his neighborhood art allows people to perceive and value it differently. If you can have an aesthetic experience of the "art of the city," you can understand that this environment is sculpted—that interpersonal relations, as well as architectural and environmental decisions, have come together to create that particular aesthetic experience. *Project Row Houses* is trying to be conscious and intentional in sculpting this experience in their precinct. They have commissioned architecture that respects the scale of the existing neighborhood without slavishly copying the shotgun houses. When you are looking at this newly built housing, the design decisions have architectural, social, economic, historical, and racial meaning *simultaneously*. The materials used in construction, the volunteer architects, the federal housing grants, and the debt structure help create the affordability of the leases offered to the tenants of the buildings, which in turn allows a set of people to move in who influence the social space of the street. It would be a different urban ballet on that same street with different dancers. At a graduation ceremony for *Project Row Houses*' Young Mothers Residential Program in spring 2011, the interweaving of the programs and of art and life was clear and present. Perhaps one hundred guests were present, including ten young kids who ran through the spacious Eldorado Ballroom, a historic stop on the African American music circuit in midcentury and now one of *Project Row Houses*' fifty-five properties. Each of the graduating mothers had spent two intensive years living at *Project Row Houses*, pursuing educational goals while abiding by a curfew and participating in weekly group meetings. Each spoke of her challenges and hope; none said it had been easy. They all credited the infusion of art into their life as a significant change, an enjoyable benefit of her residency, a transformative educational experience. Two of the mothers were staying in the community with their children, moving into the housing units. A third was off to New York to pursue a master of fine arts degree at NYU. Assata Richards, a graduate of the program (having left to obtain a Ph.D. in

sociology from Penn State), was now directing the program, speaking as forcefully and persuasively about the social power of art to the assembled crowd as she would at the American Association of Museums annual conference the next day. Family, friends, teachers, and former students cheered her on. "We can approach our lives as artists, each and every one of us," Lowe has said. "It's a choice people have. You don't have to make houses the way people always have. If you choose to, you can make every action a creative act."[36] It is an aesthetic vision as wide and anti-elitist as Dewey's, a social sculpture that is inspired by and expands upon Beuys. This gesture—calling social action and cooperation art—infuses every project in this book.

If I am proposing *social cooperation* as the name for this sort of art, does it follow that more cooperation makes the project better? I think not. The term is meant to be descriptive, not prescriptive. Calling a group of artist Impressionists does not imply that a painting is better the fuller of impressions it is. And while the ladder of citizen participation discussed in chapter 1 suggests that more participation is better in urban planning, this seems simplistic for art. Throughout this book there have been projects with varying degrees of cooperation. Perhaps the most cooperative are ones in which the artist gave a stage to others: Daniel Martinez's platform for swap meets or Pedro Lasch's opening of institutions for sonidero parties. In these cases the artist presented the platform and the content was entirely provided by others. At the other end of the spectrum would be Ernesto Pujol's installation, in which he gathered materials through a cooperative process but assembled them at a museum and designed the installation himself. Pujol's project may have been less fully cooperative, but that does not make it less potent.

What I would ask instead is whether there is a socio-aesthetic necessity for cooperation in the project. Could it have been achieved without cooperation, and if so, how would that change it? I have seen community mural projects that could have been completed more proficiently without a cooperative effort; cooperation was a feel-good but inefficient means to an end, even in community building, so it seemed unwarranted. On the other hand, I would argue that the projects in this book are inherently and necessarily cooperative. Harrell Fletcher could not have made his film alone. The idea came from Jay Dykeman; the setting was Dykeman's gas station; and the cast was his staff and customers. Wendy Ewald could not have created the *Arabic Alphabet* alone. She does not speak Arabic, and even if she learned how, the word associations with the letters were based

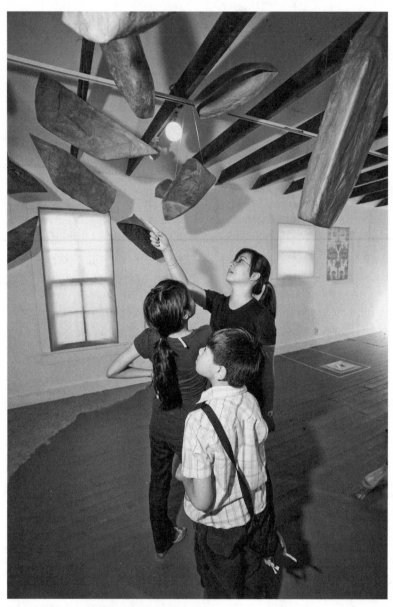

A visitor with her children at an artist installation by Marina Gutierrez within one of the original buildings at *Project Row Houses*, 2010. Photo by Eric Hester. Courtesy of *Project Row Houses*.

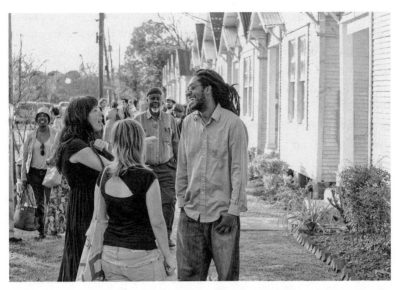

The writer Quincy Berry (far right) talks to a *Project Row Houses* Core Program artist, Kelly Sears (left), and a critic in residence, Wendy Vogel (center, back to the camera), at an opening in 2010. Rick Lowe (very far left) talks to Valerie Cassel, curator at Contemporary Art Center in Houston. Photograph by Eric Hester. Courtesy of *Project Row Houses*.

on nuanced cultural experience and the psychological complexities of her Arab American middle school collaborators' mind-sets. Evan Roth might have been able to create the data for *White Glove Tracking* with intense personal effort, but the videos created from the data clearly came from the digital imagination of others. And so on. I am proposing an echo of the Greenbergian principle of truth to medium: cooperation is often best undertaken in art out of necessity, in an artwork that could not be created otherwise.

In the case of *Project Row Houses*, cooperation is indeed necessary. A spectrum of expertise has been required—that of urban planners, architects, real estate professionals, social service providers, and artists from self-professed social sculptors to painters and photographers. Cooperation was a means to an end, but it is more than that. Just as the Port Huron Statement's participatory ideology suggests that "the political order should serve to clarify problems in a way instrumental to their solution," cooperation at *Project Row Houses* is a tool to enlist widespread support and engagement within and outside the community.[37] When Lowe and his team invited other organizations to adopt and renovate individual row

houses, they brought people from cultural, religious, and civic organiza-
tions around Houston into the fold, using cooperation as an organizing
and coalition-building tool. And because of the cooperative structure of
its creation, the atmosphere on the campus is cooperative. It is a com-
munity that looks after the children from the Young Mothers Residential
Program. It is a set of art projects that often embrace the local. And it is a
nonprofit development corporation whose goals are the collective good of
the inhabitants, not profit maximization.

To return to the questions of spectatorship that were discussed at the
beginning of this chapter and in the opening pages of this book, there is a
complex set of audiences and participants at *Project Row Houses*. Like the
Living Museum discussed in chapter 1, *Project Row Houses* enlists a large
number of participants who are at the core of the project. These are the
active nonspectators who design the buildings, live in the housing units,
develop real estate contracts, make the art installations, plant the gardens,
or work at the community development corporation. Their role mirrors
the artist-patients at Creedmoor, the group that is busily working from
week to week regardless of outside observation. But there are also the visi-
tors to the site, the consumers of the art installations, and the architecture
and planning students who might come by simply to see what is going on.
They resemble the visitors at the open house at the Living Museum, but
they are also similar in some ways to the participants in *Key to the City*,
making an unusual urban journey off their normal route. For many Hous-
tonians who live outside the Third Ward, the area tends to fade into the
background of their consciousness if they are not reminded by the pres-
ence of *Project Row Houses*, just as *Key to the City* remapped New York for
its participants. If we are to see the work of art in its totality, as an experi-
ence within "normal processes of living," then the trip across town to an
art show is part of its use. Your vision of the Third Ward, the people you
might bump into on the street, and the stop at a local restaurant are a part
of your experience. As opposed to cultural institutions that see this set of
interactions as peripheral to the art experience, at *Project Row Houses* it is
all part of the social sculpture. When you visit, you have entered the sculp-
ture, so you are a participant, not a spectator.

If, as the pragmatists say, truth is created and re-created in a matrix of
social interactions and interpersonal transactions, if expanded democracy
is modeled on social cooperation, why not explicitly use this flow to gen-
erate art that is itself a process of discursive meaning creation through co-
operative action? In pragmatism, philosophy has a more modest role; it is

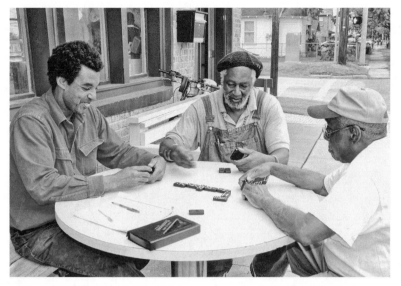

Rick Lowe (left) and Jesse Lott (center) playing dominos with Aaron Adams (right), a *Project Row Houses* community resident and expert player, 2008. A core group and passersby play dominos outside the office of *Project Row Houses* at least twice a week. Photograph by Eric Hester. Courtesy of *Project Row Houses*.

no longer the distributor of truth but the active tester of hypotheses. Just so, the socially cooperative artist is an interactive tester of propositions rather than an individual dispenser of a finished aesthetic product. But this is not self-sacrifice. Mutual creation has its own creative pleasures. Pragmatist philosophers and cooperative artists share an abiding anti-elitism, a belief that philosophy, art, and pedagogy can and should be created for and with all strata of society. The cooperative artist does not separate social insight from aesthetic vision. The aesthetic vision is in fact social. The artistic product is not secluded within the academy or the art world or "set apart from common experience," but rather is integrated into and in many cases actually consists of common experience—not "art as experience" but socially cooperative experience as art.

ONE INTRODUCTION

The Art of Social Cooperation

1 Grant Kester, letter to the editor, *Artforum*, May 2006, 22.
2 Bishop, *Participation*, 11.
3 Doherty, *Contemporary Art from Studio to Situation*, 19.
4 Kester, letter to the editor.
5 Bishop, "The Social Turn," 179.
6 The following books are an excellent introduction to the topic of human cooperation. My own conclusion in a nutshell is that the notion that we are essentially rational and self-interested has led to a dangerously antisocial political economy in the United States; our species is uniquely capable of altruism and cooperation—balanced by a clear and undisputable understanding that human beings are territorial and aggressive animals. On evolutionary game theory: Robert Axelrod, *The Evolution of Cooperation* (New York: Basic Books, 1984); Robert Axelrod, *The Complexity of Cooperation* (Princeton: Princeton University Press, 1997). On rational choice theory: S. M. Amadae, *Rationalizing Capitalist Democracy: The Cold War Origins of Rational Choice Theory* (Chicago: University of Chicago Press, 2003); Michael Taylor, *Rationality and the Ideology of Disconnection* (Cambridge: Cambridge University Press, 2006). On theory of reciprocity and altruism: Elinor Ostrom and James Walker, eds., *Trust and Reciprocity: Interdisciplinary Lessons from Experimental Research* (New York: Russell Sage Foundation, 2003); Elliot Sober and David Sloan Wilson, *Unto Others: The Evolution and Psychology of Unselfish Behavior* (Cambridge, Mass.: Harvard University Press, 1998); John Baden and Douglas Noonan, eds., *Managing the Commons* (Bloomington: Indiana University Press, 1998). On new cognitive science of interconnection: John T. Cacioppo and William Patrick, *Loneliness: Human Nature and the Need for Social Connection* (New York: W. W. Norton, 2008); Marco Iacobini, *Mirroring People* (New York: Farrar, Straus and Giroux, 2008). On evolutionary economics: Michael Shermer, *The Mind of the Market: Compassionate Apes, Competitive Humans, and Other Tales from Evolutionary Economics* (New York: Times Books, 2008).
7 Starr, "The Phantom Community," 247.
8 Ibid., 250.
9 Throughout this essay, when I refer to the influences cited by the artists in this book, I am referring either to what they said in the interviews in the book or to a survey of the artists that I conducted by email in 2008 and 2009, unless otherwise specified.
10 Washington, *A Testament of Hope*, 269–70.
11 Student Nonviolent Coordinating Committee, "Statement of Purpose," 70.
12 Starr, "The Phantom Community," 253.
13 Alinsky, *Reveille for Radicals*, 54–55.

14 Alinsky, *Rules for Radicals*, 123.

15 Alinsky, *Reveille for Radicals*, 132.

16 Arnstein, "A Ladder of Citizen Participation," 233–44.

17 Hayden, *The Port Huron Statement*, 53–54.

18 Ibid.

19 Ibid., 6.

20 Miller, "The Sixties-Era Communes," 327.

21 Case and Taylor, *Co-ops, Communes, and Collectives*, 5.

22 Martin, *The Theater Is the Street*, 106.

23 Doyle, "Staging the Revolution," 71–98.

24 Hoffman, *The Autobiography of Abbie Hoffman*, 102, 105–6.

25 Ibid., 107, 106.

26 Starr, "The Phantom Community," 246.

27 Gordon, Gordon, and Gunther, *The Split Level Trap*; Mumford, *The City in History*, 486, 509.

28 Friedan, *The Feminine Mystique*, 15.

29 Oliver, *Betty Friedan*, 73–74.

30 Ibid., 74.

31 Evans, *Personal Politics*, 125.

32 Doyle, "Staging the Revolution," 106–11.

33 Evans, *Personal Politics*, 137–38.

34 Hanisch, "The Personal Is Political," 204.

35 For example, Michaels, "From 'Consciousness Expansion' to 'Consciousness Raising,'" 48.

36 Ryan, "Gender and Public Access," 260.

37 Sarachild, "Consciousness-Raising," 144, 147.

38 Hanisch, "A Critique of the Miss America Protest," 170.

39 New York Radical Women, "No More Miss America!," 213.

40 Hanisch, "A Critique of the Miss America Protest," 169.

41 Hendricks, *Fluxus Codex*, 23, 37.

42 Maciunas, interview, 114.

43 Beuys, "Spade with Two Handles," 129.

44 Michael Kimmelman, "Guerrilla Art Action Group," *New York Times*, May 2, 1997.

45 Kaprow, "Participation Performance," *Essays on the Blurring of Art and Life*, 184, 185.

46 Ibid., 188.

47 Kaprow, "The Education of the Un-Artist," *Essays on the Blurring of Art and Life*, 97–98.

48 Kelley, *Childsplay*, 143.

49 Kohl, *36 Children*. Reading this book as a sixth grader in 1968 was compelling for me. I was the same age as the thirty-six kids in the book.

50 Kaprow, "Success and Failure When Art Changes," 153.

51 Kelley, *Childsplay*, 146.

52 Ibid., 154.

53 Mierle Laderman Ukeles, email message to author, November 22, 2007.

54 Ukeles, "Manifesto for Maintenance Art 1969!," 84–85.

55 In 1984 Ukeles wrote "Sanitation Manifesto!," which expressed the philosophy be-

hind her long-term and ongoing collaboration with the administration and the workers of the City of New York Department of Sanitation.

56 It is sometimes argued that an important generative moment in the birth of cooperative art was the attack on the centrality of the authorial voice, as European writers like Roland Barthes declared the death of the author. In the 1970s Barthes and others were promoted by important American scholars, including Paul de Man and Geoffrey Hartman at Yale. But as influential as these deconstructionists were in the academy, I see no plausible link to cooperative art practice in the United States. For the most part, their art critic allies have been hostile to cooperative and activist art, and the deconstructionists were more influential for Conceptual artists. With the death of the author, the reader may become coauthor of the text, but this analysis is a commentary on the indeterminacy of meaning of *all* texts; the demise that was theorized was a *general* death of the author, in no way a reference to artists who sought to share authorship, attack passive spectatorship, or activate the audience.

57 Debord, "Towards a Situationist International," 98–99.

58 Debord, *Society of the Spectacle*, 16.

59 Wollen, "Bitter Victory," 27.

60 Schjeldahl, "Proto SoHo," 80. It is also worth noting that Matta-Clark's father, Roberto Matta, had published lithographs in the international Parisian edition of the *Situationist Times*, no. 6 (December 1967), so Gordon may have arrived in Paris with prior knowledge of the Situationist project. On the comparison between Matta-Clark and the Situationists, see, for example, Schumacher, "Potential of the City."

61 Leandro Katz, email message to author, March 30, 2009.

62 Jacob, *Gordon Matta-Clark*, 39.

63 Beuys, "A Public Dialogue," 25–26.

64 Beuys, "Not Just a Few Are Called, but Everyone," 891.

65 Levin, introduction to *Energy Plan for the Western Man*, 1.

66 Rick Lowe, email message to author, December 2007.

67 Beuys, "I Am Searching for Field Character," 22.

68 Freire, *Pedagogy of the Oppressed*, 60–61, 161.

69 Boal, *Games for Actors and Non-actors*.

70 Kruse, *White Flight*, 258, 234, 259.

71 Hayden, *Redesigning the American Dream*, 73.

72 Krugman, "Things Pull Apart," 219–21.

73 Yenawine, "But What Has Changed?," 9.

74 Patterson, *Restless Giant*, 293–94.

75 Patterson, *Grand Expectations*, 578–79.

76 Davis, *Magical Urbanism*, 62, 67, 65.

77 Brookings Institution Metropolitan Policy Program, *The State of Metropolitan America: Race and Ethnicity*.

78 Bellah, "Community Properly Understood," 18–19. *The Essential Communitarian Reader* is a collection of essays from the publication *Responsive Community*.

79 In 1999, at the tender age of twenty-four, Jedediah Purdy made a big splash with his book *For Common Things: Irony, Trust, and Commitment in America Today* (New York: Alfred A. Knopf, 1999), in which he took aim at cultural icons like *Sein-*

feld, Saturday Night Live, and *Wayne's World.* Robert Putnam is best known for his book *Bowling Alone: The Collapse and Revival of American Community* (New York: Simon and Schuster, 2000), in which he analyzes Americans' waning tendency to be active members of civic and community associations.

80 Forester, *The Deliberative Practitioner,* 115–16.

81 Rheingold, "Technologies of Cooperation," 33, 35.

82 Fisher, "Tim Rollins + Kids of Survival," 111.

83 See, for example, the entry on Tim Rollins on the Museum of Modern Art's website: "Influenced by the theories of Brazilian educationalist Paulo Freire, Rollins led the students to develop work out of critical engagement with texts, often classics of western literature." Morgan Falconer, "About This Artist" (from Grove Art Online), 2009, http://www.moma.org/collection/artist.php?artist_id=19238.

84 Wallace, "Tim Rollins and K.O.S.," 43.

85 Lasswell, "True Colors," 30–38.

86 Romaine, "Making History," 47.

87 Lacy, *Leaving Art.*

88 Kelley, "The Body Politics of Suzanne Lacy," 245.

89 Lee, interview, 229.

90 Phillips, "Points of Departure," 22.

91 David Hammons, interview by the author, spring 1997.

92 Mary Jane Jacob, interview by the author, June 2011.

93 Jacob, Brenson, and Olson, *Culture in Action.*

94 Felshin, *But Is It Art?,* 18–22.

95 Lacy, *Mapping the Terrain,* 23.

96 Bourriaud, *Relational Aesthetics,* 14–15.

97 Ibid., 21, 28.

98 Ibid., 82.

99 Foster, "Chat Room," 193.

100 Bishop, *Participation,* 13.

101 Kester, *Conversation Pieces,* 90.

102 Jacob, "Reciprocal Generosity," 5; van Heeswijk, "A Call for Sociality," 85; McIlveen, "Exchange — The 'Other' Social Sculpture," 179.

103 Sholette and Stimson, *Collectivism after Modernism,* 13.

104 Spector, "theanyspacewhatever," 15–16.

TWO COOPERATION GOES PUBLIC

Consequences and 100 Victories, Martinez and Horowitz

1 Kwon, *One Place after Another,* 140.

2 Bourriaud, *Relational Aesthetics,* 85.

3 Horowitz later explained that that sentence was his paraphrase or interpretation of the following sentences from Adorno's *Negative Dialectics*: "That which is differentiated appears as divergent, dissonant, negative, so long as consciousness must push towards unity according to its own formation: so long as it measures that which is not identical with itself, with its claim to the totality. This is what dialectics holds up to the consciousness as the contradiction." Adorno, *Negative Dialec-*

tics, trans. Dennis Redmond, 2001, "Introduction," Dialectics Not a Standpoint
16–18, http://members.efn.org/~dredmond/ndtrans.html, accessed May 16, 2012.

Chicago Urban Ecology Action Group, Naomi Beckwith

1 Kwon, *One Place after Another*, 126, 153.
2 Jacob, Brenson, and Olson, *Culture in Action.*

THREE MUSEUM, EDUCATION, COOPERATION

Memory of Surfaces, Pujol and Henry

1 Dominic Willsdon, email message to author, April 22, 2009.

FOUR OVERVIEW

Grant Kester

1 Kester, *Conversation Pieces*, 13, 8–9.
2 Grant Kester, letter to the editor, *Artforum*, May 2006, 22.
3 Claire Bishop, letter to the editor, *Artforum*, May 2006, 23.
4 Sedgwick, *Touching Feeling*, 140.
5 Gioni and Kontova, "Vanessa Beecroft," 97.
6 Bourriaud, *Relational Aesthetics*, 14.
7 Miles, *Art, Space and the City.*

FIVE SOCIAL VISION, COOPERATIVE COMMUNITY

Project Row Houses, Lowe and Stern

1 "About Project Row Houses," http://projectrowhouses.org/about, accessed March 7, 2011.
2 Jacobs, *The Death and Life of Great American Cities*, 293–94, 317.

SIX PARTICIPATION, PLANNING, COOPERATIVE FILM

Blot Out the Sun, Fletcher and Seltzer

1 Fletcher and July started the website Learning to Love You More (http://www
.learningtoloveyoumore.com) in 2002. The last posts were accepted on May 1,
2009. A book version with the same title was published in 2007.
2 "Assignment #50: Take a flash photo under your bed," http://www.learningtolove
youmore.com/reports/50/50.php, accessed March 7, 2011. Fletcher and July added
this proviso: "Don't vacuum or alter anything under your bed beforehand. Take a
photo under there with a strong flash, preferably with the camera sitting on the
ground. Make sure your photograph is in focus! We are looking for photos that
depict the space between the bottom of the bed and the floor, please do not send
us photos if your bed is flush against the floor or if it is a loft bed."
3 Davies, "Two Versions of Engagement," 9.
4 Seltzer, "Maintaining the Working Landscape," and "It's Not an Experiment."

Blot Out the Sun, Jay Dykeman

1 Libby Tucker, "Jay's Garage in Portland Is First and Only Service Station in City to Offer B99 Biodiesel," *Daily Journal of Commerce* (Portland, Ore.), December 7, 2005.

SEVEN EDUCATION ART

Cátedra Arte de Conducta, Tania Bruguera

1 Finkelpearl, *Dialogues in Public Art,* 239–40.
2 The other Cuban artists in the residency, which took place at the Fundación Museo de Arte Contemporáneo de Maracay Mario Abreu, Maracay, Venezuela, in February–March 1998, were Sandra Ramos, Carlos Garaicoa, and Luis Gómez.
3 Only Garaicoa committed to give workshops at *Cátedra Arte de Conducta.* He taught two courses.
4 The Escuela de Artes Plásticas "San Alejandro" is a high school specializing in visual art.

Cátedra Arte de Conducta, Claire Bishop

1 The 16Beaver website describes the group thus: "16Beaver is the address of a space initiated/run by artists to create and maintain an ongoing platform for the presentation, production, and discussion of a variety of artistic/cultural/economic/political projects. It is the point of many departures/arrivals." "About 16Beaver," http://16beavergroup.org/about/, accessed November 1, 2009.
2 In 1964, for example, Althusser wrote, "The function of teaching is to transmit a determinate knowledge to subjects who do not possess this knowledge. The teaching situation thus rests on the absolute condition of *an inequality between a knowledge and a nonknowledge.*" "Problèmes Etudiants," *La Nouvelle Critique* 152 (January 1964), quoted in Ross, introduction to *The Ignorant Schoolmaster,* xvi. Althusser would also argue that this model is essential for students to understand their class position.
3 Pawel Althamer, *Einstein Class,* 2005, is described thus on the website of CUBITT Gallery and Studios: "Commissioned to make a project as part of a major celebration of Einstein's centenary in and around Berlin, Althamer used the funds to give physics classes to a group of twelve to sixteen year old boys who rarely attend school, face problems of various kinds, and hang out in the deprived neighbourhood in Warsaw where the artist's studio is situated. Led by a maverick physics teacher, who'd recently been made redundant, the boys learnt about Einstein's discoveries through practical experimentation in a rented building that served as their classroom. During the six months the project lasted, the kids went on trips to the countryside, had a week's vacation by the sea and travelled to Berlin for the opening, which for some was the first time they'd been outside Warsaw. It culminated with an outdoor science day on their own street for family, friends and neighbours. The children's experiences are documented in a half hour feature film, which receives its UK debut at Cubitt. In addition, to benefit the participants and perpetuate the project, two children who took part in 'Einstein Class' will be given a short holiday in London. 'Einstein Class' has an autobiographical dimension: Althamer,

who was disenchanted at school, devised the project according to what he would have wished for as a young boy." "What Have I Done to Deserve This?," http:// www.cubittartists.org/index.php?module=eventsmodule&action=view&id=36, accessed November 1, 2009.

4 Lind, "Models of Criticality," 150.

5 The online journal *LatinArt.com* described the performance thus: "Bruguera emphasized simplicity. She set up a podium with live microphones for members of the public to say whatever they wanted for one minute. Meanwhile a man and a woman dressed in Ministry of the Interior uniforms placed a white dove on each participant's shoulder as she or he spoke, and then helped them off the stage once their time was up. In the meantime the public took photographs, making use of the two hundred disposable cameras given away by the artist. Taking advantage of the mikes and the podium, various bloggers and opponents blasted the lack of freedom of expression on the island. Following the incident, the Biennial's organizing committee issued a press release calling the participants 'anti-Cuban dissidents' and labeling the event an 'anti-cultural act.'" Estrada and León, "10th Havana Biennial."

6 In a paper presented to the Conference of Europeanists in March 2002 in Chicago, Luc Boltanski and Eve Chiapello summarized the new spirit thus: "A new representation of the firm has emerged, featuring an organization that is very flexible; organized by projects; works in a network; features few hierarchical levels; where a logic of transversal flows has replaced a more hierarchical one, etc. This new representation contrasts specifically with a former representation of the firm, one that had focused on an organization which is hierarchical, integrated and geared towards the internal realization of activities (vertical integration). This had been a dominant form during the 1960s, praised at the time but subsequently decried (by the 1990s authors) for its excessive 'bureaucracy.' In addition, a new type of commitment has been promised in the economic domain—one that suits the new spirit of capitalism." http://www.sociologiadip.unimib.it/mastersqs/rivi/boltan .pdf (p. 4), accessed December 12, 2009.

EIGHT A POLITICAL ALPHABET

Arabic Alphabet, Ewald and Farganis

1 *Wendy Ewald—Secret Games: Collaborative Work with Children 1969–1999* was organized by the Addison Gallery with the Center for Documentary Studies, Duke University.

2 Ken Johnson, "Images of Innocence: Young Enough to See All Things Honestly," *New York Times*, April 4, 2003.

3 Corey Kilgannon, "A Single Alphabet Bridges Children's Two Cultures," *New York Times*, April 7, 2003.

4 See Taylor, "The Politics of Recognition"; Guttmann, introduction to *Multiculturalism*.

NINE CROSSING BORDERS

Lasch and Cruz

1 Rakowitz, "The Artists' Artists," 110.

2 Nicolai Ourousoff, "Learning from Tijuana: Hudson, N.Y., Considers Different Housing Model," *New York Times*, February 19, 2008.

3 Gonzalez, exhibition publication for "New Modes of Contemporary Urbanism."

4 Latour, *Reassembling the Social.*

5 After Cruz made this comment, I contacted Bruguera and asked if she would like to install a urinal almost exactly like the one that Duchamp declared an artwork in a men's room at the Queens Museum, enacting her desire to restore the urinal into the flow of use. The urinal was installed in the spring of 2011.

TEN SPIRITUALITY AND COOPERATION

Unburning and *Packer School*, Cook and Ukeles

1 Kuspit, "Concerning the Spiritual in Contemporary Art," 313.

2 Michael Brenson, "How the Spiritual Infused the Abstract," *New York Times*, December 21, 1986.

The Seer Project, Lee Mingwei

1 Beuys, "I Am Searching for Field Character," 26.

2 Rick Lowe quoted in Michael Kimmelman, "In Houston, Art Is Where the Home Is," *New York Times*, December 17, 2006.

3 Larson, "Shaping the Unbound," 65.

4 Lacy, "Having It Good," 102.

5 Teil Silverstein, email message to author, September 21, 2009.

6 Kay Larson, "Transforming Death's Wound: A Healing Art," *New York Times*, November 15, 1998.

7 Jullien, *In Praise of Blandness.*

ELEVEN INTERACTIVE INTERNET COMMUNICATION

White Glove Tracking, Evan Roth

1 Rheingold, "Technologies of Cooperation," 33.

2 Michiko Kakutani, "A Rebel in Cyberspace, Fighting Collectivism," review of *You Are Not a Gadget* by Jaron Lanier, *New York Times*, January 15, 2010.

3 "Available Online for Free," http://evan-roth.com/available-online-for-free-book .php, accessed June 30, 2011.

4 This observation is based on a Google search on January 1, 2010. The search was conducted on a computer of a friend who had not previously searched for any of Roth's work, so presumably it was a neutral search uninfluenced by my own previous searches.

White Glove Tracking, Jonah Peretti

1 Peretti, interview.

Pragmatism and Social Cooperation

1 West, *The American Evasion of Philosophy*, 5.

2 Ibid., 92.

3 Dewey, "The Need for a Recovery of Philosophy," 41.

4 James, *Pragmatism and Other Writings*, 88.

5 Dewey, "The Influence of Darwin on Philosophy," 39.

6 Rorty, "Universality and Truth," 24.

7 Dewey, "The Influence of Darwin on Philosophy," 44.

8 Dewey, "The Ethics of Democracy," 231–32.

9 Honneth, "Democracy as Reflexive Cooperation," 775, 765, 767.

10 Depew, introduction to *Pragmatism*, 8.

11 Dewey, *Art as Experience*, 3, 9, 8.

12 Ibid., 358.

13 Beuys, "Not Just a Few Are Called, but Everyone," 891.

14 Westbrook, *John Dewey and American Democracy*, 394.

15 John Dewey, letter to Alice Dewey, quoted in Menand, *The Metaphysical Club*, 295.

16 Shusterman, *Pragmatist Aesthetics*, xi.

17 Dewey, *Art as Experience*, 9.

18 Kelley, introduction to *Essays on the Blurring of Art and Life*, xvi.

19 Mary Jane Jacob, email message to author, March 15, 2010.

20 Dewey, "My Pedagogic Creed," 229, 230, 233.

21 Ibid., 234.

22 West, *The American Evasion of Philosophy*, 84.

23 Ryan, *John Dewey and the High Tide of American Liberalism*, 352, 343–44. Ryan describes, for example, a vituperative and amazingly inaccurate attack on Dewey by Russell Kirk in his book *The Conservative Mind* (Chicago: H. Regnery, 1953).

24 Ryan, *John Dewey and the High Tide of American Liberalism*, 355.

25 Rorty, *Objectivity, Relativism, and Truth*, 198–99.

26 Rorty, *Achieving Our Country*, 31.

27 Ibid., 93–94.

28 Ibid., 43.

29 Rorty, *Philosophy and Social Hope*, 119.

30 The website of *Project Row Houses* states that their programs "are inspired by the work of world renowned artist Dr. John Biggers (1924–2001) and his principles concerning the creation of effective communities," specifically that "art and creativity should be viewed as an integral part of life"; that "quality education is defined through impartation of knowledge and wisdom—including understanding that is passed from generation to generation"; that "strong neighborhoods have social safety nets"; and that communities need "good and relevant architecture, meaning housing that should not only be well designed, but also make sense to preserve a community's historic character." "About Project Row Houses," http://projectrowhouses.org/about, accessed May 1, 2011.

31 Dewey, *Art as Experience*, 9.

32 Peter Coy, "How Houston Gets Along without Zoning," October 1, 2007, *Bloomberg BusinessWeek*, http://www.businessweek.com.

33 Rick Lowe, conversation with author, January 12, 2010.

34 Jacobs, *The Death and Life of Great American Cities*, 50.

35 Fullilove, "The Logic of Small Pieces," 75–76.

36 Rick Lowe quoted in Michael Kimmelman, "In Houston, Art Is Where the Home Is," *New York Times*, December 17, 2006.

37 Hayden, *The Port Huron Statement*, 53–54.

BIBLIOGRAPHY

Alinsky, Saul. *Reveille for Radicals*. New York: Vintage Books, 1946.

———. *Rules for Radicals*. 1971. New York: Vintage Books, 1989.

Arnstein, Sherry. "A Ladder of Citizen Participation." 1969. *The City Reader*, edited by Richard T. LeGates and Frederic Stout, 4th ed. New York: Routledge, 2007, 233–44.

Bass, Jacquelynn, and Mary Jane Jacob, eds. *Buddha Mind in Contemporary Art*. Berkeley: University of California Press, 2004.

Becker, Carol. "The Education of Young Artists and the Issue of Audience." *Zones of Contention: Essays on Art, Institutions, Gender, and Anxiety*. Albany: State University of New York Press, 1996, 101–12.

Bellah, Robert. "Community Properly Understood: A Defense of 'Democratic Communitarianism.'" *The Essential Communitarian Reader*, edited by Amitai Etzioni. Lanham, Md.: Rowman and Littlefield, 1998, 15–21.

Beuys, Joseph. "I Am Searching for Field Character." 1973. *Energy Plan for the Western Man: Joseph Beuys in America*, edited by Carin Kuoni. New York: Four Walls Eight Windows, 1990, 21–25.

———. "Not Just a Few Are Called, but Everyone." Interview by Georg Jappe. 1972. *Art in Theory, 1900–1990*, edited by Charles Harrison and Paul Wood. Oxford: Blackwell, 1992, 889–92.

———. "A Public Dialogue." 1974. *Energy Plan for the Western Man: Joseph Beuys in America*, edited by Carin Kuoni. New York: Four Walls Eight Windows, 1990, 25–39.

———. "Spade with Two Handles." 1965. *Energy Plan for the Western Man: Joseph Beuys in America*, edited by Carin Kuoni. New York: Four Walls Eight Windows, 1990, 127–29.

Bishop, Claire. "Antagonism and Relational Aesthetics." *October* 110 (fall 2004): 51–79.

———, ed. *Participation*. London: Whitechapel, 2006.

———. "The Social Turn: Collaboration and Its Discontents." *Artforum*, February 2006, 178–83.

Boal, Augusto. *Games for Actors and Non-actors*. Translated by Adrian Jackson. London: Routledge, 1992.

———. *Theatre of the Oppressed*. New York: Theatre Communications Group, 1993.

Boltanski, Luc, and Eve Chiapello. *The New Spirit of Capitalism*. Translated by Gregory Elliott. New York: Verso, 2005.

Bourriaud, Nicolas. *Relational Aesthetics*. Dijon: Les Presses du réel, 2002.

Braunstein, Peter, and Michael William Doyle, eds. *Imagine Nation: The American Counter Culture of the 1960s and '70s*. New York: Routledge, 2002.

Brookings Institution Metropolitan Policy Program. *The State of Metropolitan America: Race and Ethnicity*. May 9, 2010. http://www.brookings.edu.

Case, John, and Rosemary C. R. Taylor, eds. *Co-ops, Communes, and Collectives: Experiments in Social Change in the 1960s and 1970s*. New York: Pantheon Books, 1979.

Crimp, Douglas, with Adam Rolston. *AIDS Demo Graphics*. Seattle: Bay Press, 1990.

Davies, Jon. "Two Versions of Engagement." *C Magazine* 95 (fall 2007): 7–9.

Davis, Mike. *Magical Urbanism: Latinos Reinvent the U.S. City*. New York: Verso, 2000.

Debord, Guy. *Society of the Spectacle*. Translated by Ken Knabb. London: Rebel Press, 1983.

———. "Towards a Situationist International." 1957. *Participation*, edited by Claire Bishop. London: Whitechapel, 2006, 98–99.

Depew, David. Introduction to *Pragmatism: From Progressivism to Postmodernism*, edited by Robert Hollinger and David Depew. Westport, Conn.: Praeger, 1990, xiii–xviii.

Dewey, John. *Art as Experience*. 1934. New York: Pedigree, 1980.

———. "The Ethics of Democracy." *The Early Works of John Dewey, 1882–1898*, edited by George Axtelle et al. Carbondale: Southern Illinois University Press, 1969, 1:227–53.

———. "The Influence of Darwin on Philosophy." 1909. *The Essential Dewey*, edited by Larry A. Hickman and Thomas M. Alexander. Bloomington: Indiana University Press, 1998, 1:39–46.

———. "My Pedagogic Creed." *The Essential Dewey*, edited by Larry A. Hickman and Thomas M. Alexander. Bloomington: Indiana University Press, 1998, 1:229–36.

———. "The Need for a Recovery of Philosophy." 1917. *Dewey on Experience, Nature, and Freedom: Representative Selections*, edited by Richard J. Bernstein. Indianapolis: Bobbs-Merrill, 1960, 19–70.

Doherty, Claire, ed. *Contemporary Art from Studio to Situation*. London: Black Dog, 2004.

Doyle, Michael William. "Staging the Revolution: Guerilla Theater as Countercultural Practice 1965–68." *Imagine Nation: The American Counter Culture of the 1960s and '70s*, edited by Peter Braunstein and Michael William Doyle. New York: Routledge, 2002, 71–98.

Estrada, Pily, and Christian Léon. "10th Havana Biennial." *Latin Art*, November 1, 2009. http://LatinArt.com.

Evans, Sara. *Personal Politics*. New York: Vintage Books, 1979.

Ewald, Wendy. *American Alphabets*. New York: Scalo Books, 2005.

Felshin, Nina, ed. *But Is It Art? The Spirit of Art as Activism*. Seattle: Bay Press, 1995.

Finkelpearl, Tom. *Dialogues in Public Art*. Cambridge, Mass.: MIT Press, 2000.

Firestone, Shulie, and Anne Koedt, eds. *Notes from the Second Year: Women's Liberation*. New York: Radical Feminism, 1970.

Fisher, Jean. "Tim Rollins + Kids of Survival." *Artforum*, January 1987, 111.

Fletcher, Harrell, and Miranda July. Learning to Love You More. http://www.learningtoloveyoumore.com.

———. *Learning to Love You More*. Munich: Prestel, 2007.

Forester, John. *The Deliberative Practitioner: Encouraging Participatory Planning Processes*. Cambridge, Mass.: MIT Press, 1999.

Foster, Hal. "Chat Room" (2004). *Participation*, edited by Claire Bishop. London: Whitechapel, 2006, 190–95.

Freire, Paulo. *Pedagogy of the Oppressed*. New York: Continuum, 1993.

Friedan, Betty. *The Feminine Mystique*. 1963. 6th ed. New York: W. W. Norton, 1997.

Fullilove, Mindy Thompson. "The Logic of Small Pieces." *What We See: Advancing the*

Observations of Jane Jacobs, edited by Stephen A. Goldsmith and Lynne Elizabeth. Oakland, Calif.: New Village Press, 2010, 68–77.

Gioni, Massimiliano, and Helena Kontova. "Vanessa Beecroft: Skin Trade." *Flash Art International* 228 (January–February 2003): 97.

Gonzalez, Jennifer A. Exhibition publication for "New Modes of Contemporary Urbanism." Movimiento de Arte y Cultura Latino Americana, San Jose, Calif., October 2010.

Gordon, Richard E., Katherine K. Gordon, and Max Gunther. *The Split Level Trap*. New York: Bernard Geis Associates, 1960.

Guttmann, Amy, ed. *Multiculturalism: Examining the Politics of Recognition*. Princeton: Princeton University Press, 1994.

Hanisch, Carol. "A Critique of the Miss America Protest." 1968. *Public Women, Public Words: A Documentary History of American Feminism*, vol. 3, edited by Dawn Keetley and John Pettegrew. Lanham, Md.: Rowman and Littlefield, 2005, 169–72.

———. "The Personal Is Political." 1969. *Feminist Revolution*, edited by Redstockings. New York: Random House, 1975, 204–5.

Hayden, Dolores. *Redesigning the American Dream: Gender, Housing, and Family Life*. 1984. Rev. ed. New York: W. W. Norton, 2002.

Hayden, Tom. *The Port Huron Statement: The Visionary Call of the 1960s Revolution*. New York: Thunder Mouth Press, 2005.

Hendricks, Jon. *Fluxus Codex*. New York: Harry N. Abrams, 1988.

Hickman, Larry A., and Thomas M. Alexander, eds. *The Essential John Dewey*, vol. 1. Bloomington: Indiana University Press, 1998.

Hoffman, Abbie. *The Autobiography of Abbie Hoffman*. New York: Four Walls Eight Windows, 1980.

Honneth, Axel. "Democracy as Reflexive Cooperation: John Dewey and the Theory of Democracy Today." *Political Theory* 26 (December 1998): 763–83.

IRWIN, eds. *East Art Map: Contemporary Art and Eastern Europe*. London: Afterall, 2006.

Jacob, Mary Jane. *Gordon Matta-Clark: A Retrospective*. Exhibition catalogue. Chicago: Museum of Contemporary Art, 1985.

———. "Reciprocal Generosity." *What We Want Is Free: Generosity and Exchange in Recent Art*, ed. Ted Purves. Albany: State University of New York Press, 2005, 3–10.

Jacob, Mary Jane, Michael Brenson, and Eva M. Olson. *Culture in Action: A Public Art Program of Sculpture Chicago*. Seattle: Bay Press, 1995.

Jacobs, Jane. *The Death and Life of Great American Cities*. New York: Random House, 1961.

James, William. *Pragmatism and Other Writings*. New York: Penguin, 2000.

Jullien, François. *In Praise of Blandness*. New York: Zone Books, 2004.

Kaprow, Allan. *Essays on the Blurring of Art and Life*. Edited by Jeff Kelley. Berkeley: University of California Press, 1993.

———. "Success and Failure When Art Changes." *Mapping the Terrain: New Genre Public Art*, edited by Suzanne Lacy. Seattle: Bay Press, 1995, 152–58.

Kelley, Jeff. "The Body Politics of Suzanne Lacy." *But Is It Art? The Spirit of Art as Activism*, edited by Nina Felshin. Seattle: Bay Press, 1995, 221–51.

———. *Childsplay: The Art of Allan Kaprow*. Berkeley: University of California Press, 2004.

―――. Introduction to *Essays on the Blurring of Art and Life*, by Allan Kaprow, edited by Jeff Kelley. Berkeley: University of California Press, 1993, xi–xxvi.

Kester, Grant. "Aesthetic Evangelists: Conversion and Empowerment in Contemporary Community Art." *Afterimage* 22 (January 1995): 5–11.

―――. *Conversation Pieces: Community and Communication in Modern Art.* Berkeley: University of California Press, 2004.

Kohl, Herbert. *36 Children.* New York: Signet, 1968.

Krugman, Paul. "Things Pull Apart." *The Great Unraveling: Losing Our Way in the New Century.* New York: W. W. Norton, 2003, 219–21.

Kruse, Kevin M. *White Flight: Atlanta and the Making of Modern Conservatism.* Princeton: Princeton University Press, 2005.

Kuoni, Carin, ed. *Energy Plan for the Western Man: Joseph Beuys in America.* New York: Four Walls Eight Windows, 1990.

Kuspit, Donald. "Concerning the Spiritual in Contemporary Art." *The Spiritual in Art: Abstract Painting, 1890–1985*, edited by Maurice Tuchman. Exhibition catalogue. New York: Abbeville, 1986, 313–25.

Kwon, Miwon. *One Place after Another: Site-Specific Art and Locational Identity.* Cambridge, Mass.: MIT Press, 2002.

Lacy, Suzanne. "Having It Good." *Buddha Mind in Contemporary Art*, edited by Jacquelynn Bass and Mary Jane Jacob. Berkeley: University of California Press, 2004, 97–113.

―――. *Leaving Art: Writings on Performance, Politics, and Publics, 1974–2007.* Durham: Duke University Press, 2010.

―――, ed. *Mapping the Terrain: New Genre Public Art.* Seattle: Bay Press, 1995.

Larson, Kay. "Shaping the Unbound." *Buddha Mind in Contemporary Art*, edited by Jacquelynn Bass and Mary Jane Jacob. Berkeley: University of California Press, 2004, 61–75.

Lasswell, Mark. "True Colors: Tim Rollins's Odd Life with the Kids of Survival." *New York Magazine*, July 29, 1991, 30–38.

Latour, Bruno, *Reassembling the Social: An Introduction to Actor-Network Theory*, Oxford: Oxford University Press, 2005.

Lee Mingwei. Interview by Mary Jane Jacob. *Buddha Mind in Contemporary Art*, edited by Jacquelynn Bass and Mary Jane Jacob. Berkeley: University of California Press, 2004, 228–33.

Levin, Kim. Introduction to *Energy Plan for the Western Man: Joseph Beuys in America*, edited by Carin Kuoni. New York: Four Walls Eight Windows, 1990, 1–6.

Lind, Maria, "Models of Criticality." *Contextualize.* Hamburg: Kunstverein Hamburg, 2002, 150–60.

Maciunas, George. Interview by Larry Miller. 1978. *Mr. Fluxus*, by Emmett Williams and Ann Noel. London: Thames and Hudson, 1997, 114.

Martin, Bradford. *The Theater Is the Street: Politics and Public Performance in Sixties America.* Amherst: University of Massachusetts Press, 2004.

McIlveen, Francis. "Exchange—The 'Other' Social Sculpture." *What We Want Is Free: Generosity and Exchange in Recent Art*, edited by Ted Purves. Albany: State University of New York Press, 2005, 169–82.

Menand, Louis. *The Metaphysical Club.* New York: Farrar, Straus and Giroux, 2001.

Michaels, Debra. "From 'Consciousness Expansion' to 'Consciousness Raising': Feminism and the Countercultural Politics of Self." *Imagine Nation: The American Counter Culture of the 1960s and '70s*, edited by Peter Braunstein and Michael William Doyle. New York: Routledge, 2002, 41–69.

Miles, Malcolm. *Art, Space and the City: Public Art and Urban Fixtures*. London: Routledge, 1997.

Miller, Timothy. "The Sixties-Era Communes." *Imagine Nation: The American Counter Culture of the 1960s and '70s*, edited by Peter Braunstein and Michael William Doyle. New York: Routledge, 2002, 327–52.

Mulvey, Laura. "Visual Pleasure and Narrative Cinema." 1975. *Visual and Other Pleasures*. Bloomington: Indiana University Press, 1989, 14–28.

Mumford, Lewis. *The City in History: Its Origins, Its Transformations, and Its Prospects*. New York: Harcourt, Brace and World, 1961.

New York Radical Women. "No More Miss America!" 1968. *The Times Were A Changin': The Sixties Reader*, edited by Irwin Unger and Debi Unger. New York: Three Rivers Press, 1998, 212–13.

Oliver, Susan. *Betty Friedan: The Personal Is Political*. New York: Pearson Longman, 2008.

Patterson, James T. *Grand Expectations: The United States, 1945–1974*. New York: Oxford University Press, 1996.

———. *Restless Giant: The United States from Watergate to Bush v. Gore*. New York: Oxford University Press, 2005.

Peretti, Jonah. Interview by Jen Chung. June 4, 2005. Gothamist. http://gothamist.com.

Phillips, Patricia. "Points of Departure: Public Art's Intentions, Indignities, and Interventions." *Sculpture* 17, no. 3 (March 1998): 18–25.

Purves, Ted, ed. *What We Want Is Free: Generosity and Exchange in Recent Art*. Albany: State University of New York Press, 2005.

Rakowitz, Michael. "The Artists' Artists: To Take Stock of the Past Year." *Artforum*, December 2009, 110.

Rancière, Jacques. *The Ignorant Schoolmaster: Five Lessons in Intellectual Emancipation*. Translated by Kristin Ross. Palo Alto, Calif.: Stanford University Press, 1991.

Redstockings, eds. *Feminist Revolution*. New York: Random House, 1975.

Rheingold, Howard. "Technologies of Cooperation." *The Art of Free Cooperation*, edited by Geert Lovink and Trebor Scholz. Brooklyn: Autonomedia, 2007, 29–65.

Romaine, James. "Making History." *Tim Rollins and K.O.S.: A History*, edited by Ian Berry. Cambridge, Mass.: MIT Press, 2009, 41–99.

Rorty, Richard. *Achieving Our Country: Leftist Thought in Twentieth-Century America*. Cambridge, Mass.: Harvard University Press, 1998.

———. *Objectivity, Relativism, and Truth*. Cambridge: Cambridge University Press, 1991.

———. *Philosophy and the Mirror of Nature*. Princeton: Princeton University Press, 1979.

———. *Philosophy and Social Hope*. London: Penguin Books, 1999.

———. "Universality and Truth." *Rorty and His Critics*, edited by Robert B. Brandom. Oxford: Blackwell, 2000, 1–31.

Ross, Kristin. Translator's introduction to *The Ignorant Schoolmaster: Five Lessons in Intellectual Emancipation*, by Jacques Rancière, translated by Kristin Ross. Palo Alto, Calif.: Stanford University Press, 1991.

Ryan, Alan. *John Dewey and the High Tide of American Liberalism*. New York: W. W. Norton, 1995.

Ryan, Mary. "Gender and Public Access." *Habermas and the Public Sphere*, edited by Craig Calhoun. Cambridge, Mass.: MIT Press, 1992, 259–89.

Sarachild, Kathie. "Consciousness-Raising: A Radical Weapon." *Feminist Revolution*, edited by Redstockings. New York: Random House, 1975, 144–51.

Schjeldahl, Peter. "Proto SoHo: Gordon Matta-Clark and 112 Greene Street." *New Yorker*, January 7, 2011, 80–81.

Schumacher, Brian James. "Potential of the City: Interventions of the Situationist International and Gordon Matta-Clark." Master's thesis, University of California, San Diego, 2008.

Sedgwick, Eve Kosofsky. *Touching Feeling: Affect, Pedagogy and Performativity*. Durham: Duke University Press, 2003.

Seltzer, Ethan. "It's Not an Experiment: Regional Planning at Metro, 1990 to the Present." *The Portland Edge: Challenges and Successes in Growing Communities*, edited by Connie P. Ozawa. Washington, D.C.: Island Press, 2004, 35–60.

———. "Maintaining the Working Landscape: The Portland Metro Urban Growth Boundary." *Regional Planning for Open Space*, edited by Arnold van der Valk and Terry van Dijk. London: Routledge, 2009, 151–78.

Sholette, Gregory, and Blake Stimson, eds. *Collectivism after Modernism: The Art of Social Imagination after 1945*. Minneapolis: University of Minnesota Press, 2007.

Shusterman, Richard. *Pragmatist Aesthetics: Living Beauty, Rethinking Art*. Lanham, Md.: Rowman and Littlefield, 2000.

Spector, Nancy. "theanyspacewhatever: An Exhibition in Ten Parts." *theanyspacewhatever*, organized by Nancy Spector. Exhibition catalogue. New York: Guggenheim Museum, 2008, 13–29.

Starr, Paul. "The Phantom Community." *Co-ops, Communes, and Collectives: Experiments in Social Change in the 1960s and 1970s*, edited by John Case and Rosemary C. R. Taylor. New York: Pantheon Books, 1979, 245–73.

Student Nonviolent Coordinating Committee. "Statement of Purpose." 1960. *The 1960s: A Documentary Reader*, edited by Brian Ward. Chichester: Wiley-Blackwell, 2010, 69–70.

Sussman, Elisabeth, ed. *On the Passage of a Few People through a Rather Brief Moment in Time: The Situationist International 1957–1972*. Cambridge, Mass.: MIT Press, 1989.

Taylor, Charles. "The Politics of Recognition." *Multiculturalism: Examining the Politics of Recognition*, edited by Amy Guttmann. Princeton: Princeton University Press, 1994, 25–74.

Ukeles, Mierle Laderman. "Manifesto for Maintenance Art 1969!" *Documents*, no. 10 (fall 1997): 6–7.

———. "Sanitation Manifesto!" 1984. *The Act* 2, no. 1 (1990): 84–85.

van Heeswijk, Jeanne. "A Call for Sociality." *What We Want Is Free: Generosity and Exchange in Recent Art*, edited by Ted Purves. Albany: State University of New York Press, 2005, 85–100.

Wallace, Michele. "Tim Rollins and K.O.S.: The 'Amerika' Series." *Amerika: Tim Rollins and K.O.S.*, by Gary Garrels. New York: Dia Art Foundation, 1989, 37–48.

Washington, James M., ed. *A Testament of Hope: The Essential Writings of Martin Luther King Jr.* New York: Harper Collins, 1986.

West, Cornel. *The American Evasion of Philosophy.* Madison: University of Wisconsin Press, 1989.

Westbrook, Robert B. *John Dewey and American Democracy.* Ithaca, N.Y.: Cornell University Press, 1991.

Wollen, Peter. "Bitter Victory: The Art and Politics of the Situationist International." *On the Passage of a Few People through a Rather Brief Moment in Time: The Situationist International 1957–1972*, edited by Elisabeth Sussman. Cambridge, Mass.: MIT Press, 1989, 20–61.

Yenawine, Philip. "But What Has Changed?" *Art Matters: How the Culture Wars Changed America*, edited by Brian Wallis, Marianne Weems, and Philip Yenawine. New York: New York University Press, 1999, 8–23.

Note: page numbers in italics refer to figures.

TOM FINKELPEARL is the executive director of the Queens Museum of Art. He is the author of *Dialogues in Public Art* (2000) and coauthor of *David Hammons: Rousing the Rubble* (with Steve Cannon and Kellie Jones, 1991).

Library of Congress Cataloging-in-Publication Data
Finkelpearl, Tom
What we made : conversations on
art and social cooperation /
Tom Finkelpearl.
p. cm.
Includes bibliographical references and index.
ISBN 978-0-8223-5284-6 (cloth : alk. paper)
ISBN 978-0-8223-5289-1 (pbk. : alk. paper)
1. Arts and society. 2. Group work in art.
3. Community arts projects. 4. Cooperation. I. Title.
NX180.S6F56 2013 701′.03—dc23 2012033852